D1349875

HARRY JONES THADDEUS

The Life and Work of

Harry Jones Thaddeus

1859–1929

Brendan Rooney

FOUR COURTS PRESS

Typeset in 10.5 pt on 12.5 pt Ehrhardt by
Carrigboy Typesetting Services for
FOUR COURTS PRESS LTD
7 Malpas Street, Dublin 8, Ireland
e-mail: info@four-courts-press.ie
and in North America for
FOUR COURTS PRESS
c/o ISBS, 920 N.E., 58th Avenue, Suite 300, Portland, OR 97213.

A catalogue record for this title is available
from the British Library.

ISBN 1–85182–692–0

Printed in Ireland by
ßetaprint Ltd., Dublin

In memory of Terry Rooney and Jan Thaddeus

The colour illustrations in this book were funded by an admirer
of the artist, to whom the author extends heartfelt thanks.

Contents

Illustrations

FIGURES

PLATES
Plates occur between pp 176 and 177.

PHOTOGRAPHIC CREDITS

All works of art illustrated in this book are by Harry Jones Thaddeus unless otherwise stated. Further technical details (inscriptions, provenance etc.) are provided in the List of Works section. While every effort has been made to contact and obtain permission from holders of copyright, if any infringement of copyright has occurred, sincere apologies are offered and the owner of the copyright is requested to contact the author. In most cases the illustrations have

been made using photographs and transparencies provided by the owners or custodians of the associated works. Those illustrations for which further credit is due are as follows:

Abbreviations

comp(s)	compiler(s)
DL	Deputy Lieutenant
ed(s)	editor(s)
exh.	exhibited
exh. cat.	exhibition catalogue
JCHAS	*Journal of the Cork Historical and Archaeological Society*
JP	Justice of the Peace
MC	Mencken Collection, Manuscript and Archives Section, New York Public Library
MP	Member of Parliament
NEAC	New English Art Club
NGI	National Gallery of Ireland
RA	Royal Academy
RDS	Royal Dublin Society
RHA	Royal Hibernian Academy
RW	Royal Archives, Windsor
s.	signed
SBA	Society of British Artists
s.d.	signed and dated
s.d.i.	signed, dated and inscribed
SLNSW	State Library of New South Wales
TICCBC	General Minutes of the Technical Instruction Committee of the County Borough of Cork, Crawford Municipal Art Gallery, Cork

Acknowledgements

Drawing on the scholarship of others was an essential element in the production of this book, a development of my doctoral thesis. I am very grateful to Dr Philip McEvansoneya for his expertise, guidance and practical advice and to Anne Crookshank, Fellow Emerita of Trinity College, for monitoring and aiding my progress with characteristic zeal. In the early years of my research, I corresponded regularly with Dr Julian Campbell, who was always willing to share both information and insight. I also profited greatly from the assistance of Professor Roger Stalley, the Knight of Glin, Dr Nicola Figgis, Dr Síghle Bhreathnach-Lynch, Dr Niamh O'Sullivan, Catherine Marshall, Dr Stephen Vernoit, Charles Clarke, Theo Snoddy and Professor Will Vaughan.

One of my first tasks when I began my research on Thaddeus almost a decade ago was to assemble as many paintings by the artist as possible. As the vast majority are in private collections and, it seems, likely to remain there, it was necessary to keep an eye on the art market constantly, and glean whatever possible from its history. This task was made immeasurably easier by Therese and Jim Gorry, of the Gorry Gallery, Dublin, though their contribution to my work extended far beyond this. I appreciate deeply their encouragement and friendship.

In 1997, I had the enormous good fortune of tracking down the grandson of Harry Jones Thaddeus. Patrick Thaddeus, Professor of Astrophysics at Harvard University, and his wife Jan, also an academic at that university, embraced my work without hesitation, and were as forthcoming with moral support and good advice as they were with invaluable biographical information on the artist. Through my association with them, I also received the assistance of other members of the family, Anne de Lagarenne, Maria Thaddeus and Deirdre Stapp. I benefited hugely from their enthusiasm and intelligence, and feel humbled by the degree to which they trusted me to do justice to their information. Sadly, Jan, who with Patrick had retained a keen interest in my progress on the book, died towards the end of 2001.

My experiences over the last few years have demonstrated that many people had strong opinions about Thaddeus and his work, or were curious about him. Their thoughts often influenced mine, and I greatly enjoyed this discursive aspect of the research. The generosity and, in many cases, hospitality, I received from private individuals, many of whom I contacted completely out of the blue, was astonishing. Their generosity and support sustained me when my energies waned. I am particularly grateful in this regard to Dr Peter Barton, the earl of

Bessborough, Lord Clifford of Chudleigh, Paul Conran, Robert and Vivienne Davies, Major E.H.C. Davies, Ruth Downes, Viscount Duncannon, Lady Stella Durand, Lady Sheelagh and Lord Robert Goff, Fred Krehbiel, Dr Paul McMonagle; Bláthnaid O'Brolcháin, Col. Serge Paveau, Dr Tony Ryan, Dr Dan Waugh, Gerd Wetterlind, Dr Michael Whelton and the marquess of Zetland.

Various institutions provided me with privileged access to information, archives, and indeed pictures, and numerous individuals made considerable efforts to accommodate me. Among them I would like to thank especially Susan Ashworth, senior keeper at the City Museum, Lancaster; Margaret Betteridge, curator of the Sydney Town Hall Collection; Roy Brinton, formerly of Carisbrooke Castle Museum, Newport, Isle of Wight; Mary Clark, archivist with Dublin Corporation; Arthur Easton of the Manuscripts Section of the State Library of New South Wales; William Gallagher, visual arts coordinator, and Aoife Ní Bhriain, archivist, at University College Cork; Arlene Hess, librarian in the Henry Meade Williams Local History Department of Harrison Memorial Library, Carmel-by-the-Sea; the Mappin Art Gallery, Sheffield; Roy Mattocks of St John's Church, Ryde; Chris Moock of the Heatherley School of Fine Art; Peter Murray and Colleen O'Sullivan of the Crawford Municipal Art Gallery, Cork; John Owen of the Learning Resources Centre, Sandbach School, Chesire; Victoria Rawlings and Sylvia Hopkins of the National Army Museum, Chelhea; the Rev. Vincent Redden, formerly dean of St Mary's Cathedral, Sydney; the Reform Club, London; William Stingone of the New York Public Library Manuscripts Department; Dr A.F. Tatham of the Royal Geographical Society; and the staff of the Town Hall, Stratford-upon-Avon. For their photographic skills, I also owe a great debt to Stephen Burrows, Brendan Dempsey, Michael Diggin, Roy Hewson, Brian McGovern and Michael Olohan. I must also thank Trinity College Library; the British Library; Christie's, Dublin and London; Mealy's Fine Art and Rare Book Auctioneers, Co. Kilkenny; the Musée d'Orsay, Paris; Neales, Nottingham; the Royal Collection Enterprises; Sotheby's, Dublin and London; and the Walker Art Gallery, Liverpool.

Finally, I extend my heartfelt thanks to Margaret Rooney, Liam Rooney, Laurence Paveau and Alice Cooper, and to my friends, notably Eve McAulay, Barry and Eithne Cunningham, Oisín Coghlan, William Laffan, Dr Niall McCormack and Elline von Monschaw, whose loyalty was limitless, and without whose advice and encouragement this work would never have been completed.

Preface

Recollections of a court painter, the autobiography of Harry Jones Thaddeus, was published in 1912, when the artist was living in the United States. With the book, Thaddeus proved himself an entertaining author – familiar, opinionated, humorous, enthusiastic, frequently unguarded. His book provides a colourful account of the ambition, expectations and experiences of a successful society portrait painter at the end of the nineteenth century and beginning of the twentieth. It is also, however, selective, and frustratingly unreliable. In these respects, it was typical of its age. In the final decades of the nineteenth century, an astonishing number of private individuals became one-time writers, publishing memoirs, accounts of travel, and family histories. In their writings, with which they sought to bear witness to an age, anecdotes usually took precedence over analysis. Thaddeus, in his efforts to entertain, embellished repeatedly (rather than fabricated) in a manner that can, to say the least, distract and confound the reader. Acquaintances became friends, incidents were disasters, pranks gave way to pandemonium. *Recollections of a court painter* tells the reader more of Thaddeus' social life and circle than of his profession or artistic philosophy. References to individual paintings or professional practice are piecemeal, and often justified by fond remembrances or, conversely, obloquy. It is an anthology of anecdotes. Predictably perhaps, in it Thaddeus did not engage in the self-assessment and catharsis that characterized the published manifestos and reflections of subsequent generations of artists. Ultimately, *Recollections of a court painter* represented the manner in which Thaddeus wished to be seen and remembered, rather than the actuality of his life and work.

Thaddeus was a prodigy, and from humble beginnings and a provincial, though sound, early artistic education, earned plaudits from all quarters, and in turn made astonishing progress professionally. He developed a valuable talent for recognising and exploiting social and professional opportunities, and by his mid-twenties had made the acquaintance and/or secured the patronage of some of Europe's most elevated individuals and families. His sitters included royalty, nobility, politicians, diplomats, academics and senior ecclesiastical figures, including two popes. He was lionized by the Irish press, who remained loyal to him right to the end of his career in Europe, despite the fact that he did not live in Ireland again having left in his late teens. Earning a living as a portrait painter both facilitated and complemented his ever-present *wanderlust*, and he travelled all over the world, working throughout. Portraiture also provided Thaddeus, for most of his life, with the means of maintaining a high standard of living, but

also exposed him to many associated risks and pitfalls. He exhibited regularly in Ireland and England, and never lost interest in, or contact with, his native city and country. Ostensibly, his life was carefree, glamorous and cosmopolitan.

There were, however, other elements to Thaddeus' life and work crucial to our understanding of him, which he did not address in his writings and were not suggested by his portrait commissions. Throughout his life, conflicts arose, again both social and professional, the resolution of which had a profound bearing on the art that he produced, and on the way his image as a professional artist developed. Some of these issues pursued him through his working life, others he dealt with directly as they arose. Conspicuous among them was an ongoing conflict between artistic invention, which allowed him to realize his creative potential, and artistic convention, which ensured his livelihood. Thaddeus' pragmatism was equalled only by his ambition, and the influence that these characteristics exercised on his decision-making and, consequently, his career, underpins this study.

When Thaddeus emigrated to the United States with his family in his late forties, he removed himself almost entirely from European art circles. His enviable reputation and profile, which had reached their highest pitch between the mid-1880s and the mid-1890s, departed with him. Approximately ten years later, he returned to a Britain that did not know him and, in 1929, died in relative obscurity. Over subsequent decades, his extraordinary achievements were all but forgotten. His name occasionally featured in the pages of newspapers in his native Cork, but a wider interest in his art only re-emerged in the mid 1980s, as his works began to appear in the market place, in response to a growing appetite for Irish nineteenth-century painting in general.

The breadth of Thaddeus' work is remarkable, not least because he made his name and fortune primarily as a portrait painter. Moreover, portrait painting was the aspect of his profession that he seemed eager to promote in conversation, and in print, with its *haute monde* associations and lucrative benefits. During his career, Thaddeus produced historical, literary and biblical works, landscapes and genre paintings. Indeed, his genre paintings are often among his most intriguing, technically complex and historically significant works. He was responsible for painting arguably the most powerful image of Irish agrarian turmoil of the nineteenth century, but never mentioned it in his writing. He painted in watercolour and oil and was, when necessary, resourceful in his use of materials. He was also a very accomplished and instinctive draughtsman, a fact recognised by those who knew him well, but of which there is no marked evidence in either his austere or saccharine society portraits.

This book is not a critique of *Recollections of a court painter*. Neither, however, does it dismiss it. Thaddeus' memoirs serve as an extensive, if sometimes shaky, framework on which to build. Presented here is a contextual reconstruction of Thaddeus' life, viewing his personality, and his work, in their

own time. It draws on new material from four continents, including the testimony of family members, friends, associates, patrons, writers and critics, as well as the invaluable evidence of the artist's pictures themselves. It places Thaddeus' artistic achievement and significance in the context of his contemporaries, in Ireland, Britain, Europe and America. Particular attention is given to his relationship with his native country, and how it found expression in his art. Thaddeus possessed a creative instinct that was more expressive and experimental than the artist himself was prepared to indulge, or even vocalize, but which was constantly and necessarily at odds with his careerist inclinations. Examining these sources and new evidence, one begins to see a much more complex, eclectic, but essentially challenged personality at work than appeared in *Recollections*. Thaddeus longed for commercial success and the respectability that accompanied it, but also wished to exercise and demonstrate publicly through his art a greater range to his talents than portraiture alone could accommodate. Fundamentally, this book seeks to establish the extent to which Thaddeus was successful in these ambitions, and, consequently, where he stands in comparison with his contemporaries, particularly in Ireland.

Beginnings in Cork

Cork is famed for its butter, drisheens and dissentions,
Its orators, artists and writers proclaim
That North Gate and South Gate have greater pretentions
Than Leinster and Ulster as cradles of fame.

(Cork poet)

Though the percentage of the population who benefited directly from it was limited, it can be said that Cork was experiencing something of an upsurge in the second half of the nineteenth century. The changes in fortune of Ireland's third city (after Dublin and Belfast) altered its aspect economically, architecturally, politically and commercially. Patrick Street, Grand Parade and the South Mall were developed into grand, wide and in some cases opulent thoroughfares, befitting a prosperous administrative and mercantile city. Cork could now boast an impressive Gothic university campus just outside the city centre, two cathedrals, St Finbarr's and St Patrick's, a sizeable railway station, a theatre, a large new Custom House built by the Harbour Commissioners and fashionable, high-quality hotels such as the Imperial and the Victoria. A number of new bridges spanned the broad River Lee, and corporate investors, such as the Steam Packet Company, erected new premises. Private enterprise also flourished, and the streets were populated with all manner of street traders, benefiting from the expanding urban middle classes who occupied the fashionable and expensive residential areas on the outskirts and in the suburbs of the city.[1]

Modern popular entertainment accompanied Cork's expansion and rising national status and citizens of all classes were provided with a wide choice of musical and theatrical entertainment. This activity focussed largely on the old Opera House, situated between the river and Patrick Street, next door to the School of Art. The building had in fact been opened in 1852 as the Athenaeum, following the first National Exhibition in Cork that year, and was intended to serve as a centre for art and industrial exhibitions. It came into the ownership of James Scanlan (1833–1909) around 1874, who added to it an auditorium large enough to seat seven hundred people, and changed the name of the venue to the

1 Pettit, 1977, pp. 251–4.

Munster Hall or Halls. Two years later, it became the Cork Theatre House Co.
Ltd. Scanlan retired in 1888, but the theatre ran as 'The Opera House' until it
was burnt down in 1955.[2] It provided a wide range of entertainment, including
'Victorian melodrama, Italian grand opera, the productions of touring com-
panies from Dublin and London, the offering of local talent'.[3]

It was into this lively urban environment that Harry Thaddeus Jones was
born, probably in 1859. The exact year of Thaddeus' birth differs from one
source to another. An article in the *New York Herald* of 1896 actually quoted
Thaddeus himself as saying that he was born in 1859. His self-portrait of 1900
is inscribed '1900, XL', which means that he *could* have been born in 1860, but,
on his marriage certificate, dated 2 November 1893, which he signed himself,
he is recorded as aged 34. Unfortunately, all parish records for that period for
Cork city were destroyed in the Custom House fire of 1922.

Thaddeus' family lived at No. 32 Nile Street (subsequently renamed Sheares
Street), a short distance from the Mardyke and St Finbarr's Cathedral, in an
area of central Cork known as 'Hammonds Marsh'. Nile Street itself was
narrow and residential, with long terraces of small houses extending along both
sides. No. 32 was probably a modest two- or three-storey house, quite narrow
and shallow. According to Victor Thaddeus, Harry's younger son, his father
'came from a large family – there were fourteen or fifteen children', so there can
have been little luxury or even comfort in a house of that size.[4] Admittedly,
there is something decidedly fanciful in Victor's account of his father's back-
ground, which may stem from his lack of familiarity with Ireland (he never
visited the country) as well as from a generally romantic image of his father's
rise from impoverished origins to international recognition. For instance, Victor
described how the windows of the cottage 'freely admitted hens and chickens;
there were pigs running around, and a donkey warmed its backside at the large
stove'. He recalled that his father used to enjoy nothing more than speaking of
his childhood in Cork, and, of all things, 'the number of loaves of bread baked
by his mother for her large family'.[5] It seems improbable that such a chaotic
environment, interrupted by farm animals and troops of children, could
accommodate artistic ambition as pronounced as that of the young Harry
Thaddeus Jones, but perhaps a lack of privilege in his youth served to trigger
that very ambition.

There was a strong artistic influence on Harry's life from the beginning.
Thomas Jones, Harry's father, was himself an artist or artisan, perhaps both. A
Cork Directory of 1871 recorded a 'Thomas Jones Japanner' at the above-
mentioned address in Nile Street.[6] This is absolutely consistent with local Cork
history, as towards the end of the century, the area of Cork known colloquially

2 MacCarthy, 1985, p. 199. 3 Pettit, 1977, pp. 281–2. 4 V. Thaddeus, Letter to H.L.
Mencken, 17 March 1943, MC. 5 Ibid. 6 O'Donovan, 'A Court Painter from Cork', 1961.

as 'The Marsh' was populated by large numbers of craftsmen and artisans, and there 'the old crafts of cabinet making, carving and gilding, copper and tin work, musical instruments, heraldic painting, and minor home industries flourished'.[7] Michael Holland, Harry's friend for many years, repeated the claim that Thomas Jones was an artificer in japanning, a technique employed to imitate the decoration of laquerwares of China and Japan, including metal objects and furniture. This copying and adaptation of Asian forms and decoration, also known as 'chinoiserie', had been popular in Europe since the seventeenth century, and was very much in demand towards the end of the nineteenth century, though the work itself was of extremely variable quality. Alternative accounts of Harry's childhood suggest that his father was not a japanner, but rather a fine artist in his own right, albeit of limited talent. Victor Thaddeus recalled that, as a child, his image of his grandfather, based on descriptions provided by Harry, was of 'a big lazy man with a big beard who made a precarious living for the family by painting murals in churches'.[8] It is difficult to accept that a city the size of Cork could support an artist whose skills were developed exclusively for mural painting. It seems more reasonable that mural painting featured among the work that Thomas Jones undertook, and that he executed church commissions, for which the remuneration may not have been considerable, to supplement his income from japanning.

There was, of course, nothing unusual in the fact that Harry's father had been an artist or artisan. There were myriad precedents for such lineage, not just in Ireland, but throughout Europe, and artistic dynasties, often incorporating cousins and in-laws, were common. Nor is this merely coincidental, as children of parents involved in arts and/or crafts would invariably have been introduced to, and in many cases, trained in artistic techniques. This was the case with Harry Thaddeus Jones, whose father encouraged him to work with him when Harry was a child. Mrs MacDonell, daughter of one of Harry's early patrons, Denny Lane, remembered that Harry was the son of a japanner, 'who painted enamel pictures on tea tins and such things' and that he [Harry] told her that as a young boy, he had spent 'most of his time painting figures of Chinese ladies on tea tins'.[9] The precision and detail that work in japanning entailed would have complemented well his early training in draughtsmanship at the Cork School of Art, enhancing his dexterity and keenness of observation. Such refined skills would also serve him well when he came to undertake his first portraits.

Harry's father was a Protestant, his mother a Catholic. There is no evidence to suggest that a mixed background complicated his childhood in any way, or had a marked influence on his political views in adulthood. The extent to which Harry practised any religion is, in any case, unknown, though he was, nominally

7 Holland, 'From the Marsh to the Vatican, 1937, p. 32. **8** V. Thaddeus, op. cit., 17 March 1943. **9** Gwynn, *Cork Examiner*, 7 August 1951.

at any rate, raised a Protestant. He certainly harboured no prejudices about either religion, and socialised comfortably with both lay and clerical members of both affiliations. According to Michael Holland, it was his mother, whose name was O'Sullivan, who chose Thaddeus as his middle name, in acknowledgement of her own faith. Blessed Thaddeus McCarthy (or Thady/Teige Machari) was bishop of Cloyne from 1490 to 1492, and traditionally has given his name to many children born in the Cork area. Holland referred to Harry's mother as 'one of the O'Sullivans of the Carberies', indicating that her family was from West Cork. Holland also claimed that Harry received dual baptism, but this seems extremely unlikely.[10]

Harry was the eldest son in the Jones family, and the only sibling to pursue a career in the arts. He was, however, not alone in displaying artistic abilities in youth. The talent and intellect of the Jones children were acknowledged by their peers. 'Among the children of the neighbourhood', wrote Diarmuid O'Donovan 'the "Joneses" were admired and respected for their book-learning, and Harry particularly for his skill in "drawing pictures".'[11] At least one other brother, Frank, showed an unusual capacity for drawing, and Henry later sent money home to him to allow him to travel to London to receive a formal art education. Unfortunately, Frank frittered the money away on alcohol, and never made the journey. His subsequent success as a soldier was, however, a source of great pride for Harry. Having enlisted in the British Army, Frank Jones reached quite a senior rank (either colonel or, more likely, sergeant-major) in the India Lancers, received a commission during the Boer War, and was a major in the Camel Corps in the First World War. He appears to have shared some of his elder brother's traits, including his jocular air, dapper appearance and even his prominent moustache. Harry would refer to Frank as 'the finest rider and swordsman in the British Army', though he probably had no evidence for this, and Frank became the 'favourite uncle' of Harry's children, despite the fact that they knew him only through anecdotes and a single photograph taken in India.[12]

Harry was indeed very fond of his siblings, and made further efforts in later years to contribute to their welfare and security. At twenty-one, due to his father's lack of work and apparent disinclination to find any, Harry was the main provider for his brothers and sisters but 'never begrudged all the money he sent home to Cork to his mother'.[13] To what extent he stayed in direct contact with them through his life is unclear, but he certainly returned to Cork on a number of occasions and, one imagines, sought them out. At least two siblings, his sisters Nelly and Lizzy, visited him while he was living away from Ireland. Victor remembered Nelly, who he always believed to be his father's

10 M. Holland, 1937. Dual baptism would not have been sanctioned, but he may have been blessed as an infant in both churches. 11 D. O'Donovan, op. cit., 1961. 12 Victor Thaddeus, Letter to H.L. Mencken, 30 May 1943, MC. 13 Ibid.

favourite sister, visiting the Thaddeus family and being doted upon by the artist, although it is not known where this meeting took place.[14] One of Harry's sisters certainly remained in Cork, though she may not have died there. In a letter of 1928 from Cork to the National Gallery of Ireland, Michael Holland referred to Harry's brother-in-law as 'his only relative here'.[15]

The Jones sons followed disparate careers. One of Harry's brothers emigrated to South Africa, where he ran a diamond mine, and married a local black woman, much to the surprise of the family.[16] Another became a fine surgeon, but died young, having contracted smallpox. As was common among Irish families throughout the nineteenth century, a number of Harry's brothers joined the British army, and served in various conflicts around the world. Unlike the above-mentioned Uncle Frank who survived it, two other brothers died in the Boer War, another while fighting in India. Yet another appears to have fought in the British Army through the First World War, and subsequently against it in Dublin during the Irish War of Independence of 1919 to 1921.[17]

Some time between the ages of ten and twelve, Harry entered the Cork School of Art, situated a short distance from his home. From a very early stage, he had expressed his rather grand ambition to become a great and famous artist. Perhaps his decision to attend the Crawford elicited less resistance from his parents than might have been the case had his father not been involved in the arts himself. One might even suppose that his father, who is unlikely to have received a formal education, artistic or otherwise, actively encouraged his eldest son to study at the Cork School, in order to ensure that he would be given a thorough grounding in technique, but also that he would be introduced early to the commercial possibilities of a career in art and to individuals who might make such a career viable.[18]

The Cork School of Art had a reputation for offering students a sound education. However, somewhat out of step with the increasing prosperity of Cork City in general, it was appallingly underfunded, and in a state of lamentable disrepair throughout Harry Thaddeus Jones' period there. A journalist writing in the *Irish Builder* some six years after Harry's arrival at the school spoke of often being 'pained in looking upon the dilapidated state of the building'.[19] Thaddeus corroborated this view with his frequently quoted description of the school as 'a ramshackle, tumble-down building, with a

14 Ibid. 15 M. Holland, Letter to B. MacNamara, 22 February 1928, NGI Archives. 16 P. Thaddeus, Letter to the author, 21 July 1997. 17 V. Thaddeus, Letter to H.L. Mencken, 30 September 1939, MC. 18 A number of artisans, albeit small, both men and women, including japanners, are listed among the students at the Cork School of Art in the 1860s. These would have been in a minority, however. 19 'Science & Art Prospects in Cork', 1876, p. 85. The author lamented further that 'notwithstanding the reputation of the city of having given birth to great artists, and acting betimes as a nursery of Art, Cork at present can boast of little'.

pathetic notice at the head of its staircase imploring students not to jump or run down in a body, as the steps would probably give way'.[20] As far as equipment and conditions were concerned, the school, cursed with 'indifferent lighting' and poor classroom facilities, had little to recommend it.[21] The *Irish Builder* went as far as to say that very little at all about the school was conducive to the production of art, claiming that it 'could not be more badly housed, and, without the building, the surroundings are the reverse of enticing in look, appearance, or approach'.[22] In his address at the prize giving ceremony in 1872, the mayor of Cork alluded specifically to the disadvantages facing students in Cork, including the lack of a municipal gallery in which students could 'instruct themselves', and the absence in the school of apartments 'in which one would go with feelings of personal comfort, and apply himself to study'.[23] Thaddeus' memories of the place were slightly more positive, tinged with a romanticism and nostalgia that belie the school's seriously regrettable state. His description, however, provided some insight into the environment and atmosphere in which the young Cork students worked.

Notwithstanding the poor resources available, and the dinginess of the building, the Cork School of Art managed to provide a comprehensive and serious, albeit conventional, instruction in art. Michael Holland, himself a student at the school, stated that the purpose of the institution was, in common with many art schools in England, to 'educate original designers – not mere copyists or rule and compass draughtsmen'. He listed the branches of instruction as 'ornament-outline drawing from the flat and round, shading, painting and modelling; geometrical and perspective drawing; drawing, painting and model-ling figures from the cast; painting in watercolours, tempera and oil; plants, fruits and flowers drawn, painted or modelled from nature; and composition as applied to design'.[24] In 1872, the schools had a total of 126 registered students. The atmosphere was positive, and regulations were, by and large, observed. Provisions were made for students unable to attend during the day, the school remaining open late into the evening, and 'night students' often excelled in the annual examinations.[25] Again, in 1872, fifty-seven students were attending classes in the evening, while sixty-nine did so during the day. The college boasted a small library, from which books were made available to students to borrow once a week. Thaddeus, a day student, is likely to have kept regular working hours, particularly in his first years at the school. His progress was

20 H.J. Thaddeus, *Recollections of a court painter*, London 1912, p. 1. In an interview with the *New York Herald*, Thaddeus was even more derogatory, quipping that 'such a crazy place as that old building was', where there was a staircase 'that trembled for its life every time you put a foot on it'. 'A Chat with a Famous Painter', 1896. **21** M. Holland, 1937. **22** *Irish Builder*, 1 April 1876. **23** *Cork Examiner*, 21 December 1872. **24** M. Holland, 1942–3, p. 100. **25** M. Holland, op. cit., 1937.

swift, and he seems to have excelled in the annual competitions that served as an incentive to the students to work and improve. The school awarded a large number of prizes every year during spring for exceptional works produced by its students in the previous year. These prizes, of which there were two sets, the 'Mayor's Prizes' and 'Local Prizes', corresponded to all the major disciplines practised at the school. A 'Henry Jones' is listed among those who received awards from the Department of Science and Art following the annual School of Art examinations in May of 1871.[26] Admittedly, references to 'Henry Jones' in the Cork records do not necessarily point to Thaddeus. Another Henry Jones, for instance, was attending the school in 1862. The reference would be consistent, however, with Thaddeus' rapid progress.

Apart from the teaching, perhaps the school's finest resource, and one of which Thaddeus himself made good use, was the set of casts that Cork city had acquired from the prince regent (later George IV) in 1818. The casts, all of which were taken from antique sculptures in the Vatican Collections, had been commissioned by Pope Pius VII as a gift to Prince George in acknowledgement of help provided in the recovery for the Vatican of treasures looted by Napoleon. The collection, the production of which had been overseen by Antonio Canova, included among others the Laöcoon, the Belvedere Torso, the Clapping Faun, the Apollo Belvedere and the Venus de Milo, and were of extremely high quality.[27] The prince regent was apparently underwhelmed by the gift and consented to have the casts taken permanently from Carlton Gardens in London to Cork. This was achieved largely as a result of the efforts of Viscount Ennismore of Convamore (Lord Listowel), a personal friend of the prince.[28] Thaddeus' account of the circumstances surrounding the acquisition by Cork of the casts, which he described as 'the most complete collection in the United Kingdom' was, as it happens, totally inaccurate, and no doubt owed some debt to local folklore. He believed that the ship on which the collection was being carried from Italy to London sank in Cork harbour, and that Prince George, having no interest in the sculptures, agreed to leave the salvaging to the people of Cork themselves, on the understanding that it was undertaken at their own expense. It is certainly more romantic than the actual circumstances, and lent some extra weight to Cork's popular, and deserved, reputation as a city of culture and fine taste. The casts are still in the possession of the Crawford Gallery.

Thaddeus recognised the importance of the Vatican casts, and imagined that they had been used for early studies by his great Cork predecessors, including,

26 P. Murray, 1991, p. 243. **27** For a detailed discussion on the Vatican collection and its importance in the history of art, see F. Haskell and N. Penny, *Taste and the Antique – the lure of Classical sculpture, 1500–1900*, New Haven and London 1988. For information on the Crawford Gallery casts, see P. Murray, op. cit., 1991 and P. Murray, Dublin 1993, pp. 813–72. **28** Murray, 1993, p. 825.

'Maclise, Mulready, Barry, Foley, and many others'.[29] In making such a claim, however, he displayed a surprising ignorance of the history of Cork art. Had he investigated further, he would have discovered that James Barry (1741–1806) had already died by the time the casts arrived in Ireland, that John Foley (1818–74) trained at the Royal Dublin Society *c*.1831–4 and then in London, and that William Mulready (1786–1863) left Ireland as a child, and, as far as one can tell, did not return. Thaddeus recorded that the maintenance of the casts reflected that of the school in general. He told a journalist from the *New York Herald* rather flippantly that studying at the Cork School of Art 'was a funny experience. There was divil a thing in the place except a lot of plaster casts that had been sent to George IV by the then pope. This collection was all we had to draw upon and to draw. And dirty! ... The very size of the muscles was increased and the shapes of the faces altered by the thick layers of dust!'[30] The casts were cleaned during his time there, following the intervention of an 'enlightened visitor', and it was only then that the real quality of the collection was revealed to Thaddeus and his fellow students.[31] Thaddeus explained that students were required to work their way through the casts in order to advance to more sophisticated studies and exercises. He himself began his studies by drawing freehand, and then proceeded to study from the casts, beginning with 'a bust of Homer'.[32] He completed his work in that discipline by the age of fourteen and, remarkably, at that point, rather then being encouraged to follow the conventional progression through the school, was chosen to occupy an educational post himself. Curiously, an article in the *Irishman* of 1881 maintained that Thaddeus was actually appointed to the position 'in his seventeenth year', but this claim is not necessarily more accurate than Thaddeus' own.[33] In any case, it seems clear that a position as 'assistant-master' became available, to which he was appointed at a young age.

That Thaddeus' precocious talent was so publicly, and formally, acknowledged was an admirable, and unusual, achievement, though perhaps not quite as impressive as he himself would have had readers of his *Recollections* believe. According to the artist, his responsibilities as assistant master included presenting lectures on 'practical, plane, and solid geometry, building construction, elementary anatomy, and perspective' in all which disciplines he considered himself competent and sufficiently qualified to teach.[34] However, it is interesting to note in this regard that Thaddeus was awarded a Free Studentship at the school in 1875.[35] Even allowing for the artist's repeated

29 H.J. Thaddeus, 1912, p. 2. 30 *New York Herald*, 27 March 1896. 31 H.J. Thaddeus, 1912, p. 2. 32 Ibid., p. 1. The George IV casts featured a number of busts, but none specifically identifiable as Homer. Thaddeus may have assigned the title to the piece himself. 33 'Irlande et France. An Irish artist in Paris', *Irishman*, 4 June 1881. 34 H.J. Thaddeus, 1912, p. 3. 35 Murray, 1991, p. 244.

inaccuracies, which render many of the details of his account a year out in date, this award suggests that he was still a student, rather than a paid member of staff. One wonders if perhaps he elevated this studentship, with any extra responsibilities it might have entailed, to the level of a teaching post. There were precedents for this arrangement, including the example of Joseph Poole Addey, who served as a 'student teacher' at the school just a few years before Thaddeus. As well as the Free Studentship, Thaddeus received another prize for a work that year, which was, along with those of some thirteen other artists, put forward for the National Competition. Regardless of his talent and artistic maturity, it is unlikely that at fourteen Thaddeus commanded as much authority as he claimed. He said that his appointment to the position was met with universal approval by his contemporaries, who attended his lectures diligently, and never provided him with problems of discipline. In his own judgement, the reason for this was that his 'former prowess endeared me to them'.[36] One imagines that he alluded here to the *potential* he had displayed, and his ability relative to his contemporaries, rather than impressive individual works or public commissions of note that might have brought him some celebrity. Important commissions were, however, soon to follow.

The high profile that Thaddeus commanded was an augury of the future, as few of his peers achieved the level of success and recognition that he enjoyed later as a professional painter. Artists such as Thomas W. Barry, Allen J. Gilman, Anna M. Tuohy and George Thomas, all of whom were award winners while at the Cork School of Art, experienced, at best, moderate success as professional artists, and are unfamiliar to us now. John Drummond received plaudits in his native Cork during the 1870s for his paintings of local fishing scenes and the like, but remained essentially a regional figure. As a result, it is difficult to gauge what impact the work of Thaddeus' contemporaries might have had on him. After all, their current obscurity does not *necessarily* reflect a lack of talent. Thaddeus proved himself single-minded and expansive in personality, but as an artist, open to the influence of others. In fact, some of the more successful contemporaries, or near contemporaries, make interesting comparisons. The abovementioned Joseph Poole Addey (*fl.* 1871–1914), for instance, attended the school of art in Cork in the early seventies, and went on to gain considerable recognition and financial success in Ireland and Britain. Thaddeus may well have known him, and certainly would have been aware of his reputation. Though Addey made his name as a watercolour artist, the trajectory of his early career preempted that of Thaddeus, which might hint at the aspirations of the school for its more promising students, and the way they were directed. Addey was born in Cork, and while at the School of Art became, as mentioned above, a student teacher (although not, perhaps, at as young an

36 H.J. Thaddeus, 1912, p. 3.

age as Thaddeus). In 1871 or 1872, he was admitted to the training school for art masters in South Kensington, and then moved to Derry, where he started teaching in the school of art *c.*1879. In Cork, where he won a number of prizes, he painted portraits and landscapes, and soon became a regular exhibitor at the Royal Hibernian Academy, submitting the last of over 130 works for their annual exhibition in 1914. Egerton Coghill (1853–1921) enjoyed some renown, particularly later in his career, when he was a regular exhibitor in Ireland. An artist whose early career makes for a much more telling comparison, however, is Hugh Charde (1858–1946), just two years older than Thaddeus and also destined to train on the Continent. Charde attended the School of Art in Cork before transferring to Antwerp in the winter of 1882–3, where he continued his studies for a year at the Académie Royale alongside other Irish artists, including Richard Thomas Moynan and Roderic O'Conor. Charde submitted works to the Royal Dublin Society from his address there and, unlike Thaddeus, returned to Ireland permanently after a couple of years more abroad, in 1886. It was also in that year that he showed at the Royal Hibernian Academy for the first time, with a picture entitled *Market Women.*[37] This picture reflected his Continental experience, and the influence of the *pleinairists* who were following the example of Jules Bastien-Lepage and others. Charde was predominantly a landscape artist, but did produce a number of genre works, the titles of which are comparable with some of Thaddeus'. It is not certain that Charde was attending the Cork school at the same time as Thaddeus, but as the latter was there for many years, it would make sense that they shared time there. Charde had neither the strength of draughtsmanship nor the inventiveness of colour of Thaddeus, but he was a confident painter with wide ranging abilities and artistic interests. Overall, Thaddeus' skills far exceeded those of his fellow Corkonian, though both men made swift progress in their youth. Indeed, Charde was to return to Cork as headmaster of the school, and, as a founder member of the Munster Fine Arts Club in 1920, was a leading figure in the development of the city as an artistic centre in the early decades of the twentieth century. Charde's relatively limited recognition and success serves to place Thaddeus' rise to fame in context, particularly as an Irish artist.

One of the first of Thaddeus' works to attract attention was a design for a book cover featuring 'the picturesque figure of a gallant' drawing back a curtain to reveal the façade of the Theatre Royal, George's Street, a renowned Cork landmark, and a building commanding much attention at the time.[38] The Theatre Royal had been refurbished in the previous decade, reopening in December 1867, when it constituted 'a resplendent addition to the city's streetscape'.[39] The building, now the General Post Office, had been remodelled

37 Charde did not exhibit again at the RHA until 1899, but thereafter exhibited regularly up to 1938. 38 M. Holland, 1942–3, p. 101. 39 MacCarthy, 1985, p. 199.

from designs under the supervision of the Cork architect Sir John Benson. In 1875, around the time that Thaddeus produced his drawing, the theatre was acquired by the postal authority, and was opened for business two years later. Whether or not Thaddeus' illustration was commissioned, published, or even ever a fully finished work is unknown. However, it was a dramatic and ambitious design to undertake, incorporating classical figures, unusual in Thaddeus' *oeuvre*, and architectural detail. Though his attempts were not always unsuccessful, the representation of the human figure was not one of his strengths.

Considerable evidence points to the influence on Thaddeus of James Brenan (1837–1907), his master at the Cork School of Art.[40] Thaddeus himself made little of this in *Recollections*, even though Brenan was held in very high regard by the art establishment in Ireland in the final decades of the nineteenth century, as both artist and educator. He is likely to have played a pivotal role not only in Thaddeus' initial training and, later, his decision to travel to London, but also in his choice of subject matter as a young artist.[41] Brenan's commitment to his students is well-documented, and he, like any master, must have been particularly aware of those who showed unusual promise.

The parallels that one can draw between Brenan's early artistic and professional development and that of Thaddeus, his young student, are remarkable. Brenan was born in Dublin in 1837, and began his art training at the Dublin Metropolitan School of Art and the school of the Royal Hibernian Academy. He next went to London, where he studied under Owen Jones (1809–74) and Matthew Digby Wyatt (1820–77). In 1851, with Jones and Wyatt, he worked on the decoration of Pompeiian and Roman courts at the Crystal Palace. He next took a position teaching at the Dublin Society's school, but returned to London, where he completed his studies at the National Art Training School in Marlborough House. He went on to teach at the School of Art in Birmingham, at the South Kensington schools, and in Liverpool, Taunton and Yarmouth.[42] In 1860, he was appointed headmaster of the Cork School of Art, a position he held until 1889, when he transferred to what Thaddeus called 'the more important School of Art in Dublin'.[43] His departure was much regretted in Cork, but he maintained contact with the city and its artistic community. Canon Sheehan, on the occasion of Brenan's departure from Cork, was quoted as saying that 'the history of Mr Brenan's connection with the school was ... the history of the school, at all events, in this generation, wherever the Cork School of Art was known also. He had a deep knowledge of his art, a whole-souled

40 For a detailed discussion of Brenan's artistic philosophy and practice, see P. Murray, 1996, pp. 40–6. **41** Thaddeus even claimed that his lectures were interrupted less frequently than Brenan's. H.J. Thaddeus, 1912, p. 3. **42** W. Strickland, *A dictionary of Irish artists*, i, Dublin 1913, pp. 77–8. **43** H.J. Thaddeus, 1912, p. 3. He also makes the relatively common mistake of spelling his name incorrectly ('Brennan' rather than 'Brenan').

devotion to its propagation, and possessed at the same time a quality of no small importance to one in his position – an urbanity of manner which endeared him in an especial degree to his pupils.'[44] Brenan was a popular, affable character, and greatly respected in Dublin, as he had been in Cork. Among his skills was an ability to speak Irish.[45] Always interested in the applied arts and crafts, he was actively involved in the establishment of classes in various Munster convents in skills such as lace-making.[46] Later in his career, after he had moved to Dublin, Brenan, in collaboration with Alan S. Cole of the South Kensington Museum, became more proactive in his support of local co-operatives, promoting cottage industries in traditional Irish crafts (including lace-making and weaving). He believed that such initiatives could provide impoverished and isolated communities in rural Ireland, such as those in Kinsale, Kenmare and Youghal, with a means of supplementing the meagre income they eked out from small-scale farming.

Brenan was also an accomplished artist, and a regular exhibitor at the Royal Hibernian Academy between 1861 and 1906. The themes of his paintings often reflected his deep and enduring interest in the plight of the rural poor, and the influence of such artists as David Wilkie and William Mulready, whose similar (albeit less powerful) work he must have encountered in England. The majority of the paintings he showed at the RHA, the Walker Gallery in Liverpool, and the Royal Society of Artists in London were cottage interiors and scenes of Irish peasant life. Among them were *The Prayer of the Penitent* (*c*.1863), *Letter from America* (1875), *Committee of Inspection* (1877), *Notice to Quit* (1881), *The Spinning Lesson* (exh. 1882), *A Friend in Need* (1882), *Bankrupt* (exh. 1888) and *Girls Quilting, Patchwork* (1891).[47] Brenan's paintings invariably displayed technical competence rather than innovation, but he had an admirable ability in draughtsmanship and the handling of tone, which greatly enhanced his subjects. Thaddeus must have been impressed by Brenan's paintings, not least because of the attention they attracted when on show. They were for the most part more sentimental than dramatic or explicitly political, *Notice to Quit* being a typical example. However, they were often painted on quite a large scale, thus elevating the Irish peasantry as a subject in art, showing them as dignified, industrious and good-natured, in contrast to their traditional representation in the pictorial arts. Brenan also produced a large number of fine landscapes recording views in counties Cork, Kerry, Mayo, Wicklow and Donegal.

Thaddeus may well have drawn inspiration for a number of his early genre subjects from paintings such as these, which may also account for his general

44 *Cork Examiner*, 30 March 1889. 45 M. Holland, 1942–3, p. 101. 46 Brenan was responsible for the Fine Art Section of the Cork International Exhibition in 1883, at which Thaddeus exhibited publicly in his native city for the first time. 47 Brenan exhibited on some thirty-nine occasions at the Royal Hibernian Academy (contributing 107 works).

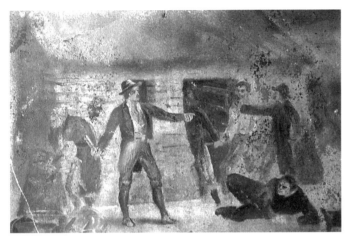

1 *Eviction
Scene*, 1877.
Watercolour on
paper 10.5 × 15
(approx.).
Private
collection.

awareness of, interest in, and sympathy for, the impoverished Irish peasant
population. Titles for early pictures of Irish subjects included *Petitioning for
Rent, Rent Day, A Composition of Four Figures – Interior of an Irish Cottage* and
A Letter from America. Unfortunately, as these early pictures are untraced (or
inaccessible), it is impossible to judge how derivative or, conversely, distinctive
and experimental Thaddeus' style was at this point. Some possible evidence is
provided by a postcard-sized study, which has been plausibly attributed to
Thaddeus (fig. 1). The sketch, a rather underworked and unrefined watercolour,
is signed 'Jones '77', so both the name and date are appropriate to the artist, and
the subject matter is certainly in keeping with his interests at this time. The
painting depicts a peasant family being evicted from their tiny cottage. Two
women, one with her head in her hands, sit among their few possessions, as the
eviction party empties their home. One man, belonging to the family, perhaps
the husband, stands defiantly in the middle of the picture, a stick drawn back in
his hand as he tries to protect the women from further harm. He appears to
have just sent the bailiff to the ground with a blow. The bailiff, his top-hat lying
beside him in the dirt, attempts to pick himself up. Artistically, the picture is
too small and roughly executed to tell us much about the sophistication of
technique or level of skill of the artist. Nor does it suggest in any detail how a
larger work might have evolved from it. Thematically, however, and in terms of
theatrical intent, it represents an early essay in the dramatic possibilities of such
subjects. The drama and tension that is at least attempted preempts that
communicated in Thaddeus' great political work, *An Irish Eviction – Co.
Galway*, painted in 1889 (pl. 22). Moreover, the central act of resistance, the
defiant gesture of the young man with the stick, prefigures the peasant in
Thaddeus' later work who holds back a cauldron of hot liquid preparing to
repel the intruders (see Chapter 8). In the watercolour, both protagonists are

suspended in a moment of high drama, emphasising the charged and violent nature of the overall subject. At no point did James Brenan's pictures reach this dramatic pitch, but his work did help to raise the profile of rural hardship as a worthy theme in fine art and to suggest the dramatic potential of such subject matter. He was among few artists to address such subjects directly and, of course, had the distinction, as stated above, of being actively involved in attempts to alleviate the conditions in which Irish peasants worked and lived.

In 1879 Thaddeus submitted a work to the Royal Dublin Society entitled *A Composition of Four Figures – Interior of a Cottage* for which he received a Taylor Art Prize of £15.[48] Strangely, he did not refer to this success, which is listed in the records of the Royal Dublin Society, in *Recollections*, and was, in fact, totally inaccurate in his references to the Taylor Prize. He may well have used his family as models for *A Composition of Four Figures*, as he certainly seems to have done so for a more ambitious work, *The Convalescent*, 'an incident from home life', which dates from the same period.[49] This practice would not have been unusual, and one is reminded of the figures in Courbet's *After Dinner at Ornans* (1849; Lille, Musée des Beaux-Arts), which were modelled on members of that artist's family.[50] Given the fact that *A Composition of Four Figures* was an Irish subject, that Thaddeus lacked the resources to hire a private model, and that he was unlikely to have had the opportunity to compose and execute such pictures with any degree of freedom at the Cork School, it is entirely reasonable that he should have asked his family to pose for him.

The subjects of illness, medicine and incapacity were extremely popular throughout the Victorian era, as they fed a British audience's insatiable appetite for sentiment and pathos. Though Thaddeus did not produce many works of this kind during his career, there are a small number that appeal to similar sensibilities (see Chapter 9). His second success at the RDS came with another picture of an unmistakably Irish subject, though here with a strongly political dimension. *Renewal of the Lease Refused*, which may well have been painted in England was, Thaddeus wrote, 'inspired by an incident of the Land War then agitating Ireland'.[51] In *Recollections*, Thaddeus made the erroneous claim that the award he received from the RDS for *Renewal of the Lease Refused* was worth £60, and that it was awarded to him when he was about seventeen. The records of the RDS show that Thaddeus received a Taylor Prize of £50 in 1880, and list him as a student at Heatherley's in London.[52] Living in Cork city, he is less

48 The Taylor Prizes of Scholarship for the promotion of the Fine Arts in Ireland were established in 1863, according to the wishes of the late Captain George Archibald Taylor (d. 1860), to allow promising students of art, who had been enrolled for at least two years at an art school in Ireland, to travel abroad to continue their studies. 49 M. Holland, 1942–3, p. 101. 50 M. Holland, 1937, p. 32. 51 H.J. Thaddeus, 1912, p. 3. 52 The France correspondent for the *Irishman* claimed that Thaddeus was living in Dublin when he painted *Paying for Rent (Renewal of the Lease Refused)*. *Irishman*, 4 June 1881.

likely to have witnessed an eviction first-hand than would have been the case among the rural population, but it is by no means impossible and, in any case, the government's coercion policies with regard to rent arrears were widespread and widely reported. This theme had been tackled by Irish artists before, though the pictures tended to be poignant rather than dramatic or polemical. Examples include the Scottish artist Erskine Nicol's *Deputation*, and James Brenan's *Notice to Quit*. In the latter, exhibited at the RHA in 1881, a peasant, sitting with his family in his cottage, clenches his fist on a table as he gazes wistfully out of the window. Behind him at the hearth, his wife, her head in her hands, is comforted by her young son who, sitting on the floor, leans against her knees. Of Brenan's exhibited works, it is one in which he incorporated his interest in the sentimental into a work of a socio-political nature. It deals with an imminent or impending eviction, and the desolation of the helpless family, rather than the act of eviction itself and the violence and distress that attended it.

Historically, there had been no real demand for pictures of obviously political subjects or even with political undertones, so very few were produced. Ireland's turbulent political condition throughout the nineteenth century rendered attempts at social reportage in the fine arts unpopular. A few artists tackled such themes with varying degrees of emotion or invective, but they tended to indulge the sentimental nature of their audience, rather than the controversial potential of the subject.

Both Erskine Nicol and James Brenan also produced works on the subject of the Irish peasant family, or individual, reading a letter from a member abroad. In Nicol's watercolour, *The 'merican difficulty* of 1862 (Ulster Museum), an old woman, sitting at a table, peers through tiny round glasses at a newspaper, presumably searching for news of her son who is involved in some way in the American Civil War. As many immigrants enlisted on both sides during that war, Nicol's picture is a valuable historical record, but the emphasis is still placed on the emotional response of the old peasant woman. Broader issues are merely suggested. Brenan's much larger work, *Letter from America* (1875), is more emotive, incorporating three generations of one peasant family. A young girl, evidently the only literate member of the family, dutifully performs the task of reading the letter aloud to her rapt audience.

It would thus be inaccurate to claim that Thaddeus, and Brenan immediately before him, were somehow pioneers in the depiction of scenes from the hard life of the Irish peasantry. It is notable in Thaddeus' case, however, that he should have chosen so early to tackle such unpopular themes, as critical acclaim did not ensure patronage. Moreover, the paucity of works of this kind with which he would have been familiar, and the even smaller number of those that were of any quality, meant that Thaddeus had a somewhat limited frame of reference on which to draw. It seems very appropriate, therefore, to acknowledge that Thaddeus was indebted to Brenan for introducing him to Irish subject

matter. Perhaps the confidence of youth, as well as Thaddeus' personal regard for Brenan, explain his inclination to execute basically uncommercial work. He would have known that there was certainly no 'ready market' for political pictures. Therefore, to actually receive a prize for a work of that subject was an important affirmation of his talent and readiness to avoid convention.

Thaddeus' success with the picture was compounded when he managed to sell it, having exhibited it at the RDS, to none other than an English politician. Henry Chaplin was Unionist MP for Mid-Lincolnshire, and later served in Lord Salisbury's ministries. He evidently had some involvement and interest in agrarian issues, as he was, when he purchased Thaddeus' painting, serving on a commission monitoring the Land War itself. His interest continued and ultimately, in 1893, he became a member of the Royal Commission on Agricultural Depression. In the absence of the picture itself, one can merely hypothesise about how Chaplin came to purchase it.[53] It is conceivable that, as a Unionist at that time, he was not well-disposed towards the Irish peasant population, who were widely perceived as malingering and unruly, but mellowed in his views having witnessed and reported on the conditions in which they were living. Thaddeus' picture captured, perhaps, something of that experience. Alternatively, he was simply unaware of the political thrust of the picture and read it superficially as an anodyne genre scene. The most likely explanation, however, is that the picture was produced in much the same idiom as Brenan's *Notice to Quit* and that, visually at any rate, it posed no serious challenges to, nor asked questions of, the viewer. The picture was simply not as polemical in content as its title suggests, and certainly not as powerful as Thaddeus' picture of a similar title of ten years later.

Though Thaddeus' genre paintings were well received, it was his work in a totally different genre, that of portraiture, that indicated how his career was destined to develop. He did not take long to make a name for himself in Cork, and, to his credit, managed to secure commissions while still a student. It says a lot of his adaptability that he managed to alternate between genre works, the subjects for which he chose himself, and the exacting practice of portrait painting, when still in his teens. His unusually high quality draughtsmanship, the above-mentioned 'skill in drawing pictures', was noticed at a very early age, as was, in due course, his ability to capture likenesses accurately and quickly. It was the latter that accounted for the requests for drawings that, according to the *Irishman*, were 'showered upon him'.[54] These 'extra mural' works, portraits of prominent Cork citizens, were executed in pencil, charcoal and pastel. Sitters included the young Dr McNaughton Jones, professor at Queen's University in Ireland, and surgeon to the Cork Ophthalmic and Aural Hospital; the Cork

53 In February 1993, a picture in oils, signed and dated 'H Jones 1877' and entitled *Petitioning for Rent* was sold by Christie's in South Kensington. 54 *Irishman*, 4 June 1881.

composer Paul or Peter Paul McSwiney (1856–89), whose work *Amergin* was hailed as the first full opera based on a purely Irish subject; the philanthropist, writer and erstwhile Young Irelander Denny Lane; the chief accountant to the Cork Distilleries Company, Timothy Joseph Murphy, and his wife; and the ageing politician Isaac Butt. Thaddeus did not come upon these opportunities by chance. Rather, he was sought out and actively patronized during his teens, and evidently responded positively to such attention.

The earliest portraits by Thaddeus of this kind, the current whereabouts of which are unknown, were of a young married couple, Timothy Joseph Murphy and his wife. According to William Ludgate, writing to the *Cork Examiner* in 1951, these 'small portraits', which belonged to him, were dated 1876. Consistent with our impressions of the young Thaddeus, Denis Gwynn, who saw the portraits, says that they showed 'his mastery of drawing and also of delicate colour'.[55] Ludgate lived at No. 30 Gillabbey Street in Cork, a house of which Timothy Joseph Murphy was the licensee at the time that the portraits were produced, and where they had remained until at least the 1950s. The pictures were most likely executed in pastel, which was a difficult medium to master but one that allowed the artist to work with great speed and spontaneity. It was certainly a sign of confidence that Thaddeus tackled coloured portraits so early in his career, and these efforts served him well in the future, as portraiture was a discipline for which the art schools reserved little attention.

A portrait in pastel and pencil of Denny Lane (1818–95) was apparently the first commission for which Thaddeus actually received payment, and was certainly an important work (fig. 2).[56] Lane, of independent means, was a foundation member and vice-president of the Cork Historical and Archaeological Society, a lawyer, a prominent member of the 'Nation' writers, and a well-known philanthropist. Thaddeus was just one of a number of young talented individuals who were befriended by Lane and who received assistance from him at the beginning of their careers.[57]

2 Denny Lane, 1877. Pencil and watercolour on paper. Untraced.

55 Gwynn, *Cork Examiner*, 3 August 1951. **56** Denny Lane's daughter, Mrs MacDonnell, corresponded with Denis Gwynn on the subject of Thaddeus' portrait of her father. The information she provided was included in Gwynn's miscellaneous column in the *Cork Examiner*, 7 August 1951. **57** Lane was also painted by Hugh C. Charde. See *Holly Bough*,

Lane had a long association with the School of Art in Cork. In February 1896, shortly after his death, his wife offered the school eight pictures to hang in the Art Gallery, and the following month, the Denny Lane Memorial Scholarships were established.[58] Thaddeus' portrait of Lane, executed in 1877, is another testament to the competence of Thaddeus' draughtsmanship and evolving talent. It was executed in a conventional, stiff and rather old-fashioned style much in vogue in Britain in the middle years of the nineteenth century, but one that required considerable control and precision in the execution of the facial details and cross-hatched shading. Throughout his career, Thaddeus preferred to represent his sitters from oblique angles, or in profile, but rarely at the expense of compositional balance or character. In this case, the inclusion of Lane's right hand both strengthens the composition and, in a traditional fashion, alludes to the sitter's intellect and propensity for contemplation. It compares well with the portraiture of artists of an older generation including Rossetti, Millais, Leighton and particularly Frederick Sandys (1829–1904), who was still producing works of that kind at the same time as Thaddeus. These pictures display the artist's dexterity and painstaking attention to detail. Sandys was actually a confrère of Rossetti, whom he first met in 1857. While it would be rash to refer to Thaddeus as Sandys' equal, there are notable similarities in their artistic development. As a young man, Sandys applied his precocious skills of draughtsmanship to numerous different subjects, including birds, architecture and topography, but also undertook portraits, such as those of *Margaret Oliphant* (1881), *George Lillie Craik* (1882) and *Mrs Elizabeth Wylie* (1901).[59] Moreover, in undertaking portrait commissions, Sandys confronted the challenge of photography, which since the 1840s had served as an affordable alternative to the elaborately drawn or painted portraits of many minor artists.[60] The market for the work of this kind of artist had been eroded even more by the time Thaddeus was seeking commissions in the late 1870s. Thaddeus did, admittedly, aspire to greater things than plying his trade as a regional portraitist, but it was no small achievement to be sought out at such a young age by individuals who could have, and no doubt did, on occasion take their business to photographic studios in the city. To have employed his services in preference to a professional studio photograph, these individuals must have identified a distinctive quality in Thaddeus' work.

This principle was borne out in the case of one of Thaddeus' most prestigious early commissions, the portrait of Isaac Butt (1813–79; fig. 3). Possibly in response to the portrait of Denny Lane, or perhaps ones like it that were seen, Thaddeus was approached by Count Plunkett and asked to produce

op. cit., 1935, p. 40. **58** TICCBC, 24 February and 12 March 1896. **59** See Raymond Watkinson, 'Identifying Sandys', *Frederick Sandys 1829–1904*, exh. cat., Brighton Museum and Art Gallery 1974. **60** Ibid.

a portrait, in exactly the same style, of Butt, the man regarded by many as the founder of the Home Rule movement. Butt, a native of Donegal, had begun his political life in the Conservative Party, serving as MP for Youghal from 1852 to 1865, before putting his energies into the campaign for Home Rule. He sat as MP for Limerick from 1871 until his death, eight years later. Dated 1878, and featuring a very confident, stylised signature quite different from that which appears on the Denny Lane portrait, Thaddeus' picture shows a politician of noble stature and dignity, rather than an ageing one whose career was already in decline. Count Plunkett knew of Thaddeus, and evidently entrusted him with the job of producing the portrait because he believed that none of the portraits of Butt available, which were photographs, did the sitter

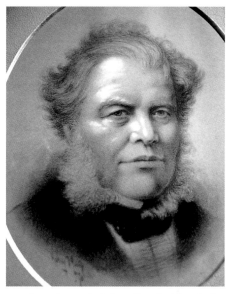

3 *Isaac Butt*, 1878. Pencil and white chalk on card. Private collection.

justice. The portrait was actually executed with the suggestions from Count Plunkett himself, who was extremely pleased with the results, telling his daughter, Geraldine, that it was a 'very fair likeness'.[61] The personal insight with which some artists, including Sandys, could imbue a portrait, a quality which set them apart from the photographer, was obviously identified in Thaddeus by Plunkett and others, and was the recognition on which his confidence as a portrait artist was built. Count Plunkett's affection or high regard for the portrait of Butt endured, as he lent the picture for the Whitechapel Exhibition of Irish Art in 1913.

By his late teens, Thaddeus had thus achieved an enviable level of success and recognition, which must have fuelled his ambition and hastened his departure abroad. Cork, despite its attractions and opportunities could not hold him, nor could Dublin, where he appears to have spent a few months, and he followed his great Cork artistic predecessors to London.[62]

61 Geraldine Plunkett, note on the back of the picture. **62** *Irishman*, 4 June 1881.

CHAPTER TWO

First period in London

Despite his regional Irish background, Thaddeus appears to have experienced few problems in adapting to life in London. Indeed, it was in London that Thaddeus was to live longer than any other place and with which, professionally, he was most closely associated. Cork city, where he had grown up, was thriving at the time, culturally and economically, but the sheer scale and density of the English capital must have represented a dramatic change for the young artist. His readiness to embrace life there signalled the way in which he would conduct himself over subsequent decades all over the world, both socially and professionally. He demonstrated there his capacity to adapt to diverse and unfamiliar social situations and to infiltrate social circles to which, under normal circumstances, someone of his background would simply not have had access. It was a characteristic that he had displayed early, and one on which he practically built a career.

Notwithstanding Paris' status as Europe's artistic capital, with its numerous, renowned art schools drawing students from all over Europe and America, London too could boast some progressive art schools by the late nineteenth century. Among them was Heatherley's studio, which attracted a broad range of students, from young career-orientated artists, to middle-aged enthusiasts. The training that Thaddeus received there was more varied and intensive than that to which he was used, but, fundamentally, followed the same pattern as the training provided at the Cork School of Art. For many Irish artists of Thaddeus' generation, attendance at a school outside Ireland was both a logical progression and a reasonable expectation. Generations of Irish artists, from Charles Jervas (1675–1739), to James Barry (1741–1806), to James Arthur O'Connor (c.1792–1841) had travelled overseas for training and experience, and/or to establish themselves as professional artists. The benefits that accrued from acceptance and success abroad were no less marked in the 1870s and 1880s than they had been throughout the eighteenth and early nineteenth centuries. London, so much larger than any Irish city, and more cosmopolitan, was a challenging environment, but Irish artists had inherited a deep-rooted emigrant spirit, and for those with artistic ambition, the value of experience overseas far outweighed the potential discomfort and isolation associated with its acquisition.

By the late nineteenth century, London had become for many Irish-born artists, in effect, a stepping-stone to other European cities, particularly Paris and

Antwerp.[1] Artists who moved on from London included Stanhope Forbes (1857–1947), who attended the Lambeth School of Art and the Royal Academy Schools before enrolling at Bonnat's atelier, and John Lavery (1856–1941), who arrived at Heatherley's shortly after Thaddeus' departure before following him to the Académie Julian in Paris, albeit to train there under different masters (Lavery trained under Bouguereau and Robert-Fleury). A number of women artists followed the same course. Edith Somerville (1858–1949) studied in South Kensington before training in Düsseldorf and then in Colarossi's in Paris while Mary Kate Benson studied under Herkomer and Calderon in England, and then under Lazare in Paris. Constance Gore-Booth (1868–1927) attended the Slade School and then the Académie Julian.

In his *Recollections*, Thaddeus wrote very little about his early years in England, which is strange, perhaps, when one remembers that London was to become the fulcrum of his professional and personal life for many decades. Indeed, he implied that there was nothing unusual or intrinsically difficult about his decision to continue on to France from London. Never lacking in confidence, he may well have harboured ambitions to go to France even before he left Cork. It was relatively easy for him to understate, in retrospect, London's formative influence on him in his youth.

There were also, of course, financial considerations that may have had a bearing on Thaddeus' decision to travel to London at this point. It is clear, and unsurprising, that he relied on patronage and sponsorship to pursue his artistic education and to allow him to travel. He claimed that the Taylor Art Prize awarded to him in 1879 was crucial in this regard, maintaining that the award, when pooled with the money paid to him by Henry Chaplin for *Renewal of the Lease Refused*, 'enabled' him to go to London.[2] Again, he was inaccurate in his details. He claimed to have won a Taylor Art Prize, worth £60 a year, when he was 'about seventeen' but in fact was awarded a prize of £15 in 1879 and £50 in 1880.[3] He was already a student at Heatherley's by 1879, so one might assume that the initial sum sustained him in London, while the second gave him the means of going to Paris. Thus, Thaddeus appears to have been awarded the prize *after* he had moved to London, but his account of the circumstances surrounding his move there certainly points to a lack of financial resources.[4] A less compassionate interpretation of his account might suggest that Thaddeus was pleading poverty in order to exaggerate his rise from humble origins to international success.

1 For a full account of Irish artists who travelled to the Continent for training, see Julian Campbell, 'Irish artists in France, and Belgium 1850–1914', PhD thesis, Trinity College Dublin, 1980. 2 H.J. Thaddeus, 1912, p. 3. 3 Records of the Taylor Prizes and Scholarships, Royal Dublin Society. 4 The *Irishman* newspaper claimed that, at one point in Cork, Thaddeus was forced to sell a picture for a suit of clothes. *Irishman*, 4 June 1881.

Regardless of the exact motivations or sequence of events that brought Thaddeus to London, Heatherley's itself was by no means an incidental choice. Though not a major school when compared to the South Kensington School, the Royal Academy, the Slade and the Central School, it was nevertheless respected, and a cursory glance over the list of alumni would have convinced any prospective student of its reputation and pedigree. Among those who had attended the school by the time Thaddeus arrived in London were Gabriel Dante Rossetti (1828–82), Edward Burne-Jones (1833–98), Edwin Poynter (1836–1919), Frederick Lord Leighton (1830–96), Fred Walker (1840–75), Samuel Butler (1835–1902) and John Butler Yeats (1839–1922). As well as many 'fine artists', the school attracted a sizeable complement of writers and illustrators, many of whom, such as William Makepiece Thackeray, Lewis Carroll, Henry and Walter Paget and Hablot Browne (known as Phiz), later achieved considerable success in those disciplines. Some artists attended Heatherley's en route to larger institutions such as the Royal Academy Schools. Writing in 1896, Tessa Mackenzie stated explicitly that Heatherley's ran 'on the lines of the Royal Academy Schools, and students are here prepared to be qualified, if they desire it, for admission to the latter School'.[5] Other students spent time there before moving on to various schools of continental Europe. There was a strong sense that Heatherley's could equip a student with the requisite basic skills to progress elsewhere. From its earliest days, preparing students for academies was an expressed function of the school, and one which it retained to the end of the century. As a result, many students would have felt some urgency to complete their studies and move onwards. Thaddeus may have also felt such a compulsion, which could explain the relatively short period he spent there.

Leigh's School of Art, as Heatherley's was originally known, was established in 1845 by a number of disgruntled students of the Government School of Design (then at Somerset House), who felt that they were being trained principally as designers rather than fine artists. In 1848, the school moved from Maddox Street to premises at No. 79 Newman Street, where it was to remain for nearly sixty years. Newman Street runs between Oxford Street and Goodge Street, in the heart of the West End, a vibrant and exciting location, particularly for those students who, like Thaddeus, had come from outside London. Marlyebone was, admittedly, the focal point of the London scene by this time, but Soho still held some claim to being an artistic quarter, and Heatherley's students would not have felt unduly isolated. The first principal of the school was James Mathews Leigh (d. 1860), a competent artist, but more importantly, a gifted and enthusiastic teacher, whose ambitions and inclusive attitude to artistic education defined the school. His was the first school in London, for instance, to admit women students. At the school, they were afforded the

5 T. Mackenzie, 1896, p. 38.

opportunity of studying at the Costume Model classes *only*, as distinct from the Figure Model classes, to which only male students were admitted. This was progressive in itself, however, as many institutions did not make the model available to female students at all. Moreover, Heatherley's was known to actively encourage women to join, and they duly did so, in ever increasing numbers.[6]

Though Leigh received most of his own artistic training in England, the only student of William Etty, he finished his studies in Paris, an experience that left a deep impression on him. His successors, none more so than Thomas Heatherley, inherited his admiration for French methods. Leigh sought to emulate the French *atelier* system, which placed a strong emphasis on drawing from the life-model. In keeping with the French approach, he considered the skills developed through this practice fundamental to mastering the craft of painting in general. To those ends, he made this facility available to all of his students, unlike other more conservative institutions, which extended such privileges only to those who had proved themselves in, and graduated from, other disciplines, such as the established practices of copying from antique sculpture. Such a system had been in operation at the Cork School of Art during Thaddeus' time there. The provision of life-drawing classes to all male students at Heatherley's was in itself, therefore, an attraction to prospective students. Life-classes were not conducted to the exclusion of those other, more traditional exercises, however. Students at Leigh's were also required to practise the 'disintegrating' approach to figure-drawing, which involved reproducing, from casts, 'anatomical fragments before fusing them into a hopefully organic whole'.[7] Not surprisingly, they were also instructed to draw from the antique.

Every effort was made to facilitate students and to engender an atmosphere of industry at Heatherley's, which opened from six in the morning until six in the evening, and later from seven till ten.[8] The students themselves had considerable freedom, and the atmosphere was rather relaxed. Discipline was important and students were expected to be punctual and conscientious, but Leigh, and Heatherley after him, did not present themselves as unapproachable, authoritarian figures. On the contrary, another feature of the French system that Leigh had adopted was the direct involvement of the principal tutor with the students. He was available to assist students technically, give general advice and also criticise their efforts as they worked.

Thomas Heatherley, who became principal of the school in 1860, following Leigh's death, inherited and developed most of his predecessor's practices. He had himself been a student under Leigh, enrolling in 1850, and had been taken on subsequently by Leigh as his assistant. Thus, completely familiar with the teaching styles, the disciplinary practice of the school, and the industrious atmosphere that prevailed there, Heatherley was the ideal candidate to assume

6 See P. Gillett, 1990, p. 293. 7 R. Eva, 'Heatherley's: the first 100 years', p. 4. 8 Ibid.

Leigh's mantle and safeguard the values and reputation of his school. When Heatherley took over as director, the title of the school changed accordingly, and it retains the name Heatherley's to the present day.

The transition from one principal to the next was not seamless, however. Heatherley and Leigh differed profoundly as personalities. While Leigh was strongly built, square-jawed and effusive, Heatherley was diminutive, undemonstrative and much less vocal in his dealings with students. Leigh was a notorious talker, Heatherley relatively reserved. Nevertheless, they shared a vigour and ambition with regard to the school, which must have had a positive influence on the students. They also chose the same bohemian attire favoured by so many artists and dilettanti at that time. Thaddeus' memories of Heatherley's physical appearance were typical of those who recalled him. 'Robed in a long, dark crimson-velvet dressing-gown,' Thaddeus wrote, 'with black skull-cap, long white hair and flowing beard, he resembled, as he meandered at regular intervals through the studio, a resurrected alchemist of mediaeval times'.[9] Samuel Butler, who attended the school in the 1860s, in a letter to his father, said of Heatherley 'He looks very absurd and at first I thought him very affected in his manner and dress – his get-up being dishevelled and what he thinks artistic … '[10]

Despite his rather lackadaisical manner and undemonstrative approach to teaching, Heatherley did generate an atmosphere conducive to industry at the school. He apparently kept the school open every day except Sundays, Christmas Day and Good Friday.[11] He sought to develop an institution geared deliberately and obviously to the production of art. In that context, Butler's reference to Heatherley finding items 'artistic' is very apposite. Heatherley attempted to create an environment that was both oriented to the practical side of artistic endeavour, but also artistic in its own right. His behaviour in this regard bordered on obsessive. He spent little time away from the school, a fact immortalised, not to say romanticised, in Samuel Butler's exhibition painting *Mr Heatherley's Holiday* (Tate Britain), painted in 1874 and hung on the line at the Royal Academy that same year. In the picture, Heatherley appears mending one of the skeletons used by the students. It was an interesting illustration of Heatherley's character, and absolutely consistent with later photographs that recorded the physical environment of the school. Behind the intense, seated figure of Heatherley, one can see some of the sculpture (including the Discobulus and Illyssus) and other paraphernalia (including pots and pans and a stuffed owl) that he, and Leigh before him, had accumulated over time for the use of the students.

Heatherley also adopted Leigh's 'relaxed method of instruction', gliding silently through the classroom, proffering advice and judgement before moving

9 H.J. Thaddeus, 1912, p. 4. **10** H. Festing-Jones, 1919, p. 127. **11** C. Neve, *Country Life*, 17 August 1978, p. 448.

on to the next student.[12] Walter Crane, who attended the school in the late 1860s, recalled that the master 'did not attempt much teaching, at least in the life class, and would only offer a gentle criticism or suggestion in an undertone now and then as he glanced at one's work and passed on'.[13] John Butler Yeats, for his part, described the atmosphere at Heatherley's as 'tranquillizing, like a peaceful day in the country'.[14] Heatherley was, nevertheless, capable of uncompromising directness on occasion. The number of students increased consistently during his incumbency, especially women, many of whom, including Lady Butler, Helen Allingham and Kate Greenaway, went on to enjoy considerable success.

Thaddeus did not respond as positively as some to this 'gentle critic and dispenser of sage advice'.[15] In fact, he was rather dismissive of Heatherley's reticent manner and irregular instruction. Thaddeus found him inadequate as both technician and teacher, and believed that in the classes one could learn more from one's contemporaries than from Heatherley himself. In his *Recollections*, he claimed, with typical self-assurance, that Heatherley 'knew little about painting, and judiciously gave us a wide berth. He simply ran the studio, only venturing on suggestions or corrections with regard to the work of beginners, or of the young ladies' class'.[16] It certainly was the case that students at Heatherley's, while having to adhere to house rules and discipline, were left to their own devices, free of censure, for much of the time. This was something of a gamble, though no doubt carefully thought out, and true to Heatherley's libertarian artistic philosophy. Students who left Heatherley's for schools on the Continent could not assume to enjoy there the freedom afforded them in London, and French masters, for instance, were intolerant of any inadequacies in the technical skills of their foreign charges.

From a practical point of view, Thaddeus' paucity of funds should not have been as much of a concern at Heatherley's as might have been the case elsewhere. Though there is no record among the archives of Heatherley's College of Art of how much the fees were precisely, the studio certainly emulated the Parisian ateliers in the relatively low fees it charged. Thaddeus would certainly have chosen cheap lodgings during his stay in London, keeping his subsistence costs low to allow him to make the most of the social life that the city provided. He may also have taken work to supplement what limited funds he had. John Gilbert, writing in 1913, claimed that Thaddeus supported himself by 'drawing in black and white for the illustrated newspapers'.[17] It is most likely that, rather than executing his own autograph illustrations, Thaddeus was employed in producing drawings for wood-engravers working for the illustrated newspapers. This involved reducing other artists' paintings or drawings to the dimensions

12 Eva, 1996, p. 7. **13** W. Crane, 1907, p. 81. **14** W. M. Murphy, 1978, p. 53. **15** Neve, 17 August 1978, p. 448. **16** H.J. Thaddeus, 1912, p. 4. **17** J. Gilbert, *JCHAS*, 1913, p. 177.

needed for the printer's wood-block. The artist would be required to produce not only a scaled down version of a painting or drawing, but also to reproduce this onto the smooth boxwood surface into which the engraver would then cut. Hundreds of thousands of these were produced from the mid-century onwards, and an appropriate number of artists, including the above-mentioned Frederick Sandys, earned a living through the process. No specific illustrations have come to light to confirm that Thaddeus was actually presenting his own illustrations. However, the poor health that he suffered in London, which at one point confined him to bed for some months, may be attributable more to an onerous work-load than to a gruelling social life.[18]

Whether or not Thaddeus was aware of the connection, actual or symbolic, between Heatherley's and the French ateliers is impossible to ascertain. Had he believed that the French system represented the model on which his training at Heatherley's was based, it might have made the transition from an Anglophone environment somewhat easier. It would appear that the identification of Heatherley's with France was widely recognised. It advertised itself as a French style studio in London, and a journalist for *the Sketch* wrote, in reverential tones, in 1895, that Heatherley's was 'to London what Julian's is to Paris'.[19] If the association was as strong as this comment suggests, it is perhaps no surprise that Thaddeus moved on from London to the Académie Julian in particular in October 1880.

The one known work dating from Thaddeus' time in Heatherley's, a painting of a costumed model, is consistent with what we know of the teaching practice in London, but, significantly, is also evidence of a practice not made available in Paris, or indeed elsewhere in London (pl. 1). At the Royal Academy, students engaged in the study of drapery, but not costume, while in the École des Beaux-Arts, concentration on the nude was of paramount importance. The Académie Royale des Beaux-Arts in Antwerp, so popular among British and Irish artists during the 1870s and 1880s, was exceptional in that it encouraged students to work from the costumed model, and in fact had introduced the practice as early as 1843 for the benefit of genre painters.[20] By coincidence, Thaddeus told the *Irishman* newspaper in 1881 that when Heatherley saw him work, he assumed that he had spent time in Antwerp, because he had 'the Antwerp touch'.[21] 'No more graceful compliment', the correspondent remarked, 'could be paid to our countryman's talent'.[22] In Thaddeus' painting, signed 'Harry Jones 1880', a fully-finished painting in oils on canvas, a young man, in a suit of armour, holds a staff or flag pole around which a flag or banner is furled. He wears a soft, plumed cap and stands on bare wooden boards against a tapestry backdrop. No attempt has been made to disguise the fact that it is a studio work, the only

18 *Irishman*, 4 June 1881. 19 Neve, 1978, p. 448. 20 See J. Sheehy, 1997, pp. 124–53.
21 *Irishman*, 4 June 1881. 22 Ibid.

artifice lying in the rather incongruous, anachronistic clothes worn by the model. This kind of study set the student numerous technical challenges including accuracy of proportion, the rendering of different textures and materials, light effects, and variation of palette. It is an assured effort, if a little flatly painted and anatomically imprecise (the distance from knee to ankle seems decidedly short). Thaddeus dealt with the armour effectively and confidently, painting in broad strokes and strips of unmixed colour. Curiously, when one considers how Thaddeus' career was to develop, the picture's greatest weakness is in the rendering of the flesh tones. This was a feature of portraiture that he was soon to master and that was to prove one of his greatest strengths. In this case, it appears that Thaddeus applied the same technique for the flesh as he used for the armour, rendering the figure rather opaque and lifeless. There is little modulation of tone in general, and the whole ensemble is painted in areas of single colour, illustrated very clearly, for instance, by the figure's breastplate, and the wrapped flag. Thaddeus favoured an extensive use of black and strong outlines in both his portraits and genre works throughout his career, which suggests an affinity with illustration. It is conceivable, when considered in this context, that Thaddeus did work as an illustrator in London. It is evident from this picture, and from the portraits Thaddeus produced in Cork, that draughts-manship was one of his particular skills as a young artist, and work with the illustrated press, in whatever capacity, would have given him an excellent opportunity to develop further his skills in that area. Other Irish artists had worked as illustrators, including John Butler Yeats, and Aloysius O'Kelly, who worked for some time for the *Illustrated London News* as special reporter in Ireland and elsewhere.[23]

It is not surprising that Thaddeus' painting lacks character or distinction. It represents, despite its relatively large size and high finish, a technical exercise, and as such afforded the student little room to express himself or be particularly inventive. This is made clear when one looks at a strikingly similar painting by John Lavery, which he too produced at Heatherley's, and for which he may even have used the same model. That picture, given the rather grandiose title *Monsieur le troubadour*, is also devoid of character. The similarities in style and subject-type between this painting and Thaddeus' figure in armour are remark-able. Of most immediate note is the similarity of the setting and action (or, more correctly, inaction) of the figures. Both are painted full-length, in quasi-historical costume, backed by a rather incongruous tapestry. Technically, the pictures are also very similar, though Thaddeus' is more refined. In various details, the pictures are, stylistically, practically interchangeable. For example, the squarely-drawn hands are almost identical. The plumed cap worn by Thaddeus' figure is also very similar to one in another picture by Lavery, a head

23 See N. O'Sullivan, 1995, pp. 10–16.

and shoulders study, dating from this period, entitled *Faust*.[24] These pictures suggest strongly that there was a prevailing style and technique at the school, which the students were inclined to follow. These may have been developed by the students themselves, or may have been the result of adherence to specific principles and guidelines laid down by Heatherley.

Both pictures are highly finished easel paintings on which the artists must have spent considerable time, and are competent rather than remarkable. The costumed figures have not been placed in any historical or thematic context, and there is no obvious significance to their actions. They lack animation (Lavery's figure is patently not playing the guitar), and one can identify in both something of the *ennui* that accompanied posing for long periods in the studio.

The title of Lavery's picture serves to elevate it somewhat, but these were essentially non-commercial paintings. As it happens, Lavery did exhibit his picture at the Royal Hibernian Academy in 1882, under the above title, but it is nevertheless an unconventional exhibition piece and, despite the fact that eighteenth century genre scenes were very much in vogue at this time, not produced for the art market. More notably, both Thaddeus' and Lavery's paintings were serious studies which could have been transplanted into or adapted for full-scale history paintings. Lavery's early biographer and friend, Walter Shaw-Sparrow, recorded that the artist would paint 'from costume models', and add 'composed backgrounds such as would turn life studies into marketable pictures'.[25] This is definitely what Heatherley intended his students to do with the studies they produced at the school. It was largely with this purpose in mind that he assembled a vast collection of studio props, including pottery and furniture, and suits of armour and costumes. A photograph survives of Sir Johnson Forbes Robertson, aged seventeen, in one of Heatherley's suits of armour.[26] Samuel Butler, who took the photograph, described Heatherley's private room as 'a wilderness of Flemish tapestry, Venetian mirrors, armour, tortoise-shell cabinets from Spain, pictures in gilded frames and chairs upholstered in tattered brocade'.[27] Thaddeus referred to Heatherley's rooms, somewhat irreverently, as '*his sanctum sanctorum*'.[28] Heatherley collected authentic peasant and Oriental costume as well as items from theatrical wardrobes.[29] These props and costumes encouraged Heatherley's students to vary texture and colour in their work, and to produce studies that they could incorporate into full exhibition works and saleable items. This was, for example, the case with a picture by Lavery, entitled *The Courtship of Julian Peveril*. In the painting, the whereabouts of which are unknown, Lavery appropriated studies of a girl 'in quaker costume and a young man dressed as a cavalier', produced in

24 See K. McConkey, 1993, p. 18. 25 W.S. Sparrow, 1912, p. 32. 26 Eva, 1996, p. 8.
27 Neve, 1978, p. 448. 28 H.J. Thaddeus, 1912, p. 6. 29 Neve, 1978, p. 449.

Heatherley's studio, to the final painting.[30] It was the first of many pictures that Lavery showed at the Royal Scottish Academy over the subsequent decades.

Though the *Studio Model in a Suit of Armour* is the only known work of this period by Thaddeus, the generic titles of some of his early paintings do suggest that they could have been worked up from or inspired by studies executed at Heatherley's. However, referring to these as 'early' is effectively as precise as one can be. The subject matter can help to place them, but that is not always reliable. Titles include *The Old Connoisseur, Collin's Explorer* and *A Gentleman*, all of which were listed in the Crawford Gallery Catalogue of 1953. One can easily see how Thaddeus might have adapted his figure in armour for inclusion in a grand history painting, although that was a genre in which he showed little interest.[31] When not painting portraits, he was drawn much more strongly to contemporary genre pieces, of which he produced a sizeable number.

Heatherley's facilitated more than simply artistic development, offering a vibrant social life for those students who wished to avail of it, both within the school itself and by nature of its location in central London. The lifestyle at Heatherley's, of which Thaddeus and others spoke, was not necessarily enjoyed by all, however. John Lavery, who arrived at Heatherley's in 1880, just a year after Thaddeus, declared his period in London as 'the loneliest year I have spent in my life. Every morning I walked from Liverpool Street Station and back in the evening without meeting a soul I knew. For a whole year, for all the communion I had with my fellow men, I might have been in the middle of the Gobi. In the school everyone went their own way when the classes were over in the well-known English manner.'[32] Lavery was quick to qualify this statement by explaining that London was a city to which he subsequently grew very attached, but the city was for him initially, when his ambition, perhaps, exceeded his confidence, a hostile environment.

Confidence was a commodity in which Thaddeus was never lacking, and he threw himself headlong into London social life. He frequented the music halls with companions from the school of art, the Oxford being the students' 'great rendezvous'.[33] Situated on Oxford Street, a short distance from Heatherley's, it was opened on 23 March 1861, and thrived for three decades as one of the most popular venues of its kind in London.[34] By the end of the 1870s, a vast number of theatres and music-halls entertained the public, the latter outnumbering the former by a considerable margin. Thaddeus described the shows at the music halls as raucous, anarchic affairs, at least for himself and his student friends. He recalled fist-fights breaking out at the theatre between students, as a result of which they were ejected from the building. At an alternative venue, the

30 McConkey, 1993, p. 17. **31** A notable exception was *Arthur Finds the Sword Excalibur*, exhibited at the SBA in its winter show of 1885/6. **32** J. Lavery, 1940, p. 45. **33** H.J. Thaddeus, 1912, p. 7. **34** D.F. Cheshire, 1974, pp. 27–32.

Criterion Music Hall, 'patronised by rival bands of art and medical students, often reinforced by contingents of military cadets from Sandhurst', even more brutal exchanges allegedly took place.[35] Though youthful exuberance must have lead them astray in many instances, Thaddeus' trips with his friends to the music halls may not have been quite as dramatic and eventful as he suggests. The music hall became increasingly popular and inclusive towards the end of the century, and the most expensive category of theatre, situated in the West End had 'always attracted an audience of bohemians, aristocrats and students'.[36] Anstey, writing in *Harper's Monthly Magazine* in the 1890s, classified the Oxford as one of the 'large bourgeois music halls of the less fashionable parts [of London] and in the suburbs'.[37] That is not to say that the evenings that Thaddeus described were quiet and reserved, but they were perhaps less proletarian than he intimated. In 1879, great music hall stars began to appear in pantomimes in the major theatres in front of stock middle-class audiences. Their success there attracted these audiences to the music halls themselves, changing the character of the theatres and performances irrevocably. These performers included G.H. MacDermott, referred to by Thaddeus as 'the lion of the music halls', with whom he and his companions sung along on many occasions.[38] Among other changes, the music halls became subject to stringent safety regulations, which influenced audience sizes and the like, but also encompassed the content of the acts themselves and their appropriateness for a family audience. Rowdiness and audience participation had characterised public perception of music hall recreation, and Thaddeus appears to have indulged this image in *Recollections* in an attempt to place himself right in the centre of contemporary urban activity.

As he had done in Cork, Thaddeus displayed in London an extraordinary ability to infiltrate fashionable social circles, no modest achievement for a young man from an artisan background. His artistic talent can go only some way to explaining this social precociousness. His innate charm and wit, alluded to so often by those who knew and wrote of him, allowed him to expand his social circle almost effortlessly. It was a pattern that was to repeat throughout his lifetime.

Early acquaintances in London for whom he reserved special mention came from the world of literature, music and journalism. Among them were the accomplished and popular novelists Elizabeth Braddon (1837–1915) and Ellen Wood (1814–87), and the eclectic Georgina Weldon (b. 1837). The work of Ellen Wood was well-known outside England, as many of her numerous novels had been translated into other languages, particularly French. She was also

35 H.J. Thaddeus, 1912, p. 8. 36 Dagmar Höher, 1986, p. 75. 37 Ibid., p. 76. 38 H.J. Thaddeus, 1912, p. 8.

editor of the *Argosy: a magazine for the fireside and the journey* for over twenty years. Braddon was a prodigious writer of both poetry and prose, whose success came essentially from popular fiction, and whose readers, in the words of L.C. Sanders, belonged 'to a class that does not seek metaphysical subtleties and philosophical intentions, but is content with a frank story of sensation'.[39] She was married to the well-known London publisher Maxwell. Georgina Weldon was a 'musician, composer, lecturer, philanthropist and reformer', and a powerfully driven personality, committed to the musical education and reha- bilitation of orphans, despite considerable resistance from her husband and others.[40] Thaddeus said that she was 'then much talked about' and that he remembered her in particular probably because she was 'a very pretty woman who deigned to notice me'.[41] It is perhaps no surprise that she was occupying the public's consciousness, as in 1878, just a year earlier, her husband attempted to have her committed to Dr Forbes Winslow's Lunatic Asylum. She subse- quently brought a law suit against four doctors involved for misdiagnosing her as insane. Significantly, all of these women were considerably older than Thaddeus, and one wonders to what extent he can actually have known them. Nevertheless, the mere mention of their names indicates Thaddeus' image of himself as a young man. He also described Sutherland Edwards of *The Times* as a 'friend', who introduced him to Heatherley's studio, and mentioned Edwards' wife, the pianist Arabella Goddard, and their circle.[42] Thus, from a very early point, Thaddeus was looking beyond the limits of the art world for his social group. In his *Recollections*, he mentioned few early London acquaintances by name. Conspicuous absentees are his fellow students, from whom he himself conceded he had much to learn. Typically, he appears to have been disinclined to speak of other artists, or at least those of his own generation.

In 1883, Samuel Butler wrote to Mr O.T.F. Alpers that when he was studying under Heatherley, he heard 'a student ask how long a man might hope to go on improving. Mr Heatherley said: "As long as he is not satisfied with his own work"'.[43] One imagines that it was similar motivation, and an emerging *wanderlust*, rather than disenchantment that prompted Thaddeus to leave Heatherley's and travel to Paris in the autumn of 1880. He said that he left for France with 'abounding confidence' in his motto 'Nil Desperandum'.[44]

39 See L.C. Sanders, 1887. **40** See F. Hays, 1885. **41** H.J. Thaddeus, 1912, p. 9. **42** H.J. Thaddeus, 1912, p. 9, and *The Irishman*, 4 June 1881. **43** Festing-Jones, 1919, p. 381. **44** This translates approximately as 'Despair of nothing'. H.J. Thaddeus, 1912, p. 10.

The importance of Paris

Throughout the last decades of the nineteenth century, Irish and British artists travelled directly to Paris or Antwerp without apparent difficulty or disadvantage, but Heatherley's nevertheless introduced its 'transiting' students to an environment more cosmopolitan and competitive than they had previously known, yet still less frenetic than that in Paris. There, away from the distractions and parochialism of his native city, Thaddeus was free to commit himself fully to his work and broaden his social horizons. The *artistic* benefits of training in London are difficult to quantify, however, and Thaddeus was to receive a rude awakening on arriving at the Académie Julian, where any technical advances he had made up to that point stood for little.

Thaddeus seems to have arrived in Paris in November 1880. Predictably, he understated the long-term importance of his training at the Académie Julian. When, some years later, a journalist from the *New York Herald* remarked that he had studied at that atelier, the artist quipped 'I'd like to know who didn't'.[1] Julian's was the largest art school in Paris after the École des Beaux Arts when Thaddeus arrived, though the precise number of students in attendance is unclear. George Moore estimated that there were only about twenty-five students studying there in 1873, but by 1880, according to A.S. Hartrick, the English artist, 'there were usually several hundred students of all ages, nationalities and conditions gathered there'.[2] Thaddeus, for his part, said that there were between sixty and seventy students at Julian's.[3] These echo the figures of Arthur Dow, the American, who suggested that, when he arrived at Julian's in 1884, there were about fifty students in the studio directed by Boulanger and Lefèbvre. What is irrefutable is that Julian's expanded rapidly during the 1870s, and continued to do so until the turn of the century.

Though the Académie Julian had been established by Rodolph Julian in 1868, Thaddeus, arriving there towards the end of 1880, was among the first Irish artists to attend. Only a few Irish visitors, most famously George Moore, had studied at Julian's in its earliest years. Moore's artistic talent was somewhat limited, and he relinquished painting to make his name as a critic and writer.

1 *New York Herald*, op. cit., 27 March 1896. 2 A.S. Hartrick, 1939, p. 17. 3 H.J. Thaddeus, 1912, p. 11.

Sarah Purser arrived at the Académie Julian in the winter of 1878, but stayed for just six months, due to commitments elsewhere. She later maintained that Julian himself wanted her to return, claiming that two years at the school would make her 'a fully proficient artist'.[4] The atelier, situated on the Passage de Panoramas, just off the Boulevard Montmartre, proved the most popular school in Paris for Irish students during the final decades of the nineteenth century, and one of the city's most successful schools in general. Julian's, unlike the dominant École des Beaux-Arts, was an inclusive and progressive institution, which embraced students of all nationalities, ages and abilities. For admission to the École des Beaux-Arts, prospective students were required to take part in a highly competitive entrance examination, conducted in French, but in contrast, the Académie Julian effectively operated an open-door policy. The availability of space was a relatively minor consideration, and Julian's studios were notoriously crowded. The standard of students at Julian's was unpredictable, but those who showed potential and application generally prospered. The atmosphere, while lively and good-humoured, favoured those who were thoroughly committed to their work. There was little room for the casual student. Julian's was also the first studio in Paris to admit women on an equal footing with men.[5] Up to 1880, men and women worked together, but thereafter occupied different studios. Colarossi's could claim to be the cheapest atelier in Paris, but Julian's tuition fees were still relatively low, and certainly smaller than those for equivalent schools in London. Julian was even understood to have admitted free of charge indigent students who showed promise. Effectively all aspects of student life were cheaper in Paris than in London. Tuition fees and studio expenses were lower (study at the École des Beaux-Arts was free, although there was an enrolment fee for foreign students), as were accommodation, subsistence and studio rental. Stanhope Alexander Forbes, who was attending Bonnat's studio in 1880, paid 'about eighty francs a month for a studio with a bedroom; in London he would have had to pay four times as much'.[6] George Moore recorded in his *Confessions of a jury man* that his tuition fees amounted to just 40 francs a month. Julian was renowned for welcoming students of various nationalities, so that by 1880, there were representatives of countries throughout Europe, and from the United States, enrolled at the atelier. The Académie Julian, therefore, had an immediate and enduring international appeal and reputation. Julian did not aim to subvert all elements of academic training, but rather, acutely aware of the hegemonic status of the École des Beaux-Arts, sought to introduce a more democratic element into the Parisian art world. His original intention was to train students for entry into the École, but his studio soon became identified as one of the École's foremost competitors.[7]

4 J. O'Grady, 1996, p. 29. 5 For a detailed discussion of women at the atelier, see C. Fehrer 1994, pp. 752–7. 6 Ibid., p. 75. 7 Fehrer, 1994, p. 752.

Julian himself was a moderately successful painter and illustrator, but had struggled at the beginning of his career, and was consequently widely regarded as sympathetic to the difficulties and uncertainties encountered by the young artist arriving in Paris. He had studied under Cogniet and Cabanel, and exhibited at the Salon des Refusés of 1863, and at the Salon between 1865 and 1878, but success had come relatively slowly. He was, fortunately, a pragmatist with considerable business acumen, and, by 1878, was directing his energies towards training artists rather than practising as one.[8]

Julian's was chaotic, crowded, and rather dingy, though this did not discourage its body of reckless students. Edward Simmons (1852–1931) remembered with some distaste that 'on a hot July day, what with paints, dirty Frenchmen, stuffy air, nude models, and the place below, this room stank worse than anything I can think of. Not much calculation for comfort, but possibly an enormous inspiration for genius'.[9] May Alcott Niericker also attested to the poor state of Julian's academy, speaking of the crowded, dirty and close rooms.[10]

Shortly before Thaddeus' arrived at Julian's, a separate studio had been established for female students, while male students were assigned to one of two studios reserved for them. The separate groups came under the guidance of two invited *maîtres* who would visit the students alternately to supervise and criticise their work. The visits would occur on average twice a week. Day-to-day practicalities in the studio were entrusted to *massiers* or *massières*, elected figures who were themselves students. Their vicarious responsibilities included posing the model and collecting fees. Students were otherwise, to all intents and purposes, left to their own devices, and learnt as much from practice, and by observing one another as they did from the criticism of their visiting masters, though this did not diminish the students' respect for them.

The American artist Birge Harrison stated that Julian's ambition was 'to rival, and if possible to surpass, the famous École des Beaux Arts, and he was careful to choose masters who would train his students upon the academic lines then in vogue'.[11] When Thaddeus was at the atelier, William Bouguereau (1825–1905) and Tony Robert-Fleury (1837–1911) were the masters of one studio, while Gustave Boulanger (1824–88) and Jules Lefèbvre (1836–1911) oversaw the other. All were mature artists by this time, prominent establishment figures, and, in the case of Bouguereau, Boulanger and Lefèbvre, members of the Institut Nationale des Sciences et des Arts, the single most powerful art body in France. Each worked in a thoroughly academic, Neo-classical style and were regular exhibitors at the Salon. As Lefèbvre, Boulanger and Bouguereau also taught at the École des Beaux-Arts, and as all four were commercially highly successful, they were in an incomparable position to recommend what

8 H. Barbara Weinberg, 1991, p. 221. 9 Ibid. 10 C. Fehrer, 1984, p. 207. 11 B. Harrison, 1890, p. 757.

work, both in terms of style and content, was appropriate for the Salon, and furthermore, attractive to prospective buyers attending it. All four of these masters had also figured on the Salon jury, and actively encouraged their students to aspire to success in that forum. The ultimate goal, for which they would have encouraged their students to aim, was the Prix de Rome, which Boulanger, Bouguereau and Lefèbvre had all won, in 1849, 1850 and 1861 respectively. However, non-students of the École des Beaux-Arts were rarely successful. The Salon was still the preeminent exhibition in France (though not for long, as there was a growing number of alternatives), and in the eyes of most young artists, to have one's work endorsed by the Académie was to have one's status altered irrevocably.[12] It could be likened to a coming-of-age, and a proper introduction to the higher echelons of the art world and the commercial opportunities within it. The euphoria that Thaddeus experienced when he was first accepted at the Salon in 1881 was, therefore, typical. Significantly, Julian was notorious for exerting whatever influence he could to ensure that his students were represented at the Salon.[13] Not surprisingly, however, Thaddeus gave no indication that representations had been made on his behalf when his work was accepted.

Thaddeus entered the studio of Boulanger and Lefèbvre, both of whom he remembered as commanding the respect of all the students. Boulanger, in his own work, favoured classical themes, such as *Hercules at the Feet of Omphale* (1861), and worked on the grand scale typical of that genre. He also produced a number of decorative schemes, including one in the theatre of the Casino in Monte Carlo, finished shortly before Thaddeus arrived in Paris. The prominence given to the academic figure in his work indicates the extent to which he adhered to academic principles and tastes, and his dismissive attitude toward modern movements such as Impressionism was well-known. Lefèbvre, too, concentrated on classical themes, though latterly he favoured portraiture, and was best known for his Neo-grecian nudes, such as *The Source*. Lefèbvre was known for 'his sensitivity to precision in his students' life drawing', though in Thaddeus' case this may have been manifest more in his portraits, studies of heads and the like, than in his full-length studies.[14] Despite his guidance and example, and the emphasis placed at Julian's on the accurate drawing of the figure, anatomy was not Thaddeus' *métier*, though he managed skilfully to disguise this shortcoming. Lefèbvre might be said to have provided a more obvious example to Thaddeus with his portraiture, as it was an area in which he excelled, and the one in which Thaddeus was soon to make his name.

To some extent, the training provided at Julian's was not so far removed from that which Thaddeus received at Heatherley's. The fundamental difference lay in

12 For a full discussion of the status and decline of the Salon in the nineteenth century, see P. Mainardi, 1993. 13 Fehrer, 1994, p. 754. 14 J. Kaplan, 1996, p. 6.

the constant and guaranteed availability of the male and female model. In any case, the masters at Julian's made no allowances for those students with previous training, regardless of their experience or reputation. From this point of view, Julian's maintained a meritocratic approach that was admirable in principle, but often rather difficult to adapt to initially. Boulanger and the other masters were brutally honest in their criticisms. Henry Savage-Landor, who attended Julian's in the mid-eighties, having studied under Thaddeus in Florence, observed comically that Boulanger was 'violent in his remarks, and his language of the coarsest kind – strange from a man famous for his pictures of sweet virgins and angels, white and pink like strawberries and cream'.[15] The masters at Julian's respected the individuality of their students to a point, but did not give them a free rein, and expected them to demonstrate a grasp of the fundamentals of technique.[16] Thaddeus received an introduction to Julian's strikingly similar to that of Edward Simmons, with whom he was to remain in contact for some time. Both had arrived in Paris full of exuberance and high expectation, but were quickly brought down to earth by their masters. As Clive Holland cautioned in 1902, 'the nouveau will find that he has a lot to unlearn when he crosses the Channel to plunge into the actuality of Parisian modern art'.[17] Simmons had been praised by one of his teachers in Boston for his *chic* and imagined that this (effectively indefinable) quality would pave the way to greater accolades and acknowledgement in Paris. Instead, according to Simmons himself, Boulanger dismissed one of his first works out of hand, leaving the artist crestfallen. When he asked Boulanger how he might improve, he was told to take a week to copy the outline drawings of Gérôme, which he did, with fervour.[18]

Thaddeus came to Paris with equally high expectations, and unchecked confidence. His initial application, according to the artist himself, was rejected by Julian, who ordered him to go away and learn to draw. Thaddeus found the rejection humiliating, but also considered it the best lesson he had ever learnt. In response to the setback, he laboured hard for months on his drawing, and was admitted to Julian's at the second attempt. This account seems slightly fanciful, as students were not required to produce work for admission to the atelier, but it does demonstrate the particular standard to which newcomers were expected to aspire. Numerous students attested to the paramount importance placed on drawing at Julian's. A.S. Hartrick, who also trained under Boulanger and Lefèbvre, explained that Lefèbvre awarded him the monthly 'Concours', a fundamental part of the atelier system, for composition shortly after his arrival, but finished his complimentary comments about his work by saying that he, too, must 'learn to draw!'[19] Marie Bashkirtseff, despite regular and enthusiastic praise from Julian, was told by him that though she could draw 'ten times better

15 H. Savage Landor, 1924, p. 37. 16 Fehrer, 1984, p. 210. 17 C. Holland, 1902–3, p. 33. 18 E. Simmons, 1922, pp. 124–5. 19 Hartrick, 1939, p. 11.

than Manet', she still did not know how to draw.[20] John Lavery also received an uncompromising assessment, in his case from Bouguereau, of his first efforts at drawing the live model at Julian's. Bouguereau told him that his drawings were like wood, and that he should seek to capture 'la caractère et les valeurs' (the character and the values) of the subject.[21]

Both at the Cork School and Heatherley's, Thaddeus' masters would have impressed upon him constantly the importance of drawing. It is surprising, therefore, that his previously acknowledged proficiency in this area was not recognised, or failed to impress, when he arrived in Paris. Such was the regularity and certainty with which he and other young British and Irish artists were humbled, one wonders if it was a device adopted by the masters to assert their authority and keep the student's ambitions and confidence in check. Students tolerated the apparently harsh treatment, content in their belief that they were receiving the best training available, from some of the finest artists in France at the time.

Furthermore, as in Cork and at Heatherley's, students at Julian's advanced from one discipline to another by demonstrating their proficiency. Having been admitted, they would first study from engravings, which must have proved frustrating for many, including Thaddeus, who had had extensive training elsewhere. Next, they worked from the Antique. This was an area in which Thaddeus was well-versed and competent, and which should have provided him with few problems. Students were then given the opportunity of drawing the live model. Occasionally, the more talented and advanced students were allowed to draw from the nude model as soon as they enrolled, but it is not known if Thaddeus enjoyed the privilege. In any case, those artists who wrote of their experiences at Julian's all testified, irrespective of their progress, to the paramount importance given to drawing.[22]

The strict application demanded in drawing exercises extended, not surprisingly, to painting, as students were obliged, in effect, to demonstrate that they had mastered the basics. Before they were allowed to paint from the model, they first had to paint still-life pictures. Patience and discipline were rewarded, as male and female models stood all day, so once the students were admitted to the life classes, they had ample opportunity to make up for what they might have seen as misspent time.

In view of the adverse criticism to which he was subjected, and the backward step he may have been forced to take in training, one might wonder why Thaddeus left London at all. Fundamentally, British and Irish artists believed that the teaching and opportunities they would receive in Paris and, to a lesser extent, Antwerp, were superior to those provided in Britain and Ireland.

20 M. Bashkirtseff, 1985, p. 391. 21 Lavery, 1940, p. 49. 22 For a discussion of the differences in teaching methods between Ireland and Paris, see J. Turpin, 1997, pp. 188–93.

Though largely inherited and sometimes exaggerated, these beliefs were not based purely on hearsay and reputation. Many artists saw in French painting itself evidence of the superlative quality of French art education. French artists' technical competence in areas such as anatomy and drawing, which were considered eminently 'teachable', were admired and aspired to by British and Irish painters.[23] Training in Britain, by comparison, was considered regressive, limiting, and lacking in vitality. Clive Holland, writing in 1902, expressed an opinion that would have been equally prevalent among British students twenty years earlier:

> It is to Paris – wonderful Seine side Paris – with its treasures of art, its freedom for the exercise of instincts in pursuance of the painter's craft and for the untrammelled development of talents, that the true student turns with longing. A year or two at Julian's, the Beaux Arts, or Colarossi's, is worthy a cycle of South Kensington, with all its 'correctness' and plaster casts.[24]

Ironically, the newer generation of British schools, including the Slade, the South Kensington Schools and Heatherley's were themselves responsible for sending students across the Channel. Rather than merely emulating a French system, they tacitly encouraged students to experience it first-hand.

Thaddeus made good progress at Julian's, and success at the Salon came improbably quickly. This is all the more remarkable in light of the fact that Julian discouraged artists from submitting too freely or quickly to the Salon. Marie Bashkirtseff remembered that Julian felt strongly that she should make an impression at the Salon or not exhibit at all.[25] Thaddeus certainly appears to have followed a similar lead. His first success at the Salon has been referred to as his 'first finished work', but it is more likely that Thaddeus was encouraged to wait until he had produced a work which Boulanger, Lefèbvre and/or Julian deemed of sufficient quality to submit to the Salon.[26] In May 1881, just a year after his arrival at Julian's, Thaddeus' painting entitled *Le retour du bracconier-Irlande* (pl. 3) – exhibited in Ireland as *The Wounded Poacher* – was accepted, and, much to his surprise and delight, hung 'on the line'. This meant that it was hung in the most advantageous position, at approximately eye-level, rather than positioned high up on the wall ('skied'), or placed near the floor, as so often happened to the work of lesser artists and first-time exhibitors. A picture hung 'on the line', and thereby to best effect, was not only likely to attract critical comment, but was also more likely to find a buyer.

23 See E. Morris and A. McKay, 1992, pp. 78–84. 24 C. Holland, 1902–3, p. 33.
25 Bashkirtseff, 1985, pp. 390–1 (5 January 1880). 26 M. Holland, 1937, p. 32.

There is, again, some confusion regarding where Thaddeus was living when he painted *The Wounded Poacher*. While in his *Recollections*, he wrote that he painted it during his first year at Julian's, in his interview with the *New York Herald* of 1896, he was quoted as saying that it was, rather, in Brittany 'that I painted my first Salon picture, "A Wounded Poacher"'. The address for the artist, Cité du Retire, 3 Faubourg Saint-Honoré, given to the Salon at the time, suggests that he was still living in Paris.

In 1880, responsibility for the annual Salon was abdicated by the state, and handed over to the Societé des Artistes Français, which aimed to reintroduce some order, both 'moral' and practical, into proceedings. As a consequence, the 1881 exhibition was reduced to just two-thirds the size it had been the previous year, which compounds Thaddeus' achievement in having his picture hung so prominently.[27] Though the picture's position was something of a surprise, its acceptance at the Salon was understandable, as it featured many of the qualities valued and looked for by the juries. The two figures, well modelled and carefully posed, testify to the artist's experience of drawing from the live model. It is, both thematically and compositionally, a theatrical picture. The two figures face the viewer as if on a stage, the woman attending to the wounded man over his shoulder. The theatrical quality is enhanced by the introduction of strong light from the foreground, illuminating the protagonists and casting the background into murky darkness. This was a device that Thaddeus used to great effect in a number of his later paintings. Theatricality here is complemented by narrative clarity. An overturned chair in the background, and a shotgun, hat and two poached rabbits, which have been cast to the ground, indicate the chaos that has just passed. The man, who appears to have been shot, has hung his jacket over the back of the chair on which he sits, but has not bothered to take off his shirt properly, rather opening it from the top, leaving it to hang from the waist. To this scene of commotion, the young woman introduces calm and succour. While the space occupied by the poacher is awry and cast into shadow, that surrounding the young woman is more orderly and bright. Even the appearance of the woman herself provides a dramatic contrast with the wounded poacher. She is fair skinned, pale and neatly (albeit simply) dressed, frowning slightly in sympathy as she tends to the wound on the young man's shoulder. The manner in which she cradles his head, which he has cast back, is reminiscent of religious iconography as seen, for instance, in images of St Sebastian and St Irene.

There has been some debate as to whether or not this is an Irish scene.[28] When the picture was shown at the Salon in 1881, it was listed in the accompanying catalogue as *Le retour du braconier*; – *Island*, but the final word is undoubtedly a misspelling of 'Irlande'. However, though the title was ascribed

27 See Mainardi, 1993. 28 See J. Campbell, 1984, p. 182 and M. Wynne and A. Le Harivel, 1986, p. 40.

to the picture by Thaddeus himself, who evidently intended it to be viewed as an Irish subject, it is not immediately identifiable as such. Any confusion derives from the fact that the picture is not 'wholly' Irish in character. What one sees is an assembly of objects and details taken both from life and memory. French objects have been appropriated to an Irish setting, while recognisable Irish elements, not least the cottage interior itself, have been drawn from memory. A clay pipe, for example, very Irish in character, is juxtaposed with a wine bottle, identified more with France than with rural Ireland. The multitude of details, scrupulously executed, ranging from the repaired leg of the table to the spoon hanging beside the hearth, illustrate the artist's skills rather than connote identity. Significantly, Michael Holland claimed that the figure of the poacher was inspired by a 'burly water-bailiff' who had been a model at the Cork School of Art when Thaddeus was studying there.[29] Elsewhere, he claimed that the theme of the picture was suggested by a story related by this water-bailiff.[30] Thaddeus may have suggested either possibility, which Holland took as affirmation of the 'Irishness' of the picture. Ultimately, however, it is impossible to ascertain whether Thaddeus' poacher actually represents that Cork character, or if the artist merely acknowledged to Holland the relevance and long-term benefits of drawing that model as a student in Ireland. In any case, it is interesting to consider a direct link between this picture and Thaddeus' experience at the Cork school. The correspondent with the *Irishman* was in no doubt about the origins of the painting, proclaiming that the artist was 'to be congratulated for not having wandered outside the island of his birth to seek a suitable subject for the display of his artistic talent'.[31]

Thaddeus was careful not to make the picture too provincial, and limit its appeal. Traditionally, Irish peasants were depicted in instantly recognisable costume; green frock coat, felt hat and breeches. Here the poacher appears in more generic peasant attire, though not entirely unrelated to the Irish type. Moreover, the poacher's clothes have been carefully chosen to demonstrate the artist's competence in rendering different textures, and the quality of his draughtsmanship. The poacher's boots, with the laces undone, like other elements within the picture, represent excellent studies in their own right. The multitude and variety of items within the picture also allowed Thaddeus to show his skills in modelling paint, and in rendering contrasting textural qualities. Such contrasts appear throughout the painting, and include the dead rabbits laid across the butt of the shotgun, the bottle and ceramic bowl set on the wooden table, and the cabbage in and beside the wicker basket.

The figure of the young woman is not so recognizably Irish. In fact, she resembles very closely young peasant women in the paintings of Millet and

29 M. Holland, 1942–3, p. 101. **30** M. Holland, 1937, p. 32. **31** *Irishman*, op. cit., 21 May 1881.

Jules Breton. Her refinement and classical features, certainly call to mind Breton's female French peasants, such as those in *Girl with Rake* (1859; NGI) and *The Potato Harvest* (1868; Pennsylvania Academy of Fine Arts). However, the young woman's importance in a painting of high finish and with sentimental undertones is also redolent of Victorian narrative painting. Her slender frame and refined features contrast with the thick-set muscular poacher that she nurses. In fact, Thaddeus actually changed his painting style to accentuate these differences, and consequently the woman's fair complexion counters dramatically the roughness of the poacher's weather-beaten skin. This appearance gives the young woman, the embodiment of tenderness and care, an almost angelic quality.

Despite its apparent 'Irishness', and the symbolism of the poacher as the desperate, heroic criminal, this picture does not make a strong political statement.[32] Rather than concentrating on the impoverished conditions in which the peasant couple live, Thaddeus presented them as healthy physical specimens, studio models, in a moment of high tension. Irish peasants were not *necessarily* undernourished, but had Thaddeus wished to highlight the plight of the Irish rural poor, who in this case, have been forced to poach for either food or money, he could have contrived their physiques and general conditions accordingly.

The Wounded Poacher allowed Thaddeus to show his proficiency in many of the areas so valued by Salon judges, teaching masters and conventional critics alike. It is, fundamentally, a *tour de force* of draughtsmanship, in which Thaddeus presented two academic models in a cameo that might have been taken directly from the atelier. The poacher, stripped to the waist, supplanted the semi-clad classical figure, and afforded Thaddeus the opportunity to display his knowledge of and accuracy in anatomy, as well as his ability to render drapery on the human figure. The painstaking attention to detail Thaddeus displayed with this figure, down to the inclusion of individual eyelashes, can be attributed to a formal training which placed such emphasis on drawing, and to a lesser extent, to the influence of Victorian narrative painting.

For a young artist seeking public recognition and acceptability in establishment circles, *The Wounded Poacher* was the quintessential exhibition piece. To an extent, Thaddeus offered his audience all things at once: drama, technical competence, imagination and a slightly understated individuality. It was painted on a large scale, and introduced into a genre scene an almost classical heroism. With it, Thaddeus manifestly sought to impress. This might be said to be the picture's weakness. It is, perhaps, too self-conscious, too contrived. Thaddeus wanted to arrest the viewer's attention, and for the picture, among the thousands on view, to stay in his audience's memory. This is even borne out by

32 See also J. Campbell, 1986, p. 95.

the boldness of the signature, drawn in large, clear, block capitals and placed prominently in the bottom left corner, in a manner reminiscent of Courbet and Bastien-Lepage.

Recognition by the Salon jury was as much as Thaddeus could have hoped for at this stage of his career. To have his first success hung on the line gilded the achievement. To receive accolades from important contemporary French critics surpassed all expectations. Thaddeus claimed that *The Wounded Poacher* received special mention from none other than Albert Wolff, the renowned critic for *Le Figaro*, who Thaddeus himself referred to as 'the terror of painters', but strangely, no such references have come to light.[33] A review of the 1881 Salon exhibition, written by Wolff, appeared as a special supplement to the newspaper, but Thaddeus was not mentioned in it. Regardless of whether or not Wolff praised the picture, Thaddeus did not manage to sell it in Paris, and shortly after the Salon closed, returned to Dublin to exhibit it there at the Irish Exhibition of Arts and Manufactures. There it was seen by Vincent Scully, who was to become one of Thaddeus' most important patrons. Scully (b. 1846) came from a high profile family, well-known in political, literary and legal circles, and was himself JP and DL for Tipperary, and high sheriff of the county. He had an obvious interest in painting, and lent works to a number of major exhibitions. His collection seems to have been quite disparate, and contained a number of Irish pictures, including at least three by Thaddeus. Having seen *The Wounded Poacher*, Scully sent the artist 100 guineas to buy it. This was apparently twice the figure for which Thaddeus was asking, so he sent the cheque directly back to sender.[34] Scully was insistent, however, explaining that he thought even that amount did not represent the true value of the work.[35] Thaddeus himself identified this as a key moment in his career, when he began to acknowledge the commercial potential of his work. He did not, however, meet Scully until many years later.

The subject of the poacher itself was not uncommon in Irish painting, particularly among painters of Thaddeus' generation and those who followed immediately afterwards, and there were precedents earlier in the century. James Arthur O'Connor produced the large painting *The Poachers* (NGI) in 1835 which, though overwhelmingly romantic rather than realist (and, in that sense, in no way political), was spoken of by Sir Richard Garnett as 'a composition steeped in Irish sentiment'.[36] Alfred Downing Fripp, who visited Ireland three times during the 1840s, addressed the subject more dramatically in 1844 in a work entitled *The Poachers Alarmed* (Whitworth Gallery) in which two peasant children keep watch behind the locked door of their family's Spartan hut, as

33 H.J. Thaddeus, 1912, p. 17. 34 *New York Herald*, 27 March 1896. 35 H.J. Thaddeus, 1912, p. 18. 36 T. Bodkin, 1920, no page number.

their mother suckles a baby and their father sleeps. The meagre spoils of their poaching, a rabbit and a small bird, lie discarded in the foreground. Walter Osborne, Joseph Malachy Kavanagh and Augustus Burke all painted poachers some decades later, and while none of these artists could be categorised as 'political', they would have been aware of the association of their imagery with Ireland, and the hardship and struggles of the country's peasant population. Moreover, they, like Thaddeus, recognised the dramatic possibilities of the subject, while also, either consciously or unconsciously, acknowledging its broader socio-political connotations. While in nineteenth-century English painting, images of poaching often 'cast doubt on the virtues of the farm labourer', reflecting a commonly held conservative view that poaching led to other more serious social problems, the equivalent subjects in Irish art pointed to injustices meted out to a peasant population forced at times to resort to poaching for food and income.[37] By the second half of the century, the subject had even more political resonance in an Irish context. Some British artists focussed on the physical dangers of poaching for both poacher (see Edward Bird's *The Poacher's Reprieve*, 1813; Guildhall Art Gallery) and game keeper (see William Mulready's *Interior of an English Cottage*, 1828; Royal Collection), particularly at night, without making any explicit moral judgement. In contrast, in *The Wounded Poacher*, the viewer's sympathy is firmly with the peasant couple. William Orpen and Sean Keating went one step further, and identifying, however erroneously, with the heroism and recklessness of the poacher, presented *themselves* in that role.

Thaddeus returned to the subject of poaching some time later, with a work much more in the vein of Fripp's painting. Thaddeus' picture, which has been referred to variously as *The Poachers* and *Protecting the Homestead* is a per-plexing work (pl. 2) as, uncharacteristically, it is not dated, and does not appear to have been exhibited, despite the fact that it is a large-scale and extremely highly-finished work. It is possible that it was privately commissioned, perhaps by an individual familiar with and impressed by *The Wounded Poacher*. Unlike the earlier picture, however, it almost certainly depicts an English scene. The building in which the action takes place, a large red-bricked barn, is of a kind found throughout the south of England. The three male poachers, a blonde boy, a young man (who again has been injured), and an older man, have taken refuge in the farm building, and prepare to resist apprehension. Their costume is not distinctively Irish, and unusually elaborate for a picture of this kind. Stylistically, it is a mature work, incorporating precise draughtsmanship, an impressive handling of paint and tonal range, and a dramatic use of chiaroscuro. It shares these strengths with Thaddeus' painting *Christ before Caiaphas* (pl. 35),

37 C. Payne, 1998, pp. 25–6.

judged by some to have been his *magnum opus*, the date of which is also unrecorded. The sophistication of the composition and technique in *The Poachers*, coupled with the similarities between it and *Christ before Caiaphas*, would seem to indicate that the picture dates from the 1890s, when Thaddeus was living in London.

As well as *The Wounded Poacher*, Thaddeus sent another picture, *A Passing Mist on the Champs Elysées*, to the RDS exhibition in 1881. This picture is untraced, but its title evokes something more akin to the urban work of Jean Béraud, Henri Gervex, Edouard-Joseph Dantan and Giuseppe de Nittis than to paintings by his Naturalist contemporaries. In the last decades of the nineteenth century, a plethora of artists dedicated themselves to painting conventional, bourgeois street-scenes. These pictures were technically sound, but often visually unchallenging, celebrating the life of the urban middle classes: their fashions, recreation and quotidian activities. They were descriptive works, occupying that vast category known somewhat pejoratively as the *juste milieu*, and owed little debt to the advances made by the Impressionists and their successors, or to the rustic Naturalism prevalent at the time. Instead, they represented the application of academic techniques to contemporary subject matter. One imagines that Thaddeus' early street scenes followed this more visible model, rather than those of a more inventive generation. *A Parisian Fairground Scene*, the only known work of this kind by Thaddeus, and indeed one of very few known works by Irish students of Parisian scenes of this period, supports this theory (fig. 4). Judging from its size, it is more than just a highly finished study, but it does not appear to have been exhibited. The tightness of the handling, almost formulaic composition, and unremarkable nature of the subject matter suggest that the picture was produced before the melodramatic *Wounded Poacher*, which Thaddeus imbued with so much more character.

There are qualities to admire in the picture, however, not least the standard of drawing, which complement well Thaddeus' attention to detail. The focal points of the composition, such as the stall in the left foreground, with its abundance of food, toys and trinkets, and the well-dressed trio of a mother and her children to its right, are carefully observed. The narrative is negligible; the little boy in his sailor's outfit, so fashionable for middle-class children well into the twentieth century, glances across at the stall, as his sister gazes up at the balloon she holds by a string. The mother, meanwhile, gliding more than walking, appears aloof and impassive. With detail concentrated in the foreground, the limited activity appears to take place in front of a backdrop. This staged effect is particularly evident in the contrast in treatment between the aforementioned trio in the foreground, and those figures behind, including the little girl buying from the canopied stall, and the tall bearded gentleman and woman with a parasol strolling together further back to the right. The composition as a whole recedes into a haze, accentuating the leisurely atmosphere.

4 *A Parisian Fairground Scene*, 1881. Oil on canvas 46 × 63.5. Private collection.

In the context of Thaddeus' overall *œuvre*, it is interesting to note the strange, almost naïvely painted rural figure on the extreme right of the picture. Many of Thaddeus' paintings, both portraits and genre pictures, are characterized by the closeness to caricature of their figures. Here a stereotypical yokel, seen from behind, wearing a broad-brimmed hat, loose fitting smock and distinctive *sabots*, ambles with his hands in his pockets. Even his flatfooted gait, a counterpoint to the upright correctness of those around him, seems inappropriate to the scene.

Thaddeus enjoyed the camaraderie that was such a feature of student-life in Paris and was well suited to the active social life of Paris in general. He was also equipped to handle the curious customs of the atelier, which were not to all visitors' liking. Parisian ateliers were not for the faint-hearted, and survival required resilience, a sense of humour, and a generous capacity to forgive and forget. Many students wrote at length of the practical jokes and initiation 'rituals' which punctuated the year. New students, or *nouveaux*, invariably fell victim to the pranks of their older colleagues, though they were normally goodhumoured, and off-set by less malevolent practices. Many artists, including John Lavery, recorded that all *nouveaux* on their arrival were expected to

provide, at their own expense, punch and *brioche* for all at the atelier.[38] Thaddeus mentioned that he paid for punch for the other students 'with the greatest good humour', and that obliging them in this way saved him from 'many further inflictions'.[39] Some former students highlighted the hedonistic aspect of student life. John Lavery, for instance, related the tale of an innocent *nouveau* being taken under false pretences to a Paris brothel, while Thaddeus spoke of the presence of *grisettes*, working-class girls who served as escorts to young men, who would socialise with the students, and accompany them on trips to 'Marly, St. Cloud or some other place on the banks of the Seine' when the sale of a picture or some other windfall allowed them to travel.[40] Money was, by all accounts, a constant concern, but extenuated by regular episodes of anarchy and mischief. Thaddeus provided a detailed description of a practical joke that involved hanging a fully-clothed mannequin by the neck from one of the windows, which resulted in some of those *rapins* responsible being taken to the local police station for questioning.

The ateliers were not always harmonious, and it would appear that much conflict could be attributed to differences in nationality. Lavery certainly identified such tensions, as did Hartrick, who described a fracas involving an older English student, his compatriots and numerous French fellow students.[41] Simmons, for his part, recalled a fight that took place in the Café Américain between two young Americans and a group of Frenchmen. He observed, however, that overall, a marked solidarity existed between students at Julian's and that, regardless of origin, they would come to one another's aid whenever necessary.[42] An elderly English general, who was Thaddeus' successor as *nouveau*, was a great favourite with all at the atelier, and gave generously of his plentiful resources to support them.

In Thaddeus' experience, the only difference in nationality that posed a difficulty was that between the large number of Americans and the rest of the student body. With so many nationalities attending, there was a lack of overall cohesion, and students tended to gravitate towards their own national, or linguistic, groups. In Thaddeus' opinion, Americans were particularly guilty in this regard. Despite his affection for Paris, the success he had enjoyed there, and the valuable training he had received, his departure was somewhat premature, precipitated, he claimed, by the arrival of too many American students. He felt that they lacked the sense of humour necessary to integrate, and were utterly disinclined to learn French. He felt that much bad feeling resulted in one

38 Lavery, 1940, p. 49. 39 H.J. Thaddeus, 1912, p. 12. 40 Ibid., p. 19. A *grisette*, in this context, was a young working-class girl, who might work as a seamstress or such like, but also serve when possible as an escort to young men. The term originated from the fact that their *type* would originally have been seen as wearing grey. 41 Hartrick, 1939, pp. 22–3. 42 Simmons, 1922, p. 123.

instance from the refusal of one of the American students to undergo the standard initiation, and came to the damning conclusion that

> The American rarely thinks it worth his while to learn the language of the country where he resides; consequently he is debarred from intimate association with his foreign surroundings, and not being always attracted to his British relations, ends by consorting with his own compatriots.[43]

There was certainly no shortage of American students at Julian's at the time, though a disinclination to learn or speak French was by no means their preserve.[44] The linguistic difference presented a considerable obstacle to many students, and it was not necessarily the case that those who mastered the language fared better in the long term. As far as one can tell, Thaddeus had both a reasonable capacity to learn languages and the confidence to speak them, evinced by the freedom with which he quoted in French and Italian in *Recollections*. Coupled with his gregarious character, this facility made his introduction to Paris somewhat easier. His countryman, John Lavery, took French lessons from an early patron in Glasgow some years before he travelled to France, but nevertheless struggled with the language.[45] He too, however, relied on his personality, and subsequently spent a long period in France without any undue difficulty. Many did not take to Paris at all, and at best had to maintain a workmanlike approach during their stay there. Herbert La Thangue, for example, experienced little of the flamboyant life of the young student in Paris spoken about by so many of his contemporaries, and led a relatively isolated existence.[46] By the early 1880s, the Parisian studios, particularly the commercial ones (Julian's, Colarossi's, Delécluse's etc.), were making special efforts to attract and accommodate foreign students, such as charging special tuition rates for short-term students. In some cases, ateliers even introduced interpreters. Indeed, one of the reasons why some British and Irish students chose to attend the Académie Royale des Beaux-Arts in Antwerp in preference to an education in Paris was that most of the teachers there spoke English.[47]

Thaddeus maligned Americans further, saying that he had 'of late spent some time in the United States, and like all newcomers been much impressed by the absence of all *joie de vivre* in the men, apart from business matters and the chase of the dollar. It is I think this racial characteristic, retained strongly by the American student studying abroad for a liberal profession, which raises so great a barrier between him and the youth of other countries where different ideals exist'.[48] Thaddeus' caustic remarks about the American influence on

43 H.J. Thaddeus, 1912, p. 20. 44 See L.M. Fink, 1990, appendix. 45 Lavery, 1940, p. 46.
46 Morris and McKay, 1992, p. 81. 47 See Sheehy, 1997, p. 126. 48 H.J. Thaddeus, 1912,

Julian's, and Americans in general are all the more audacious when one considers that he was actually living in America when he came to write them. One suspects that he was slightly disingenuous in his comments, as he lived in comfort on the west coast of America for around ten years, and was quite happy fraternising with the social and artistic set there. He also seems to have been well acquainted with at least one of the Americans, Edward Simmons. Simmons was exceptional, however, and challenged Thaddeus' image of Americans abroad, while being aware of their propensities. Simmons wrote that 'one advantage in not having money in Europe is that it forces one to live with the natives and not mingle with transplanted America, vulgar with luxury, that exists in every large capital. We had a good chance to learn the French nature, bear with its eccentricities, and appreciate its wonderful charm'.[49] The sentiment is close to that expressed by Thaddeus, and it is perhaps not surprising that the two men should have met up in Concarneau a short time afterwards. It is certainly amusing, considering his expressed reasons for abandoning Paris, that Thaddeus might have ended up working and socialising with Americans in Brittany.

Thaddeus' choice of Brittany as his next destination was by no means incidental, even though it appears that he originally envisaged staying in Paris 'for a few years'.[50] A number of his specifically 'French camarades' were going to Concarneau, in Finistère to paint *en plein air*, and he decided to follow them. In practice, the prospect of living a carefree life with his peers on the picturesque French coast was probably more responsible for Thaddeus' departure from Paris than any change in atmosphere attributable to the Americans. Thaddeus described Concarneau, albeit retrospectively, as 'that paradise of painters', and would have been well aware of the steady, seasonal exodus of artists from Paris to Brittany, and the reasons for choosing that area. He had also already achieved success at the Salon, and, short of putting down roots in Paris, had little to gain by staying. Once again, he followed the examples provided by his predecessors, hoping to produce 'most wonderful masterpieces'.[51]

p. 20. **49** Simmons, 1922, p. 134. **50** *Irishman*, 4 June 1881. **51** H.J. Thaddeus, 1912, p. 20.

Brittany and beyond

In the early 1880s, Concarneau was not the obvious destination for an Irish artist venturing forth from Paris. Unlike nearby Pont-Aven, where the lives of the local and artist communities seemed integrally linked, Concarneau remained primarily a fishing town, albeit one that welcomed its visiting artists. It was one of the most important sardine fishing ports in France, and boasted not only a vast fishing fleet, but also an extensive sardine processing and canning industry. Henry Blackburn and Randolph Waldecott wrote in their entertaining book *Breton folk* in 1880, just a year before Thaddeus arrived, that Concarneau was 'certainly not a place for visitors to stay in; the work and life at Concarneau is to catch and cure little fishes, and the odours of the dead and the dying, the cured and the fried, pervade the air'.[1] The odour of the sardine factories was compounded by that of the fetid mud of the bay at low tide, which Thaddeus said 'on a hot day, was far from fragrant'.[2] However, these smells failed to dissuade a growing number of artists from settling in the town towards the end of the century, making it ultimately into 'the most vibrant of the different centres of painting in Brittany'.[3] Nor was the artists' presence there unrelated to the major industry in the town, as the daily schedules of the small, square-sailed fishing-boats and the activity that attended their arrivals and departures provided the resident artists with a constant supply of subject matter. Moreover, the factories themselves did not escape the attentions of the artists, as demonstrated in the striking *Les sardinières à Concarneau* of 1879 by the Danish artist Peter Krøyer and the festive *Les sardinières de Concarneau* by Alfred Guillou (1844–1926), who, alongside his friend and brother-in-law, Théophile Deyrolle (1844–1923), was a stalwart member of the artist colony.[4]

Concarneau's attraction did not lie solely in the routines of its fishing fleet, but rather, like so many other popular Breton towns, it offered what the Irish artist Helen Mabel Trevor later described lyrically as 'animate and inanimate paintability'.[5] For those individuals willing to brave the pungent atmosphere, Concarneau had many distinctive picturesque features to recommend it. Foremost among these was the Ville Close, the medieval heart of the town. This

1 H. Blackburn and R. Caldecott, 1880, p. 123.　2 H.J. Thaddeus, 1912, p. 25.　3 L.P. le Maitre, 1993, p. 36.　4 See R. Le Bihan, 1993, pp. 25–30.

5 Chapelle de la Trinité, Ville Close, Concarneau.

fortified island situated in the middle of the harbour, set the town apart from other commercial and industrial ports in Brittany and elsewhere in France. It attracted the eye, and served as the backdrop to many paintings.[6] It was, in fact, on the Ville Close itself, among its narrow streets and castellations, that Thaddeus had the good fortune to establish his studio, in a small medieval chapel, the Chapelle de la Trinité (fig. 5). He claimed that it was placed at his disposal by the mayor of Concarneau, and that its large Gothic window served his purpose 'admirably'.[7] Though Thaddeus worked in this small, simple building, which, appropriately, serves as an art gallery today, he lived on the mainland. There, in 'a kind of suburb to the original city',[8] he was among the 'very happy crowd' boarding at the Hôtel des Voyageurs, one of a number of hotels in Concarneau frequented by artists.[9] It was slightly more expensive than the equivalent accommodation in Pont-Aven, but modern and more comfortable, and provided copious amounts of wine, a much less injurious beverage, in Thaddeus' opinion, than Pont-Aven's cider. His subsistence costs would have been low, and he seems to have enjoyed a comfortable existence, managing to pay his models without difficulty.

Thaddeus had, in fact, spent a short time, en route to Concarneau, in Pont-Aven, the best known and most romanticized of the Breton artist colonies, where he met a number of artists whom he had known in Paris. He seems to have stayed at the Pension Gloanec, an inn in the centre of the village patronised by myriad artists, including Pont-Aven's most celebrated visitors, and run by the irrepressible matriarch Marie-Jeanne Gloanec (fig. 6). Among those to stay there were Paul Serusier, Émile Bernard and Paul Gauguin. Much of Thaddeus' description of his chosen accommodation could apply to the other establishments, such as the fact that the students received constant and plentiful supplies of cider and good wholesome food, but he did specify that 'the buxom daughters of the house, in their white coifs and picturesque Breton costumes, did the service, whilst their more amply-proportioned mother superintended the cooking'.[10] This description echoes those of other patrons of

5 H.M. Trevor, London 1901, p. 83. 6 See Belbéoch, 1993, p. 13. 7 H.J. Thaddeus, 1912, p. 33. 8 Ibid., p. 25. 9 Simmons, 1922, p. 145. 10 Ibid., p. 24.

that particular hostelry. Madame Gloanec was generous in spirit and kind to her artist clientèle, providing them with regular meals, tolerating both their boisterous, unruly behaviour, and the delays in their payment of rent (which itself was far from exorbitant). Thaddeus arrived during the summer, when all, artists and locals alike, enjoyed an apparently idyllic outdoor lifestyle. The local community as a whole indulged their bohemian visitors, but also subtly exploited their presence, serving as models for the artists whenever called upon. They were pragmatic when it came to posing, though it was not a particularly taxing task. Blackburn and Caldecott remarked that 'the inhabitants of Pont-Aven, in their picturesque costume (which remains unaltered) have learned that to sit as a model is a pleasant and lucrative profession, and they do this for a small fee without hesitation'.[11] Thaddeus' practically utopian impressions of Pont-Aven, which

6 La Pension Glouanec, Pont-Aven.

'resembled a gigantic studio, with its picturesque streets full of painters at work', correspond to many contemporaneous accounts.[12] He even went as far as to say that 'local laws and mandates' proved as flexible as necessary, according to the wishes and behaviour of the artists. If Pont-Aven was as idyllic as he described, and the routine of working throughout the day and socialising in the evening did, as he claimed, constitute 'an ideal existence to which I know no parallel', it seems odd that he left at all.[13] Perhaps it was *too* idyllic for his taste. It seems unlikely that Thaddeus was one of those artists who fled to Brittany out of disgust at their generation's preoccupation with industrialization.[14] He had, after all, thoroughly enjoyed the urban environment of both London and Paris. Concarneau's industrial status meant that it was not quite as removed as Pont-Aven from the modernized France Thaddeus knew in Paris, while still retaining those distinctive cultural and physical qualities so sought after by artists. Concarneau offered 'to visitors not only the draw-bridge, the towers, the gates, the quayside steps and the little cider taverns but the town hall … "the markets, the jetty, the aquarium, the fish market on which hangs a little ship adorned with bunting"'.[15] It is also possible that Thaddeus found the disproportionate

11 Blackburn and Caldecott, 1880, p. 134. 12 H.J. Thaddeus, 1912, p. 24. 13 Ibid., p. 25.
14 M. Jacobs, 1985, p. 42. 15 'aux visiteurs non plus le pont-levis, les tours, les portes, les

size of the artists' colony at Pont-Aven, regardless of the unique atmosphere it engendered, ultimately undesirable. Though he enjoyed the company of his fellow painters, at no point in his career did Thaddeus seek to immerse himself in social circles exclusive to artists. Though there was a large number of them in Concarneau, they did not take the town over as they did in tiny Pont-Aven. Pont-Aven's character, which itself drew artists to the village, was perhaps in danger of being corrupted under the artists' influence. Simmons identified something to this effect in his autobiography, and rejected the village's contrived authenticity. He actually disliked Pont-Aven, labelling it 'that place for predigested food for artists and ready made motifs', and added later, rather dismissively, that it was particularly suited to watercolourists.[16]

The likelihood is that Thaddeus travelled to Brittany with a group of fellow artists, possibly including Simmons, having made plans in advance to liaise with others in Concarneau. Concarneau, like Pont-Aven, retained its strong Celtic identity, evident in the Breton language, the costumes and the religious customs, particularly the *pardons*, annual religious festivals in which the people celebrated their culture. Furthermore, Concarneau also offered the daily possibility of painting the sea. Pont-Aven was indeed a port, but was situated on a protected inlet and, therefore, did not provide artists with ready access to the coast. Simmons alleged rather pompously that British artists merely passed by Concarneau on their way to Pont-Aven, frightened by the 'bigness of the coast', which they left to the French and Americans.[17] One could travel quite easily from popular inland towns like Quimperlé and Pont-Aven to the sea, but one missed its constant imposing presence. In fact, if one looks at the corpus of work produced by the plethora of artists who travelled to Brittany during the last years of the century, one can see that those artists who settled inland generally concentrated on subjects available in those areas, while those in Concarneau continually looked to the sea for subject matter. Thus it seems probable that colleagues, who had preceded Thaddeus to Concarneau, recommended it because of its coastal location.

Ironically, if Thaddeus really did leave Julian's to get away from Americans, Concarneau was the last of all the artist colonies that he should have gone to. There, as had happened in Pont-Aven many years earlier, an American community of artists had been established of which Edward Simmons was a founding member.[18] Moreover, the American presence not only distinguished Concarneau from its neighbours, but was a source of pride for the local community.[19] Stanhope Forbes visited Concarneau in 1883, but returned to

escaliers et les estaminets à cidre mais "la mairie … les halles, la jetée, l'aquarium, la halle à la grande mer et d'où pend un petit navire tout orné de pavois."' Le Bihan, 1993, p. 26. **16** Simmons, 1922, pp. 145, 150. **17** Ibid., p. 145. **18** Weinberg, 1991, p. 234. **19** See Belbéoch, 1993, p. 18.

Quimperlé because he found it too crowded. He shared Thaddeus' (expressed) suspicion of the American contingent, and wrote: 'There are at least twenty American artists there now. How glad I am that I did not remain.'[20]

Though Thaddeus was not the first Irish artist to travel to Concarneau, he was the first to establish himself there with any permanence.[21] Indeed, he has recently been described as, paradoxically, 'le premier animateur de la colonie anglo-saxonne'.[22] Thaddeus may have accompanied Simmons to Concarneau.[23] Though Simmons himself did not suggest that he and the Irish artist arrived together, Thaddeus was one of a small number that he mentioned by name in the relevant section of his autobiography. Curiously, Simmons included Thaddeus not among the British artists (who he saw as merely 'passing by'), but rather ambiguously, either among the Americans or the French. Alongside 'Thaddeus Jones, who has since painted a portrait of the Pope', he singled out the Americans Alexander Harrison, Frank Chadwick (who had also studied under Boulanger and Lefèbvre at the Académie Julian) and Howard Russell Butler, as well as the French artists M. Brion, Émile Renouf, Bastien-Lepage and the sculptor Paul Dubois.[24] Thaddeus also received a fleeting mention in *Guenn: a wave on the Breton coast*, a novel written in Simmons' studio in Concarneau by a young American woman, Blanche Willis Howard, and published in 1883. She based the principal character, Everett Hamor, on Simmons himself, renamed the town Plouvenec, and made thinly disguised references to other artists and visitors in Concarneau around this time. Describing Hamor's artist-contemporaries, she wrote that 'Jones was a man with a second medal'.[25] By the time the book was published, Thaddeus had exhibited twice at the Salon.

The French and Americans did constitute two of the largest groups of artists in the town, though there was also a sizeable number of Scandinavians. Perhaps because Thaddeus, like the Americans, was Anglophone but not English, and also had a reasonable command of French, he was identified with those groups while he was there. However, he certainly did not avoid the Scandinavians, and in fact remembered a Swedish artist, prone to falling asleep after meals, whose colleagues, including Thaddeus himself, placed him in the front row at the circus while he was unconscious.[26] The identity of the artist is unknown, but he does not appear to have been one of the best-known Swedish artists of that period to have spent time in France.[27]

Overall, Thaddeus' Breton subjects are relatively conventional, but this did not necessarily impede his progress. If *The Wounded Poacher* was Thaddeus'

20 Letter dated 27 May 1883. C. Fox and F. Greenacre, 1979, p. 57. 21 Among the other Irish artists who subsequently spent time in Concarneau were Aloysius O'Kelly, Helen Mabel Trevor, John Lavery, Walter Chetwood-Aiken and William John Leech. 22 Belbéoch, 1991, p. 19. 23 Ibid. 24 Simmons, 1922, p. 145. 25 B.W. Howard, 1883, p. 71. 26 H.J. Thaddeus, 1912, pp. 26–8. 27 See K. Varnedoe, 1988.

first impetuous attempt to impress the Salon judges – and a successful one at that – *Jour de marché, Finistère (Market Day, Finistère*; pl. 4), painted in 1882, allowed him to show that he had exhausted neither his talents nor his artistic ambitions with that picture. The sheer scale of the painting, and its complexity, affirm its status as a major exhibition work. It draws on many of the elements that attracted artists to Brittany, and Concarneau in particular, including the distinctive costume and physical type, the characteristic fare, traditional practices, and the reliance on and influence of the sea. In the picture, Thaddeus presented a rustic scene of monumental proportions, not simply in the dimensions of the physical object, but in the statuesque solidity of the almost life-size figures that occupy the foreground. It is, as Julian Campbell has said, 'a modern "History Painting"', in which rural characters are elevated to the scale of heroic figures.[28] The drama on which *The Wounded Poacher* relied was replaced here by complexity and ornament, as the artist presented the viewer with a rich variety of textures and an elaborate composition. To those ends, he took liberties with accuracy, and manipulated and fabricated elements skilfully. Most notably, he presented the dominant figure of the young woman with the basket of leeks in an ornamental *coiffe* and relatively flamboyant costume, which it would have been quite inappropriate to wear on a normal market day. The headdress, exclusive to the Plougastel region of Brittany, and complete with delicately detailed lace trimming, is of the type that local women wore on festive and ceremonial occasions.

Despite his apparent commitment to verisimilitude, Thaddeus seems to have kept the tastes of an urban audience likely to see his work at the Salon very much in mind, and contrived the scene accordingly. In what is the signal work of his Breton period, he did not depict a woman of the exact physical type that he described in *Recollections* as being so typical of the region. There, he wrote:

> Strongly built, with a Mongol type of countenance and unusual head-dress, they belonged to a Celtic tribe, the women of which had for generations been employed in heavy manual labour and the unloading of ships, whilst the men stayed at home to look after the family. Regularly on Saturday nights, reversing the usual order of things, these stalwart women got drunk, and whilst in that condition generally assaulted their husbands, who were physically their inferiors.[29]

The figure in the picture, though not classical (in accordance with conservative artistic principles), resembles equivalent figures in the work of such artists as William Bouguereau, who visited Brittany in the late 1860s (e.g. *Les lavandières de Fouesnant,*) and Jules Breton, who spent time in the region in the 1890s (e.g.

28 J. Campbell, 1986, p. 16. 29 H.J. Thaddeus, 1912, p. 26.

A la fontaine). The women in their pictures have an elegance and refinement that belie the physical nature of their work, and their reputation among many of these artists. The Breton people were seen as quaint and old-fashioned, and therefore of great artistic interest, but were often at the same time considered ignorant, physically unattractive, crude, indolent and dirty. The writings of a number of artists, including Simmons, suggest an exploitative and rather condescending relationship with the local people, despite what one might imagine from the work produced. Thaddeus, however, did not appear do have harboured such extreme prejudice.

In the case of the young woman standing, and the kneeling figure of the old woman on the right of the picture, one also sees Thaddeus' predilection for presenting faces in profile. The contradistinction of youth and age is strongly asserted by these figures: one fresh-faced, upright and expressive, the other wizened, sedentary and contemplative, cradling her chin in her hand. The visual tension between these two is broken by the intercession of the young round-faced boy, who appears to be addressing one of them. He, more than the young woman, represents that Breton physical type that was less than attractive to the sophis-ticated, but astonishingly chauvinistic Parisian audience. Their conservatism had been clearly expressed by elements of the press in relation to the figures in Bastien-Lepage's painting *Les foins*, exhibited at the Paris Salon in 1878. Certain reviewers took exception to the male peasant's stare in that painting, as well as to the posture of the young peasant woman by his side, and to the facial expression which they thought made her look rather stupid.[30] While these precise criticisms cannot be levelled at Thaddeus' picture, the principle remains that, as a rule, the Breton type was not admired by the classically-biased Parisian audience.

Another notable similarity between Thaddeus' picture and *Les foins* is the attention paid to foreground detail. Bastien-Lepage was preoccupied with minutiae, and laboriously detailed the foreground of *Les foins*.[31] The same can be said of Thaddeus in this case, where every detail relating to the figures in the foreground is studiously observed, from the langoustines in the basket the young boy presents from under his arm, to the roast chestnuts and brazier in front of the old woman, the light striking the girl's shoes, and in particular, the shrimp net that the boy carries over his shoulder. This last detail was an important element to balance the composition as a whole, but was also a confident demonstration of technical ability. Thaddeus did not arrive in Paris early enough to see either Bastien-Lepage's *Les foins*, or *Jeanne d'Arc*, exhibited in 1880. He would, however, have been well aware of Bastien-Lepage's influence and reputation, and was very likely to have been familiar with some of his work. They also missed meeting in Concarneau, as Bastien-Lepage arrived there in the summer of 1883, over a year after Thaddeus' departure.

30 G.P. Weisberg, 1992, p. 62. 31 Ibid.

The variety of brushwork visible in *Market Day, Finistère* was common among the *pleinairists* at work in France at this time.[32] The greatest contrast in Thaddeus' picture is to be found between the tight, 'academic' treatment of the principal figures' faces, and the broadly rendered *impasto* of the wet sand on which the whole scene takes place. One can even identify different techniques within the same single form or element, such as the figure of the young woman, in which the dress and belt are broadly painted relative to the detailing of her face. The figures in the middle-ground, which draw the viewer's eye back into the picture, are even more loosely painted, but still detailed enough to complement and connect with the principal figures. Further back, the many figures that occupy the wide expanses of the beach are now merely suggested with simple dabs of unmixed paint. Concarneau was characterized by the broad stretches of sand and mud that were exposed when the tide receded, and here they provide an ideal location for a market of local produce. In the extreme distance, but quite centrally placed, are a couple of studies of animals, a horse and two cattle, rare in Thaddeus' work, but well-observed nonetheless. The picture has the uniform light so typical of Naturalist painting of this period, and captures the haziness of an overcast day. The subdued palette is cleverly lifted by the inclusion of small areas of bright colour, a device that Thaddeus would use throughout his career. Here it is not quite as idiosyncratic perhaps as in subsequent pictures, but equally visible. The glowing coals in the brazier, the red fabric in the young woman's headdress, the pink of the langoustines and the basket of strawberries on the left of the picture, as well as a wide variety of blues, counter the composition's overall greyness.

The uniformity of light might suggest that Thaddeus painted the picture outdoors, or at least made studies for it *en plein air*. He did intend to paint outdoors when he went to Brittany, and many of his pictures suggest that they were the result of direct observation, but the process here was probably more controlled. There are two main mitigating factors. Firstly, and perhaps more convincingly, the figure of the young girl does not seem to be firmly set in the pictorial space, but rather seems to float above the ground. This indicates strongly that the figures were painted in the studio and introduced onto an existing (or at least already studied) background. The problems Thaddeus encountered in trying to incorporate the figures into the setting were shared by many artists. A factor that contributed to this lack of cohesion is the broad treatment of the ground. While the individual figures lose definition as they recede, the sandy surface on which they stand has been handled in a uniform fashion throughout. This broad handling, and the absence of any directional pattern give the ground an almost transparent quality. Secondly, Thaddeus raised the horizon deliberately to allow him to include more detail and activity

32 See Campbell, 1986, p. 16.

in the background. It is an interesting manipulation of space, and undoubtedly serves its function, but does render the image exceptionally frontal, pushing foreground figures very close to the picture plane. Gustave Caillebotte used a very similar device in his urban pictures of the 1870s.[33]

In this context, it is interesting to compare Thaddeus' work with that produced by Edward Simmons in Brittany and to consider their common experience. In Simmons' painting of 1883, *Spring*, executed in Concarneau, he displayed exactly the same difficulty in incorporating a figure into the background as Thaddeus did in *Market Day, Finistère*. The difficulty may be less obvious in Thaddeus' picture because of the background detail, but it is worth remembering that both men had graduated from the atelier Julian, where the doctrine espoused years before by George Moore that 'the studio model was the truth, the truth in essence; if we could draw the nude, we could draw anything' still prevailed.[34] At Julian's, Moore had been convinced that 'the world in the fields and the streets, that living world full of passionate colour and joyous movement was but an illusive temptation'.[35] Though many artists managed to liberate themselves from academic dogma, and embrace landscape painting instinctively, others struggled to do so.[36] Enticed by the principles of *pleinairism*, yet still bound to some extent by the formulaic approach they had inherited in Paris, some of these artists found it difficult to marry the two. They were not always unsuccessful, but one can recognise in many works a struggle in reconciling spontaneous landscape painting with academicism. Moreover, Thaddeus would not have received any instruction in perspective at the Académie Julian, and thus was forced to rely to a certain extent on intuition and trial-and-error to master its complexities.

Notwithstanding two Breton paintings that are vaguely redolent of Impressionism, Thaddeus practised what has been called succinctly 'careful plein-airism', in which colour, and its expressive potential, is obviously subordinate to tone.[37] Conservative critics tended to make a clear distinction between academic painting and the work of Bastien-Lepage and his Naturalist followers. In so doing, they also established their relative positions in a hierarchy, so that though Naturalist works could be admirable and skilfully executed, they could not compare with great academic works. Writing in the *Athenaeum* of a work by Julian-educated M.L.W. Hawkins at the Paris Salon of 1882, one critic wrote that 'the treatment owes much to M.B. Lepage; the subtle humour attests to M. Hawkins' English origin. What remains of his three French teachers [Bouguereau, Lefèbvre and Boulanger] it is hard to see. They

33 See K. Varnedoe, 1987, p. 44. 34 G. Moore, 1891, p. 273. 35 Ibid. 36 By the time William John Leech came to work at Julian's in 1901, students were free to be more expressive and loose in their studies of the nude, and to use colour and tone rather than precise linear drawing. See D. Ferran, 1996, pp. 26–9. 37 Weinberg, 1991, p. 244.

are all Académicians, and he is anything but academical … The technical attainments of M. Bastien Lepage are obviously affected by a confused invention, not yet thoroughly digested.'[38]

One can also identify certain similarities between *Market Day, Finistère* and two works by Stanhope Forbes, who arrived in Brittany a short time after Thaddeus.[39] Forbes painted *A Street in Brittany* in Concalé, in the north of the region, in 1881, just a few months before Thaddeus executed his picture. There are echoes in the prominent placement and pose of the principal female figures, and in the overall scale of the compositions, but the setting of Forbes' painting, with strong directional, architectural lines and relatively shallow depth of field means that he avoided the problems of recession encountered by Thaddeus in his beach scene.[40] More interesting is a comparison of Thaddeus' Salon painting with a later work by Forbes, *A Fish Sale on a Cornish Beach*, which he produced in Newlyn in 1885. Here, beyond the obvious similarities in theme, there are technical attributes which reflect shared aims and might even indicate that Forbes had seen Thaddeus' work at the Salon of 1882. Forbes was more successful in terms of spatial illusion, largely by turning a canvas of standard dimensions on its side, an orientation that lent itself much more readily to the subject at hand. Indeed, Thaddeus was soon to recognise the benefits of doing so. Overall, in terms of finish, tone, and broad composition, Thaddeus' picture and Forbes' sit comfortably together.[41]

As mentioned above, the work produced by the artists who had congregated in Concarneau during the 1870s and 1880s was usually inspired by everyday scenes with which the artists themselves were familiar. Furthermore, they reflected not only the artists' common experience and observations, but also the widespread and habitual exchange of ideas between individuals, to which Thaddeus was as susceptible as any. Scenes of children recur in the work of these transiting artists, partly because they embodied many of the characteristics that artists found so distinctive and attractive about Breton life – their carefree air, innocence, vitality, and their apparent obliviousness to the world around them. Many of the visitors to Brittany spoke of how it appeared to have been caught in time. Childrens' apparent indifference to time exemplified a characteristic of the region overall. Thaddeus' paintings *On the Sands, Concarneau* (pl. 5), *On the Beach* (pl. 6), and *Spilt Milk* (pl. 7) all concentrate on the experiences and daily life of children and, being physically smaller pictures, and sentimental in tone, are decidedly more personal than the imposing *Market*

38 'The Salon Paris – Third and Final Notice', *Athenaeum*, 1882, p. 737. **39** See Campbell, 1986, p. 16. Forbes was born in Dublin, but moved to England at a very early age. **40** Dagnan-Bouveret's painting of 1886, *Le Pardon en Bretagne* presents figures as frontally as Thaddeus does in *Market Day, Finistère*, but avoids the perspectival problems by featuring the wall of a church almost parallel to the picture plane. **41** See Mrs L. Birch, 1906, p. 19.

Day, Finistère. They were, however, highly finished and, in the case of *On the Sands, Concarneau*, intended for exhibition.[42] As in *Market Day, Finistère*, the setting of *On the Sands, Concarneau* is deliberately identifiable. To the aspirant *pleinairist*, this enhanced the picture's authenticity as a scene directly observed. In the background, one can make out the headland of Baie de la Forêt, at the mouth of the bay at Concarneau, with the signal station of Beg Meil.[43] Though the figures seem absorbed in recreational pursuits, their presence on the beach is intrinsically linked to the convoy of fishing boats in full sail that makes its way to port. Many artists in Brittany chose for their painting the theme of locals awaiting the return of the fishing fleet. It represented an ideal means of communicating reliance on the sea, as well as the sea's picturesque potential. In Victorian painting, the theme had often been exploited to great emotional and dramatic effect (e.g. Frank Holl, *No Tidings from the Sea*, 1870; Frank Bramley, *A Hopeless Dawn*, 1888), but Breton paintings, while acknowledging its dominance, generally evoked a harmonious co-existence between humans and the sea.[44] For example, Achille Granchi-Taylor produced a painting entitled *L'attente des pêcheurs*, which, infused with glowing light from an unseen sunset, focuses on everyday reality in Concarneau. Granchi-Taylor's attendants, one of whom carries a creel under her arm in anticipation of the catch, are calm and patient, gazing out at the returning trawlers. Edward Simmons' *L'attente du retour* is a similarly timeless image, with a suggestion of solitude and anonymity absent from Thaddeus' animated children, one of whom stands knitting with studious concentration, while another at her feet teases the youngest with a crab.

The young boy lying on the sand calls to mind the lone figure in Alexander Harrison's *Castles in Spain (Castles in the Air)*, well received at the Salon of 1882, in which a boy appears lying on his back on a beach, daydreaming.[45] The specific pose, as well as the setting of the pictures, are similar, and they certainly suggest a common understanding of the temperament of children. Harrison's picture was painted in Pont-Aven rather than Concarneau, though it is not set in the village, and his figure is absorbed in thought, while Thaddeus' is engaged in idle fun. If one infers from Simmons' selective references to Thaddeus and Harrison that those artists knew each other, if only by association, it is interesting to consider whether they might have seen each other's work, or even exchanged ideas. As we do not know which picture was painted first, it is

42 A painting entitled *On the Sands, Concarneau* was shown at the SBA exhibition of 1881–2, and though no details of that picture have come to light, it seems likely that this is the picture in question. **43** J. Campbell, *Gorry Gallery Catalogue*, May-June 1995. **44** Some similar English works display an obvious debt to French movements, such as Stanhope Forbes' aforementioned *A Fish Sale on a Cornish Beach*, and Albert Chevallier Taylor's *Awaiting the Boats* (1892), both of which were painted in Newlyn. **45** This picture so impressed Bastien-Lepage that he sought out Harrison after he saw it. Weisberg, 1992, p. 149.

impossible to say which artist might have influenced which. Nevertheless, the likenesses do hint at a shared approach to Breton subjects by artists with academic training but Naturalist leanings.

With *On the Beach*, Thaddeus also proved himself resourceful, as he painted it on what seems to be a furniture panel. Artists took art materials with them to Brittany, and exchanged and shared them with one another when necessary, but one can imagine that resources became scarce at times, particularly during the colder months, when there were fewer artists residing in the town. A shop selling art materials had existed in Pont-Aven since 1876.[46] Thaddeus remained in Concarneau for the first few months of 1882, at which time the artist population was relatively small, due to the mass exodus following the outbreak of a smallpox epidemic, and it is conceivable that Thaddeus' reserves of materials were running short by this time

Technically, *On the Beach* is very close to *On the Sands, Concarneau*. In both paintings the concentration on, and firm modelling of the figures contrast with the flat, bold rendering of the sand against which they are set. Consequently, though here perhaps less obviously than in *Market Day, Finistère*, the figures in the painting do not seem to make firm contact with the ground. This is particularly true of the child closest to the viewer in *On the Beach*. Having said this, some of the figures, particularly this boy and the prostrate figure in *On the Sands, Concarneau*, are notable for the novelty of their poses. The extreme foreshortening of the legs of the boy in *On the Beach* illustrates Thaddeus' willingness to innovate and experiment. Nor do these works lack painterly qualities. The wild flowers that sprout up through the sand were painted with delicate touches of a fine brush, a technique adopted by many artists, inlcuding Walter Osborne. The earthy colours and even tonality again link the pictures to Naturalist painting of the period.

On the Beach represents an interesting conjunction of Victorian narrative painting and French Naturalism. Featuring a fleet of fishing boats, merely suggested by simple brushstrokes, along the horizon, it is consistent with Thaddeus' other Breton scenes. However, Thaddeus introduced a humorous subtext to this otherwise typical Breton painting of local children at leisure. For this he must have owed some debt to his training and experience in London and Cork, where artists so often aimed to engage the emotions and sentimentality of the viewer. *On the Beach* certainly suggests Victorian sensibilities, albeit without their associated moral undertones. The two young boys who lie on a dune smoking, evidently playing truant from school, having discarded their books in the sand, represent, rather, a carefree existence, and benign mischief. Thaddeus did not present them for judgement, or to convey some moral message. Something to this effect can be said, however of a picture of similar theme,

46 Jacobs, 1985, p. 58.

which Thaddeus painted many years later. *Master Harold Maxwell*, shown at the Royal Hibernian Academy in 1901, depicted a young truant, bearing the injuries of a fall on his knees, standing to receive a reprimand, his spelling book lying trampled at his feet. The critic for the *Irish Daily Independent* did not know quite how to classify the picture, referring to it as both a 'portrait' and a 'very refreshing study', but while criticising the misjudged proportions of the figure of the boy, remarked positively on the fact that the child's face was full of boyish defiance.[47] The melodrama of the scene and concentration on facial expression, so much at odds with the informality of *On the Beach*, attest to how Thaddeus retreated to more obviously sentimentalised Victorian genre pictures later in his career.

Never is Thaddeus' understated humour and latent sentimentality more evident than in *Spilt Milk*, painted in 1881. A hapless little girl lies face down in the dirt, the jug that she was carrying shattered in pieces around her. The figure of the girl is extremely well observed, and has a graphic quality in the modelling and strong outline that marks much of Thaddeus' genre work.[48] There is relatively little modulation of tone; folds are dark and solid, as are shadows cast on the ground. In the artist's treatment of surface colour and texture, and his partiality for strong contrasts of light and shade, one can identify tendencies which would receive full expression in his most successful portraits, where stark contrasts in light and tone prove vital ingredients in the dynamism of the images.

Among Thaddeus' finest Breton works is *Young Breton Fisher Boy* (pl. 8), in which the artist flirted with techniques associated more readily with the modernist movements of the time, particularly Impressionism. The brushwork is freer and more expressive than in his other work of this period, but more noticeable still is the lustre of the colour range. Thaddeus later promoted the idea that he had no time for Impressionism, but in this small work one sees evidence of him identifying with their interests to some extent. As discussed above, though Thaddeus (and many of his contemporaries) embraced *pleinairism* with enthusiasm in principle, in practice he was still a studio-oriented artist, who valued and required the controllable conditions that that guaranteed. In the picture of the fisher boy, or *mousse*, however, there is a greater sense of spontaneity and instant translation to canvas of a subject observed. The suffused, even light that pervades the other pictures is supplanted here by the bright sunlight that plays on the surface of the boy's clothes and on the creel he carries. Here, light and volume take precedence over detail and complexity of composition. At the same time, it is not totally removed from Thaddeus' other Breton work. Once again, the picture features a child or youth, engaged in some

47 *Irish Daily Independent and Natio*n, 11 March 1901. **48** For other examples, see *An Irish Peasant* (1888), *Mediterranean Fishermen* (*c*.1895) and *A Native American Encampment* (*c*.1910).

prosaic activity. He might be waiting for the return of the fishing fleet, like the children in *On the Sands, Concarneau*, as a single fishing boat can be seen at sea in the distance, and the creel on his arm denotes impending or completed labour.

Thaddeus no doubt revelled in the social life that Concarneau offered. There, as in Pont-Aven, painters devoted themselves 'equally to the spoiling of canvas and to a thorough enjoyment of the open-air life'.[49] He wrote that the artists worked diligently during the day, but in the evenings indulged in the same kind of carousing with which they had filled their evenings in Paris. Indeed, on one occasion, Thaddeus and some 'confrères at Pont-Aven', having staged a fake burial, received a reprimand from the local Commissaire, but promptly placated him with whiskey.[50]

Thaddeus obviously had a great affection for the children he befriended and painted during his stay in Concarneau. He explained in his *Recollections* that he would often have a number of children in his studio, who would take turns 'to pose for a child I was painting in one of my pictures'.[51] The central role of youth in his work of this period is all the more poignant when one considers that the child population of the town was decimated by a small-pox epidemic which broke out at the end of the summer of 1881, just a few months after he arrived there. Thaddeus claimed that the epidemic was so severe and rapid that by the time it abated, it had wiped out half the population in a month and 'not a single child was living in Concarneau or its environs'.[52] Though he may be accused of poorly judged sensationalism in making such a comment, it is clear that the outbreak of the disease distressed him deeply. Unlike the majority of his fellow artists in Concarneau, and oblivious to the danger and eager to finish his canvases for the Salon, Thaddeus chose to remain in the town after the outbreak of illness, and witnessed the distress endured by the local community. In fact, he even claimed that one of the children, who had posed for him, died in his studio. One might imagine that such an event would have found expression in his work in some way, but that does not seem to have been the case. On the contrary, his output did not change in nature, and he continued to paint children and rustic scenes, including *On the Beach* and *Market Day, Finistère*.

Thaddeus' decision to stay in Concarneau through the winter of 1881–2 to finish his paintings for the Salon was vindicated, professionally at least, when two works, *Jour de marché, Finistère*, and *Les amies du modèle* were selected for the 1882 exhibition. The present whereabouts of the latter is unknown, but judging from Thaddeus' own references to the numerous children who would take it in turns to pose for him, and the generally rustic nature of his Breton subjects, it is conceivable that the picture, rather than dealing with a scene from a sophisticated professional studio or such like, actually presented a scene of local girls interacting with one of their number who was posing for the artist.

49 H.J. Thaddeus, 1912, p. 22. 50 Ibid., p. 28. 51 Ibid., p. 33. 52 Ibid.

Thaddeus' success in exhibiting at the Salon in consecutive years was not particularly remarkable, but having two works accepted on this occasion must have been quite a fillip, and must have whetted his appetite for further success. This second representation at the Salon was, however, also his last. Thaddeus never recorded why this was the case, but it is likely that once he had moved from France and set about seeking new audiences and clientèles elsewhere in Europe, the importance of the Salon diminished for him. That is not to say that he withdrew from or lost interest in exhibiting in general, as he continued to show his work in England, Scotland, Ireland and elsewhere for many years.

In the summer of 1882, the Irish Exhibition of Arts and Manufactures took place at the Rotunda, Dublin, at which Vincent Scully bought *The Wounded Poacher*. Thaddeus showed two other pictures there, which were also on sale, *The Sunshine of Life* (priced at £25), and *By the Well* (costing a modest £6 6s.).[53] In these early years, he also maintained strong links with his native city, and in July 1883, identified by the *Cork Examiner* as a 'distinguished fellow citizen', took part in his first major exhibition there, submitting ten works to the Cork Industrial and Fine Arts Exhibition.[54] Significantly, James Brenan was in charge of the Fine Art Department, and managed to assemble works by artists, living and dead, from Italy, France and England as well as Ireland. Among the works on view by Thaddeus were, again, *The Wounded Poacher*, lent by Vincent Scully, another picture entitled *Rent Day*, *Les amies du modèle*, and *Market Day, Finistère*. Despite the success of these last two pictures at the Salon of 1882, it was on others that the national press focussed their attention. Particularly intriguing was a picture of St Patrick, which the *Irish Times* referred to as 'remarkable for able workmanship not less than daring unconventionality'.[55] The patron saint was a novel choice of subject, for grand easel painting at any rate, a fact not lost on the informed audience, and Thaddeus' secularisation of the image would have added to the surprise. Representations of St Patrick were not unusual in ecclesiastical art, but were otherwise extremely rare. According to contemporary accounts, Thaddeus portrayed the saint as an old man, holding a book in one hand, from which he reads, and a shamrock in the other. A journalist with the *Cork Constitution* remarked that though it was regarded as a splendid picture, 'the treatment of the subject is of a somewhat extraordinary character, and were it not known, the patron saint of Ireland would be the last person one would think of as having been in the artist's mind'.[56] The quirkiness that he identified in the picture anticipated other unorthodox works that Thaddeus produced during his career. It is not surprising that the picture elicited such comment in Ireland, as the theme was both novel and quintessentially Irish. Art

53 Another work, listed as the work of Henry Jones (as opposed to H.T. Jones, as was the case in the other three) may have also been by Thaddeus. 54 *Cork Examiner*, 6 October 1883. 55 *Irish Times*, 28 June 1883. 56 *Cork Constitution*, 4 July 1883.

criticism in Ireland at that time tended to concentrate more on theme and drama than technique, so the practical complexities inherent in *Market Day, Finistère* impressed them less than the challenging image of St Patrick. Their conventional outlook was typified, however, by the choice of *Without a Care*, a sentimental, rural picture, as the 'gem of the exhibition'.[57] It depicted a peasant girl, peeping over the rim of a basin of milk from which she drinks.

In late spring 1882, Thaddeus returned to Paris, where he appears to have stayed at No. 167 Boulevard Saint-Michel. This was probably the address of a friend, as Thaddeus had not been resident in the city for some time, and did not remain for long on this occasion. Nevertheless, this seems to have been an important visit. In his *Recollections*, he displayed a constant eagerness to portray himself as an opportunist, both professionally and socially, who was inclined to move beyond art circles. He made the acquaintance, however peripherally, of writers, musicians and critics when a student in London, and continued to do so during this short period in Paris. There, he met Alphonse Daudet (1840–97) and Edmund de Goncourt (1822–96). He could scarcely have mentioned more illustrious French literary figures of the period. Daudet was a renowned novelist and playwright, and for a period was one of the leading figures in the Naturalist movement in literature. Daudet's works reflect an interest in documentation typical of the Naturalist movement, but also in the poetic and fantastical possibilities of stories relating to business, political, religious and social life. Among the best-known works which he had produced by the time Thaddeus met him were *Le petit chose*, a semi-autobiographical work of 1868; *Fromont Jeune et Risler aîné* (1874); *Le Nabab* (1877); *Les Rois en exil* (1879) and *Numa Roumenstan* (1881). Goncourt for his part was a novelist, diarist, playwright, critic and collector of art. The Goncourt diary, maintained by Edmund and his brother Jules originally, and continued by Edmund after Jules's premature death in 1870, spanned a remarkable period of over forty-five years (1851–96). In their *Journal*, they spoke in detail of many of the most important figures in the Parisian artistic, literary, social and political world. Such was Edmund de Goncourt's standing that he was invited by Magnard of *Le Figaro* to succeed Albert Wolff as art critic of that paper, but he declined.[58] Both Goncourt and Daudet were prominent members of an artistic coterie which included Turgenev, Zola and Flaubert, and enjoyed extraordinary celebrity. Naturalist literature, of which they were both prime exponents, was at its zenith during the few years that Thaddeus was in France, and one can only assume from his reaction that he had read the work of both of these writers. Thaddeus did not explain the circumstances that led to their meeting, but maintained that his encounter with them, particularly Daudet, left a 'vivid impression' on him, although he qualified this by adding that his reaction was nothing compared to

57 Ibid.　58 E. de Goncourt, 1971, p. 292.

that of the many young authors who sought Daudet's advice on their work. To them, Thaddeus said 'he assumed the form of a demi-god, whose benign influence and comforting counsel refreshed and strengthened the despairing soul; and he differed from more celestial deities by also helping them materially'.[59] Since the 1860s, Edmund de Goncourt and his brother Jules had advocated the relegation of the art of the past, as they felt that relying on traditional models held the artist back. They reiterated Baudelaire's dictate 'il faut être de son temps', by urging artists to address their own time rather than rely on models of the past. It is not known if Daudet and Goncourt were familiar with Thaddeus' work. Much of it, certainly the two major pictures that Thaddeus had produced by this time, *The Wounded Poacher* and *Market Day, Finistère*, reflect Naturalist sensibilities in painting, and was close to the work of its great figures, notably Jules Bastien-Lepage, by whom Edmund de Goncourt was much impressed. In 1885, some seven years after *Les Foins* was exhibited at the Salon, Goncourt described Bastien-Lepage's work as 'pre-Raphaelite painting applied to the motifs and compositions of Millet'.[60] Unlike other commentators on the arts, he considered Naturalism as a serious movement, worthy of attention and having the *gravitas* of the French artistic tradition. Though one can see clear evidence of Naturalist leanings at this stage of his career, Thaddeus, ever prescient and pragmatic, did not commit himself fully to Naturalist theory. His work of this period varies from detailed, literal 'Victorian' pictures (e.g. *On the Beach*), to grand Naturalist works (e.g. *Market Day, Finistère*), to the almost Impressionistic (e.g. *Young Breton Fisher Boy*). Despite this diversity, it is significant that Goncourt and Daudet should have made such an impact on Thaddeus. Some of the pictures he produced in Brittany, particularly *Market Day, Finistère*, were so firmly of a Naturalist idiom, it is conceivable that, in other circumstances, he might have remained in France to find his niche, working in the style of those artists to whom he obviously responded. Any such inclinations were mitigated, it would appear, by a marked careerism, and a deep-rooted *wanderlust*, which reasserted themselves at regular intervals throughout his career.

Thaddeus did not remain in Paris for long, but moved on, again with friends (whose identity he neglected to disclose), to the Forest of Fontainebleau. This was not a surprising decision in light of his recent experience as Fontainebleau had been attracting artists for many years, and was renowned for its beauty, and Thaddeus, while a student in Paris, would have been well aware of its popularity. Furthermore, a number of artists, including the American brothers Alexander and Birge Harrison, who Thaddeus may well have known in Concarneau, had spent time there before coming to Brittany and may have influenced fellow artists' decision to investigate the region. 1882 saw a very large number of Scandinavian artists arrive in Fontainebleau, including Skredsvig, Krohg, Bergh

59 H.J. Thaddeus, 1912, p. 36. 60 Milner, 1988, p. 225.

and Carl Larsson. The great Swedish writer and painter August Strindberg was also attracted to the area, as the Scot Robert Louis Stevenson had been before him. In this context, it is also intriguing to note that Edmund and Jules de Goncourt had been regular, if not always enthusiastic, visitors to Marlotte and Barbizon, two villages in the area, in the 1860s. Edmund, admittedly, certainly acknowledged the atmospheric qualities the region offered to the artist.[61] Many of the artists working at Grez were successful at the Salon of 1882, in which Thaddeus exhibited his two pictures. Of these, a significant number were American, and if Thaddeus was indeed travelling with artists of that nationality, or perhaps even Scandinavians, there was sufficient communication between artists for him to have travelled to Fontainebleau on the direct advice of their compatriots. There is also an Irish connection to consider. Nathaniel Hone had settled in Barbizon in the 1850s, the Fenian Leader John O'Leary spent some time there in 1877, and Frank O'Meara, who also exhibited at the Salon of 1882, had been resident in Fontainebleau for a number of years by this time.[62] Coincidentally, John O'Leary had also been in Paris regularly between 1872 and 1884, and knew George Moore and Turgenev, who belonged to the Goncourt's literary circle.[63]

Thaddeus settled with his friends in the medieval walled town of Moret, situated on the Loing river. This again was a relatively unconventional choice, as the town of Grez, situated a short distance upstream, was much more popular among artists, and in these last decades of the century attracted a multitude from all over Europe and America, including the Irish artists Nathaniel Hone, Frank O'Meara, John Lavery, Katherine MacCausland and Roderic O'Conor. John P. Peacan is the only other Irish artist understood to have spent any length of time in Moret. He was there *c.*1885–86, and sent a number of French pictures to the Royal Hibernian Academy between 1885 and 1887. Besides Grez, other towns, such as Marlotte, Montigny, Fontainebleau itself and the celebrated Barbizon, would have been more obvious destinations in the area for artists. Once again, Moret's secondary status might have been its chief attraction for Thaddeus. Having said this, he did travel to Grez by train at least once to paint, accompanied by a fellow artist whose appearance seems suspiciously close to that of Toulouse-Lautrec. Thaddeus wrote of his companion: 'Nature herself seemed to have been in a farcical humour when she formed him; she had furnished him with a properly-proportioned body, and the legs of a child of eight.'[64] One suspects that Thaddeus was happy for his readership to believe that the artist was in fact Toulouse-Lautrec, and did not provide any more information to establish the man's identity. Toulouse-Lautrec is not known to have travelled during this period, and, in any case, it is difficult to believe that he and Thaddeus would have seen eye to eye on artistic matters.

61 Jacobs, 1985, p. 23. 62 See J. Campbell, 1989, p. 24. 63 See Campbell, 1984, p. 271.
64 H.J. Thaddeus, 1912, p. 36.

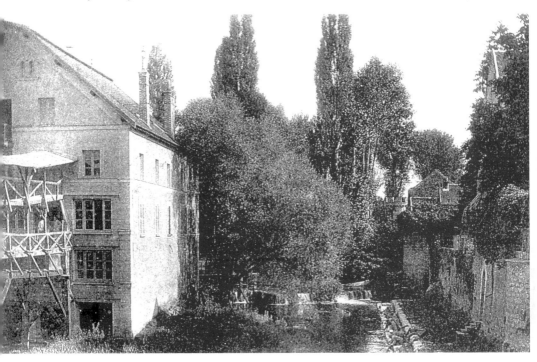

7 Provencher's Mill and washerwomen, Moret-sur-Loing, *c*.1900.

A painting by Thaddeus entitled *Washing Day*, painted in Moret, survives, which again focuses on the daily routine and activity of local peasants (pl. 9). Artists' perception of life in the villages in and around the Forest of Fontainebleau echoed to a great extent their view of life in Brittany, though the region was much less isolated than Finistère, and its people, by the 1880s, interacted much more with bourgeois urban society than their counterparts in Brittany. The relatively slow pace of life and picturesque quality were regularly celebrated in the work produced there. The representation of toil and unre-lenting hardship that qualified so many paintings of the French peasantry in the nineteenth century is hardly in evidence in these images of Fontainebleau.[65] Thaddeus' *Washing Day* is unusual in this respect, as it records the physical effort demanded by daily life. The activity takes place opposite Provencher's Mill, a large building just outside the town. Thaddeus probably painted the picture from beside the main bridge, which was connected to the mill by a wooden walkway (fig. 7). In the painting, a long line of women kneel at a popular place at the foot of the wall surrounding the town, washing clothes in the river. While it hardly qualifies as stern social realism, it does provide

65 McConkey, 1993, p. 34.

something of a counterpoint to the timeless, serene pictures by Thaddeus' contemporaries in the Forest of Fontainebleau or, significantly, a work by Alfred Sisley (1839–99) of precisely the same subject. Sisley, the sole Impressionist associated with the town, painted *Provencher's Mill at Moret* the same year as Thaddeus' picture, and included washerwomen at exactly the same point at the wall. Predictably, however, Sisley concentrated on colour and light effects rather than human activity. These pictures of precisely the same subject demonstrate how fundamentally opposed their approaches to their work were. Sisley is the artist associated most readily with Moret-sur-Loing, where he settled first in 1882. He may have been in Moret at the same time as Thaddeus in 1883, but moved on that year to Les Sablons. He moved back to the Moret in 1889, where he remained until his death a decade later.

In *Washing Day*, the individual figures, so prominent in Thaddeus' Breton work, have been subordinated to the setting and overall compositional scheme. This may reflect the influence of those working around Thaddeus, as the horizontal orientation of the canvas and relative scale of the elements within the composition are very much in keeping with the work being produced by other artists in Fontainebleau. Among these was John Lavery, who arrived in Grez in the summer of 1883. Lavery spent just a few weeks in Fontainebleau on this initial visit, but returned mid-way through 1884, when he stayed for nine months. His experience in the village had a profound and lasting effect on him and his work. He wrote that his 'happiest days in France were passed in the colony outside Paris at Gres-sur-Loigne [sic], an inexpensive and delightful place sheltering not only painters but an occasional writer'.[66] There he painted some of his most enduring images, concentrating chiefly on life on and around the river Loing, although most of these pictures represent the river as a place of recreation and relaxation, rather than labour.[67] Despite the thematic differences between Thaddeus' and Lavery's paintings, *Washing Day* does possess something of the tranquillity and stillness central to paintings such as Lavery's *The Bridge at Grez* (1883), *On the Loing: An Afternoon Chat* (1884) and *A Grey Summer's Day, Grez* (1883). Moreover, Lavery too painted washerwomen, and in *La laveuse* of 1883 employed a similar style and technique as Thaddeus did in *Washing Day*, with a relatively muted colour range and very even tonality. Both pictures are highly finished and feature tight brushwork and flat, smooth surfaces. It also seems very likely that Thaddeus was looking to contemporaries in Fontainebleau for the long, narrow format of his picture. Lavery chose a comparable ratio of height to width for some of his canvases, including *The Bridge at Grez, On the Bridge at Grez*, and some years later, the famous *Tennis Party* (1885). So too did William Stott of Oldham in *Le passeur* (1882), Egerton Coghill in *Landscape with Figure* (c.1887), and Frank O'Meara in such paintings

66 Lavery, 1940, p. 53. 67 McConkey, 1993, p. 32.

as *Old Woman Gathering Faggots* and *Autumnal Sorrows* (1878). Unlike Thaddeus, however, both Lavery and O'Meara produced works in which they rotated these markedly narrower canvases to achieve vertical compositions.

A painting by Thaddeus of a lone fisherman in a punt, probably dating from this period, demonstrates further how receptive he was to current stylistic trends, and his willingness to experiment, however fleetingly, with alternative techniques. Lavery's first success at the Salon came, coincidentally, in 1883 with two paintings, one of which was entitled *Les deux pecheurs*. He actually painted it before he arrived at Grez, but Thaddeus may well have known it, as he is likely to have visited the Salon during his brief interlude in Paris. The solitude and serenity that characterises Thaddeus' work is typical of Fontainbleau paintings of the period, as was the square-brush technique that he appears to have adopted. It gives the picture a tightly patterned effect, well suited to communicating even light and reflections in water, and was a technique favoured and refined by Lavery during his sojourn in Grez, and notably in his paintings of the village's famous bridge.

The influence of artists on one another in Fontainebleau is well documented, so Thaddeus' susceptibility to prevailing artistic tendencies is entirely consistent with common practice. Frank O'Meara contributed immeasurably to Lavery's beneficial stay in the area, and was one of the most influential and curious characters in Grez during the 1870s and 1880s. He had come to the village first in 1874, and was living there permanently when Lavery arrived in 1883. Lavery befriended many of the prominent artists, of various nationalities, in Grez, and later remarked that 'Harrison the American, Stott the English, and O'Meara the Irish, have much influenced me, above all the last during the three or four seasons that I spent at Grez'.[68] Despite Lavery's obviously high regard for his fellow countryman, and the influence he was so willing to acknowledge, the visible connections between their paintings seem at best tangential. While Lavery was preoccupied with tone, pattern and the interaction, however understated, between figures, O'Meara's paintings are laden with symbolism, focussing on isolation, reflection, sorrow and the passing of time. Furthermore, their approach to their task differed considerably. Despite the undoubted quality of his work, O'Meara developed a reputation for idleness among his contemporaries in Grez. This was to some extent an inherited notion, as it related more to his early years there, but it is true that Lavery was much more productive than O'Meara during his stay in the village. Nevertheless, O'Meara and Lavery shared an instinctive affection for Fontainebleau, and were inspired by its renowned atmosphere.

Thaddeus probably knew of O'Meara, as it would have been reasonable for him to monitor the progress and recognition of other Irish and British artists in

68 See Campbell, 1989, p. 28.

France. O'Meara, seven years his senior, exhibited at the Salon for just the second time in 1882, when two of Thaddeus' works were also on view. While there is no evidence to indicate that the artists ever met, there are slight pictorial similarities between their work. The rather melancholy figure of the old woman who stands on the right in *Washing Day* looking out at the viewer calls to mind old peasant women in O'Meara's paintings *Twilight* (1883), *October* (1887) and *On the Quay, Etaples* (1888). These characters represent a world and experience that was being eroded by industrialisation; the expansion of cities and towns, the broadening and extension of the rail network and the generally increased mobility of the individual. Thaddeus' pictures are not imbued with the symbolism so evident in O'Meara's work, with its inherent notions of transience and mortality, but it is interesting to note that there are echoes of O'Meara's painting in *Time Flies*, a work by Thaddeus' erstwhile student, William Gerard Barry, who hailed from Carrigtwohill, Co. Cork. Thaddeus appears to have taught Barry on a visit to his native city some time in 1883, although Thaddeus does not mention it himself.[69] He is unlikely to have had much time to work with Barry, but a significant consequence of their brief encounter was Barry's decision to travel to Paris to continue his art studies.[70] Barry painted *Time Flies* in Etaples, in the Pas-de-Calais, in 1887, the same year that O'Meara moved there.

It is tempting, and reasonable to imagine, in light of their early common experience, that Thaddeus and Lavery met as young men.[71] Both studied at Heatherley's in London and then at Julian's in Paris. Both exhibited at the Salon while still young students and worked on the river Loing. These apparent coincidences are compelling, but one important fact remains: neither Thaddeus nor the equally loquacious Lavery ever mentioned the other in their writings. Furthermore, the coincidences may not have been as close as appears at first glance. Firstly, Thaddeus definitely progressed through Heatherley's and Julian's months ahead of Lavery, though Lavery was a year older. Thaddeus joined Heatherley's studio in 1879, and left in the autumn of 1880. Lavery enrolled at Heatherley's some time in 1880, leaving for Paris in November 1881, by which time Thaddeus had already left for Concarneau.[72] As a result, there is little chance that they met in either place. They never exhibited together at the Salon (Thaddeus exhibited there in 1881 and 1882, Lavery from 1883 onwards). They might have encountered one another in Grez-sur-Loing in the summer of 1883, but it is not known how frequent Thaddeus' visits to the village were, and Lavery was there for just six weeks that year.

If Thaddeus and Lavery did meet, it is most likely to have happened in England some years later. Both operated from and exhibited extensively in

69 *Recollections of Edie Bourke of French's Walk, Cobh* (niece of the artist), Crawford Municipal Gallery Records, Cork, undated. **70** Ibid. **71** Campbell, 1984, p. 62. **72** Thaddeus and Lavery could have met in London in 1880, but it seems unlikely.

Britain, and became highly successful and sought-after portraitists. As a result, their social circles at least are likely to have overlapped. They almost certainly knew of one another, and may have met briefly at an exhibition or on some other social occasion, but their mutual neglect in their writing suggests that they were certainly not regular acquaintances. Admittedly, as neither was of a retiring nature or a stranger to self-promotion, there remains the possibility that professional jealousies and competition might figure in the equation. It is true that Thaddeus mentioned very few artists at all in *Recollections*, and when he did, it is invariably in the context of controversy (Jan van Beers, Frank Holl) or conflict (Whistler). Thaddeus intended this selectivity to place him within a much broader social grouping, and to elevate his own status among the artist fraternity. The tone of Lavery's autobiography, *The Life of a Painter*, published in 1940, was much the same, although Lavery did acknowledge at length his debt to such artists as Whistler. It is also worth pointing out that Lavery and Thaddeus were never in direct competition during their careers, and Thaddeus was abroad for much of his. Moreover, they were just two of many successful portrait artists active in Britain in the final decades of the nineteenth and early decades of the twentieth century.

Thaddeus claimed that while in Moret-sur-Loing, one of his fellow artists expressed an interest in travelling to Italy, and that he decided immediately to accompany him there. As already mentioned, his journey there was probably more circuitous then he maintained in his *Recollections*, but it is clear that regardless of means, route, or circumstances, he made the journey to Florence in late 1882. As it was an unorthodox choice, one can only assume that Thaddeus was, as he claimed, genuinely attracted by the prospect of seeing the city's great art. Painting in Italy was, on the whole, very conservative at this time, and though its academies were attracting artists from abroad, it ranked well below France in the hierarchy of Europe's dynamic artistic centres. Thaddeus certainly did not expect the course of his career to be determined in Florence, writing that as he left Paris, he 'little imagined' that he was leaving his 'pleasant student life and the good old vagabonding existence behind for ever'.[73]

73 H.J. Thaddeus, 1912, p. 40.

To the cradle of European art

Throughout the second half of the nineteenth century, thousands made the journey by train to Florence to immerse themselves in its culture and familiarise themselves with its medieval and quattrocento treasures. The renewed interest in the Renaissance, Ruskin's florid reflections on Italy (including *Mornings in Florence* of 1875–7), Baedeker's comprehensive guide books, and Thomas Cook's innovative organised tours combined to make the city one of the most attractive and accessible destinations for the middle-classes of Europe.[1] Thaddeus, in travelling there in the autumn of 1882, was therefore following a well-established trend. What was less conventional, however, was his decision to settle. The majority of foreign visitors who choked Florence's *pensione* were transient guests, who had limited contact with the local population and hardly touched on the city's daily life. Whether by circumstance or design, on this first visit alone Thaddeus spent three years (albeit with interruptions) in Florence. More importantly, this period, marked by great artistic productivity, social activity, and good fortune, ultimately dictated the course of his career.[2]

Predictably, during his first winter in the city, Thaddeus spent time in the Pitti and Uffizi galleries 'copying and otherwise studying the Florentine school of painting'.[3] Somehow, he managed to acquire a studio on the Via Ghibellina, which he retained for over a year. His immediate impressions of the city were positive, and he made much in his writing of the ubiquitous nature of art in the city. In his *Recollections*, he pointed out that Michelangelo's house was also on the Via Ghibellina and that he passed its door every day, as well as spending 'many a thoughtful hour in [its] peaceful interior'.[4] If one believes his account, Thaddeus did not even have to leave his own studio to be exposed to Renaissance art, as he found serendipitously beneath the plaster on his studio walls a fresco of the 'early Florentine school'.[5] He even provided his reader with a long list of great artists, poets and writers associated with the city, to whom he referred collectively as 'a galaxy of genius and talent'. Those he singled out included Fra Angelico, Fra Bartolomeo, Carlo Dolci, Andrea Del Sarto, Donatello, Ghiberti and Giotto, Michelangelo, Leonardo da Vinci and Benvenuto Cellini. Continuing his hyperbolic assessment of the city with a list of writers, astronomers and

1 See M. Levey, 1996, p. 459. 2 For another account of Thaddeus' contact with Italy, see B. Rooney, 1999, pp. 126–33. 3 H.J. Thaddeus, 1912, p. 43. 4 Ibid., p. 49. 5 Ibid., p. 43.

discoverers, Thaddeus concluded that 'the list of great men in every profession is endless; and no other city in the world can produce from the past so imposing a procession of intellectual giants'.[6] As well as celebrating its historical figures, Thaddeus revelled in the character of the city itself, presenting a number of descriptive accounts and anecdotes relating to civic history and traditions, such as the church festival of 'Santo Spirito'.

Thaddeus was left alone in Florence in Spring 1883, when the artist who had accompanied him there from France departed for Rome, but this does not seem to have had an adverse effect on his mood or activity. It is unclear how he financed himself in these early months, but one assumes that his apparent stability is attributable to the speed with which he began to make inroads into the higher echelons of Florentine society. In particular, he soon made acquaintances among the sizeable and wealthy British community. In the autumn of 1883, he had his most auspicious encounter, when Major Light, President of the English Club in Florence, introduced him to the duke of Teck. A rapport quickly developed between Thaddeus and the duke, and in due course, the artist befriended the entire Teck family. Through them, over the next few years, Thaddeus received a large number of defining portrait commissions. From the moment he met the Teck family, Thaddeus' social and artistic progress was, in the words of the historian Diarmuid O'Donovan, 'little short of meteoric'.[7]

Thaddeus could not rely on the Tecks' financial or political influence in Florence for business, but rather on their popularity. The family, related to the Cambridge household and, in turn, Queen Victoria, were effectively exiled in Florence at the time, and were living, somewhat uncomfortably, at Paoli's Hotel on the Lungarno.[8] Princess Mary Adelaide, duchess of Teck, described as 'one of those persons who are genuinely and temperamentally incapable of understanding the simplest finance', was principally responsible for the families financial straits.[9] The Tecks had for some time been maintaining two residences, Kensington Palace and White Lodge, and were spending approximately twice their income. The wresting of control of their affairs was undertaken by the duchess of Cambridge, Mary Adelaide's mother, the duke of Cambridge, her reactionary brother, and the grand duke of Mecklenburg-Strelitz and the grand duchess, Mary Adelaide's sister. Her money troubles dated back many years, but by the early 1880s, they were such a concern to her relations that it was decided that she should move abroad with her family to curtail her spending. Ultimately the directive to relocate came, in April 1883, from Queen Victoria herself and, having spent some time with their Württemberg relations in

6 Ibid., pp. 50–1. **7** O'Donovan, 1961, p. 42. **8** Mary Adelaide, duchess of Teck (1833–97) was the daughter of Augusta, duchess of Cambridge (1797–1889). Queen Victoria (1819–1901) was the duchess of Cambridge's niece. Francis, duke of Teck (1837–1900) was the son of Prince Alexander of Württemberg. **9** J. Pope-Hennessy, 1959, p. 114.

Switzerland, the Teck family, with the exception of the two boys, Adolphus (Dolly) and Frank, who had been sent back to boarding school in England, arrived in Florence in October of that year.

Though it took the Teck family some time to acclimatise and familiarise themselves with their surroundings, their life soon assumed a familiar routine, and the city, infinitely more social than they, or those who had sent them there, had anticipated, proved to be far from an ideal place of retrenchment. In practice, Princess Mary Adelaide's expatriation did little to curb her habits. While the duke did not share his wife's 'reckless, inborn extravagance', he was remiss when it came to monitoring domestic debts, and also enjoyed the life considered appropriate to their social position, if not their resources.[10] The duchess of Teck's gregarious character and generosity, which had been pre-dominantly responsible for the situation in which the family found itself, were enhanced rather than stifled by cosmopolitan Florence. Fortuitously for Thaddeus, the duke and duchess were therefore in exuberant spirits when he was first introduced to them.

Thaddeus had responded instantly to the duke's genial nature, particularly his 'unaffected simplicity of manner and bearing', and even more so to that of his wife.[11] The positive manner in which he was received by the Tecks meant that he was swiftly admitted into their family and intimate circle. Of the three Teck children, Thaddeus was closest to the eldest, Princess May (later Queen Mary), who was her mother's constant companion. Socially, May – shy, reserved and cautious – was the antithesis of the duchess, but Thaddeus recognized that she shared her mother's sense of humour and intelligence. Moreover, Thaddeus observed that Princess May, though still only seventeen, 'exhibited a remarkable maturity and soundness of judgement', and exercised a significant stabilising influence over her rather more capricious mother.[12]

The social life in Florence in which the Tecks took a full part was, for much of the time, extravagant and exhausting. The English community, which congregated in the English Club, was among the most hospitable, and at times hedonistic national groups in the city. Lady Orford, who Thaddeus knew, was the community's unofficial figurehead, and received guests at her *salon* every week, from ten at night until four in the morning, and 'during that time never ceased smoking strong cigars'.[13] The local aristocratic and wealthy Italian families were perhaps less prodigious in their entertaining than some, but when they did host dinner parties, these were lavish affairs. As a rule, Thaddeus was neither particularly impressed by nor attracted to the native Florentine upper classes, who he thought, rather than indulging their friends, 'confined their expenditure to outside show, driving about the "Cascine" in smart carriages and resplendent toilettes, many returning to their gloomy palaces to partake of a

10 Ibid., 1959, p. 116. 11 H.J. Thaddeus, 1912, p. 59. 12 Ibid., p. 60. 13 Ibid., p. 93.

modest dinner of macaroni, varied with tripa a la Milanese'.[14] The Russian nobility and aristocracy, for their part, were positively sybaritic, and noticeably the richest single group in the city. Thaddeus, with characteristic alacrity, infiltrated all these groups, and from them acquired numerous lucrative commissions.

Despite making inroads into these elevated social circles, Thaddeus himself lived in reasonably modest circumstances, lodging with an elderly Scottish woman, Mrs Eliza Jane Smillie. They seem to have had at times a charged relationship, but a mutual understanding nonetheless, which the artist attributed to their shared Celtic origins. He grew extremely fond of her, referring to her as his 'adopted mother', and made a point of introducing her to the duchess of Teck, who found her most engaging. As well as providing Thaddeus, unsolicited, with food, Mrs Smillie took the responsibility of cleaning up his studio, which was usually in disarray, when he was away from the city. Their friendship survived after Thaddeus had left Florence permanently, and years later, in 1890, he dedicated one of his pictures, painted in Egypt, to her (fig. 29). It is interesting to consider, in the context of the subsequent development of Thaddeus' social group and artistic tendencies, how friendly he might have been with William Sharp, Mrs Smillie's nephew, who also lodged with her during the summer of 1883. Sharp (1856–1905) was a writer and poet who, particularly under the *nom de plume* (and effective *alter ego*) Fionna Macleod, achieved considerable success. Until his death, few people other than Sharp's wife and close friends knew the true identity of Macleod. By coincidence, as William Sharp, he published a novel entitled *Fellowe and his wife* with Blanche Willis Howard, author of *Guenn: a wave on the Breton coast*, in which Thaddeus was mentioned (see Chapter 4). Sharp had become acquainted in the 1870s with important literary and artistic figures in London and, just a year before meeting Thaddeus, had published the first biography of his friend Dante Gabriel Rossetti. Another early, but very different, influence on Sharp's life and art was the critic and essayist Walter Pater, who was one of the most important figures of the aesthetic movement in England in the second half of the nineteenth century.[15] Though Thaddeus subscribed to neither Rossetti's nor Pater's disparate artistic philosophies in practice, it is reasonable to assume that he became familiar with both through his contact with Sharp. There is no evidence to suggest that Thaddeus made efforts to stay in touch with him following the summer of 1883, but their paths may well have crossed during the 1880s and 1890s. Having had work published regularly in the *Pall Mall Gazette*, Sharp was appointed art critic of the *Glasgow Herald* in 1885.

The earliest known work Thaddeus painted in Florence is an undeniably odd, but admirably executed portrait of an old widow, possibly a member of the English community (pl. 10). In many respects, it is a conventional picture, and

14 Ibid. 15 S. Kunitz and H. Haycraft, 1936, p. 553.

most probably typical of the kind of work he was being commissioned to produce at the time. The woman sits at a slight angle to the viewer, her hands loosely crossed in her lap. Unusually, however, her eyes are closed, as if she is asleep, though she sits bolt upright. One might guess that she is blind or that the slight twist in her mouth, and the posing of the hands might indicate that she had suffered a stroke, but it is impossible to be certain. Despite its perplexing character, the picture can be seen as a virtuoso piece of portrait painting from so young an artist. At this stage of his career, Thaddeus had had little experience of painting full-scale portraits in oil, but produced a creditable and mature work. It is, admittedly, an austere and less than engaging picture but nevertheless contains many features of technical merit. Thaddeus was particularly successful in rendering the old woman's diaphanous skin, and the slight limpness of the flesh on her face and hands. Equally impressive is the detail of the metal choker at the woman's neck, strongly and skilfully modelled in juxtaposition with the delicate transparency of the white lace on her shawl and dress. Composition is perhaps the picture's most obvious weakness, but one which the artist would soon, in other works, remedy. Nor is the picture, despite its severity and genre, totally removed from Thaddeus' earlier work. The unorthodox colouring which characterizes much of his genre painting, reappears here in the garish blue of the wool in the knitting basket by the woman's side, which would have been much more obvious when the picture was first painted.

Presumably on the strength of such pictures, the duke of Teck asked Thaddeus, whom he had not known for long, to paint his portrait, and shortly afterwards, a companion picture of his wife (figs. 8 & 9). Princess May, with understandable bias, certainly admired both pictures, writing to her Aunt Augusta (the duchess of Mecklenberg-Strelitz) in England that 'Mr Jones, a young Irish artist, has painted both Mama and Papa, the two pictures are rather good and are going to be sent to London, perhaps to the Royal Academy'.[16] She reiterated her praise and confirmed her expectations for Thaddeus' work in a slightly later letter to her brother Dolly, writing that 'Jones' pictures of Mama & Papa were sent to England to go to the Academy, they were very good'.[17] In reality, though hung at the Royal Academy in 1884, neither picture appears to have been of exceptional quality. In his review for the *Academy*, Cosmo Monkhouse stated that in the 'sketch (for it is little more)' of the duke, the artist showed 'power, if not of a very agreeable kind'.[18]

It may have been to Thaddeus' slight advantage that he had exhibited a genre picture, *A Wine Carrier*, presumably also painted in Florence, at the Royal Academy the previous year. It is also vaguely possible that representations were

16 Letter from Princess May to her Aunt Augusta (grand duchess of Mecklenburg-Strelitz), 13 March 1884, RW, RA CC 21/22. 17 Letter from Princess May to her brother Dolly, March 1884, RW, RA CC 50/107. 18 C. Monkhouse, 1884.

8 *The Duke of Teck*, 1884. Oil on canvas. Untraced.

9 *The Duchess of Teck*, 1884. Oil on canvas. Untraced.

made on the artist's behalf to ensure the inclusion of the Teck portraits in the RA exhibition, however misinformed such intervention might have been. This was certainly attempted in 1885, whether or not Thaddeus was aware of it. In March of that year, Princess May wrote again to her Aunt Augusta regarding Thaddeus' work, this time a portrait of May herself, asking if her grandmother, the duchess of Cambridge, might be 'so very gracious as to apply to Sir Harry Ponsonby [private secretary to Queen Victoria] for a Royal Command for its admittance to the Royal Academy'.[19] Furthermore, pointing out zealously that Thaddeus was 'naturally most anxious about the hanging of the picture,' she added that her mother 'not having seen the picture after it was quite finished cannot judge as well as Grandmama, who we hear was delighted with it'.[20] The RA's policy, then as now, dictated that it did not practise preferential treatment to any artists. As an Academician, an artist would have had an automatic entitlement to submit to the Summer Exhibition, but beyond that, all works

19 Letter from Princess May to her aunt Augusta, 22 March 1885, RW, RA CC 21/22.
20 Ibid.

were submitted to a selection committee and then on to a hanging committee before they were shown.[21] It is possible, however, that Princess May was aware and seeking naïvely to bring about a repeat of recent exceptions to this rule. In 1881, a portrait of Disraeli by John Everett Millais, unfinished at his death was, on Queen Victoria's request, completed by Millais and sent to the Royal Academy as the late, special exhibit'.[22] In the same year, a portrait by James Jebusa Shannon of the Hon. Horatia Stopford, one of Queen Victoria's maids of honour, was included in the RA exhibition by command of the monarch.[23]

The duke and duchess of Teck were also anxious that Thaddeus' portrait of May be hung at the Royal Academy, and believed, erroneously, that May could exercise some influence over its acceptance. The duchess wrote to Thaddeus explaining that May had written to her sister, in an attempt to ensure that the painting was hung well at the Academy, adding confidently that 'this [letter] I fancy it secures'.[24] In the event, the picture did not appear in the exhibition, and Thaddeus was destined never to exhibit again at the RA.

Acceptance at the Royal Academy had no doubt been a source of great pride for Thaddeus, but his work was more readily welcomed at other exhibitions in Britain and Ireland during his sojourn in Italy. He had exhibited in England for the first time in 1881, when *On the Sands: Concarneau* was shown at the Society of British Artists, and he would have been well acquainted with the various exhibition locations available to him.[25] No fewer than ten of his pictures were hung at the Cork Industrial and Fine Arts Exhibition in July 1883. Though not as prestigious as his successes at the Paris Salon, this was generous affirmation for an artist who had not yet shown work at the Royal Hibernian Academy. He also contributed three paintings to the Royal Scottish Academy, including, once again, his two Salon pictures of 1882. Thaddeus obviously sought to maximise the benefits accruing from success at the Salon, by showing his works elsewhere. By reappearing at major exhibitions, his work developed a pedigree, which might be recognised on subsequent occasions. In the space of twelve months, *Market Day, Finistère* was seen in Paris, Cork and Edinburgh.

Thaddeus' close relationship with the Teck family was never more clearly demonstrated than on his trip to London in 1884 to see his portraits of the duke and duchess on show at the RA. On that visit, he carried with him letters of introduction to the duchess of Teck's mother and sister, as well as to Lady Holland and Lady Hopetoun. He also visited the Teck boys, Frank and Dolly at Wellington College, at the duchess' request, and even stayed with one of her

21 Royal Academy of Arts, Letter to the author, 11 February 1997. 22 National Portrait Gallery, 1996 (no page number). 23 F. Rinder, 1901, p. 42. 24 H.J. Thaddeus, 1912, p. 99. 25 Curiously, Thaddeus' address in the catalogue accompanying the SBA exhibition is the Grand Hotel, Concarneau, though Edward Simmons counts him among the artists resident at the Hôtel des Voyageurs.

friends, Robert Percy ffrench, in London. ffrench, who was of landed gentry from Monivea, Co. Galway, was a high ranking diplomat, who held numerous posts during his career, including general secretary to the British embassy in Russia, and was 'known in high society all over Europe as a fine type'.[26] He and Thaddeus had first met in Florence, and subsequently forged a close friendship. In the late 1880s Thaddeus produced at least one extraordinary portrait of ffrench (pl. 17).

One particularly dramatic event in the lives of the Tecks undoubtedly contributed to the prominent role Thaddeus played among them. Since the duke's sittings for his portrait, he and Thaddeus had been regular companions, joining one another for long walks in the Cascine or into the countryside. On these excursions, they discussed all manner of subjects, and though rarely in agreement, found each other pleasant company. Thaddeus felt that the duke was dismissive of the radical ideas he had acquired as a student in Paris, which, improbable though it may seem, included subscription to the theories of Jean Jacques Rousseau. Their outings were abruptly ended, however, when the duke suffered a stroke in March 1884, which left him partially paralysed. Amazingly, Thaddeus, the duchess and Princess May all believed that the duke's doctor had ascribed his symptoms to sunstroke, but it would seem more reasonable to assume that this is what he told them to lessen their distress.[27] Though Thaddeus saw him as a relatively sanguine character, it has been suggested that the duke's unpredictable temper, aggravated by the family's exile and pecuniary difficulties, contributed to his stroke.[28] In any case, Thaddeus was among those enlisted to raise the duke's spirits during his convalescence. Contrary to the immediate family's expectations, the duke's condition remained poor, and Thaddeus' close contact with the family, perhaps originally seen as a temporary measure, continued, and he became a constant among their intimate circle. His name appeared repeatedly in the family correspondence, in relation to such disparate matters as his portraits and his role in the choice of the family's new chef![29]

Shortly after the duke became ill, the Teck family managed to 'escape' from the Hotel Paoli. In April 1884, Miss Bianca Light, sister of the above-mentioned Major Light, agreed to share her house, I Cedri, with them. I Cedri, a fifteenth-century villa, stood on the left bank of the Arno, approximately three miles from the Porta San Niccolò, near Bagno a Ripoli, and boasted commanding views of the city. The Tecks did not pay rent for the villa, but took it on the understanding that Miss Light could use an apartment there whenever she did not wish to stay in Florence. The villa, an ideal location for the duke's

26 C. Conor O'Malley, Letter to Diarmuid O'Donovan, 8 August 1968, Crawford Municipal Art Gallery, Cork. 27 H.J. Thaddeus, 1912, p. 61. 28 See D. Duff, 1985, p. 52. 29 Letter from Princess May to her brother Dolly, 23, 24, 25, 28 and 30 January 1885, RW, RA CC 50/126.

convalescence, became a focus of Thaddeus' social life. It stood in an English garden, from which *poderi* led down to the river Arno, where Thaddeus painted on occasion. His pictures include a charming watercolour of the well beside the farmhouse that, along with a mill and vine-covered pergola, enhanced the character of the setting (pl. 11). The picture was produced perhaps more for the benefit of Princess May, to whom Thaddeus gave occasional lessons, and who produced a drawing of the same subject from a slightly different angle, than as a piece for his own portfolio.[30] Nevertheless, it is an attractive work, which suggests a more relaxed approach to painting than that communicated through Thaddeus' portraiture. The picture is notable among Thaddeus' landscapes and genre works for the absence of strong outlines. The lack of underdrawing and delineation gives an impression of spontaneity that is quite refreshing among his *œuvre*. The picture was dedicated to 'HRH Princess Mary Adelaide' and found its way, through Princess May, into the Royal Collection. The duchess had a great appetite for painting, and would have appreciated the gift. Princess May, for her part, was by then a zealous and conscientious student of both the practical application and history of art, and her studies required almost daily visits to the museums in Florence. Thaddeus paid her the compliment of presenting her on her seventeenth birthday with a fan, which he had decorated himself with painted apple blossom.[31]

The parties at I Cedri, which always attracted a variety of august relatives and friends, and involved games, recitals and music, as well as bountiful food, delighted Thaddeus. Here he was introduced to many grandees, some of whom he remained friendly with for years. Most important among them were the Russian, Baron Dmitri de Benckendorff, whom Thaddeus painted in 1906 (fig. 50), and the grand duke of Mecklenburg-Schwerin, a relation of the Tecks. In mid-May of 1884, in fact, Thaddeus travelled with the baron and the grand duke to Bellagio, remaining there with them for about a week.

Thaddeus now had two large adjoining studios at No. 7 Lung Arno Giucciardini, one of which he used as his own workplace, the other he reserved for a small number of students he had taken on.[32] His decision to provide tuition may have been influenced by his recent experience teaching William Gerard Barry in Cork. His students in Florence formed a motley group, comprising a 'semi-blind English general, an equally decrepit colonel … one or two others, who rather late in life endeavoured to develop their artistic talent' and, most notably, the young Henry Savage Landor, later a renowned explorer, whose fond reminiscences of his time studying there corroborated Thaddeus' own account.[33] Landor, who subsequently wrote and illustrated a large number

30 See D. Millar, 1995, p. 486. 31 Pope-Hennessy, 1959, p. 136. Also listed among May's birthday presents is a gold bangle from 'Mr ffrench', referring to Robert Percy ffrench. 32 H.S. Landor, 1924, p. 29. 33 Ibid., p. 30.

of books about his exploits and experiences on expedition, recorded that at the studio, Thaddeus received daily swarms of visitors, 'all tip-top people in the social world'.[34] He singled out for mention the family of Don Carlos, the duke of Mecklenburg-Schwerin and the duke and duchess of Teck. He too found the Tecks, all of whom were regular visitors, amiable 'whether in Thaddeus's studio or elsewhere'. Landor's claim that he met the Tecks constantly in friends' houses illustrates the tight-knit nature of the community to which they belonged. He found the image of the slender Princess May and the 'extremely stout' duchess side by side irresistible, and on one occasion produced a caricature of them. They were amused, rather than offended, by the results, and kept the drawing.[35]

Landor reserved his greatest praise for Thaddeus, whom he portrayed as an attentive teacher, who showed particular interest in his immature artistic efforts (he was still only sixteen years old). He admitted that this was due in part to the artist's affection for his family, who lived in Florence, but also to the rapid progress that Landor felt he was making. In any case, Thaddeus allowed him to remain working in the studio 'all day and every day'.[36] It was, by any standards, an unusual environment. While royalty dropped by regularly, Thaddeus' unlikely assemblage of students honed their skills as natural talent and inclination allowed, and an aged valet, whom Thaddeus had apparently rescued from destitution, tottered about. 'Daddi', the valet in question was, according to Landor, the son of the man who discovered a process of embalming dead bodies, and would frequently have his pockets full with various human anatomical remains.[37] He was Thaddeus' servant, but also posed for the students. Thaddeus recorded his name as 'Raddi', but otherwise portrayed him in much the same vein as Landor. Such was the unusual nature of his appearance, with long white flowing beard and hair, that Thaddeus felt that visitors who encountered him at the door to his studio were made to feel that they were 'entering a sanctuary'.[38]

It is unclear for how long Thaddeus took students. He wrote that he merely dedicated 'his leisure moments' to them, and that 'more important work soon obliged [him] to dissolve the class'.[39] Landor claimed that he passed just three months in the studio before Thaddeus left Florence altogether. Regardless of the circumstances of his departure, it was for Landor an artistically worthwhile, enjoyable, and socially significant interlude, during which he and Thaddeus established a lasting friendship. Having left Thaddeus' studio, Landor rented his own, in the Villa Trollope, enrolled at the Academy in Florence for a few weeks working from the nude, and also attended anatomy classes twice a week, and 'went to the hospital to draw anatomical studies'.[40] It is perhaps no coincidence that Landor, like Barry, then opted to pursue further art studies in Paris. In fact, so emphatic must Thaddeus' endorsement of the training available

34 Ibid. 35 Ibid. 36 Ibid. 37 Ibid., p. 30. 38 H.J. Thaddeus, 1912, p. 71. 39 Ibid., p. 64. 40 H.S. Landor, 1924, p. 32.

there have been that Landor enrolled at the Académie Julian, specifically under the tutelage of Thaddeus' former masters, Boulanger and Lefèbvre. Landor described at length and in familiar tones the praise he received for his art work at the Académie Julian, even from the formidable Boulanger, who declared at one point: 'Here is a true artist! Bravo! and what originality'.[41] Thaddeus' assessment of Landor's abilities, however, despite his affection for him, was rather less emphatic. 'In those early days', wrote Thaddeus 'his genius lay chiefly in the way of practical jokes, of which I was frequently the victim'.[42]

As well as the picture of the farm and well at I Cedri in the Royal Collection, there is a small water-colour of the harbour in Viareggio, to the west of Florence, which is inscribed 'a thumbnail souvenir of Viareggio by "Thady"/ Sketched whilst thinking of Florence' (pl. 12). 'Thady' was the pet name by which the Tecks referred to Thaddeus, though his surname was still Jones when they met him. The picture may well have been painted in the winter of 1883/4 when Thaddeus went on a walking trip with Landor across the Appenines to Viareggio, 'via Pistoia, San Marcello, the Baths of Lucca and Lucca'. It was a trip on which Thaddeus does not appear to have fared very well. Undertaken in the depths of winter, when the mountains were covered with snow 'several feet high', he was unable to keep pace with his resilient friend and, having broken down altogether, completed the journey by carriage, while Landor continued on foot. When they returned to Florence, they were both, according to Thaddeus, 'great heroes in Anglo-American society, but not among the Italians, who could not understand why we had gone on foot when we could have gone by rail!'.[43] Thaddeus' attractive little drawing of Viareggio, in which the notation is deft and strong, and which was sketched with even more spontaneity and freedom than the picture of the well at I Cedri, may have functioned like a post-card (the dimensions are very comparable).

Placing Thaddeus' work in Florence in context is problematic. Though he was resident there for a lengthy period, and busily occupied for much of that time, the work he produced cannot be considered Italian in the way that his Breton work can be seen as French. The reasons for this are straightforward. First of all, Thaddeus seems to have mixed predominantly with expatriate communities in Florence and as a result, his frame of reference, both social and artistic, was not Italian. Secondly, he does not appear to have submitted works to Italian exhibitions or bodies, such as the Florentine Promotrice, a private organization of artists and patrons who held annual exhibitions in the city as an alternative to the exhibitions sponsored by the state-controlled academies. Instead, he preferred to send paintings back to Britain and Ireland where, one imagines, he felt his future lay. Most importantly, however, on the evidence of the works themselves, it seems clear that Thaddeus was drawing on artistic

41 Ibid., p. 38. 42 H.J. Thaddeus, 1912, p. 64. 43 H.S. Landor, 1924, p. 32.

models from Britain and Ireland (particularly England) for his own work, rather than Continental, or specifically Italian, equivalents.

Thaddeus was, consequently, engaging perhaps for the first time in a serious decision-making process regarding his work and the course it should take. Commercial considerations now impinged upon his practice, whereas before it was determined by academic direction or, latterly, his own tastes. It was now important for him to take into account the preferences of his new-found, enthusiastic, but relatively conservative clientèle.

In the 1880s and 1890s, something akin to a changing of the guard was taking place within portrait painting in Britain, which was to be fully realised in the first decades of the twentieth century. An older generation of academically oriented artists still enjoyed widespread popularity and patronage, but their patrons were ageing and many of the artists themselves were finding it difficult to compete with the similarly literal, but more novel medium of photography. At the same time, a series of young, innovative (albeit usually academically trained) artists, who sought to establish new techniques and capture more esoteric qualities in their portraiture, were emerging and securing their own audience. Thaddeus' absence from England for a number of years in the 1880s, and lucrative dealings with a conservative clientèle, meant not only that he was less susceptible to the influence of the radical stylistic changes evident in the work of some of these contemporaries, but also that he was probably relatively isolated from the type of criticism that young artists of his ilk were attracting within ostensibly more pioneering circles.

The contempt that many critics and artists harboured for those artists whose career pattern and artistic development they thought were dictated largely by the traditionalism and vanity of the gentry and moribund aristocracy to whom they pandered was expressed by the Irish critic and champion of modern French painting, George Moore, in his novel *A modern lover*. This work was published first in 1883, the same year that Thaddeus arrived in Florence and began to make headway as a professional portrait painter. It is a very thinly disguised attack on a fashionable, academic painter who, in the author's view, was willing to compromise (not to say prostitute) his art to further his career. The chief protagonist, Lewis Seymour, a young man of humble origins, modest talent but great ambition, having endured abject poverty and utter despair at the beginning of his career, infiltrates elevated London society, and ultimately comes to enjoy commercial success, but not critical credibility. His professional survival, which culminates in his election to the Royal Academy, is in fact ensured only by the blind devotion and secret munificence of Mrs Bentham, a fashionable and affluent woman, separated from her husband, and emotionally dependent on Seymour. However, Seymour confidently attributes his success to his rare and formerly unrecognised talent. As the narrative, maintained by trysts and romantic jealousies, unfolds, Seymour becomes a progressively unsympathetic

character. He is a conniving, vain and deceitful philanderer, whose self-absorption quickly erodes his prudence and loyalty and leads him to abuse and neglect those from whom he received compassion and affirmation, most notably the three women in love with him.

Moore's book, which he subtitled 'A realistic novel', essentially served as a vehicle with which the author expounded his theories on Modernism, and exposed the fundamental bankruptcy (both creative and moral) he saw in academicism. The manner in which he superimposed a narrative on his treatise often appears mechanical, but Moore would have made no apologies for such directness. His concern with what he would have seen as 'actuality' is a fundamental characteristic of Realist literature.

The biographical parallels between Thaddeus and Moore's Lewis Seymour are at times striking, but there are some important differences. While Thaddeus showed a capacity for self-promotion of which Seymour would have been proud, his behaviour, unlike Seymour's, was certainly not distinguished by amorality, and his success was attributable infinitely more to his talent than to his readiness to indulge the tastes and exploit the gullibility of his champions and patrons. Many of Moore's barbed comments and observations, not least his description of the fashionable artist as one 'who lives surrounded by grand people, and who rarely speaks to an artist' could be levelled at Thaddeus, but are only superficially applicable.[44] Seymour's ascent from obscurity to high society, like Thaddeus', was serendipitous, but Thaddeus' success was guaranteed, and in a sense legitimised, by his ability to adapt his style and technique to the taste and requirements of his clientèle *without* blindly compromising the technical quality of the work.

It is tempting to view patterns and developments in Thaddeus' career as though they adhere to some pre-determined or consciously orchestrated plan on the part of the artist. In fact, Thaddeus might be said to have encouraged this at times in his *Recollections*. However, he was still in his early twenties when he arrived in Florence and had up to that point received the training and shared the experiences of a distinctly 'modern' student. While he quickly recognized the professional and social benefits that accrued from his association with the upper echelons of Florentine society, and the commercial potential of a broadly academic style, there is no contemporary evidence to suggest that he necessarily recognised himself as a strictly academic or 'fashionable' portrait painter. Though Thaddeus had faith in academic means and an inclination towards academic effects, these were not borne of a failure to succeed as one of 'the moderns', as was the case with Moore's Seymour. Equally, though at no point does Thaddeus work approach what one might describe as *avant-garde*, he certainly did not see his work as regressive or conservative.

44 G. Moore, 1883 p. 208.

Furthermore, it is extremely unlikely that Thaddeus had any real concept of what it meant to establish oneself formally as a court painter. He entitled his book *Recollections of a court painter* but this self-definition related essentially to one specific period of his life, and when applied to his entire career is something of a misnomer. There is nothing to indicate that in Florence Thaddeus aspired to the status and activities of artists like Flandrin and Winterhalter, or understood the complexity and protocol of their practice. At this stage, his was a freer and more eclectic existence.

Thaddeus did not travel to Italy to establish a practice in portrait painting. Nor could he have been sure, even having procured some major commissions there, and regardless of the character or quality of his work, that portraiture would provide him with professional security once he had left the close social network of Florence. It is worth remembering that James McNeill Whistler, over twenty-five years Thaddeus' senior, and now generally acknowledged as one of the most pioneering and influential artists of the late nineteenth century, had altogether more immediate ambitions to establish himself as a portrait painter in Britain in the 1870s, but failed miserably. He operated precariously, finding himself painting uncommissioned portraits of sitters in the hope that they might wish to buy the finished product, and fled to Venice, 'a bankrupt, humiliated forty-five year old' in November 1880.[45] Whistler's commercial situation was, of course, damaged further by the Ruskin liable trial of 1878. However, he did persevere and by the end of the 1880s had garnered support from many quarters, in Britain, France and America, though the criteria by which his portrait 'arrangements' were judged seem quite different to those applied to more conventional portraiture such as Thaddeus'.

One might describe Thaddeus as artistically 'displaced' in Italy, detached from the trends and artistic establishment of London, but also from the indigenous art scene in Florence. While writing in long and reverent tones of the great Florentine artists of the Renaissance, Thaddeus did not mention a single modern artist in the city. Such omissions are in no way out of character (he mentioned very few artists at all in his writing), but when taken in conjunction with the visual evidence provided by his work from Florence, they suggest that he neither knew of, nor desired to investigate, fashions in contemporary Italian art. Significantly, he displayed a surprising ignorance of a particularly important character in the Florentine art milieu. Immediately after suffering another stroke, the duke of Teck was dispatched to the Villa Stibbert, a 'feudal castle' situated in the hills overlooking the city where it was hoped he would recoup some of his strength.[46] Thaddeus, who accompanied the duke's family there while he was convalescing, wrote that the

45 R. Dorment, 1995, p. 21. **46** H.J. Thaddeus, 1912, p. 62.

larger portion of the villa was devoted to Stibbert's collection, the great hall being filled with dummy knights and warriors of the Middle Ages in every conceivable style of armour, the knights on well-carved horses, caparisoned cap-à-pie. The other reception rooms were filled with objets d'art and pictures, the tout-ensemble resembling a remarkably well-kept museum.[47]

It seems extraordinary that Thaddeus did not recognize or discover subsequently, that the villa was indeed a museum, opened to the public in 1884. Federigo Stibbert (1838–1906), described simply by Thaddeus as 'an enthusiastic collector of bric-à-brac', was in fact a world traveller and lifelong collector of Oriental and European armaments, costumes and works of art. He was also an amateur painter and a friend of local artists, and may have introduced a younger generation of Florentine artists to Japanese culture and art as early as the 1870s.[48] Japanese prints became a very considerable influence on young Italian artists, as they had been in France just a short period earlier, and in Britain.

According to Henry Savage Landor, whose experience and scope, admittedly, must have been relatively limited, Thaddeus was better known to local artists than they were to him. He remembered that Thaddeus 'became the fashionable portrait painter among distinguished foreigners visiting Florence, and being unusually good looking, always smartly dressed, a witty raconteur, and possessing amusing eccentricities of his own ... soon became the most popular fellow in the town, except, of course, among local artists, above whose heads he rose miles'.[49]

Landor gave no indication as to which 'local artists' he was speaking of, but it is conceivable that a young student of his kind had celebrated painters, such as the former members of the Macchiaioli, in mind. Thaddeus' painting style, however, is so far removed from that of the Macchiaioli that it is difficult to imagine that they were ever in competition. That the Florentine art scene had reached, or descended to, something of a plateau by the early 1880s is not at issue. The Macchiaioli, whose progressive art work of the 1860s had been intrinsically linked to the Risorgimento, were never quite as coherent a group as their collective title suggests, and by the time Thaddeus arrived in the city, they had long since dissolved as an identifiable movement. Some of the foremost artists among them, such as Abbati and Sernesi, had in fact died in the 1860s, and the remaining members of the group had little to bind them together in the relatively settled environment of Florence in a united Italy. Thaddeus was probably familiar with the work of these patriotic and altruistic artists, but any similarities, either thematic or stylistic, between his work and theirs seem merely coincidental. Thaddeus' delicate watercolour, *Florence: Distant View*

47 Ibid., p. 63. 48 N. Broude, 1987, p. 115. 49 H.S. Landor, 1924, p. 29.

from the Podere of I Cedri of 1884 for instance (pl. 13), in which the viewer looks towards Florence across the weir near the lock at Bagno a Ripoli, recorded a view familiar to both the artist and his hosts, but is also an image of the Arno favoured by a number of Florentine artists.[50] However, it does not betray the schematic, reductive approach to landscape painting that one sees in ostensibly similar paintings by such artists as Giovanni Costa (*Sunset on the Arno at the Cascine, c.*1859–61), and a number of artists prominent among the Macchia whom he influenced, including Telemaco Signorini, Serafino De Tivoli (*The Arno at the Cascine, c.*1863) and Giovanni Fattori.

Ultimately, it seems likely that the parallels between Thaddeus' riverscape and those of the Macchiaioli result simply from the intrinsic qualities of the environment that attracted a painter's eye. Moreover, Thaddeus' interpretation of the scene, painted from the groves at the edge of the grounds of I Cedri, is notably, and perhaps predictably, literal. In the background, above the trees, are clearly visible the dome and campanile of the cathedral, and various other architectural details. This is much more in keeping with the practice among artists visiting Florence, such as Henry Roderick Newman, whose preference was for distant, but specific, views of the city.[51] In contrast, the Macchiaioli's paintings' very lack of specificity, despite the known identity of their locations, and predominant tonal qualities, introduce an atmospheric dimension beyond the documentary. While these Italian painters stressed the element of 'effect' in their work, Thaddeus only ever toyed with 'effect' in his landscapes, and certainly never committed himself to developing a consistent formula in pursuit of it.[52]

During this period, Thaddeus also travelled outside Italy. On medical advice, the duke of Teck left Florence in the summer of 1884 for Seelisberg, in Canton Uri in Switzerland, with his family (except the two boys who were at school in England) and a number of attendants in tow. There, it was hoped, he would benefit from a water cure. The Tecks took a large apartment at the Hotel Sonnenberg, whence the duchess promptly issued invitations to Thaddeus, who was in London visiting the Academy exhibition, to Bianca Light, and to another friend from Florence, Peter Wells, to join them there. Wells was a wealthy English widower, who spent the winter months in Florence where 'his one desire in life was to fit as many parties as possible into one night, after attending most of the afternoon tea fights …'[53] Otherwise, the Tecks sought, and made, few acquaintances, with the exception of the landscape painter Commendatore Corrodi and his wife. Comically, Thaddeus referred to Corrodi as '*persona gratissima* with most of the royalties of Europe', apparently unaware of how accurately the term already applied to himself.[54] The duke's condition having

50 Millar, 1995, p. 486. **51** For a useful overview of visiting artists in Florence, see Th. E. Stebbins Jr, 1992. **52** Broude, 1987, pp. 3–4. **53** H.J. Thaddeus, 1912, p. 77. **54** Ibid., p. 76.

improved somewhat, the Tecks and their entourage moved on to stay with their
Württemberg cousins, at the Hotel Horn, at Bad Horn, on the Bodensee (Lake
Constance). Bad Horn was within walking distance of the Villa Seefeld (though
it was in Switzerland, not Württemberg), where they had stayed en route to
Florence the previous year. It belonged to Princess Catherine of Württemberg,
mother of Prince William and sister of King Carl I. At Bad Horn, Thaddeus
conceived and executed a portrait of Princess May with the Bodensee in the
background, one of the few portraits into which he incorporated a landscape.
Life at the Villa Seefeld was far from hectic, but contact with some of the
aristocrats and royalty who lived in the area, including the duchess of Hamilton
and her daughter Countess Festetics introduced some variety. The duke of
Parma and the duchess of Madrid also resided along the lake. Occasionally,
Princess Catherine of Württemberg would host parties at which games, such as
ombres chinoises, which involved all the guests, were played.[55] Thaddeus, with
card tricks and customary good humour, had by now managed to inveigle his
way into the affections of old Princess Catherine as well. In September, he
accompanied Prince William on a trip to observe military manoeuvres, which
the prince was directing, on the plains of Württemberg, and on this visit may
have painted a portrait of the young Princess Pauline of Württemberg.[56] The
portrait was hung in one of the drawing-rooms at Marienwahl, the house built
by King William II a short distance from the vast Schloss at Ludwigsburg for
his first wife, Pauline's mother. While Thaddeus accompanied Prince William,
the Tecks travelled to Gmunden on the Traun See in Austria, where they joined
various members of the English, Danish and Greek royal families. From there
they moved on to Graz, then Venice, and finally, after an absence of some five
months, arrived back in Florence.

Thaddeus spent the winter of 1884 in Florence with the Teck family, having
been invited back there by the duchess, who thought that he might avail of the
opportunity to 'finish the work still on hand'.[57] It speaks volumes of his
standing as a portrait artist in Florence that, though still only twenty-four years
of age, he could leave work unfinished and/or commissions neglected while he
went travelling elsewhere in Europe. Perhaps he was in a stronger position to
negotiate with his particular clientèle when he could say that he was abroad with
the king of Württemberg, or alternatively, as was the case in the spring of 1885,
in Cannes with the grand duke of Mecklenburg-Schwerin. In any case, many of
these Florentine socialites had an excess of both time and money, and could
afford to wait for his services.

In Florence, patronage had come from all sections of the *haute monde*. Sitters
ranged from Lady Goldsmid to the queen of Serbia, who was one of the most

55 H.J. Thaddeus, 1912, pp. 81–2. 56 Pope-Hennessy, 1959, p. 241. 57 H.J. Thaddeus,
1912, p. 90.

renowned beauties in the city. During his last season in Florence, Thaddeus met Olga, Queen of Württemberg and her niece, the Grand Duchess Anastasie in his studio, committing the *faux pas* of not recognising them. He socialised with and/or painted a number of individuals from the august ranks of the Russian aristocracy, including Grand Duke Michael Michaelovitch, the Grand Duchess Elene Vladimirovna Romanov and Princess Woronzoff. The extravagant princess was renowned for her jewellery, and in his portrait of her, Thaddeus made sure to include her twelve rows of pearls 'perfectly matched, perfect in colour, the last row reaching to her knees'.[58] He was among the last witnesses to the colourful Russian presence in Florence, as the tsar summoned the community back to Russia in 1885, leaving a vacuum in Florentine high society.

Thaddeus finally left Florence in May 1885, having spent much of the spring in Cannes as guest of the grand duke of Mecklenburg-Schwerin, who was there to benefit from the warm climate. It appears to have been a period of extreme relaxation, and one that he repeated the following year. Arriving in London, Thaddeus managed to secure an apartment and studio alongside George Baldry, the sculptor George Curtis and the architect Charles J. Ferguson, at No. 42 Clareville Grove, Brompton Road, South Kensington. That street was soon to become a very fashionable address for artists, and was the location for a number of studios, including the eponymous Clareville Studios, established in 1889.[59]

Coincidentally, the Teck family also left Florence at the end of May 1885, having been summoned home by the duchess of Cambridge, who still saw Mary Adelaide as something of a delinquent. By August, they were back at White Lodge, Richmond Park and, inevitably, soon issued an invitation to Thaddeus to visit them there. Despite settling back in London, the *wanderlust* that enticed Thaddeus to Florence, and the undeniable assistance of the Tecks' widely dispersed and well-connected friends, took him all over Europe over subsequent years. In London, he was reacquainted with Henry Savage Landor who, though still a teenager, had just completed an extensive trip the length and breadth of England. Together they embarked on another arduous walking-trip, this time through the Netherlands. They crossed over to Flushing and, as Landor related,

> started on our walk along canals and windmills to Middelburg and Vere, the latter a delightfully neat and clean little fishing village on the island of Zeeland …
>
> We stayed there some weeks, painting numberless pictures; then, to the sorrow of the population, we had to leave …
>
> Having visited the Hague, Amsterdam and Rotterdam and their marvellous artistic treasures, we returned to London.[60]

58 Ibid., p. 97. 59 G. Walkley, 1994, p. 239. 60 H.S. Landor, 1924, p. 37.

This visit had a definite impact on Thaddeus' art. Not only did he exhibit Dutch subjects (e.g. *The Sands, Drenheim, Holland* at the Irish Exhibition in Olympia in 1888), painted on this occasion or conceivably on a subsequent visit, but later in his career, he painted at least two portraits of characters in a pastiche of Dutch seventeenth-century costume. However, this was not necessarily his first visit to the Netherlands, as he painted a picture entitled *The Dutch Boy* in 1881.

Shortly after his return to London in 1885, Thaddeus took one of the most significant decisions of his career, changing his name by deed poll. Notice of the change appeared on the front page of *The Times*, where Thaddeus declared that on 22 June he did

> renounce, discontinue and abandon the surname of Jones, and did TAKE and ADOPT in place and stead of the surname of Jones my said Christian name of THADDEUS as my only SURNAME, and I did also assume, take and adopt the name of Jones before that of Thaddeus.[61]

Various explanations have been forwarded as to why Thaddeus made such a change. Among the most fanciful is the contention that he did not wish to be confused with Edward Burne-Jones (1833–98).[62] This, however, suggests delusions of grandeur even beyond Thaddeus' capacity, as he and Burne-Jones were never in direct competition. A more prosaic view was expressed by Thaddeus' friend Michael Holland, who believed that the artist had changed his name in France 'as the name Jones was already common to several other students and created confusion'.[63] Though Holland was incorrect in assuming that Thaddeus changed his name while in France, there is a large element of truth in what he said. Jones was indeed a very common name, in Britain and abroad, and though it is unlikely that it ever led to mistaken identity, Thaddeus was probably awakened quite early to the fact that his name might prove a hindrance in London, where Jones would be particularly common. As already mentioned, a 'Henry Jones' had attended the Cork School of Art just a few years before Thaddeus enrolled. Among the artists working in Brittany in the 1870s and 1880s was the American Hugh Bolton Jones, who enjoyed considerable success exhibiting in Britain and France, and was often referred to in the form 'H.B. Jones'. However, it seems reasonable to assume that Thaddeus really made his decision in Italy, where for the first time in earnest he was presented with the challenge of attracting regular patronage and assembling his own clientèle. 'Jones' certainly did not carry the distinction among cosmopolitan social and artistic circles that he would have desired. Fortunately, he did not have to look hard to find a name that better suited his purposes. Thaddeus, or

61 *The Times*, 24 June 1885. 62 Patrick Thaddeus, Letter to the author, 28 May 1997. This is a suggestion of which Patrick Thaddeus has a hazy memory from childhood. 63 Holland,

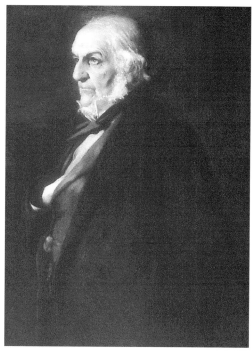

12 *William Ewart Gladstone,*
MP, 1888. Oil on canvas.
Reform Club, London.

special appointment for Queen Victoria, who had first met him forty-three years earlier. She thought he now had the appearance of a 'quiet benevolent old Priest' and played beautifully.[70] He enjoyed his greatest reception at the Grosvenor Gallery, at a concert in his honour attended by some four hundred guests, representing music, art, literature, medicine and the church.

This final heartening visit to London also began just five days before Gladstone delivered the first reading of his controversial first Home Rule Bill. Gladstone's 'radical stroke of policy' served as the counterpoint to the excitement associated with Liszt's presence in England.[71] The counterpoint was not lost on *Punch*, which published a cartoon lampooning the two old men together, Gladstone singing, shamrock in lapel and rose and thistle at his feet, accompanied on piano by Liszt. Coincidentally, Gladstone was the next great figure to sit for Thaddeus in Italy.

Thaddeus' portrait of Gladstone, painted in Florence in January 1888, is one of his most accomplished works (fig. 12).[72] Gladstone, still leader of the Liberal Party, but out of the office of prime minister since 1886, was residing with his wife in the city at the time, and had been lent an apartment by Sir James Lacaita. It is not known for what purpose the portrait was intended, or how

70 Walker, 1997, p. 486. **71** Allsobrook, 1991, p. 195. **72** Thaddeus states, inaccurately, that he painted Gladstone's portrait in the spring of 1887. H.J Thaddeus, 1912, p. 100.

Ireland, and indeed the city of Cork. Liszt had travelled to Ireland as early as 1840, when he played in both Dublin and Cork. It was a trip he enjoyed greatly. On subsequent visits, he travelled more extensively around the country visiting, among other places Limerick, Clonmel and Belfast. He is also likely to have been attracted by the social circles that Thaddeus was now habitually occupying, as he both loved and envied the aristocracy.[67]

Thaddeus must have painted Liszt between 25 October 1885 and 20 January 1886, as this was the period Liszt spent in Rome, residing at the Alibert Hotel. The inscription 'Febr. 1886' on the picture must therefore refer to the date of completion, rather than the sitting. Thaddeus was one of the last people to paint the composer, who died later that year. Liszt was painted and photographed many times during his life, right up to his death. In June 1886, Mihály Munkácsy, one of the foremost Hungarian painters of his day, produced a portrait of his fellow countryman which bears a strong resemblance to Thaddeus' work of just a few months earlier.[68] There are a number of formal similarities between Thaddeus' and Munkácsy' portraits, including the placing of the sitter at the piano, but Thaddeus' choice of expression is perhaps more authentic, though apparently not of his own invention, as it echoes that chosen by a number of other artists, including Charles Renouard. In various paintings, drawings and photographs, Liszt seems to have assumed the same pose, glancing upwards, as if unaware of his observer, and appearing simultaneously contemplative and aloof.

Thaddeus' portrait of Liszt was painted from an oblique angle, one of the artist's favoured views. However, the artist did not choose it in an attempt to idealise his subject. In fact, Liszt's pause in contemplation, with that distinctive glance upwards, a subtle allusion to his intellect, is Thaddeus' only concession to flattery. By this stage of his life, Liszt was considerably over-weight as a result of dropsy, had lost most of his teeth, had failing sight and was increasingly immobile. The distress caused by his lack of success and recognition as a composer was alleviated slightly that year by a later visit to London, during which he was lionised by press and public alike, but the wistfulness communicated through Thaddeus' portrait is consistent with his general state of mind in these last months.[69]

Liszt arrived in England in April 1886, and his exhausting itinerary included a visit to St James' Palace on Sunday the eleventh, insisted upon by Augusta, duchess of Cambridge. The duke and duchess of Teck and Princess May attended, and Liszt in due course left with the duke and duchess to dine with the prince and princess of Wales at Marlborough House. It is tempting to think that Thaddeus, in whose company both parties had been so recently, might have come up in conversation *en route*. During the same trip, Liszt also played by

67 D.I. Allsobrook, 1991, p. 31. 68 See Z. László and B. Mátéka, 1968. 69 For a comprehensive account of Liszt's final months, see Walker, 1997.

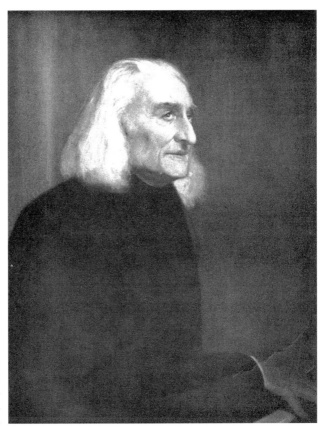

11 *Franz Liszt*, 1886.
Oil on canvas 107 × 84.
Private collection.

Thaddeus attracted individuals of wide renown. While painting the pope, he was visited at his studio by the elderly composer and virtuoso pianist Franz Liszt (1811–86), who showed a great interest in Leo's portrait as it progressed, and played the piano 'divinely' for Thaddeus while he worked.[65] Liszt paid Thaddeus a compliment by playing for him, as he had relinquished performing publicly many years earlier, and would only play in private for friends, admirers and pupils. In February 1886, apparently resisting invitations to give public recitals in England, he wrote that his 'seventy-five-year-old fingers are no longer suited to it'.[66] Thaddeus was still just twenty-five, Liszt well into his seventies, struggling with long bouts of melancholy, and in rapidly declining health. However, Liszt obviously enjoyed the artist's company, and sat for him the following year (fig. 11). Their friendship, though brief, was not altogether unlikely. As well as an affection for, and experience of France (both spoke French fluently), Abbé Liszt and Thaddeus shared a considerable interest in

65 Ibid., p. 134. 66 A. Walker, 1997, p. 478.

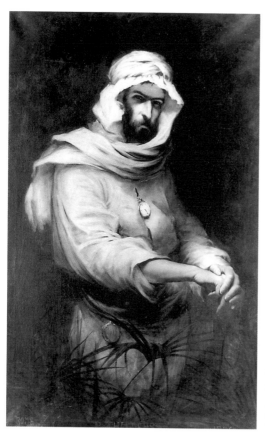

10 *Savorgnan de Brazza en costume de brousse,* 1886. Oil on canvas 153 × 100. Musée des Arts d'Afrique et d'Océanie, Paris.

'Thady', was relatively common in his native Cork, but may also have had an international appeal, and certainly was more distinctive. Ultimately, it seems less likely that Thaddeus sought to distinguish himself from any single artist in particular, than that he wished to assign himself a more sophisticated persona.

Italy, with its manifold social, as well as artistic associations, made a deep and enduring impression on Thaddeus, and he returned on a number of occasions after his first extended period there. Towards the end of 1885, having spent just a few months back at his studio in London, he made his first visit to Rome. There the connections made in Florence paid dividends, and within a very short time, he had obtained commissions to paint both Father Anderledy, vicar general of the Jesuits, and Pope Leo XIII. A studio was placed at his disposal in the Palazzo Savorgnan di Brazza by Count Ludovico of that family, a friend of Thaddeus and a painter in his own right. His brother, an explorer (one of a number Thaddeus knew) arrived back in Rome during this time, where Thaddeus produced a fine portrait of him (fig. 10).[64] In Rome, as in Florence,

1937, p. 32. **64** H.J. Thaddeus, 1912, pp. 134–5.

Thaddeus came to be introduced to the 'Grand Old Man', but such were Thaddeus' connections in Florence, the arrangement could have involved any one of a number of high-ranking individuals. According to Thaddeus himself, Gladstone had been impressed by his portrait of Leo XIII, which he had seen at the Grosvenor Gallery Summer Exhibition the previous year. Gladstone was a popular figure in Italy, as he had been an outspoken supporter of Italian nationalism and unity. He was busily employed preparing speeches for the Syndic, and was '[wrestling] with his Italian verbs like a diligent schoolboy', when Thaddeus met him, so the artist was forced to prepare studies while his sitter worked.[73] Thaddeus claimed that Gladstone committed himself to formal sittings for the portrait once he had completed his official duties but in practice sat just once, with the result that the artist was forced to begin the final canvas while the paint of the compositional sketching was still wet. He completed the head in a couple of hours but, despite his efforts, had insufficient time left for the proper modelling of the hands. Fortunately, however, when he asked Gladstone to assume his usual stance when addressing the House of Commons, the old man, after brief consideration, 'placed his right hand inside his frock coat, only the wrist being visible', and then, to Thaddeus' relief, 'put his left hand behind his back'.[74] It is a compelling account, but Gladstone's own diary, written *post facto*, records that he actually met Thaddeus for at least two sittings (albeit not very long ones) on separate days. Gladstone met Thaddeus on Tuesday, 24 January, sat for him from 11:30 to 1:30 on Friday, 27 January, and again for three-quarters of an hour on Monday 30 January. He also saw Thaddeus at his studio in London on Tuesday 1 May of that year.[75] The diaries are comprehensive, but it is possible, though unlikely, that Thaddeus and Gladstone had appointments at other times as well.

Notwithstanding Thaddeus' embellishments, one must concede that he appears to have had little time to work directly from the model. Sir John Everett Millais, by comparison, was afforded six sittings, five of which lasted for an hour each, for his portrait of Gladstone of 1879.[76] It is remarkably similar to Thaddeus' work, in scale, format, size, style and technique, and demonstrates clearly Thaddeus' debt to a slightly older generation of portrait painters, including Millais, Holl and Herkomer.

Thaddeus' finished portrait of Gladstone is a considerable achievement, not least because the subject's intensity of expression was notoriously difficult to capture accurately. His success in this regard was acknowledged by the press, who praised the picture when it was exhibited, first in London in the summer of 1888 (at the Irish Exhibition in Olympia, appropriately), then at the Walker Gallery in Liverpool in the autumn of 1889, and finally at the Royal Hibernian

73 Ibid., p. 101. 74 Ibid. 75 H.C.G. Matthew 1994. 76 P. Funnell, et al. *Millais:* 1999, p. 166.

Academy in 1890. A reviewer for the *Liverpool Daily Post*, referring presumably to the bright highlights on the face and head and the gloomy, empty background, against which the figure appeared in relief, likened the portrait to the work of Rembrandt, and declared that it was a 'very remarkable and penetrative likeness', which, in engraved form 'will probably be one of the most popular of the greatest statesmen of this generation'.[77] The *Liverpool Mercury* of 31 August 1889 recorded that the picture was a 'grave and forcible likeness', while Lord Powerscourt, addressing the RHA in 1890, commented that Thaddeus had 'shown truly that wonderful face with all its subtle expression, in a way which does the artist the greatest credit'.[78] The picture even merited inclusion, alongside works by G.F. Watts, Millais, Leech and Furness, in an article dealing specifically with portraits of Gladstone in the *Magazine of Art* of 1889. There, T. Wemyss Reid, a biographer of Gladstone, said of Thaddeus' 'extremely clever portrait' that the artist 'seems to have been still more fortunate in selecting for representation one of those rare moments when Mr Gladstone forgets the anxieties of the day and the labours of the morrow, and indulges in the long calm retrospective survey which is one of the privileges of age'.[79] It would be interesting to speculate how Thaddeus might have reacted to such curious analysis. He may well have been proud of his apparent success in hiding the stress that attended the sittings.

The picture's popularity did not, however, extend to the Royal Academy. Thaddeus was upset to see it rejected by the hanging committee in favour of a portrait of the same sitter by the Academician, Frank Holl. Thaddeus knew this to be consistent with the rules of the institution, but resented the favouritism deeply, primarily because he felt his picture to be far superior. In expressing his disappointment, however, his intention was not to denigrate Holl. On the contrary, Thaddeus admired Holl greatly. Holl's picture was, rather, in Thaddeus' retrospective view, 'the imperfect work of a dying man'.[80] Ironically, Holl showed a characteristic lack of confidence in relation to his portrait of Gladstone. He was frequently overawed by his sitters and admitted that when painting Gladstone at Hawarden Castle in 1888, he felt 'like a man about to walk the slack wire before the world'. In the opinion of Holl's daughter, he endured such anxiety while painting the portrait, which remains at Hawarden, that it 'sounded the first stroke of my father's death knell'.[81] Thaddeus experienced no such feelings of insecurity, and the rejection of his work apparently prompted him to decide never to submit to the Academy again. A vindication of sorts did come, however, from the Reform Club in London, which, having commissioned Holl to paint Gladstone, rejected his portrait on artistic grounds, and chose

77 *Liverpool Daily Post*, 2 September 1899. 78 *Freeman's Journal*, 21 March 1890.
79 T.W. Reid, 'Mr Gladstone and his Portraits', *Magazine of Art*, 1889, pp. 82–9.
80 H.J. Thaddeus, 1912, p. 102. 81 Reynolds, 1912, p. 271.

instead to purchase Thaddeus' work. The club was represented by the eminent journalist George Augustus Sala, who, coincidentally, was probably responsible for much of the ferocious criticism to which Holl was subjected by the *Daily Telegraph* during the late 1870s.

The supposed injustices that Thaddeus suffered at the hands of the Royal Academy were apparently compounded when someone thrust an umbrella through the painting when it was on public display. Thaddeus was sensitive to the possible political motive behind the attack, suggesting wryly to a reporter in 1896 that it had probably been perpetrated 'by a countryman of mine from the North'.[82] A portrait of Gladstone by Thaddeus was indeed placed on display 'between 3 and 6 o'clock in the painter's studio [in London] ... on presentation of a visiting card' in June 1894. This is consistent with the suggestion that the artist had just finished repairs to his 1888 picture.[83] He may have had little opportunity to complete this work in the years since he painted it. Gladstone himself recorded in his diary that he sat for Thaddeus twice in November 1893. He referred specifically to a 'quasi-sitting', which might indicate that he visited Thaddeus to allow the artist to make repairs to an existing picture, rather than paint an entirely new one.[84]

However apocryphal Thaddeus' accounts regarding the Gladstone portrait may be, what is certain is that he valued it highly himself. It is indeed a fine picture, in which he employed dramatic lighting to great effect, isolating and accentuating the sitter's distinctive facial features. This was not a device he reserved solely for his portraiture as some of his most powerful subject pictures are illuminated in a similar fashion.

82 *New York Herald*, 27 March 1896. **83** *Irish Daily Independent*, 18 June 1894. **84** Matthew, 1994, p. 322.

Unlikely patronage? Thaddeus and the Catholic Church

In his own mind, Thaddeus' greatest distinction as an artist was that he was the first Irishman to paint a pope. Though the patronage of the Vatican did not carry in the late nineteenth century the kudos guaranteed in previous ages, it was nevertheless an enviable endorsement of an artist's abilities and standing. Moreover, when Thaddeus was accorded on his first visit to Rome in 1885 the privilege of painting Pope Leo XIII, he was still in his mid-twenties. Unfortunately, the circumstances of the commission are unknown, but it is implicit from Thaddeus' own account that the pope himself took no part in selecting him, so one can assume that a member of the Vatican staff, or the papal court, or perhaps an Irish intermediary was responding to the artist's reputation in Italy and abroad.

Leo XIII (1810–1903) was a phlegmatic character, rather severe in countenance, and haughty in manner. His great intellect was universally acknowledged (he was a prodigious writer), and he proved an astute if over-zealous diplomat, involving himself in, and speaking out on, various matters of international political import, including agrarian reform in Ireland. He was conservative, but showed pragmatism through such acts as appointing John Henry Newman a cardinal in 1879, and encouraged Catholic biblical scholarship, opening the Vatican archives to historians during his pontificate.

In his direct dealings with people, however, Leo XIII was rather unprepossessing. He was acutely aware of the high station he occupied and, it has been remarked, was 'perhaps too keenly conscious of the prerogatives of the papal office to inspire much affection'.[1] This assessment is corroborated more through Thaddeus' account of their encounters than through the resulting portrait (fig. 13). Thaddeus and the pope must have made entertaining adversaries: one young, adroit but headstrong; the other, elderly, aloof and cerebral. Leo proved an accommodating, if restless sitter, and Thaddeus was forced to rely on his speed of draughtsmanship for success. He conceded that he had never worked as diligently on a portrait as he did on this one, which was not a straightforward undertaking. True to character, Leo XIII had very clear ideas

1 M.J. Walsh, 1998, p. 237.

regarding how his portrait should look. He envisaged himself assuming some grand, symbolic pose of benediction, but was promptly counselled against this by Thaddeus, who recalled that that was 'exactly how I had determined not to represent Leo XIII'.[2] Instead, Thaddeus was adamant that he should paint 'the heart and soul, which appeared to shine through the frail, almost diaphanous flesh they had subdued'.[3] The result is a relatively informal portrait, in which the pontiff's pose, sitting at a desk in his study, emphasises his scholarship more than the preeminence of his position. Thaddeus himself wrote that when the pope expressed some surprise at seeing the face of an old man in the portrait, he reassured him that his 'principal object had been to represent the intellectual qualities, &c., which distinguished him'.[4]

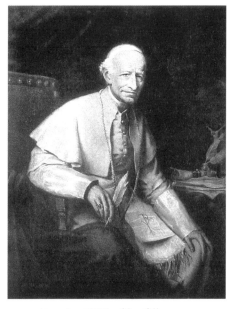

13 *Pope Leo XIII*, 1885. Oil on canvas. Untraced.

Fundamentally, the picture is conventional in both composition and rendition. In fact, it is at first glance remarkably similar in tone and aspect to an official photograph taken in 1878, in which the basic pose, the pope's apparel, and various other details are repeated, down to the ebony and ivory crucifix, and the quill and inkwells. The one major difference, however, lies in the activity of the sitter. Thaddeus' figure leans forward as if interrupted from his work, his hands resting less deliberately than is the case in the photograph. He also seems more preoccupied than the character in the photograph, who sits up looking rather self-conscious and self-satisfied.

Thaddeus recalled that during the sittings for the picture, Leo spoke authoritatively on subjects ranging from Dante, to Virgil, to the Irish situation. The splendour (albeit moderated) of the scene accommodated the pope's own image of the position he held, but Thaddeus nevertheless managed to incorporate a sympathetic, human quality, save for the rather unflattering fingers that lightly hold a quill. The abovementioned photograph does demonstrate that Leo XIII had very slender, distinctive hands, but Thaddeus seems to have accentuated their length somewhat, as a sign of intellect and refinement, perhaps, very much as van Dyck had done centuries earlier. Though the portrait may present Leo as rather more benign in expression than his reputation suggests, W.T. Stead called it a 'striking likeness' in his *Portraits and autographs*

2 H.J. Thaddeus, 1912, p. 129. 3 Ibid. 4 Ibid.

of 1891.[5] Admittedly, Stead had a vested interest in emphasising the quality of the pictures illustrated in his publication, but its inclusion, when considered in the context of the other pictures in the book, seems very deliberate. The incongruity of the portrait of Leo, and a few others, was justified in the short preface to the book, in which Stead explained that though he included portraits of several persons who had no direct connection with the *Review of Reviews* (under the auspices of which this volume was published), the majority of those featured therein were 'well wishers of the Review of Reviews, which probably enjoys the unique distinction of being the only subject upon which they are all agreed'.[6] Exactly where Thaddeus' portrait was intended for is unknown. He obviously had it on his hands for some time, as it was exhibited at the Grosvenor Gallery in 1887, and again at the Irish Exhibition at Olympia in 1888.

Shortly after completing his portrait of Leo XIII, Thaddeus produced an ecclesiastical portrait of much greater interest (pl. 14).[7] Though it is not known how Thaddeus obtained an introduction to the Vatican, it is clear that it was through acquaintances in Florence that he met Father Anthony Maria Anderledy (1819–92), who had been elected vicar-general of the Society of Jesus in 1883.[8] While living there, Thaddeus had obtained a letter of introduction to Father Anderledy, who resided in Fiesole, a short distance outside the city. Thaddeus and Anderledy subsequently became close friends, and the latter was, according to the artist, an almost weekly visitor to his studio there. It is not surprising, therefore, that Thaddeus should have sought out the Swiss-born cleric while he was residing at the Jesuit College in Rome in the early months of 1886. Father Anderledy was as much an intellectual as Leo XIII, and 'remarkable for his firmness of character', but as committed to asceticism as the pope was to pomp, luxury and the paraphernalia of high office.[9] In an interview with the *New York Herald*, Thaddeus irreverently disclosed that he had seen the pope's wardrobe, and that 'it beat Queen Elizabeth's'.[10] Comically, this is one of the very few sentences edited out of the reprint of the *New York Herald* interview in the *Cork Examiner*, although whether this was out of consideration for the sensitivity of royalists or Catholics among the readership is open to conjecture.

Anderledy was prone to melancholy, and lived in remarkably frugal conditions. Soon after Thaddeus finished his portrait of the pope, he visited Anderledy, who was suffering from a severe attack of bronchitis, at the Jesuit College. There, he found the ageing prelate occupying a 'cavernous stone-floored room', with no heating and just one small window to admit light.[11] The austerity of the priest's lifestyle was a cause of some alarm to Thaddeus but proved a powerful ingredient in the arresting portrait that he produced. To

5 W.T. Stead, 1891, p. 139. 6 Ibid. 7 See E. Morris, 1994, p. 116. 8 In 1887, on the death of Father Beckx, Anderledy assumed all the duties of general. 9 P.H. Kelly, 1907, p. 466. 10 *New York Herald*, 27 March 1896. 11 H.J. Thaddeus, 1912, p. 133.

Thaddeus Anderledy was a 'kindly humble priest' despite his awesome intellect and enormous authority.[12] One might also read in the portrait something of Anderledy's preoccupation with grave political matters, engaged as he was at the time in protracted discussions with the Vatican regarding the expulsion of the Jesuits from France. Thaddeus was grateful for Father Anderledy's cooperation at the time, admitting that it was 'a great concession on his part, as his quarrel with the Vatican was … of a very serious character'.[13] The portrait has the disarming immediacy of a photograph, achieved with powerful but controlled chiaroscuro, very different from the overall effect achieved in the portrait of Leo XIII. This tenebrist treatment is much more comparable with the portrait of Gladstone that Thaddeus executed two years later, and the picture was identified by the *Irish Daily Independent* reviewer of the 1893 Royal Hibernian Academy as being in 'his best style'.[14] Anderledy, a hand cradling his chin, is presented as an intellectual, contemplative figure – the archetypal, if not stereotypical, Jesuit. In fact, the picture's proximity to cliché is far from unusual in Thaddeus' portraiture, but crucially, here does not detract from the picture's dramatic impact.

The portraits of Leo XIII and Anderledy differ dramatically, reflecting the contrast in the sitters' positions and chosen circumstances. However, the differences originate as much, if not more, from the relationship between sitter and artist as they do from those qualifications. Thaddeus expressed this clearly to the journalist from the *New York Herald* who interviewed him many years later. 'The contrast between the two men' he commented 'was astounding. The pope is all animation, Father Anderledy was self-contained to a fault. One was surrounded with all the pomp and luxury of a court, the other, wielding almost unequalled power, lived as the veriest beggar'.[15] The style may be derivative, and the presentation contrived, but Thaddeus rarely equalled, and never surpassed his portrait of Anderledy. Numerous contemporary commentaries attested to his abilities at capturing a 'likeness', but in this portrait, and a few others, he showed a perspicacity and perception of character that elevate the picture above an accurate physical likeness. Stead, a forthright journalist, deemed this picture, for which he said Thaddeus had many sittings, 'one of his best'.[16]

The painting, now in the Lady Lever Art Gallery in Liverpool, had a slightly less auspicious introduction into that collection than it deserved. It belonged to a P. Naumann, and was accepted as security for a loan that Lever made to Wilson Barrett, later editor of the magazine *Colour*, in 1916. Lever acquired the picture outright in 1923. Naumann, interestingly, owned at least two pictures by Thaddeus, the portrait of Father Anderledy and *Christ before Caiaphas*, both of which he lent to the Irish International Exhibition in 1907.[17] Naumann is likely

12 Ibid. **13** Ibid. **14** *Irish Daily Independent*, 4 March 1893. **15** *New York Herald*, 27 March 1896. **16** Stead, 1891, p. 83. **17** *Christ before Caiaphas* appeared in the catalogue

to have been one partner of P. Naumann and R. Taylor & Co., the engravers, whose experience and knowledge of art would, presumably, have been extensive. Thaddeus was fundamentally a pragmatist, and therefore not fussy about who owned or collected his pictures, but it must have been affirming and complimentary for them to have been chosen by a fellow artist or artisan. The pictures are an unusual pairing, suggesting perhaps that Naumann knew Thaddeus personally (he may conceivably have worked for him), and acquired the pictures by private sale, or else bought them as business rather than private property, in view to producing commercial engravings.

It was with characteristic self-assurance that Thaddeus returned to the Vatican over a decade later. On this occasion, through the intercession of Prince Marc Antonio Colonna, an old friend from his first visit to Rome, he arranged to paint another portrait of the pope and incorporate it into a much grander composition (pl. 15). He chose as a subject the ceremony of the Obbedienza, or the swearing of the oath of allegiance to the pope by the cardinals, which took place in the lofty and salubrious surroundings of the Sala Regia in the Vatican, and which Thaddeus had recently witnessed.

The subject presented Thaddeus with many new artistic challenges. In the picture, the Pope sits enthroned in magnificent bejewelled and embroidered robes, flanked by prominent members of the papal court, as a cardinal genuflects suppliantly before him and kisses the papal ring. The walls of the Sala Regia were hung with vast ornate tapestries and adorned with mannerist frescoes by such artists as Giorgio Vasari, Francesco Salviati, Giuseppe Porta and Federico and Taddeo Zuccaro, details of which are visible behind the throne in Thaddeus' picture. In his *Recollections* Thaddeus, describing the scene with uncharacteristic understatement as 'one to tempt a painter's brush', regaled his reader with a detailed and uninhibited description of the painting and the characters who feature within it.[18] Here, more obviously than in any other work, the individual portraits approach caricature. Of particular note is the Bismarck-like figure of Count Pecci, captain of the Guardia Mobile and nephew of Pope Leo XIII. He stands in the foreground, crowned with the ornate helmet of his militia, a ceremonial sash exaggerating his rotund torso. Thaddeus reacted against the pomposity he thought Count Pecci displayed in the Vatican, which stemmed from his close relationship with the pope, and managed to communicate this through the inflated figure of the count. Cardinal Macchi is equally unsympathetically treated, skulking beside the throne and peering over pince-nez that cling to an improbably large nose. It is not coincidental that, on his own admission, Thaddeus disliked both of these men. Cardinal Macchi had been less than gracious when he received the artist for a

accompanying the Irish International Exhibition under the title *Christ before Pilate.* 18 H.J. Thaddeus, 1912, p. 258.

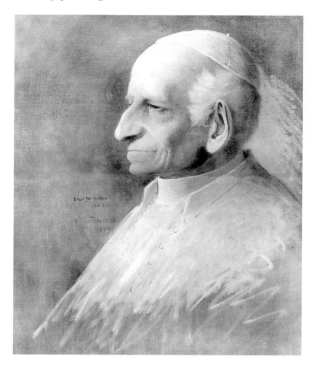

14 *Study for a Portrait: Leo XIII*, 1899. Oil on canvas. Untraced.

sitting, and Thaddeus took umbrage at his behaviour. Contrary to Thaddeus' own contention, this also negated any objectivity to which he aspired as a portrait artist. 'Speaking quite dispassionately' Thaddeus stated with almost comical disingenuousness, 'when I saw his face at close quarters I was repulsed'.[19] He was in fact rather proud of the resulting portrait, which he was forced to execute from memory due to the cardinal's lack of cooperation.

Centrally placed among this strange assortment of character types is the seated figure of Leo XIII himself, whose presentation is much less stylised. A study for this picture, reproduced in the *Illustrated London News* shortly after the death of the pope, shows no signs of manipulation or exaggeration of the sitter's appearance, despite the fact that Leo XIII's small stature, large ears, hooked nose and hooded eyes lent themselves very readily to caricature (fig. 14).[20] Moreover, if one compares it with the finished work, one can see that Thaddeus translated his study directly onto the main canvas with few or no amendments. If anything, he afforded the figure a physical presence and robustness that belied the frailty which was widely acknowledged. Thaddeus explained that when he had finished the studies for the head and came to paint the figure on the main canvas, a monsignor donned the splendid vestments that

19 Ibid., p. 261. **20** *Illustrated London News*, 5 December 1903.

the pope would have worn for the ceremony. Made of silver cloth, and enormously heavy, the garment left the wearer exhausted after each sitting.

When he came to exhibit the picture at the RHA in 1901 Thaddeus was, once again, applauded emphatically by the Irish press. Their positive reaction to the picture, and detailed descriptions of it, anticipated the coverage Thaddeus himself afforded it in his *Recollections*. He would have been pleased, though probably less surprised, to see *The Obbedienza*, of all his paintings, so well received by Ireland's art critics, who were invariably predisposed toward broadly academic artists and traditional methods. 'The drawing', stated the *Freeman's Journal*, 'is wonderfully good, and the treatment of the drapery quite a marvel in the matter of imitating texture'.[21] The *Irish Times* echoed these sentiments, opining that 'the most striking picture in the big room is, perhaps, "His Holiness Pope Leo XIII Receiving the Oath of Allegiance from the Cardinals", by H.J. Thaddeus, ARHA'.[22] It is worth noting that in the latter review, Thaddeus was acknowledged as an Associate of the RHA. According to his friend Michael Holland (who's accounts are, admittedly, often unreliable), Thaddeus was elected a full member of the Academy that year, chiefly on the strength of this one picture.[23] The reviewer of the RHA exhibition in the *Irish Daily Independent*, for his part, was equally positive in his appraisal of *The Obbedienza*. Dedicating almost half of his lengthy text on the show to a description and assessment of Thaddeus' picture, he worked through the entire composition, his only adverse criticism relating, predictably, to Thaddeus' overpowering use of crimson in the robes of the kneeling cardinal. For that figure, however, he reserved his most emphatic admiration, calling it 'an eloquent exposition of ecclesiastical obedience' in the extended outline of which 'there is not a flaw detectable'.[24] Curiously, the reviewer for the *Freeman's Journal* spoke of 'the brilliant mass of colour presented by the purple robes of the prostrate figure of the kneeling Cardinal'.[25] It is impossible to tell from the tinted print in St Mary's Cathedral, Sydney, the only form in which the picture is now known, whose description was more accurate.

In his *Recollections*, Thaddeus wrote that he painted his second portrait of Leo XIII in autumn 1896. He presented a convincing reason for remembering the date, explaining that he visited Rome while recovering from a severely broken leg, which he suffered in the spring of that year. He maintained that he travelled to Italy during his convalescence, first to Naples (and Herculaneum and Pompeii), and then onwards to Rome, where he enjoyed the unusual privilege of painting the pontiff once again. He was inaccurate in his dating of events throughout the book, but here appears to have been a full three years out chronologically. The study of Leo mentioned above is clearly dated 1899, and

21 *Freeman's Journal*, 11 March 1901. 22 *Irish Times*, 11 March 1901. 23 Holland, 1937, p. 32. 24 *Irish Daily Independent and Nation*, 11 March 1901. 25 *Freeman's Journal*, 11

the bottom of the print in Australia carries the inscription 'HJ THADDEUS RHA/ PINXT ROMA 1899'. It seems bizarre that Thaddeus could comment so authoritatively on a picture to which he ascribed the wrong date entirely.

The *Obbedienza* must stand as one of the most ambitious works of Thaddeus' mature career, presenting him with all manner of technical and political challenges. Not only was he committed to rendering accurately the environment of the Sala Regia, with its monumental architecture and variety of master paintings and tapestries, and to capturing with appropriate decorum the atmosphere of the ceremony, but he was also required to produce a series of portraits of high profile and, in some cases, formidable ecclesiastical personalities. It was, without a doubt, a mammoth undertaking, but also a testament to the artist's self-confidence. With few possible exceptions, such as the audacious *Market Day, Finistère*, the powerful *An Irish Eviction – Co. Galway*, and later *Christ before Caiaphas*, he had concentrated on relatively straightforward and uncomplicated compositions and themes in his work. In the course of his career, he was never tempted by large group portraits, busy street scenes or complex historical or subject pictures.

The artist said that on his return to London from Rome, he staged an exhibition of his work, and that the *Obbedienza* occupied 'the place of honour'.[26] He claimed that the *Obeddienza* was on show in Sydney in January 1902, and that cardinal Moran, who he met shortly beforehand, again with a letter of introduction, admired the picture and acquired it for the cathedral with the help of some benefactors. However, the only work by Thaddeus in the cathedral today is the hand-tinted print, signed and inscribed by the artist. Nor is there any record of the cathedral ever having owned an oil painting by the artist.[27] As the original picture in oils is likely to have been very large, it seems improbable that Thaddeus would have gone to the lengths of transporting it all the way to Australia. There had been, at the same time, a resurgence of interest in engravings in the last decades of the nineteenth century, and it would not have been at all unusual for Thaddeus to have put a high-quality print on show to the public. Consequently, the picture acquired for the cathedral by Cardinal Moran and the print currently in the cathedral stores are almost certainly one and the same. The inscription offers further evidence that this is the case, as it reads 'To Cardinal Moran a tribute of respect and esteem from the Painter. Sydney Jan 1902'.

The lasting prestige accruing from the painting was illustrated when Thaddeus was enlisted to comment on an official photograph of Leo XIII made available to the public by the Australian *Freeman's Journal* in 1901.[28] 'Mr

March 1901. **26** H.J. Thaddeus, 1912, p. 265. **27** Rev. Vincent J. Redden (Dean of St Mary's Cathedral), Janice Ashwell (Secretary, St Mary's Cathedral) and Judy Kennelly (Researcher, St Mary's Cathedral), Letters to the author, 1995–6. **28** The Australian *Freeman's Journal* had been edited in 1898–9 by Edward O'Sullivan, with whom Thaddeus

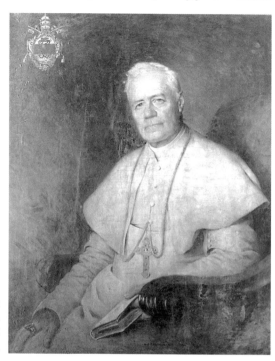

15 *Pope Pius X*, 1903. Oil on
canvas 124.5 × 102.2.
Crawford Municipal Art
Gallery.

Thaddeus, the famous painter of the "Obbedienza"', declared the promotional
article 'says [the photograph] is "the finest he has ever seen".'[29] One cannot think
of many occasions on which artists of the *fin de siècle* were called upon to endorse
commercial enterprise. Furthermore, Thaddeus appears to have been very keen to
sell his own picture, as the £1000 he demanded for the picture at the RHA
exhibition of 1901 was the highest figure he ever solicited for a painting.

Two papal commissions by the age of forty were more than any artist of
Thaddeus' generation could reasonably aspire to, but further honours awaited
Thaddeus in Rome. At the election of Pius X (1835–1914) in August 1903, just
two artists had the privilege of executing his portrait conferred upon them. The
Venetian sculptor Zucco was chosen to produce a marble bust, while Thaddeus
was directed to paint a portrait in oils (fig. 15). The significance of the
commission was acknowledged by the *New York Herald*, which devoted an
entire article to the occasion of the new pope's first portrait. The piece, which
was concerned as much with Thaddeus as it was with Pius X, was even accom-
panied by a large official photograph of artist and sitter (fig. 16), and another of
Thaddeus with his two sons (fig. 44). Thaddeus gained access to the pope

became friendly on his visit to Sydney in 1901–2. See G. Serle, 1988. **29** *Freeman's Journal*
(Australia), 28 December 1901.

within six weeks of his election and the journalist with the *New York Herald*, who may have recognised that certain parties were likely to be deeply suspicious of Thaddeus' progress, made a point of explaining how the artist had managed to do so. He maintained that Pius himself favoured Thaddeus, having seen his portrait of Leo XIII, and that he communicated with the artist through Monsignor Merry del Val, secretary of state at the Vatican. Monsignor Merry del Val was understood to have telegraphed immediately to Thaddeus 'to come to Rome, as Pius X would sit to him as soon as possible after the ceremonies were over'.[30] Not for the first time, however, Thaddeus' own account was rather different. The artist maintained that he presented himself at the Vatican without any summons and was rejected initially, in spite of extraordinary tenacity, but had his candidature accepted after a period of about a month thanks to the involvement of his old friend Cardinal Moran of Sydney who, as a senior cardinal, commanded considerable authority in the Vatican.[31] With almost mercenary matter-of-factness, Thaddeus explained that he had travelled to Rome from his home in Wales as soon as he heard that Leo XIII was close to death, with a view to securing a sitting from his successor. When Pius X was elected, Thaddeus enlisted the help of influential friends to assist him in his efforts, but was blocked by the Vatican authorities. Just as he was resigning himself to failure, he discovered that Cardinal Moran had arrived in Rome from Australia.

However proactive Thaddeus may have been in acquiring the commission, it seems clear that he did appreciate the opportunity. He instantly warmed to the pope's personality. Pius X and his predecessor were totally different in character and background. While Leo was of minor aristocracy, Pius was of peasant stock from the Veneto.[32] His mother was a dressmaker and his father a postman in Treviso. Pius was not the heady intellectual that Leo XIII had been, but he had a sincerity, strength of will and common touch that endeared him to peers and public alike. Thaddeus found him as unlike his predecessor as Father Anderledy had been, writing that whilst 'Leo gave one the impression of intellectual dignity and austerity, ... the characteristics of Pius X are homely benevolence and simple religion'.[33]

Pius was also of a profoundly different physical type to the diminutive Leo, Thaddeus describing him as 'somewhat corpulent and fairly robust ... but endowed with a natural dignity'.[34] Sittings lasted from seven to nine in the morning, throughout which Pius engaged the artist in conversation, as Leo XIII had done. Thaddeus responded especially to the pope's artistic sensitivity and appreciation, characteristics not shared by his predecessor, and remembered

30 *New York Herald* (European edition), 20 September 1903. **31** H.J. Thaddeus, 1912, pp. 305–15. **32** Walsh, 1998, p. 238. **33** H.J. Thaddeus, 1912, pp. 320–1. **34** *New York Herald* (European edition), 20 September 1903.

that 'at the end of every sitting, [Pius] asked to see the study, and his criticisms were always just, being the criticisms of an exquisite connoisseur of things relating to art'.[35]

While the press and public celebrated the 'rags to riches' nature of the new pope's ascent, Thaddeus, to his credit, was more concerned with recording his essential character. That is not to say that he did not take cognisance of his sitter's background or that it did not influence his perception. He reflected that Pius' hands, clearly visible in the portrait, were 'singularly large and powerful … not unlike those of a farm labourer, accustomed to heavy work' and that 'with no aristocratic tradition to sustain, His Holiness [was] essentially a man of the people, and with head and face … could not possibly be a bigot, or intolerant in his views'.[36] Whether or not Thaddeus recognized in Pius a kindred spirit, or identified with his humble origins is open to conjecture.[37]

Technically, Thaddeus' portrait is a consummate exercise in conventional, formal portrait painting. Here, as in his first portrait of Leo XIII, the sitter assumes a standard pose for papal portraits, sitting at a slight angle to the viewer, hands resting either on an arm of the chair, or on his lap, with the papal ring(s) clearly visible. Similar poses can be traced from Raphael's *Julius II* (1512), to Velázquez's *Innocent X* (1649–51), to Anton Rafael Mengs's *Pope Clement XIII* (1760) and right up to the nineteenth century. However, a feature of Thaddeus' picture that connects it with his secular, more 'Victorian' portraits is the way in which he paid fastidious attention to the face and head, while reducing the definition of the modelling as one moves beyond them. All extraneous elements (the chair, the book in the sitter's hand, the background) have been simplified so as not to draw the viewer's eye from the all-important 'likeness'. The draughtsmanship is admirable and the brushwork fine and controlled. In particular, flesh tones and texture have been extremely well observed, although in the painting's current condition, the pope's lips look unnaturally pink.

Thoughts of Ireland remained with Thaddeus, even when he came to paint Pius X. Contrary to the formality of the situation and the high office of his sitter, Thaddeus, identifying a familiar quality in the pontiff's mien, said to him that he had an Irish eye rather than an Italian one. 'Then we are brothers!' was the pope's allegedly jocular response.[38] This tale of almost daring familiarity is the last in *Recollections* and reflects at the very least the affection that the artist reserved for both his native country and his esteemed sitter. It is also typical of Thaddeus' late-Victorian tendency to emphasize (if not overstate) the closeness of his relationship with his sitters. The sentimentality of the story appealed to

35 Ibid. 36 H.J. Thaddeus, 1912, pp. 320–1. 37 Such an idea is mitigated somewhat by our knowledge that Thaddeus showed no hesitation or discomfort in adapting to life in the upper echelons of society. 38 H.J. Thaddeus, 1912, p. 322.

journalists, and was even repeated some years later in T.P. O'Connor's social magazine *M.A.P. (Mainly About People).*[39]

When viewed in the context of Thaddeus' entire *oeuvre*, his ecclesiastical commissions appear socially significant and prestigious, but artistically rather uninspiring, with the conspicuous exception of the incisive portrait of Father Anderledy.[40] To the artist, however, they were obviously the source of enormous pride. It seems that, to Thaddeus himself, they were a testament to his artistic standing as well as his technical ability, and he was happy to see himself represented by them to a public audience. The fact that an engraving was produced of the *Obbedienza* itself indicates the importance Thaddeus attached to the picture. He certainly presented one of these prints to Cardinal Moran. In 1891, the Technical Instruction Committee of the County Borough of Cork acknowledged receipt of a copy of Thaddeus' portrait of Leo XIII, executed by the artist himself, as a gift to the picture gallery of the Cork School of Art.[41] Painting an exact replica of one of his works was an arduous, and relatively unrewarding task, but if done with the Cork gallery specifically in mind, was quite a compliment for Thaddeus to pay his *alma mater*. Moreover, he repeated the gesture almost thirty years later by presenting a facsimile of his portrait of Pius X to the same gallery, where it remains to this day. It is not known if the copy of the Leo portrait was ever on view in the Cork gallery with the portrait of Pius X, or if it was in the collection at all. Those papal portraits would have been an impressive pairing to a conservative Irish Catholic audience.

There is an alternative, and almost certainly apocryphal, account of the circumstances surrounding the Crawford Gallery's acquisition of the portrait of Pius X. This suggests that the picture came unexpectedly again into Thaddeus' possession in 1926, and that he wrote to Hugh Charde, director of the Cork School of Art, asking him to hold on to it until he next came to the city.[42] Yet another account proposes that Thaddeus presented the portrait in response to the murder of the Lord Mayor and will be discussed in due course (see Chapter 8).

It is obvious from his lengthy and generally complimentary article on Thaddeus of 1961, that Diarmuid O'Donovan was baffled by the patronage Thaddeus received, and celebrated, from members of the hierarchy of the Catholic Church. 'A most interesting feature' he stated, 'is the fact that Jones

39 *M.A.P.* 1908, p. 581. 40 Though Thaddeus had come to Rome to paint one portrait, he received commissions for three. As well as Pius X, he also painted Monsignor Merry del Val and the duchess of Mondragone, the famous Sicilian beauty. *New York Herald* (European edition), 20 September 1903. 41 TICCBC, 21 January 1891. The picture is no longer in the collection of the Crawford Gallery, nor is any record of its existence available. 42 'Painting of the Month: Pope Pius X', Information Sheet, Crawford Municipal Art Gallery, 1954(?).

was not a Catholic, but a staunch Irish Protestant'.[43] If, as seems to be the case, O'Donovan's contention was that Thaddeus' religious denomination, or dedication to same, precluded him from painting a pope with any degree of sincerity, then he was greatly mistaken. In fact O'Donovan, like the artist himself, made a point of asserting that Thaddeus was the first Irishman to paint a pope, and that only one Englishman, Sir Thomas Lawrence, had had such a privilege conferred upon him. However, O'Donovan neglected to point out that Lawrence was not a Catholic either. More importantly, when one takes into account Thaddeus' relationship with high-ranking members of the Catholic church, his interest in the church's workings and traditions, and the manner in which he presented the various sitters, there is no evidence whatsoever to suggest that he needed to subdue or compromise his personal beliefs to undertake such work or maintain such associations. Furthermore, it seems unlikely that Thaddeus was a 'staunch' Protestant, if one understands O'Donovan's qualification to suggest that he was traditional, conservative and inherently suspicious of Catholicism. It is worth remembering that Thaddeus' mother was herself a Catholic.

References to the Catholic Church, both implicit and explicit, feature throughout *Recollections*. For example, Thaddeus recalled members of the clergy, of multifarious character and background, who left a positive impression on him. These ranged from the urbane Cardinal Howard, one of the last cardinals in Rome to maintain a semi-royal state, to the benevolent Father Healy, a 'poor' parish priest near Bray who Thaddeus met in Wicklow in 1888, and was, in the artist's opinion, 'without doubt the wittiest man of the century and the best of hosts'.[44] It is amusing that Thaddeus chose to mention what accomplished hosts both of these individuals were, as he himself was, to say the least, a zealous diner and wine enthusiast. Thaddeus thought Healy's collection of wine particularly impressive and added that the priest's only servant, an old woman, 'could cook a ham or turkey better than any chef at the Carlton'.[45]

Elsewhere, Thaddeus made more general references to church history and practice, some reflecting genuine admiration and wonder, some a disengaged fascination, and others terse disapproval. There are many indications that he was fascinated by the ritualistic dimension of Catholicism. He wrote of 'sacred events', and with obvious deliberation used terms like 'solemnity' and 'divinity'. Claiming in his *Recollections* that his first studio in Florence, on the Via Ghibellina, was built on the site of the chapel or refectory of an ancient convent of the Murati, an enclosed order of nuns, he offered the reader a lengthy description of the extraordinary hardships endured by these abstemious and pious individuals. While finding the subject compelling, however, he added that 'nowadays people afflicted with religious mania are relegated to insane asylums; and, after all, it is a more humane way of dealing with these mental aberrations

43 O'Donovan, 1961, p. 42. 44 H.J. Thaddeus, 1912, p. 159. 45 Ibid., p. 160.

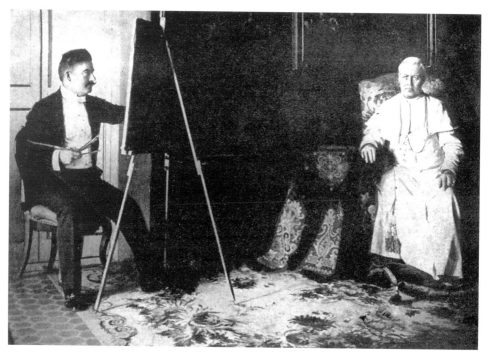

16 Pope Pius X sitting for Harry Jones Thaddeus, 1903.

than fostering such delusions by recognition of sanctity'.[46] He was even less compromising in his comments on the modern Neapolitan, whose 'fetish worship of saints and relics belongs more to the darkest of the dark ages than to the nineteenth century'.[47]

Apart from his wry reflection on the fate that befell his portrait of Gladstone at the hands, perhaps, of a compatriot from the north, Thaddeus reserved his most pointed comments on the specific relationship between Catholic and Protestant communities (as opposed to the institutions and beliefs of the churches), when writing of his experiences in Australia. There he found a bitter hostility between those descended from the Irish Catholic immigrants and those Protestants whose ancestors were English convicts. He observed that the Catholics of Sydney's love of and devotion to their Cardinal was only exceeded by 'the extreme Protestant party, whose bigotry resembled in an acute form that of the Orangemen in the North of Ireland'.[48] Typically, his assessment and historical analysis was summary and bombastic, but it is significant that he distanced himself from the divisive social tensions he described. 'Personally', he concluded, 'I take little interest in differences of religion, considering that if

46 Ibid., p. 44. 47 Ibid., pp. 256–7. 48 Ibid., p. 281.

faithfully followed one creed is as good as another; and why people, as Daniel O'Connell said, "should hate each other for the love of God" passes my understanding.'[49] Thaddeus' invocation of the champion of Catholic emancipation certainly challenges any theories regarding his suspicions of, or aversion to, Catholicism.

Having the privilege of being the first artist to paint Pope Pius X conferred upon him was arguably Thaddeus' greatest professional (as distinct from artistic) achievement. In fact, it was still the subject of scepticism decades after his death. Denis Gwynn implied in his regular column in the *Cork Examiner* that Thaddeus could not have painted the portrait from life, as he was not sufficiently eminent to have been granted a sitting with the pontiff so soon after his election.[50] A spirited defence of the artist, put forward by a gentleman who had obviously carefully read *Recollections*, was published shortly afterwards.[51] In it, he presented as evidence the photograph of Pius X sitting for Thaddeus, which is the final illustration in *Recollections* (fig. 16). In fact, that may have been the expressed purpose of the photograph. It has been suggested that Thaddeus organized to have a photographer witness a sitting to counter any allegations that he painted his portrait from photographs.[52] Thaddeus would have been well aware of the damaging potential of such allegations, as he had supported the Flemish artist Jan van Beers through a court action he took in 1887 against individuals who had accused van Beers of painting on prepared photographs.[53] Such libellous accusations had been levelled at van Beers for some time, and no such slander was to deprive Thaddeus of the prestige associated with his latest papal commission.

49 Ibid. 50 Gwynn, 31 July 1951. 51 E. O'Mahony, 1951. 52 O'Donovan, 1961.
53 H.J. Thaddeus, 1912, p. 166.

Face value – the society portrait painter

> In our epoch the painter is no longer the labouring artisan who locks
> himself away in his studio behind a closed door living in a dream. He has
> thrust his head foremost into the bustle of the world ... he has his day
> when the studio is transformed into a salon where he receives the elite of
> polite society.[1]

When Albert Wolff, the fearsome French critic, wrote these words, he
anticipated precisely the manner in which Thaddeus' career would
develop during the 1880s and 1890s. The experience was not exclusive to
Thaddeus, but unlike many artists successful in the same field in England in the
second half of the nineteenth century, such as George Frederic Watts, John
Everett Millais and Frank Holl, his decision to commit himself to portrait
painting was calculated and of his own volition. Recognizing very early the
lucrative potential and social benefits accruing from the profession, Thaddeus
welcomed into his studio to sit for him members of royalty, the military, the
aristocracy, literary figures, composers and politicians alike. In the second half
of the 1880s, he was at the height of his powers, with a large number of important
commissions behind him, a wide and well-connected collection of patrons and
friends, and a reasonably sound foothold in British and Irish exhibition circles.
His reputation as a portrait painter probably preceded him from Italy, and he
was busily, but not exhaustively, occupied, and continued to produce and exhibit
work in a variety of genres. This consolidation, combined with his innate
pragmatism, brought with them, however, a slowing in Thaddeus' technical
development, as he exhibited in his work only occasional signs of innovation or
bravura. Nevertheless, his portraiture was competent, consistent, and punctuated
on occasion with pictures of exceptional quality.

To concede that Thaddeus' pragmatism superseded an inclination to experi-
ment is not simply to relegate him to the status of a journeyman painter. He was
skilled and efficient, and could be relied upon to provide his clientèle with
exactly what they desired. His continuing interest in subject pictures and, to a
lesser extent, landscape, also reduced the risk, which dogged specialist painters,

1 Albert Wolff, *La Capitale de l'art*, Paris 1886, p.v. Quoted in Milner, 1988, p. 27.

of actually stagnating creatively. Thaddeus did not feature among the top rank of portrait painters in Britain during the last decades of the nineteenth century, but his list of sitters, and the prices he was prepared to charge, attest to his sound position at the top of the vast and competitive majority. Moreover, his work and practice bear comparison with that of his more exalted contemporaries.

In 1888 the *Academy* enumerated and assessed what it considered the foremost portrait painters of the day: 'Sir John Millais, in his best portraiture, is somewhat inspired; Mr Ouless is a thorough-going workman; Mr Herkomer is experimental; Mr Carter is very solid; Mr Cope refined; Mr Shannon extremely brilliant.'[2] The list appeared on the occasion of the death of Frank Holl who, despite his limitations, was also considered worthy of inclusion among the group. Few patrons could actually afford to employ these artists, and the majority were left to rely on the services of the plethora of other artists at work. Of these, few applied themselves strictly and exclusively to portraiture, but rather turned their hand to it as chance dictated. The result was a proliferation of society portraits of unpredictable quality. A corollary of this, however, was that there was scope for the more ambitious and opportunistic, and Thaddeus, a tenacious self-promoter, with unshakeable faith in his own abilities, was well equipped to exploit opportunities.

The list in the *Academy*, to which one can justifiably add James McNeill Whistler (1834–1903), John Singer Sargent (1856–1925) and John Collier (1850–1934), demonstrates well the disparate nature of the field of portrait painting in the late Victorian period. It was against such artists, who represented various generations and styles, that others, including Thaddeus, were judged, and on whose example they drew. However, while the writer represented the likes of Millais, Carter and Ouless as stalwarts of their genre, he reserved emphatic praise for James Jebusa Shannon (1862–1923). Just two years younger than Thaddeus, Shannon, an American of Irish parents, was a prodigious student, a prolific exhibitor, and one of the most sought-after portrait painters of his generation. Though he neither studied in Paris nor practised on the Continent (he did exhibit there), Shannon's early good fortune and success were similar to Thaddeus', and one can imagine how Thaddeus' style of fashionable portraiture might have developed had he displayed the same inclination to experiment as his American counterpart. Both men showed precocious confidence in their youth, but while it appears to have been manifest in Thaddeus' clear satisfaction with a portrait style of limited scope, in Shannon's case, it led to a subversion of convention.[3] In so-called 'fanciful subjects' like *In the Springtime* (1896) Shannon wilfully blurred the distinction between portraiture and decorative subject painting, challenging the expectations of his audience without offending their artistic sensibilities.

2 *Academy*, 11 August 1888, p. 92. 3 See K. McConkey, 1991, p. 355.

In a sense, Shannon was an innovative artist who the more conservative elements of the artistic fraternity, and their pioneering and radical equivalents alike could afford to admire. Whistler, for example, thought highly of Shannon's work, but so did the traditionally cautious guardians of the Royal Academy, who accepted his paintings with enthusiasm year after year, and elected him an Associate in 1897. Shannon had received his first major commission when just nineteen years of age, painting a portrait of the Hon. Horatia Stopford, one of Queen Victoria's maids of honour, which, as mentioned already, was shown at the Royal Academy in 1881. His portraits were usually bold and colourful, with a high tonal range and controlled, dynamic brushwork, but compositionally, were quite conventional. Shannon never risked the reproach to which both Whistler and Sargent were subjected at times by the establishment. That is not to say that Shannon avoided association with modernist circles. Alongside artists like Walter Sickert, Philip Wilson Steer and Francis Bate, all enthusiastic admirers of the Impressionists, he was a member of the New English Art Club (NEAC). Originally conceived as a society of self-defined 'Anglo-French' artists, the NEAC was established in 1886, and originally sought to salute French training and artistic influence, and to provide a forum for the expression and appropriation of these elements in British painting.[4]

A clear, considered expression of an alternative, but pervasive approach to portraiture was provided by John Collier, in his *The art of portrait painting*. Written retrospectively – Collier was fifty-six in 1906, when the book was published – it was more treatise than manifesto, and presented a moderate assessment of portrait painting through the ages, but more interestingly in the context of Collier, and indeed Thaddeus, it defended the broadly academic principles to which the author adhered in his own work. Significantly, he did not cursorily dismiss modernist portrait painting, but addressed its weaknesses from an academic perspective, as Thaddeus would probably have done. For example, Collier praised Whistler cautiously, particularly the harmony of his colours, but added that the simplicity of his compositions was 'carried so far at times as to seem to the natural man wilful eccentricity'.[5] Collier's writing indicated that his commitment to essentially academic portraiture was not necessarily a sign of a lack of imagination or fear of innovation, but rather based on a genuine belief in the fundamental legitimacy of established, academic principles.

Unlike Collier, Thaddeus gave no indication in his writings that he was affording the work of his more radical contemporaries judicious consideration. However, though he may not have been a technical innovator himself, Thaddeus

4 For a detailed discussion of the NEAC, see W.J. Laidlay, *The origin and first two years of the New English Art Club*, London 1907; Alfred Thornton, *Fifty years of the New English Art Club*, London, 1935; Anna Robins, *The New English Art Club Centenary Exhibition*, exh. cat. Christie's, London 1986 and K. McConkey, 1989. 5 J. Collier, 1906, p. 29.

was undoubtedly susceptible to the influence of others. Predictably, he did not acknowledge a debt to any specific portrait painter, and singled out just one artist of that era for praise, the relatively orthodox, but extremely accomplished Frank Holl, who he described as 'undoubtedly the greatest English portrait-painter of his time'.[6] In the context of Thaddeus' extremely selective comments on art in his writing, this amounts to a declaration, and it is not surprising to find striking similarities between Thaddeus' work and Holl's, though this is not the only evidence of the influence of other artists.

Frank Holl had not taken instinctively to portrait painting, but was rather backed into it, having been continually lambasted by the press for the morose character of his genre works. He was even accused at times of producing works that lacked masculinity, including *Her Firstborn* (*c*.1876), of which he completed a number of versions. Nevertheless, he quickly demonstrated an unusual ability with portraiture, particularly when painting older male sitters, and up to his death was inundated, to the point of utter exhaustion, with commissions.

Thaddeus' introduction to portraiture was more gradual. He had begun as a student in Cork, but as distractible as he was adaptable in his youth, set por-traiture aside for a short period, possibly because it was so incongruous with his training at both Heatherley's and the Académie Julian, and was not practised, formally at any rate, by his contemporaries in Brittany. However, he returned to it with increased enthusiasm in Florence, quickly recognising that he was more likely, though not guaranteed, to find security in portraiture than in the probably more satisfying, but precarious pursuit of subject painting. He was vindicated, and portraiture proved a profitable venture. Certainly, the fact that Thaddeus, like Holl, was not deterred by the conventionality of his patrons' taste aided his cause. Holl was willing to undertake any work that came his way, and as a result became caught in the 'vicious circle' of committing himself to 'repetitious and creatively inert work'.[7] Holl was very possibly enticed by the advantages of being a portrait painter, including the capacity to make money, as described to him by the portraitist Henry Weigall in 1874.[8] Thaddeus would certainly have been attracted by the money and society, but less to the one-dimensional nature of the subject matter, evinced by his sustained activity in other genres. Moreover, his peripatetic and social nature was ideally suited to the life of the portrait painter among fashionable society.

Even Thaddeus' roll-call of sitters resembles Holl's. For example, both artists painted Gladstone. Holl painted the anthropologist and archaeologist Augustus Pitt Rivers, Thaddeus the naturalist and anatomist, Sir Richard Owen. Holl produced portraits of numerous bishops, while Thaddeus painted

6 H.J. Thaddeus, 1912, p. 102. 7 P. McEvansoneya, 'Frank Holl and the profession of portrait painting in Victorian Britain', transcript of lecture given at the National Portrait Gallery, London 1995. 8 Reynolds, 1912, p. 127.

two popes and other high ranking church figures. Holl painted the duke of Cambridge, Thaddeus his sister Mary Adelaide of Teck. Few of their sitters were obscure figures, and most featured in the *Dictionary of national biography*.

As personalities, however, Holl and Thaddeus were the antithesis of one another. The former preferred not to mix with his sitters, and was notoriously anxious about his work. Thaddeus, in contrast, felt confident enough in many cases to count his sitters among his friends, although one wonders how genuine these claims were. During his career, Holl found the disproportionate popularity of his portraiture over his genre work somewhat disconcerting. Thaddeus, in contrast, was prudent enough to see commercial portraiture for what it was, while at the same time striving to maintain the quality of his work. He valued some of his own portraits extremely highly, particularly those of Pope Leo XIII, Gladstone and, for a slightly less benign reason, William O'Brien. He was also perhaps more resilient with regard to criticism than the likes of Holl, Millais and Watts. Millais wrote to a tormented Holl in 1888 that 'portrait painting is *killing work* to an artist who is sensitive, and he must be so to be successful, and I well understand that you are prostrated by it. Every one must have his say, and, however good the performance may be, there is some fault to find'.[9] Having said this, Thaddeus never reconciled himself to rejection by the Royal Academy.

Apart, perhaps, from Millais and Sargent, few artists had the versatility to tackle all portrait types, sitters and formats with equal competence and confidence. To a great extent, it is that rare universal ability that elevates the great portrait painters above their contemporaries. Holl was particularly skilled in portraying middle-aged and older men, and rarely painted women. Furthermore, he appears to have been most comfortable painting in three-quarter length format and on a standard 40" by 50" canvas. Thaddeus, too, worked to his particular interests and strengths. He was inclined to present sitters in profile, and often either hid or obscured his figures' hands. He also avoided group portraits, only very occasionally producing portraits of a mother or father with a child (e.g. *The Marchioness of Zetland and her son George Dundas* (1886); *The Countess Pozzo di Borgo and her son* (*c.*1895); *Mrs Thaddeus and her son Frederick* (*c.*1896)), or portrait pairs (e.g. *The Duke and Duchess of Teck* (figs. 8 & 9); *Lord* and *Lady Clifford of Chudleigh*).[10] Furthermore, Thaddeus rarely produced full-length portraits, but rather concentrated mostly on half and three-quarter length works. This option was consistent with convention, but also allowed him to disguise inadequacies, such as in the rendering of anatomy. The theory that great national figures were commonly painted in half- and

9 J.G. Millais, *The life and letters of Sir J.E. Millais*, London 1899. Quoted in Christopher Newall, 'The Victorians 1830–1880', *The British portrait, 1660–1960*, Woodbridge 1991, p. 350. **10** Thaddeus claims that he painted a portrait of *Don Carlos with his Four Daughters as the Seasons*, but this picture is untraced. *New York Herald*, 27 May 1896.

three-quarter-length so that the audience might not become too intimate with their features but at the same time not feel too distanced from them, could certainly be applied to works such as Thaddeus' portraits of Gladstone, William O'Brien, Sir Arthur Hodgson and Minister Edward O'Sullivan.[11] Accepting Thaddeus' debt to Holl, however, and his eternal adaptability, it would seem more likely that he was following an artistic model or precedent, rather than adhering to some psychological rationale. He did, however, paint men and women in almost equal measure, as well as a number of child portraits.

Typically, the style and overall appearance of Thaddeus' portraits were dictated by the age and gender of his sitters, and resulted in clearly defined portrait 'types'. His finest portraits were undoubtedly those of male sitters, characterised by solid modelling and dramatic chiaroscuro. A large number of painters, including Herkomer, Holl and Collier, had adopted this deliberate and sombre style. Holl even went to the lengths of keeping most of the large windows in his Richard Norman Shaw-designed studio covered with velvet to allow the light entering from one central window to throw his sitter into high relief.[12] The influence of those artists on Thaddeus is obvious. Denis Gwynn, in assessing Thaddeus' portraiture, recognised that it 'lacked the gay decorative colour which gave greater popularity to such Irish painters as Sir John Lavery and Sir William Orpen', and that with 'his darker colouring and strong drawing, [Thaddeus] was more like Sir Hubert von Herkomer'.[13] Thaddeus did not simply plagiarise from recent British predecessors and contemporaries, however. At root, he shared with them an interest in historical portraiture that had prevailed for much of the century, as such artists as van Dyck, Hals, Murillo, and especially Velásquez were rediscovered by British artists, scholars and critics.[14] Holl's daughter, A.M. Reynolds, wrote that his detailed study of portraits by Rembrandt 'showed him the eternal issues beyond the fashions of the day' and the 'enormous possibilities that lay in the art of portraiture'.[15] Holl did not actually see the work of Velásquez until shortly before his death, or the work of great Dutch masters until relatively late in his career, but some observers expressed in eulogies their belief that he was, to some extent, their successor. Holl had also admired the work of Israels, who brought a similar gravity to his portraits. For Thaddeus, Holl, Herkomer and others served as conduits, appropriating the portraiture of great masters to satisfy nineteenth-century demands and tastes. Thaddeus had also seen seventeenth century Dutch and Italian painting first-hand and, even in his early genre work (e.g. *The Wounded Poacher*) with its strong directional lighting, displayed a predisposition towards a more archaic, almost baroque painting style, quite unlike the suffused

11 See McConkey, 1991, p. 357. 12 H. Zimmern, 1885, pp. 148–9. 13 Gwynn, 31 July 1951. 14 For a detailed discussion of the pervasiveness of this interest in Spanish painting, see A. Braham, 1981, pp. 35–44, and A. Wilton, 1993, p. 58. 15 Reynolds, 1912, pp. 177–8.

lighting of more recent grand portraits, such as those by Landseer, Winterhalter and Flandrin.

Thaddeus' interest in Dutch portraiture received its most obvious, and literal, expression in two large portraits produced in successive years. These works typify his humour, burgeoning technical ability, and confidence, and point to a whimsical tendency quite alien to an anxious personality such as Holl's. The first of these, painted in 1889, is a portrait of Thaddeus' friend Robert Percy ffrench (1832–96), a high ranking diplomat to whom he had been introduced by the Tecks in Florence. ffrench served in the Diplomatic Service from 1852 to 1878, occupying during that period the posts of secretary of legation at Berne (1868); acting Chargé d'Affaires in Madrid (1869); and secretary at the British embassy in St Petersburg (1872) and Vienna (1873–8).[16] Thaddeus described him as resembling 'the portraits of Henry IV', the fifteenth century monarch, but rather than attempting to represent him in a style reminiscent of medieval British portraiture, adopted a style akin to Dutch painting, with a jaunty figure brightly illuminated in a dark, featureless background.[17] It is rather grandiose, if self-parodying, as if, as C. Charles O'Malley suggested, designed for 'a Castle or large hall'.[18] However, when Thaddeus exhibited the portrait at the RHA in 1890, it was overshadowed by his two other pictures on show, *An Irish Eviction – Co. Galway*, and his portrait of Gladstone. One wonders if it would have elicited a greater response, if only for its fanciful quality, had it been exhibited with less remarkable works or on its own. As it was, Lord Powerscourt, whose address at the RHA served as the review of that year's exhibition in both *Freeman's Journal* and the *Irish Times*, opined that 'the palm' in the main rooms at the RHA 'should be given to Mr Thaddeus', but made no reference to the unusual appearance of that particular portrait.[19]

Thaddeus' evident interest in seventeenth-century portraiture, though shared by many notably academic artists, was equally prevalent among their more avant-garde counterparts, though the majority were attracted principally to the work of Velásquez, and drew unashamedly on its distinctive qualities. Whistler had studied the work of Velásquez in the late 1850s, while Sargent was 'overwhelmed' by his work on a visit to Spain in 1880.[20] Lavery too admired Velásquez's distinctive skills. Numerous important writings, including William Bell Scott's *Murillo and the Spanish school of painting* of 1873, and R.A.M. Stevenson's *The art of Velasquez* of 1895, complemented contemporary artists' practical response to Spanish art. Thaddeus does not appear to have been influenced to any significant degree by the Spanish master, but looked instead more readily to seventeenth-century work of Northern Europe. This was not, however, a deliberate, orthodox alternative to Velásquez's popularity among the

16 *Burke's Landed Gentry*, 10th edition, 1904. 17 H.J. Thaddeus, 1912, p. 72. 18 O'Malley, August 1968. 19 *Irish Times*, 21 March 1890. 20 Braham, 1981, p. 37.

avant-garde, as Dutch seventeenth-century painting was attracting a similarly enthusiastic and diverse audience.

John Singer Sargent, for instance, openly quoted from seventeenth-century painting, and with infinitely more *élan* than Thaddeus was capable of, in such pictures as his portrait of *Dr Pozzi at Home* of 1881. That picture has been described as 'self consciously old masterish', but also as so sophisticated in conception as to subvert the traditional iconography on which it was based.[21] Thaddeus' portrait of ffrench is a much more obvious costume piece, which lacks the subtle connotations that distinguish Sargent's. Sargent's painting is an unmistakable contemporary record, but also acknowledges old-masters such as van Dyck (1599–1641), Philippe de Champaigne (1602–74) and even El Greco (1541–1614). Thaddeus' portrait of ffrench, in contrast, corresponds to a less complex Victorian tendency to place costume pictures in a vaguely historical context.[22] Its humour renders it oddly attractive, but ultimately, it represents obvious pastiche more than sophisticated artifice.

As if to indulge his predilections further, Thaddeus produced a more flamboyant version of the picture just a year later, which might well also be a portrait of ffrench (pl. 17). In this case, an old man dressed in rather inaccurate, but evocative, seventeenth-century Dutch costume, with black cloak and white ruff, and again a broad-brimmed hat, glances peremptorily over his shoulder at the viewer. Though the picture is modern in technique, the figure calls to mind Rembrandt's atmospheric portraits of old Jews and burghers, with a haughtiness reminiscent of the work of Hals.

Unlike the earlier portrait, which features the sitter's title in large square letters across the top of the canvas, together with a family crest, here his identity is not disclosed. However, the figure bears a distinct facial resemblance to ffrench as he appears in the 1889 portrait. The significant difference lies in the ages of the sitters. The figure in the portrait of 1890 appears considerably older, though it is feasible that Thaddeus simply aged him to suit his artistic purposes. As ffrench and Thaddeus were good friends, such a jape would not have been out of place. In fact, Thaddeus quoted in his *Recollections* from a letter he received from the grand duke of Mecklenburg-Schwerin, in which reference is made to 'quatre esquisses a l'huile que vous avez fait de moi un matin à M. Carlo, "en costume du modele"', which indicates that Thaddeus' friends would pose for him in character.[23] The apparent frivolity of these paintings should not necessarily detract from their quality.

Notwithstanding the fudging of the ear, and the deliberate omission of the hand in Thaddeus' portrait of 1890, both portraits are technically accomplished pieces, in which Thaddeus again exhibited confidence and skill in the rendering

21 See E. Kilmurray and R. Ormond, 1998, p. 96. 22 See R. Simon, *The portrait in Britain and America*, Oxford 1987, p. 32. 23 H.J. Thaddeus, 1912, pp. 108–9.

of facial detail and flesh tones. He showed an uncommonly free hand in applying paint to the face, emphasising its wizened surface with thick *impasto*. In a sense, these 'costume portraits' forge a link between the artist's early studies in London and Paris (pl. 1), and his austere, formal portraiture of the 1880s and 1890s. The pictures contain many of the elements that characterise Thaddeus' formal male portraiture. Like Holl, he minimized the detail and modelling on the torso, and concentrated on the face and, occasionally, hands of the sitter (see *W.E. Gladstone*, (fig. 12); *Sir Richard Owen*, (fig. 27); *Sir Arthur Hodgson*, (pl. 16); *W.T. Stead*, 1890; and *Minister Edward O'Sullivan*, 1902). It was an approach that was perhaps more difficult to master than its apparent economy would suggest, and when successful, was extremely striking.

Thaddeus demonstrated his command of the technique probably most impressively in the previously discussed portrait of *Father Anderledy* (pl. 14), and in a commanding portrait of *The Rev. the Earl of Bessborough* (pl. 18). However, the presentation of the figure in high relief, that quality which made the style so forceful, was also the one that incurred most criticism. Thaddeus' portrait of the earl closely resembles those pictures by Holl which Gertrude E. Campbell claimed in 1889 'give one the impression that there is no atmosphere between you and [the sitters], they "stand out," ... to such a degree that occasionally they leave the unfortunate bodies to which they are supposed to belong about six feet behind them'.[24] She would no doubt have expressed the same reservations about many of Herkomer's portraits, though, ironically, Herkomer himself was sensitive to the limitations of the style, saying of Holl's portraiture that there was a 'certain sameness in every subject ... Holl never painted an eye in his sitter; it was always in shadow'.[25] The same criticisms could be made of many of Thaddeus' works, including his portraits of *The Rev. the Earl of Bessborough*, *Sir Arthur Hodgson*, mayor of Stratford-upon-Avon from 1883 to 1888, and *William O'Brien*.

The portraits of *The Rev. the Earl of Bessborough* and *Sir Arthur Hodgson* are exceptional in Thaddeus' *oeuvre* for the manner in which features that, it seems, the artist found either irksome or technically challenging, were successfully mastered. In many of his half and three-quarter length portraits, Thaddeus attempted to obscure or hide the hands. In the case of Gladstone (fig. 12), for example, he placed one hand behind the sitter's back, the other inside his jacket, while in the portrait of the *Old Bearded Man in Dutch Costume* (pl. 17), one hand, barely visible, clutches the cloak, while the other is concealed within it. Equally, William O'Brien rests one hand directly on top of the other, while Minister Edward O'Sullivan plunges both hands in his pockets. The same hesitancy is in evidence in Thaddeus' portraits of women.

24 G.E. Campbell, 1889, p. 58. **25** H. Herkomer, *My school and my gospel*, London 1908, p. 17. Quoted in Walkley, 1994, p. 110.

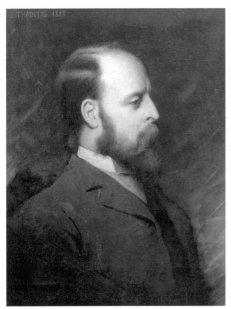

17 *Gerald, 5th Duke of Leinster*, 1888. Oil on canvas 68.5 × 53.5. Private collection.

Collier reflected on this facet of portraiture as well, encouraging the artist to approach it with patience. He suggested that the difficulty in painting hands lay fundamentally in the awkwardness with which a sitter posed them. He argued, however, that they were fundamental to the expressiveness of a portrait, and concluded that as 'a hand is in some ways more difficult to paint than a head ... an artist should be prepared, if necessary, to give more time to the former than he gives to the latter'.[26] On the available evidence, it is doubtful that Thaddeus would have endorsed Collier's opinions wholeheartedly from a practical point of view, but it is interesting that he should have displayed such precision and skill in the rendering of hands in particular works. The study of the hands in the portrait of the earl is a virtuoso display of technical competence and naturalism, which puts paid to any notions that Thaddeus lacked the wherewithal to execute such detail. Similarly, in the portraits of Hodgson, both hands are prominently displayed, and expertly observed, as they are in the portrait of Savorgnan di Brazza (fig. 10). Omitting the hands may simply have been expedient, a shrewd means of minimising his efforts, and one of which Collier would have deeply disapproved.

This practicality might also explain Thaddeus' tendency to present his sitters in profile. Admittedly, women were often painted in profile, on the assumption that it was more flattering and classical (e.g. Stanhope Alexander Forbes' *Desirée at the Piano*, (*c*.1879), John Lavery's *Miss Auras – The Red Book*, *c*.1905, and Sir Frank Dicksee's *Agnes Mallam*, 1921), but Thaddeus used the device in some of his male portraiture as well, notably in his pictures of *Gerald, Fifth Duke of Leinster* (fig. 17), and *Ronald Sutherland Gower* as well as in his subject pictures. In contrast, the figures of Bessborough and Hodgson look straight out at the viewer, as Thaddeus himself does in a self-portrait of 1900 (pl. 19), with a directness and candour that transcend the stiff formality which might otherwise deaden them, as it does his portraits of *Lord Clifford of Chudleigh* and *Colonel Thomas Garrett* (fig. 18). It is perhaps surprising that the latter, a rare martial portrait is quite so rigid and austere, as Thaddeus himself found the sitter's

26 Collier, 1906, p. 95.

profession incompatible with his character, remarking that Garrett was 'quiet, reserved, yet always pleasant and appreciative, gifted with charming manners and sterling upright character', and that painting him in 'warlike accoutrements' was 'a travesty on his peaceful nature'.[27]

The stylistic uniformity of many of Thaddeus' portraits of men did have one significant advantage as far as traditional portraiture was concerned, however, which was to focus the viewer's eye on the unique facial characteristics of the sitter. Thaddeus did not expend energies in attempting to present a more esoteric impression of the sitter, as other artists, including Whistler, were to do. Paradoxically, Thaddeus' chosen, formulaic approach, while restricting artistic variety, emphasised the diversity of sitters' physical appearance.

In short, in his portraits of men, Thaddeus was firmly committed to capturing an instantly recognizable visual record of an individual, in a pose and condition that

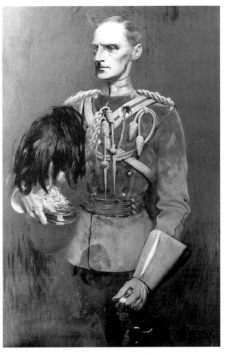

18 *Colonel Thomas Garrett*, 1891. Oil on canvas 142 × 91.5. Private collection.

would reflect their social standing. One is reminded of Richard and Samuel Redgrave's blunt judgement of Henry William Pickersgill, whom they described as a 'portrait painter whose works are distinguished more by their being satisfactory likenesses than for any artistic qualities they possess'.[28] Thaddeus, and artists of his ilk, were satisfying a popular appetite for and expectation of an accurate 'likeness', the term favoured by the contemporary press. The raking light and solid modelling also afforded his sitters the commanding presence that many of the strongest painters of the Victorian period considered central to the success and authority of the portrait.[29]

To a degree, this preoccupation with 'likeness' represented the fundamental difference between the established tradition of portrait painting, which Thaddeus espoused, and the radical, more esoteric approach of artists such as Whistler and Sargent. A re-evaluation, not to say re-definition, of 'the portrait' was at the centre of an on-going debate. The position of the more traditionalist artist was accurately articulated by Collier who, in comparing his naturalistic

27 H.J. Thaddeus, 1912, pp. 153–4. 28 R.R. and S. Redgrave, 1981, p. 358. 29 McConkey, 1991, p. 356.

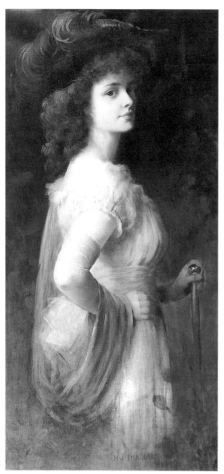

19 *Young Russian Woman*, 1889. Oil on canvas 120 × 59.5. Private collection.

portraits with Whistler's 'Harmonies', presented his case trenchantly, recognising the charges of retrogression that were likely to be levelled at him. 'Now it may be replied', he said 'that [Whistler's portraiture] is a much higher form of art than the crude representation of uninteresting people. This it may be, but it is just in this representation, whether crude or otherwise, that portraiture exists, and I am convinced that Velasquez and Rembrandt would be on my side in this controversy.'[30] Invoking those particular old masters to legitimize his argument would have done little to discourage the likes of Whistler and Sargent, as it was just as likely for them to do the same. However, once again it demonstrates the sincerity with which Collier and like-minded artists addressed the challenges of their profession.

Thaddeus' early portraits of women followed the same pattern as those of men. His first experience of painting portraits of women (rather than studies from female models) seems to have come in Florence, where he painted, among others, *An Old Widow* (pl. 10) and the *Duchess of Teck* (fig. 9). These were competent works in their own right, which, with dark, plain backgrounds, and dramatic illumination of the figures, echoed their male equivalents. However, in incurably patriarchal middle-class Victorian society, the authority and intellectual gravity with which it was appropriate to imbue a portrait of a lord mayor, a politician, an eminent musician or a *male* member of the aristocracy (i.e. head of household) were not necessarily extended to portraits of women, and Thaddeus' approach soon changed, albeit not entirely (fig. 19). This is perhaps not surprising, as Thaddeus had been introduced to the hierarchical and erroneously meritocratic nature of portraiture early in his career, when his portraits were invariably of

30 Collier, 1906, p. 30. In the same section, Collier describes Whistler's sitters as 'ghosts of people; flat, with little modelling, and no substance … far removed from the frank vigour and absolute naturalness of the work of Velasquez.' Ibid.

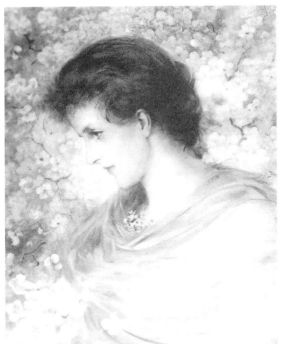

20 *A Spring Beauty*, 1885.
Oil on canvas 72 × 59.5.
Untraced.

influential and affluent men. Soon, when his attention was turned to portraits of women whose beauty, rather than achievement or position, was a matter of celebrity, the resulting pictures were, in most cases, profoundly different in appearance. They were, as a rule, lighter in tone, more delicate in technique, and more ethereal in character, typical cases being *A Spring Beauty* (fig. 20), *Blanche, Lady Howard de Walden* (fig. 21), his unashamedly twee *Princess Charming*, and his portrait of *Lady Alington*. Over a short period, Thaddeus lightened and softened his palette, and replaced the dark featureless background with a plain lightly coloured one, or in some cases, a detailed interior or exterior setting, as can be seen, for example, in his portraits of *Lily, Lady Elliot* (fig. 22) and *Princess Victoria Alexandra Olga Mary*. From the artist's point of view, they probably provided some light relief from the oppressive seriousness and sombre tone of his male portraits. It is also important to acknowledge that these works were, for the most part, intended to be hung in a domestic, rather than public, setting.

In truth, the sheer, deliberate 'prettiness' of most of Thaddeus' female portraits denied them the commanding presence that was accorded the men. If his male portraiture lacked psychological insight, some of his female sitters seem all but ciphers. In pictures like *Young Lady in a Fur-lined Coat, Lily, Lady Elliot* (fig. 22) and a *Woman in Black Coat and Bonnet*, in which emphasis seems to have been placed on beauty and fashion, even the artist's pursuit of a

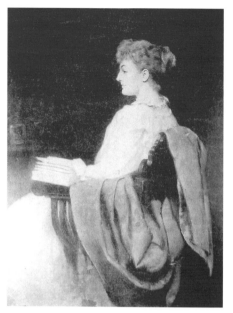

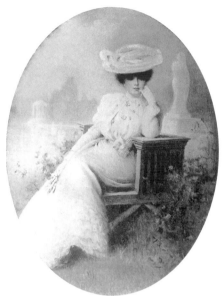

21 *Blanche, Lady Howard de Walden*, 1894. 22 *Lily, Lady Elliot*, 1897? Oil on canvas.
 Oil on canvas. Untraced. Untraced.

'likeness' appears somewhat less keen. Indeed, whereas the lack of specificity of
the 'likeness' in some of Whistler's female portraits allowed for more aesthetic
and intangible qualities, equivalent works by Thaddeus, like many by Frank
Dicksee (1853–1940) and James Tissot (1836–1902), are more akin to popular
fashion plates than records of an individual physiognomy.

Sometimes, the title marked the tone of the picture. With a work entitled,
Primroses – Portrait of Countess Bathurst (*c*.1895), for example, Thaddeus
continued a long-standing practice still popular in the nineteenth century. In the
middle decades of the century, a tendency re-emerged among British artists to
exhibit portraits under anonymous genre titles. This was motivated less by a
desire on the part of the sitters to avoid publicity, than by an appropriately
Victorian false-modesty. By assigning to the picture the sitter's name as well as
an evocative title, Thaddeus misappropriated that convention, or reduced the
portrait to the level of cloying, sentimental flattery.

Thaddeus' desire to emphasise the beauty and radiance of his sitter,
Countess Bathurst, was facilitated by his use of a formal device that certainly
owed more to modernist aesthetics than Thaddeus would have been inclined to
admit. He placed the picture in a white frame, a form of presentation that had
effectively developed in France, drawing on the influence of Pre-Raphaelite
painting and the cult of Japonisme. Among James McNeill Whistler's
numerous claims was that he, inspired by Japanese decoration, had been the first

to experiment in this way, designing his frames so that they and the paintings they held became an integrated whole. As early as the mid 1860s, Whistler was presenting his paintings at the Paris Salon and elsewhere in handmade, exclusive frames with simple ornamentation.[31] His interest in this area, however, coincided with a similar curiosity among certain members of the Impressionist circle. In the third Impressionist exhibition in 1877 (the first in which the contributors themselves adopted the title 'Impressionist'), both Degas and Pissarro presented paintings in white frames.[32] Pissarro, in fact, retained his predilection for integrated frames, and adapted them to the Divisionist technique he developed from the middle of the 1880s. Thaddeus' reticence regarding the influence of his contemporaries means that it is impossible to be sure from whom he borrowed, albeit briefly, the idea of painting frames. He may have been familiar with Pissarro's tendencies in France, but the likelihood is that he was responding to examples he had seen around him in England.

Whistler's frames were more decorative and sculptural than those designed by Degas and Pissarro appear to have been, but the fundamental principle of incorporating the frame into the picture 'effect' was common to all.[33] Moreover, Whistler was not even the only artist active in Britain to experiment with the framing of his pictures. Frederick Lord Leighton, Lawrence Alma-Tadema and others had used aedicular frames appropriate to the classical character of their paintings from the late 1870s onwards, while George Frederick Watts preferred distinctively foliated or geometrically decorated frames for his works in the 1860s and 1870s. Ultimately, it seems that Thaddeus' apparently single attempt at inventive framing was attributable not to the influence of any particular fellow artist, but to a more general, and widespread interest in framing in France and Britain in the last decades of the century.

Interestingly, just one critic of the 1877 Impressionist exhibition commented on the novel frames of Degas and Pissarro, perhaps because the frames were not considered as radical as the paintings they contained. The opposite may well have been true in Thaddeus' case, but when his painting of Countess Bathurst was exhibited at the RHA in 1896, it certainly caught the eye. Reactions to the overall effect were mixed. While *Freeman's Journal* described the frame as 'extremely trying', the critic from the *Irish Times* remarked that the picture 'is rich in primroses and primrose tints, and has a feeling and charm in the facial expression which all the other exhibits of Mr Thaddeus lack'.[34] Thaddeus himself may not have been so convinced by the picture, as it appears to have been the only work he exhibited in an integrated frame.

31 Whistler did not submit works to the Salon between 1867 and the 1880s. 32 R.R. Brettell, 1986, p. 198. 33 See A. McL. Young et al. 1980, pp. xvi–xvii. 34 *Freeman's Journal*, 2 March 1896, and *Irish Times*, 2 March 1896.

Echoes of Whistler's work are evident not just in the framing of the portrait of Countess Bathurst, but in the general aspect of the picture. Furthermore, Whistler's possible influence on Thaddeus is not evinced by that painting alone. Though mediated perhaps by the work of the more cautious followers of Whistler, an interest in the essential tonality and harmony of a composition characterises both *Primroses* and *A Spring Beauty*. Formally, and technically, both are in keeping with Thaddeus' conventional, 'beautifying' bias, but in terms of their limited but complementary range of colour and orchestrated modulation of tone, they are certainly reminiscent of Whistler's more 'fashionable' arrangements, such as *Symphony in Flesh Colour and Pink: Portrait of Mrs Frances Leyland* (1871–4: New York, Frick Collection) and *Harmony in White and Blue* (1870s; Leeds City Art Galleries). It is also worth remembering, though it may be purely coincidental, that in 1886 Whistler redecorated the rooms of the Suffolk Street Galleries, home to the Society of British Artists, in primrose yellow. He did so having recently been elected president of the Society, and in anticipation of a visit from the prince of Wales, but caused consternation among some of the society's more conservative members.

To see that Thaddeus could have followed an alternative, and more expressive, course in his portraits of women, one needs only to compare his portraiture with that of Lavery. Having produced some stilted, cloying portraits in the early 1880s, Lavery developed an unusual talent in painting female portraits, and was one of the most sought-after artists in Britain for such commissions by the turn of the century. A number of Thaddeus' works compare favourably with Lavery's, including *A Young Lady, Dressed in Brown – a Sketch*, a refined but unfinished picture of 1887 (fig. 23), which mirrors Lavery's *Girl in Black* of 1888. Furthermore, Thaddeus' *Young Lady in a Fur-lined coat,* (1891) anticipated much later works by Lavery such as the Whistlerian *Her First Communion* (1902) and even *The Lady in Black, Mrs Trevor* (1909). However, as Lavery from the early 1890s onwards proved himself increasingly innovative and spontaneous in his approach to portraiture, drawing on his knowledge of and admiration for the aesthetically-weighted work of Whistler and other modern techniques, Thaddeus became somewhat entrenched, varying his style little and relying on old models.

Thaddeus does not appear to have noticed himself being superseded at this stage. Of the five pictures that he chose to exhibit at the RHA in 1896, four were portraits of women.[35] The press in Ireland, however, were beginning to tire a little. The critic of the relatively conservative *Irish Daily Independent*, reviewing that Royal Hibernian Academy exhibition said that Thaddeus had

35 The fifth picture, *Water-seller Cairo – a study*, a presumably less finished piece, seems tokenistic in this context, as if placed there to assure the public that he was still producing subject pictures. The pictures were hung separately, but would have been easily visible.

'shown little ... that approaches originality' and that his pictures 'rather suggest drawings and colouring modelled on an older style of painting'. The reviewer did concede, however, that they were 'able works'.[36] *Freeman's Journal* deigned to suggest that Thaddeus' works were informed by old masters, commenting that the 'peculiarity about their treatment is that the artist has succeeded in giving to them a suggestion of their being quite ancient works'.[37] One can hardly imagine that this was Thaddeus' intention. By 1902, the infinitely more influential and professional magazine the *Studio* was asking its readership not to be 'too impatient with Mr Thaddeus' staring canvases'.[38]

In 1889, the *Art Journal* stated that 'no one paints children better than [Carolus-Duran]; he allows them mischief and fun, tender joy and juvenile revery'.[39] In his paintings of children in Brittany, Thaddeus managed to imbue his subjects with similar qualities, depicting them engaged in charming activities and interaction. However, he

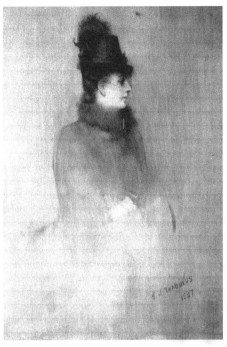

23 *A Young Lady, Dressed in Brown – a Sketch*, 1887. Oil on panel 29 × 21. Private collection.

found it difficult to transfer these qualities into his formal portraiture a short number of years later, and children who appear in his paintings, of whom there were several, often lack animation. In fact, they can appear little more than cherubic accessories. Thaddeus was manifestly not a painter of modern life, in that he was not preoccupied by contemporaneity and a desire to record the changing physical and social world around him. His portraits of children seem similarly detached from modernity, but also at odds with current academic, philosophical and psychological discussions that were becoming increasingly prevalent. Since the early decades of the nineteenth century, and particularly from the middle of the century onwards, significant and concerted efforts had been made to redefine the status of the child as an independent psychological being. Moreover, society began to acknowledge that, regardless of class, background, family circumstances etc., the child's sense of identity and perception of his or her environment were fundamentally different from those of an adult. As children were now seen as both complex and vulnerable, it was deemed

36 *Irish Daily Independent*, 2 March 1896. **37** *Freeman's Journal*, 2 March 1896. **38** *Studio*, vol. XXV, 1902, p. 209. **39** 'A Portrait', *Art Journal*, 1889, p. 318.

necessary to define their specific rights. While this new appreciation, disseminated through a plethora of publications, both academic and fictional, as well as newspaper articles and pamphlets, were not universally endorsed, they were compelling, altering the way children were viewed, and precipitating practical changes in social structures and the law. The position of children in the workforce, for example, child prostitution and the age of consent were among the concerns requiring new legislation. Thaddeus would have been aware of these developments, and indeed could count among his sitters W.T. Stead, chief protagonist in one the highest profile and significant court-cases relating to children and vice of the period. Stead, editor of the *Pall Mall Gazette*, published a series of four articles in July 1885 under the title 'The Maiden Tribute to Modern Babylon', which was an exposé of organized child prostitution in London. In order to demonstrate the scale of the problem, which previously had been expressed only in anecdotal form, Stead actually procured a child prostitute, informing her in advance of his motives. He was imprisoned for his actions, but his findings caused such a furore that the incumbent Conservative government was forced to address seriously the Criminal Law Amendment Bill, which dealt with the age of consent. The bill, which became known as 'Stead's Act', was passed the same year.

This interest in the individuality and vulnerability of the child was also expressed in the visual arts, taking disparate forms, from the naturalistic precision of paintings such as Bastien-Lepage's *A London Boot Black* (1882; Paris, Musée des Arts Décoratifs), and the documentary authenticity of James Lobley's *Ragged School Studies* (1859–80; Bradford Art Galleries and Museums), to the ostensible empiricism of photographs of boot-blacks and chimney-sweeps published by the philanthropist Thomas Barnardo.[40] At a different level, in formal portraiture, these new ideas were communicated through sophisticated compositions like John Singer Sargent's *The Daughters of Edward Darley Boit* (1882; Boston, Museum of Fine Arts), which subverted the conventional notion of the portrait-likeness.[41] While Thaddeus' early representations of children capture to some extent qualities that were distinctive to children, his equivalent formal portraits seem to adhere more closely to a principle applicable to eighteenth century child portraiture, based on the assumption that children were straightforward, uncomplicated individuals necessarily understood by adults.[42]

Portraits of children are not only commissioned and painted by adults, but are, by extension, conceived and composed by them as well.[43] This was as true of the late Victorian period as any other but, by then, children were, with increasing regularity and clarity, at least being recorded as individuals in their

40 For detailed examples of the representation and perception of the child in Victorian Britain, see L. Smith, 1998, pp. 95–110 and 111–31. 41 See E. Prettejohn, 1998, p. 23. 42 See M. Pointon, 1993, p. 177. 43 See J. Crossley, 1992, p. 31.

own right. Thaddeus' portraits of children, however, appear detached from this trend. The concept of adult negotiation is borne out graphically in his portrait of *Grand Duchess Olga Alexandrovna Romanov* (fig. 24), which presents a four year old child, sister of Tsar Nicholas II, in a manner deemed by her parents to be appropriate to her station, but provides little insight into the personality or psychology of the child herself. The stiff, contrived pose, fussy ornateness and strange scale of the composition, compounded by the bizarre costume, illustrate the authority the illustrious patrons, with whom Thaddeus had become acquainted in Florence some years earlier, exercised over him. When compared to most of his portraits of adults, the sumptuous setting of this portrait and the little girl's exaggerated costume seem to take precedence over her features. Interestingly, the denial of Grand Duchess Olga's personality is not the portrait's only calculated deceit. While Olga and her

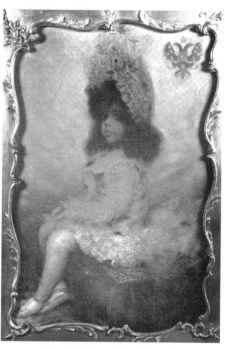

24 *Grand Duchess Olga Alexandrovna Romanov, aged four*, 1886. Oil on canvas 91.4 × 60.9. Untraced.

siblings did not have to endure the severely regimented upbringing experienced by Romanov children of previous generations, and grew up in opulent surroundings, their lifestyle at home was often little short of Spartan, as their father, Alexander III, saw no value in domestic extravagance. He was known, for instance, to have worn his clothes until they were threadbare, and to have insisted on strict economies regarding food, heating and light.[44] Thaddeus' portrait of Olga thus corresponds with and celebrates the public image of the Romanov family, rather than the individuality and everyday experience of the duchess.

Thaddeus might have benefited from looking more closely at the child portraiture of Velásquez, as Sargent, Whistler and others had done. Portraits by the Spanish master such as *Baltasar Carlos as a Hunter* (Madrid, Museo del Prado) and the seminal *Las Meninas* (Madrid, Museo del Prado) assumed a new currency and relevance in *fin de siècle* portraiture throughout Europe, which might equally have inspired Thaddeus, had he been more consciously open to such influence.

44 V. Cowles, 1971, pp. 221–8.

Portraying parents and children together, and the interaction between them, often afforded artists the opportunity to animate their young sitters. In the late autumn of 1886, Thaddeus spent a month at Aske, Lord Zetland's country seat in Yorkshire, where he painted a portrait of Lady Zetland and her youngest son George Dundas. It is a large portrait, one of few full-length works of its kind by the artist, with which he set out to communicate the fondness of the relationship between mother and son. Lady Zetland pauses while reading to listen to her young son, who points inquisitively to a bronze of a horse on a table beside him. The suggestion of human interaction distinguishes this work among Thaddeus' *oeuvre*, and introduces a dimension to his portraiture that other works lack. However, notwithstanding the fact that portraiture is fundamentally and necessarily artificial and contrived, one has to concede that Thaddeus again does not escape the formality that defines his portraiture. The figure of Lady Zetland, pale and ethereal, slightly out of focus, and in profile, replicates many others among his female sitters. Thaddeus was not indifferent to Lady Zetland's character, describing her warmly as 'a most patient, sympathetic sitter, and a perfect hostess'.[45] He said nothing in his *Recollections*, however, about her son, George, and the diminutive figure in the portrait, who stands with rouged cheeks and elfin features, is only slightly more informative.

There is limited variety in Thaddeus' figures' poses, and in some cases, he repeated them without any adjustment at all. The doll-like *Lily, Lady Eliot*, for example (fig. 22) assumes exactly the same pose as Eva Thaddeus had done in her husband's portrait of a few years earlier, now known only from an illustration in the *New York Herald*. The pose that Eva adopts is more suited to single than group portraits, as in the earlier work, it prevents any interaction between mother and son. In fact, Eva, sitting imperiously, seems strangely oblivious to her child, who clings nervously to her dress.

The portrait of Eva and Frederick Francis was moderately well received by the press when it appeared in the RHA exhibition of 1896. Both the *Irish Daily Independent* and the *Irish Times* remarked on the picture's technical qualities (the drapery and the flesh tones), rather than the artist's success in recording character or capturing expression.[46] In fact, the *Irish Times* critic noted that Thaddeus' portrait of his wife was 'expressionless, a fault which mars at least two of his other paintings'.[47] Moreover, the critic proceeded to comment that the 'chubby faced child at his mother's knee lends a good deal of effect to the whole', illustrating the extent to which children could appear almost decorative in Thaddeus' portraits.[48] The subordination of the child in Thaddeus' double portraits is consistent with the rather sentimental elevation of the 'mother

45 H.J. Thaddeus, 1912, p. 153. 46 *Irish Daily Independent*, 2 March 1896 and *Irish Times*, 2 March 1896. 47 *Irish Times*, 2 March 1896. 48 Ibid.

figure' by various Victorian observers, writers and artists, which Thaddeus, or more likely his sitters themselves, wished to emulate.

In one case at least, Thaddeus appears to have employed an alternative device in an attempt to animate a young sitter. Sentimental narratives had distinguished Victorian subject painting for decades, and had already featured in some of Thaddeus' Breton works. In his portrait of *Master Harold Maxwell*, exhibited at the RHA in 1901, he attempted to work it into formal portraiture. In the picture, now untraced, a mischievous little boy who had been playing truant, stood awaiting reprimand, his knees bruised and cut. At his feet lay his spelling-book, which calls to mind Thaddeus' Breton picture of truants, *On the Beach* (pl. 6). What the picture gained in narrative strength, however, the *Irish Times* felt it lost in the fundamental aspects of expression. In the reviewer's opinion, the absence of any traces of sorrow or anger on the child's face made the picture 'hardly a consistent work'.[49]

Little substantive evidence is available regarding the prices that Thaddeus was willing to charge per commission, but what is known confirms that his work was far from cheap. In his *Recollections*, he claimed that he charged the Reform Club five hundred guineas for his portrait of Gladstone, a full one hundred guineas more than the Club had agreed to pay Frank Holl for the original commission. The catalogues of the RHA record the prices of those works which were on sale, although these figures are somewhat misleading, as they do not represent actual transactions or negotiations between patron and artist. However, it is clear from these that Thaddeus was certainly not averse to asking very substantial amounts for his work. More specifically, at the RHA and elsewhere, he consistently charged, or quoted, higher prices than his contemporaries, which gives some indication of how he viewed himself among them. At the Irish Exhibition in Olympia in 1888, for example, he was by far the most expensive artist on show, asking £500 for his portrait of Leo XIII, and £800 for the portrait of Father Anderledy. At the RHA in 1901, his *Obbedienza* was priced at £1000, not exorbitant by the standards of the most expensive portraitists, such as Leighton, but considerable nonetheless.

Letters now in the National Library of New South Wales in Sydney provide the most reliable evidence of Thaddeus' actual practice and prices, and offer an invaluable insight into the tenacity and shrewdness with which he sought out work. His own account of his visit to Australia suggested that his motivations were fundamentally professional, though a visit to the east coast of America about two years later and his departure to California in 1907 might signify that he was visiting the Antipodes to investigate the possibility of emigrating there. Whatever the specific circumstances were, he certainly had no intention of just sightseeing.

49 *Irish Times,* 11 March 1901.

Thaddeus travelled to Australia in October 1901, bearing, predictably, letters of introduction to 'Australians of note', British diplomats and the like.[50] He infiltrated gentleman's clubs in Sydney, including the Athenaeum Club, and the Union Club, the members of which, he observed, constituted 'the aristocratic class of New South Wales'.[51] He presented himself to Cardinal Moran of Sydney, with whom he established an instant rapport and became well-acquainted with Edward O'Sullivan, minister for Public Works, to whom he wrote on his journey home aboard the SS *India*, thanking him for his hospitality and looking forward 'some day in England to the pleasure of returning your kindness'.[52] Thaddeus painted a portrait of O'Sullivan, capturing in an otherwise rather drab, but stylistically typical, picture the 'strong pugnacious type of countenance' that he ascribed to him in the *Recollections*.[53] Around the same time, he also painted a portrait of Sir Edmund Barton, premier of New South Wales (and later Australia's first Prime Minister), and in letters to him, which dealt ostensibly with the completion of the portrait, blatantly solicited for more work.

In January, Thaddeus reminded Barton of a conversation they had had regarding the possibility of painting a portrait of Lord Hopetoun for the Federal Parliament House. He attributed his urgency to his obligation to return to London for the Coronation (of Edward VII and Queen Alexandra, which was originally scheduled to take place on the 26 June 1902, but was postponed till August due to the king's illness), but expressed his confidence to Barton that the governor general 'will be pleased to be perpetuated by me'.[54] His tenacity did not end there, however, and in a move of extraordinary audacity, he offered, conditionally, to present Mrs Barton with a half-length portrait of her husband, 'if the honour of painting [Hopetoun] is conferred upon me'.[55] Barton was pursued by Thaddeus on this issue, and on a subsequent meeting, offered to lay the matter before the cabinet as soon as it was convenient. The half-length portrait of Barton appears to have been nothing more than a ruse, as the sitter had not commissioned it, and when it became probable that Barton could not secure for him the Hopetoun commission, Thaddeus proved disinclined to finish it.[56] Before Barton could do anything about the portrait of Hopetoun, Thaddeus had returned to England.

In the course of his letters to Barton, Thaddeus outlined his rates. When first investigating the possibility of painting Hopetoun, he stated that his

50 H.J. Thaddeus, 1912, p. 278. **51** Ibid., p. 280, and H.J. Thaddeus, Letter to Edmund Barton, January 1902, Papers of Edmund Barton, SLNSW. **52** H.J. Thaddeus, Letter to Edward O'Sullivan, 9 March 1902, Papers of Edward William O'Sullivan, SLNSW, ML MSS 234/2. **53** H.J. Thaddeus, 1912, p. 284. **54** H.J. Thaddeus, Letter to Edmund Barton, January 1902, Papers of Edmund Barton, SLNSW, ML MSS 249/4. **55** Ibid. **56** Note written by Sir Edmund Barton, 3 February 1902, SLNSW, ML MSS 249/4. Barton invited Thaddeus to bring his materials to his residence to finish the portrait, but the artist turned up without them, and simply made pencil sketches instead.

'London terms for a full-length portrait are Eight Hundred Guineas'.[57] These compare with John Singer Sargent's fees for a full-length portrait, which he raised to one thousand guineas in the late 1890s. They were also, however, presumably higher than Barton could even entertain, as in a memo written by him (on one of Thaddeus' letters) he recorded that he had met Thaddeus on 1 February, 'who said he would gladly paint Mr Hopetoun's portrait for £500'.[58] This price may have been for a half-length or head-and-shoulders portrait, rather than full-length, but was a considerable amount nonetheless.

Once established, and regardless of the popularity of his work at any one time, Thaddeus enjoyed a lifestyle appropriate to a society portraitist. His private life was not devoid of drama, however, and various episodes threatened his profession. On 2 November 1893, in less than ideal circumstances, Harry married in London. His wife, Mary Evelina Julia Grimshaw Woodward (1863–1946), known as Eva, came from a highly respectable family from the north of Ireland. She was the daughter of Thomas Woodward (1814–75), dean of County Down and a respected scholar, granddaughter of the Rev. H. Woodward, rector of Fethard and Cashel, and great-granddaughter of the bishop of Cloyne.[59] She probably grew up and was educated in England, and an early photograph shows that she spent time in India in her youth (fig. 25). She certainly went to India at some point with her friend Lady Violet Greville, and stayed 'for more than a year as a guest of Lord Roberts', possibly Lord Frederick Sleigh Roberts of Kandahar, Pretoria and Waterford.[60] Eva was just thirty years old when she married Harry in the Register Office at Hanover Square in London, but was already divorced, having been married to a William Howard Murphy Grimshaw, a fellow Etonian of Eva's brother Walter, and with whom she had had three daughters.[61] She and Harry were introduced to one another at a party hosted by Lady Greville, an accomplished novelist, and daughter of the fourth duke of Montrose, who subsequently appeared as witness at the wedding (the other witness was an E. Boorey), and became godmother to the couple's son Victor.[62] In 1893, Lady Greville was writing a miscellaneous article for the *Graphic* entitled 'Place aux Dames'. It is not known what year this first meeting between Harry and Eva took place, but it would appear that Eva was still married when they became involved. Victor Thaddeus understood that he had been born in January 1896 until, in the course of applying for an American

57 H.J. Thaddeus, Letter to Edmund Barton, January 1902, Papers of Edmund Barton, SLNSW, ML MSS 249/4. 58 Note written by Sir Edmund Barton, 3 February 1902, SLNSW, ML MSS 249/4. 59 Thomas Woodward, a Scholar of Trinity College Dublin, received a BA in 1837 and MA in 1849. He published widely on ecclesiastical issues. F. Boase, 1892–1921. 60 Victor Thaddeus, op. cit., 30 March 1943. 61 Marriage Certificate, 2 November 1893, Public Record Office, London. 62 Patrick Thaddeus, Letter to the author, 28 May 1997.

25 Eva Thaddeus as a Young Woman in India, *c*.1883.

army pension in the 1950s, he discovered that he had in fact been born a year earlier. His ignorance of his genuine birth date was probably the result of deliberate obfuscation on the part of his parents, who wished to conceal the fact that he was born less than two years after their wedding, his brother having been born in between. Eva's family was wealthy, and she may well have had considerable assets of her own. At the time of her marriage, she was living at No. 38 Montpelier Square, Knightsbridge, a very fashionable address in London, and seems to have moved in appropriately grand social circles. Both in terms of personality and background, she and Harry made an unlikely pairing. In the words of Victor Thaddeus, Eva, who had grown up 'in an atmosphere of culture and good taste', was 'somewhat prim and Victorian by temperament',

while Harry 'was endowed with more than his share of animal spirits'.[63] She was of delicate constitution, talented in drawing and writing, and musical.[64] He was ebullient, opinionated and vocal, with a renowned appetite for food and wine.

Eva's family vehemently opposed her liaison with Harry, and ultimately, not only disinherited, but disowned her.[65] She almost certainly never saw her daughters again after her second marriage.[66] They were, in any case, very bitter about her departure. Their father remarried and took to drink. Somehow, however, rejection by her family did not reduce Eva to penury. On the contrary, she maintained her high standard of living and, to a lesser extent, her social position, which suggests strongly that she was paid a stipend by her family to keep her distance. Victor Thaddeus claimed that his mother 'had her own income, so did not have to worry about money. But she was prudent, and an excellent housekeeper, and possessed of none of the vaulting ambition to amass enormous wealth which made [Harry] the victim of every promoter'.[67] Eva and Harry's social groups obviously overlapped and included many of London's *jeunesse dorée*. For example, both knew Henry Savage Landor, the explorer who had been a pupil of Thaddeus in Florence. He had become infatuated with Eva's friend Fanny Lucy 'Poppy' Radmall (later Lady Houston), and was devastated when she turned down his proposal of marriage.[68] Lady Greville also knew Landor, and mentioned him in an article in the *Graphic* in December 1893. After their marriage, Eva and Harry hosted dinners at home for a variety of high-profile individuals, but there is no record of how many were aware that she had been married previously. She may well have dealt with public disapproval better because of the experience of 'Poppy' Radmall (Lady Houston), who had lived with the married millionaire brewer Fred Gretton in Paris for seven or eight years, despite the consternation that their relationship caused. It is almost certain that Eva's recent history, which would have been deemed shameful and unacceptable by many in polite society, had enormous repercussions on both her and Harry's lives over subsequent years.

It is not known how fond Eva and Harry's marriage proved. Both valued good manners and propriety, were well travelled and sociable, but also, as far as one can tell, tended to lead independent lives much of the time. Eva was mentioned just twice in *Recollections*, and even then just once in transcribed letters from the grand duke of Mecklenburg-Schwerin, congratulating her and Harry on the birth of their children, and again obliquely as Thaddeus' 'better half'.[69]

63 Victor Thaddeus, op. cit., 17 March 1943. 64 Victor Thaddeus, op. cit., 30 March 1943.
65 Anne de Lagarenne, Letter to the author, 9 July 1997. Anne de Lagarenne is the grand-daughter of Eva's sister, Grace d'Orgeval, the only member of the family to maintain contact with her. 66 De Lagarenne, Letter to the author, 11 August 1997. 67 Victor Thaddeus, op. cit., 17 March 1943. 68 Eve [Eva Thaddeus], 'My greatest friend – by the writer of "Eve in Paris"', *Saturday Review*, vol. 163, 9 January 1937, p. 43. 69 H.J. Thaddeus, 1912,

It was, admittedly, relatively common in chauvinistic society for men of note not to mention their wives at length in their writings, but Thaddeus may have neglected Eva in *Recollections* because of the disapproval with which his marriage had been met, and the negative influence that this probably had on his career subsequently. Eva was, presumably, involved directly in Thaddeus' professional practice. Typically, he would have been required to entertain not just actual clients at his home, but also prospective patrons, and Eva, though quite severe in countenance, was no doubt adept at hosting such formalities. In truth, her position among the upper echelons of British society was more 'valid' than her husband's, and she could count members of high society among her own friends long before she met her relatively *arriviste* husband.

Significantly, with the exception of a house and studio in Cairo, Thaddeus never owned his own property, but from the very beginning of his career, sought out impressive residences. This was by no means incidental, and had as much to do with professionalism and self-promotion as it did with personal taste and a desire for comfort. A good address inspired confidence in an artist's sitters, as it gave the impression that that artist was well-established, solvent and in demand. The importance of image and circumstance had been identified by portraitists many generations earlier (from van Dyck onwards), especially Reynolds, who, in Marcia Pointon's words 'clearly understood the principle of investment in order to gain profits and the need to look fine to attract the most prestigious clients'.[70] Thaddeus never managed to build an edifice of his own, as Millais or Holl had done, to serve as a monument to his success, but his rented accommodation and/or studios were always of the highest order. From Clareville Grove, South Kensington, where he had lived for about three years following his return from Italy, he moved to No. 44a, Maddox Street, Hanover Square, an apartment building (now destroyed) mid-way between Bond Street and Regent Street in London's West End. Like Clareville Grove, Maddox Steet was a popular location for artist's studios and residences, and had been since the eighteenth century. Other addresses of note on Hanover Square were the Dickinsons' art school, the Hanover Square Arts Club, founded in 1863 by Arthur Lewis, and No. 29, Maddox Street, a house and studio purpose built in 1889, with a commercial gallery at street level.[71] At the time of his marriage in 1893, Thaddeus' address was No. 19, Bury Street, St James's, in an area in Piccadilly also strongly associated with artists, and shortly afterwards, in 1894, Harry and Eva moved to No. 6, William Street, Albert Gate, in Knightsbridge. Captain Augustus Savile Lumley had bought that building, and the large one adjacent to it, which had been a school of anatomy, in 1872, and converted them into studio-flats and a painting-room for himself. This highly convenient

p. 179. **70** M. Pointon, 'Portrait painting as a business enterprise in London in the 1780s', *Art History*, vol. 7, no. 2, June 1984, p. 193. **71** Walkley, op. cit., 1994, pp. 9, 23, 194, 196n.

address was ideal for portrait pain-
ters, and among the early tenants
were Lumley's friends William
Orchardson, Leslie Ward and John
Collier.[72] From there, Harry and Eva
transferred to Whitehall Court,
where they seem to have lived for a
number of years. Their first child,
Frederick Francis ('Freddy') was
born in January 1894, in Egypt, and
their second, Victor, a year later in
Whitehall, London. By August 1900,
the family had moved to No. 59

26 Rossetti Studios, Rossetti Gardens, Chelsea.

Drayton Gardens, a handsome apartment building on a leafy street in
Kensington, and in July 1902, Thaddeus was a tenant at Rossetti Studios
(Rossetti Gardens), Flood Street, Chelsea (fig. 26). Built in 1890, these studios
were not occupied until 1896, and it is not clear if this was simply Thaddeus'
work address or also his private residence. Other occupants included the
illustrator W. Maud, R. Brough, Augustus John and, from 1903 to 1906,
Thaddeus' fellow Irishman William Orpen.[73]

Overall, the 1890s was a decade of contradictions in Thaddeus' life. He
married, became a father, continued travelling, became official court painter to
the khedive of Egypt, remained visible in high society, and enjoyed all the
trappings of comfort and security. In December 1894, he was elected a Fellow
of the Royal Geographical Society, enhancing his reputation as an experienced
traveller. His candidature had been recommended by his old friend Henry
Savage Landor (who himself had only become a Fellow in January 1893), and
Lord Mayo (Dermot Robert Wyndham Bourke).[74] Appearances were deceptive,
however, as Thaddeus' resolve was continually tested. He continued to exhibit,
predominantly at the RHA, but his works elicited less enthusiastic responses
from the press as the decade progressed. In the space of five years, he was also
defeated in two damaging court cases. Though both relate ostensibly to his
artistic integrity, they actually point to financial difficulties that appear to have
plagued him for years.

The first case took place in December 1890, and was reported on at
surprising length in *The Times*. In this instance, the accomplished mezzotint
engraver Frank Sternberg (1858–1924) took an action against Thaddeus for
reneging on a financial agreement relating to the production of a print after

72 Ibid., p. 143. **73** Ibid., p. 237. **74** Certificate of Candidate for Election, Royal
Geographical Society. On the certificate, it is recorded that Thaddeus was 'Painter to H.H.
The Khedive of Egypt' and that 'He has travelled in Algeria, Morocco and Egypt'.

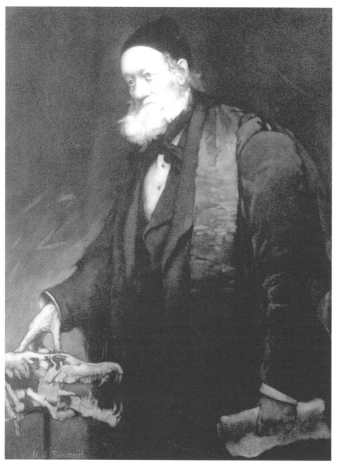

27 *Sir Richard Owen*, 1891. Mezzotint (after oil painting of 1889). Wellcome Trust.

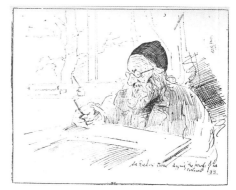

28 *Sir Richard Owen Signing the Proofs of his Portrait*, 1891. Pen and ink on paper. Untraced.

Thaddeus' portrait of Sir Richard Owen (fig. 27 & 28).[75] The artist had enlisted Sternberg at the beginning of the year to produce a plate for a price not exceeding £120. Sternberg, who had done work to Thaddeus' satisfaction before, executing an engraving after his portrait of Gladstone, undertook the commission, but received a total of just £21, in two instalments, as the artist maintained that the plate was not faithful to the original painting. Sternberg was willing to make any changes required, but Thaddeus claimed that he had lost confidence and interest in the project, and had not received important correspondence from Sternberg because he had been away in the north of England from August to November.[76] Thaddeus' defence certainly sounds flimsy, but he was still able to invoke the testimony of an esteemed witness, Frederick Lord Leighton, president of the Royal Academy, and one of the foremost personalities of the British art world. Thaddeus' counsel also called on the artist Rudolf Lehman and the engraver and print-seller Thomas McLean to testify in his defence. Their presence did not secure victory, however, and the jury almost immediately returned a verdict for the plaintiff.

Under cross-examination, Thaddeus had made much of his reliance on portrait painting for his living and of the likelihood that Sternberg's flawed work would have 'injured his reputation', but it seems more plausible that he was unable to pay his costs.[77] Alternatively, it may be that Thaddeus demurred because he felt that his new found proficiency in engraving obviated the need to avail of Sternberg's skills. In his trial, Thaddeus said that he had intended to publish the engraving, and it did appear in W.T. Stead's *Portraits and autographs: an album for the people*, in 1891. However, the engraving reproduced in Stead's book was almost certainly Thaddeus' own. In January 1891, the artist travelled again to Sir Richard Owen's residence, Sheen Lodge, Richmond Park, where the aged sitter signed proofs of Thaddeus' own mezzotint. Thaddeus even recorded the event in a sketch (fig. 28), which he submitted to a contemporary journal. The accompanying text, in which Thaddeus was described as 'the volatile artist', reported that Owen signed the first ten proofs of Thaddeus' print, and that only a further forty were issued.[78] The prints were available only from the artist himself, who was contactable at 11, Grand Avenue, Brighton.

Four years later, in May 1895, Thaddeus was back in court, this time as plaintiff. His action was against his landlord, Mr Annan, whom he held responsible for damage caused to some important preparatory drawings that he had left on a chair in his drawing room. He claimed that water had fallen on to them from the flat above, having travelled down the electric light fitting, and that this was attributable to his landlord's negligence. Westminster County Court had already found against Thaddeus, but he had fought to have the case

75 R.K. Engen, 1979, p. 190. **76** *The Times*, 2 December 1890. **77** Ibid. **78** Information courtesy of the Wellcome Trust, London.

brought before the court of appeal. It was a costly error, and the case was dismissed. Cruelly, both decisions were overseen by the same judge. Thaddeus' sole consolation, perhaps, would have come from seeing himself referred to in the report in *The Times* as 'the eminent portrait painter'.[79]

The following year, perhaps in an attempt to reestablish his status, as an Irish painter at any rate, and boost his own flagging confidence, Thaddeus presented to the Crawford School of Art a 'gold palette' which was to be included among the Special Local Prizes distributed in January to outstanding students.[80] The award, which was to be known as the 'Thaddeus Gold Medal', was to go to the artist who produced the 'Best study of a Head from Life shaded in Chalk', recalling the discipline in which Thaddeus himself had excelled at the school.[81] Indeed, Thaddeus' sensitive head and shoulders study in watercolour of an old peasant of 1894 demonstrates that his skill in this area had not diminished at all (pl. 20). In practice, circumstances seem to have overtaken him, however, and the Thaddeus Gold Medal was presented just once, in January 1898, to Miss Minnie Nagle.[82]

Ultimately, legal setbacks, combined with a presumably extremely high cost of living, probable mismanagement of funds, arguable overpricing of his work, and decline in patronage, almost forced Thaddeus into bankruptcy. On 22 January 1898, his name appeared in *The Times* among the 'Adjudications' under the Bankruptcy Acts.[83] Fortunately, he seems to have avoided bankruptcy itself, as his name was not listed later among those receiving orders. The threat must have dealt him a tremendous blow, not that one could tell from his actions. On 24 November, he opened an account with Coutts & Co. in London.[84] This would certainly indicate that in a short period, his financial situation had improved radically. Life as a professional artist was, of course, precarious at the best of times, and Thaddeus' financial difficulties might simply have been attributable to a delay in settlement from a number of clients.

Thaddeus did not exhibit as regularly and widely as might have been advisable for a portrait painter who needed to keep his name in the market place. He relied heavily on Irish exhibitions, and occasional showings at the Walker Gallery in Liverpool (1889 and 1890), the Society of British Artists (spring 1882, winter 1885/6), the Royal Scottish Academy (1883) and the Grosvenor Gallery (1884, 1887 and 1889).

Of the English establishments, Thaddeus could perhaps have exploited the Grosvenor Gallery to best effect, as from the beginning, it had welcomed

79 *The Times*, 1 May 1895. 80 Crawford Minute Books, 3 November 1896, Crawford Municipal Art Gallery. 81 Ibid., 31 January 1898. 82 Ibid., 28 February 1898. 83 Thaddeus is listed as 'Thaddeus, Harry Jones, Kensington-gate and Palace-gate, Kensington, W., late Whitehall-court, S.W., artist', *The Times*, 22 January 1898. 84 Coutts & Co., Letter to Patrick Thaddeus, 17 December 1997.

portrait painters. Portraits in a wide variety of styles and media, by emerging and renowned artists alike, were consistently afforded wall space there. Indeed, Blanche Lindsay herself, wife of the Grosvenor's founder and proprietor, Sir Coutts Lindsay, and a former student at Heatherley's, exhibited portraiture there.[85] Thaddeus showed just five works, at least four of which were portraits. The Grosvenor challenged the hegemony of the Royal Academy, which alone would have attracted Thaddeus, and some of the greatest artists of the period, including Burne-Jones, George Frederick Watts, and Leighton, were regularly invited to exhibit. Many artists continued to exhibit simultaneously at the Royal Academy, thus enjoying the kudos of the newer gallery and the respectability of the older. Thaddeus showed at the Grosvenor just three times, in 1884 (the same year as his second and last showing at the Royal Academy), 1887 and 1889 (the year after his portrait of Gladstone was rejected by the Academy, much to his chagrin). Unfortunately for him, the Grosvenor's last exhibition took place in 1890, removing the possibility of securing himself a position among its regular set, while not having to distance himself entirely from the establishment.

Having said that, it is conceivable that Thaddeus was simply too close to the establishment ever to have identified himself artistically with the cosmopolitan and more progressive circles of the Grosvenor. Among the artists to have exhibited there regularly and become associated with the gallery was Whistler, who was not only one of the most influential painters of the second half of the nineteenth century in Britain, but also one of its best known personalities.[86] He featured in the memoirs of a myriad of artists and writers, most of whom acknowledged his influence and proclaimed his genius. Thaddeus, in contrast, had time for neither Whistler's personality nor, one presumes, his theories on painting, but his work certainly suggests a debt to the American. The two artists appear to have exhibited together at the Society of British Artists in 1885.

It is significant when comparing Thaddeus' career with that of Lavery that the former had little public regard for Whistler. While Lavery elevated Whistler almost to the status of a *non-pareil* in artistic circles, Thaddeus assumed the role of the iconoclast, although one can only speculate about the extent to which his personal reservations about the American influenced his evaluation of his painting. Where others would have been in awe on meeting Whistler, Thaddeus appears to have gone out his way to antagonise him. He was introduced to Whistler first in the autumn of 1886 by the Australian painter and etcher Mortimer Menpes. Menpes was hosting a dinner party for Whistler, of whom

85 For a comprehensive analysis of the Grosvenor Gallery, see C. Newall, Cambridge, 1995, and S.P. Casteras and C. Denney, *The Grosvenor Gallery – a palace of art in Victorian England*, New Haven and London 1996. **86** Whistler also became president of the Society of British Artists, and it was during his tenure that the institution had the right to place Royal as a prefix to their title conferred upon it by Queen Victoria. D. Brook-Hart, 1975.

he was a long-suffering acolyte, and invited Thaddeus to attend. There, Thaddeus quickly fell foul of the superciliousness in Whistler that one of his many observers claimed 'from a pose, had become a habit'.[87] That said, Thaddeus was hardly well disposed towards the American even before meeting him at Menpes' party, describing himself as 'the only Philistine present; all the others worshipped at the shrine of the "White Lock"'.[88] He proceeded, rather churlishly, to relate how their differences originated from comments made by Whistler about the genius of Velásquez (with which Thaddeus would probably have been, under normal circumstances, happy to concur). Thaddeus dared to suggest that Velásquez' one weakness was perhaps in his ability to paint horses and dogs, 'the former being ... of the wooden rocking-horse variety, and the latter made of the same material', and a heated exchange ensued. Thaddeus' account was comical in its puerility. He explained that he suggested to Whistler that Landseer excelled Velásquez as a painter of animals but 'had scarcely uttered the words before [he] realised the wickedness, the almost blasphemy, of any reflection on the great departed one; above all in the actual presence of his representative on earth'.[89] The argument was abruptly ended when Thaddeus, reacting to Whistler's theatrical gesticulations, drew him on to his knee, and playfully ruffled his hair. The story might seem rather frivolous and implausible were it not for the fact that Whistler's neurosis concerning his grooming, and that single lock of white hair that he was always at such pains to set correctly, was well known.[90] Furthermore, Thaddeus' reference to Velásquez was anything but incidental. As outlined above, Velásquez occupied a singularly important place in the interests and affections of late-nineteenth-century artists in Britain and elsewhere, none more so than Whistler himself. Thaddeus' criticism of Velásquez would have amounted, therefore, to little less that sacrilege, but can be seen as a thinly veiled attempt by Thaddeus at declaring, however erroneously, his artistic or creative independence. The episode provided Thaddeus with an ideal opportunity to malign Whistler, and to dispel, albeit to a limited extent, the myth that surrounded the American. It is amusing that Thaddeus, well known for the care he took in his own personal appearance, should treat with such disdain Whistler's supposed narcissism.

Subsequent meetings between the two artists were, if one is to believe Thaddeus' account, no more harmonious. Their next encounter occurred at the offices of Sir George Lewis, the solicitor, where both had business with the proprietor. Thaddeus claimed that Whistler was seeking public redress for a reference made to him as a 'drawing master', in the Colin Campbell trial of November and December 1886, while Thaddeus had 'some trouble of my own'.[91] He maintained that on that occasion, Whistler snubbed his warmest

87 J. Hawthorne, 1928, p. 160. 88 H.J. Thaddeus, 1912, p. 146. 89 Ibid., p. 147. 90 See, for example, M. Menpes, 1904, pp. 33–5. 91 H.J. Thaddeus, 1912, pp. 149–50.

greetings. This merely increased the enmity, but Thaddeus felt that he evened the score when they next met, at Hampton Court, where he used his adversary's 'insatiable love for flattery' against him by speaking aloud of his work with hyperbolic admiration to a companion, while Whistler, coincidentally in the galleries at the time, was within earshot. When Whistler turned to see who was responsible for such adulation, and recognised Thaddeus, he gave him 'a look so charged with concentrated venom and hatred', that Thaddeus thought it 'a miracle I survived its scathing, blighting influence'.[92] These anecdotes are trivial and uncorroborated, but indicate that Thaddeus, the pragmatist, was still prone to petty professional jealousies. Thaddeus dedicated seven pages of his *Recollections* to the description of squabbles that Whistler may not even have remembered. If Whistler was familiar with Thaddeus' work, the chances are that he did not admire it. Arthur Symons quoted Whistler, always conscious of the artifice of painting, as saying of portraiture that 'the frame is … the window through which the painter looks at his model, and nothing could be more offensively inartistic than [the] brutal attempt to thrust the model on the hither side of this window'.[93] Such charges could easily have been levelled at Thaddeus, particularly in the context of his male portraiture.

The ridicule Thaddeus directed at Mortimer Menpes' supposed devotion to Whistler could conceivably have extended to Lavery, who held Whistler in similar regard, and might help to explain Thaddeus' neglect of his compatriot in his writing. They must have known of each other, and most probably met in London during the 1880s or 1890s. Their careers followed a very similar course in their youth, but Lavery's really blossomed after the turn of the century, as Thaddeus' began to decline rather prematurely. Thaddeus had become an exponent of an old style of portraiture, one that was being swiftly overtaken by the more immediate, fleeting works of some of his pioneering contemporaries, like Sargent, Furse, Lavery and Shannon. The meticulous pursuit of naturalism and an accurate likeness made way for a style of portraiture that was committed to form and effect. Apart from the occasional borrowed element, Thaddeus was never likely to be enticed by the likes of Whistler's aestheticism, which, it has been aptly stated 'diminished the importance of the sitter and exalted the aspirations of the artist'.[94] The stolid characters of many of Thaddeus' male portraits were superseded by animated, almost distractible ones. By the end of the century, the apparent speed with which many painters worked represented a characteristic modern development, but though Thaddeus' speed of draughtsmanship was admired during his career, few of his pictures, portraits or otherwise, suggest anything other than a carefully paced, arduous and systematic approach to the task.[95]

92 Ibid., p. 152. 93 A. Symons, 1906, p. 141. 94 Simon, 1987, p. 55. 95 See McConkey, 1991, p. 360.

To Whistler and his followers, oriental prints suggested new possibilities for old art-forms, but for those artists who did not see the need for reinterpretation, they had limited relevance. Thaddeus was fascinated by the Orient (albeit the Near East) but does not appear to have been receptive to the influence of its art. Whistler, in contrast, borrowed deliberately and unashamedly from Oriental art, particularly in the formal simplification of his figures and compositions, and the use of decorative frames. His belief in the equal importance of each part of a composition and his suspicion of the traditionally paramount importance of physiognomic likeness in portraiture were adopted by Thaddeus' fellow Irish artists Lavery and Orpen.[96] Occasionally, Thaddeus introduced arrangements of flowers, decorative patterns, and even a painted frame, which were at least nominally aesthetic, but he never subscribed to a strict, articulated, artistic philosophy.

96 Newall, 1991, p. 340.

An 'old grah' – Thaddeus and Ireland

Thaddeus' career as a portrait painter took him to five continents. He mixed with potentates, royalty, literati, and leading figures in the political and ecclesiastical world, but made genuine and regular efforts to stay in contact with Cork. Moreover, he maintained an interest in broader Irish affairs, and in 1889, in the most dramatic fashion, turned his attention to the plight of the rural Irish peasant. His large painting, *An Irish Eviction – Co. Galway*, is arguably the most powerful socio-political image of Ireland of the nineteenth century (pl. 22). Addressing a theme that was unpopular, neglected, and generally unmarketable, it is a truly remarkable work, an emotive scene of a sadly familiar episode of the Land War in Ireland, which had prevailed throughout the 1880s. The painting is not simply the romantic reflection of an expatriate, but rather an important visual record, closely observed and carefully composed by an artist with a sincere and sustained interest in his native country.

An *Irish Eviction* represented a mature return to a subject that had first captured Thaddeus' attention when he was a student in Cork. The theme of his second successful painting at the RDS, in 1880, *Renewal of the Lease Refused*, had been drawn directly from the Land War 'then agitating Ireland', and other titles point to Thaddeus' interest in local subjects.[1] *Renewal of the Lease Refused* may have been painted in London, but was informed by Thaddeus' experience in Cork, rather than his new training. Over the next few years, however, he moved away from Irish subject matter and as a student in England and France, and then an aspiring *pleinairist* in Brittany, developed an interest in more quotidian, rustic, and occasionally sentimental images, displaying the same concerns with technique, colour and tone as his immediate contemporaries.

Thaddeus' subsequent commitment to portraiture, which dictated his professional movements and social activity, might have put paid altogether to any lingering inclination to incorporate social themes into his work. However, he was obviously very conscious of the poor conditions in which a large proportion of the Irish rural population lived, and in his *Recollections* even compared their lot to that endured by Russian serfs at the hands of their landlords, who ground them 'down to the last farthing'.[2]

1 H.J. Thaddeus, 1912, p. 3. 2 Ibid., p. 93.

He was obviously very conscious of his nationality, and throughout *Recollections*, referred to compatriots whom he met on his travels, and to his own sense of Irish identity. He singled out, among others, an engineer in Fremantle, 'a South of Ireland man'; a 'reckless countryman from Waterford' who played a piano through an earthquake in Nice; Lady Hopetoun; and Lord Charles Beresford and Lord Dufferin, both of whom he met in Cairo. With an innate sociability and well-hewn sense of propriety, he mixed sophistication with a charm that he promoted, and many recognised, as distinctly Irish. Perhaps his relatively unconventional background – poor family, Protestant father, Catholic mother – together with his marriage to a woman originally from a staunch Church of Ireland family from the north of Ireland, gave him an unusually inclusive experience of Irish society. He may even have contrived an Irish persona that was acceptable and attractive to all manner of audiences, which might explain his success in discussing Irish politics with such diverse characters as Leo XIII, Gladstone and the duchess of Cambridge. Thaddeus met the duchess of Cambridge (the duchess of Teck's mother) at St James's Palace, and was surprised to find that she was a great admirer of Gladstone, and that, unlike other members of the Royal Family, she was not alarmed by the Home Rule Bill which Gladstone was attempting to pass through Commons. According to the artist, she deplored the opposition to the Bill and declared that 'Home Rule must come some day … and I should rather see it given to-day with a good grace than grudgingly to-morrow'.[3]

The *New York Herald* observed that 'of his native Cork [Thaddeus] retains two things: the wit and the most delicious tiny brogue imaginable, and there is also a trace of the poetical Celtic temperament in the happy way he has of adding the finishing touch to a remark by some apropos simile or illustration'.[4] Curiously, Thaddeus may not have been as refined as he appeared. His son Victor remembered that he 'was certainly not a perfect gentleman. Sometimes my mother found him incredibly vulgar'.[5] In any case, regardless of his degree of refinement, if Thaddeus did hold any contentious views on Irish politics, they impeded neither his professional career nor his social life.

Just as his early contact with important Irish figures, including Isaac Butt and Count Plunkett, is likely to have had an important influence on his early politicization, the reintroduction of Irish subject matter into Thaddeus' *oeuvre* in the second half of the 1880s must be attributable to some extent to his association (both formal and informal) with some of Ireland's foremost political figures. He recorded that he made a short visit to Bray, County Wicklow, in 1886, during which he had the 'long desired pleasure of meeting Charles Stewart Parnell'.[6] By that time, Parnell was deeply involved in parliamentary

3 Ibid., pp. 74–76. 4 *New York Herald* (European edition), 27 March 1896. 5 Victor Thaddeus, op. cit., 30 March 1943. 6 H.J. Thaddeus, 1912, p. 159.

politics (he had served as MP for Cork City since 1880), pursuing Home Rule through the Liberal alliance, and was very prominent in the House of Commons. Thaddeus may have known of Parnell for some time, as Parnell had been associated in the early 1870s with Isaac Butt, who had described him as 'a splendid recruit, an historic name'.[7] Parnell impressed Thaddeus greatly, presenting himself as 'most pleasant and cordial', contrary to the reputation he had within certain circles.[8] The two men must have met again subsequently, as Thaddeus claimed that he was to have painted the politician's portrait, but was prevented from doing so by the citation of Parnell as co-respondent in the O'Shea divorce case of November 1890, the event which ultimately brought about Parnell's downfall. It is impossible to tell how formal his arrangement with Parnell might have been. It may have amounted to little more than a brief conversation. Coincidentally, John Lavery also claimed that he was to have painted Parnell, but was prevented from doing so.[9] Thaddeus may have been introduced to Parnell through Lord Powerscourt, whose family had been a part of the Parnell family's circle of friends for some time, and who Thaddeus met on that same visit to Wicklow. He also met the immensely popular local priest, Father James Healy, a man admired for his wisdom, non party-political stance, and, socially, for his entertaining. Healy's funeral in 1894 was attended by peers, politicians, judges, representative of all professions, the local peasant community, and coincidentally, the duke of Teck. Healy was extremely well informed about political issues and personalities, and 'treated both sides [of the Irish question] with a certain jocular contempt'.[10] One of his missions was to bring together 'public men of divergent politics' and his friends were drawn from every political and religious denomination.[11] He was particularly sensitive to the policies exercised under the new coercive legislation of 1887 introduced by Balfour, the Chief Secretary, to combat the Plan of Campaign. The Plan of Campaign was a radical proposal for collective bargaining on rural estates, designed chiefly by William O'Brien and John Dillon and announced in October 1886, which remained the chief weapon of the land agitators for about five years. It involved the setting by the National League of 'fair' levels of rent that tenants should be willing to pay. If a landlord demanded more, the tenants were encouraged to hand the recommended amount to trustees, who would place it into a central fund used to assist and re-house evicted families. The lord lieutenant declared the plan a 'criminal conspiracy' and the Catholic Church condemned it. Parnell, for his part, supported it initially, but dissociated himself from it in 1888. The Criminal Law Amendment Bill, enacted in July 1887, facilitated the prosecution of a wide-range of offences in courts of summary jurisdiction. Among the offences were boycotting, intimidation, criminal

7 F.S.L. Lyons, 1977, p. 41. 8 H.J. Thaddeus, 1912, p. 159. 9 Lavery, 1940, p. 185.
10 W.J. Fitzpatrick, 1896, p. 285. 11 Ibid., p. 335.

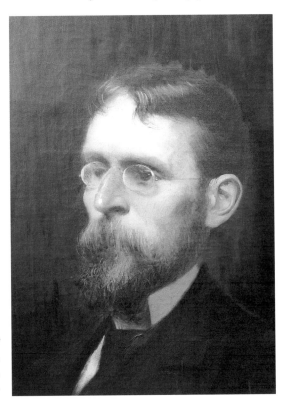

29 *William O'Brien, MP*
(unfinished: detail), 1890.
Oil on canvas 125 × 105.
University College Cork.

conspiracies concerning non-payment of rent, resistance to eviction, unlawful assembly, and the incitement of others to commit such crimes. Balfour enforced the act with increasing severity over the following three years, but met with equally firm resistance, and it was this conflict that inspired Thaddeus' picture. Balfour knew Father Healy, and when he reputedly asked the priest if he was as unpopular among the Irish as the press and politicians maintained, Healy replied, 'Well, to tell you the truth, Mr Balfour, if the Irish people only hated the devil half as much as they hate you, my occupation would be gone.'[12]

As well as preventing Thaddeus from painting a portrait of Parnell, the O'Shea divorce case had a bearing on other portrait commissions he received. He wrote that in 1888, he was approached by 'a working men's association in Cork' (in fact, the Cork Young Ireland Society) to produce a portrait of their president, William O'Brien.[13] O'Brien, a native of Mallow, County Cork, was secretary of the National League and during his career served as Home Rule Party MP for three Irish constituencies, including Mallow and Cork. He had been an ardent campaigner for agrarian reform for many years, and in 1887 had

12 Ibid., p. 286. 13 H.J. Thaddeus, 1912, p. 172.

been jailed for his part in organising the Plan of Campaign.[14] However, he was also, in Thaddeus' words, 'the first to turn on the great leader' when the Home Rule party split in 1890/1.[15] The remuneration Thaddeus stood to gain from the commission was trifling, but the society's approach was so earnest that he agreed to undertake the work regardless (fig. 29). Such magnanimity should, of course, be judged in the context of Thaddeus' understandable desire to add important political figures to his list of sitters. In practice, he did not take to O'Brien, and recorded, in vitriolic tones, his almost fruitless attempts to accommodate his sitter. O'Brien seemed uninterested in the portrait from the outset and, as far as Thaddeus was concerned, proved a far from captivating subject. He sat just once, forcing the artist to work from rather 'slender material'.[16] Thaddeus duly lost interest in the project himself, and by the time he was approached about it again by the patrons, O'Brien had disavowed Parnell's leadership of the Home Rule Party, thus turning the Cork society against him. Despite the offence caused, they wanted the picture to be completed.[17] O'Brien's apparent betrayal of Parnell merely compounded Thaddeus' negative opinion of him, and the artist claimed that, knowing O'Brien would have to live with the picture, he deliberately exaggerated his nose, the 'rich carnation of his most prominent feature'.[18] He overstated, perhaps, the conspicuousness of the slight in the painting, but it is certainly less than flattering, as O'Brien, gaunt and rigid, sits cross-legged with one hand placed over the other on his lap, staring impassively ahead. The fact that this picture looks decidedly incomplete, unlike Thaddeus' portrait of Gladstone, which appears fully finished despite a lack of sittings, supports Thaddeus' claim that he painted it both hurriedly and reluctantly. Though quite well executed, it is remarkable more for its drabness than for the irreverent way it presents O'Brien. It may contrast with the portrait painter's usual practice of enhancing or maximising the sitter's appearance, but as *caricature,* is tame when compared with Thaddeus' almost comical portraits of Count Pecci and Cardinal Macchi in the *Obeddienza*. Thaddeus compounded the negative remarks he made about his only meeting with O'Brien by claiming that the sitter provided a wholly inaccurate assessment of the picture's reception when it was placed on public view in Cork. Thaddeus' own recollection was that on the evening that the picture was placed in a shop-window in Cork City, it was seized by some of O'Brien's aggrieved supporters and taken to him, and that in the ensuing melée, O'Brien 'narrowly escaped with his life'.[19]

14 See Warwick-Haller, 1990, pp. 99–102. 15 H.J. Thaddeus, 1912, p. 173. 16 Ibid.
17 The plate on the frame reads: 'WEDDING GIFT from the MEMBERS of the CORK YOUNG IRELAND SOCIETY to MRS. WILLIAM O'BRIEN on the occasion of HER MARRIAGE WITH THEIR PRESIDENT/ June 1890/ Edward Murphy Chairman'. 18 H.J. Thaddeus, 1912, p. 173.
19 Ibid., p. 174.

When Thaddeus came to paint Thomas Sexton, lord mayor of Dublin 1888–89, it was 'attended with similar difficulties to those attending the presentation to Mr William O'Brien in Cork'.[20] Sexton, a former Fenian, who had been elected an MP in the general election of 1880, was another of the many senior politicians to remove his support from Parnell in 1890 (although by that time, Sexton had retired from parliamentary politics). Dublin Corporation commissioned the portrait before the split in the Home Rule Party, but afterwards only some of the members wished for it to be completed. It is a curious reflection on Thaddeus' political views that he seems to have been better disposed towards Sexton than he was to O'Brien, despite their similar treatment of Parnell. While O'Brien was ungracious and uncooperative, Sexton was, as far as Thaddeus was concerned, 'sympathetic in manner and a perfect sitter ... Endowed with regular features and a noble intellectual brow.'[21] While quick to berate O'Brien for his betrayal of Parnell, Thaddeus spoke of Sexton as though his attractive demeanour and the financial acumen he displayed as lord mayor compensated for his regrettable errors of judgement. When the portrait was completed, the extreme tension between the pro- and anti-Parnellites left them so preoccupied that Thaddeus ended up delivering the picture to Dublin himself. During this visit, which he probably made in 1891, within months of the split in the party, he may have produced his portrait of Colonel Thomas Garrett, who was at the time serving on the Army Staff in Ireland (fig. 18). Unfortunately, the portrait of Thomas Sexton was destroyed in a fire at the council chamber in City Hall in 1908, but the corporation enlisted Dermod O'Brien (1865-1945), president of the Royal Hibernian Academy from 1910 to 1945, and one of the most admired and respected artists of his generation, to produce a replica.[22]

In view of Thaddeus' obvious admiration for Parnell, it is interesting to note that he reserved equal praise for Michael Davitt, who had promoted a much more militant approach to the struggle for agrarian reform and Home Rule. Davitt, who Thaddeus described as a man of 'exceptionally pure and elevated nature' sat for the artist in 1889.[23] However, though Thaddeus provided considerable biographical information on Davitt in his *Recollections*, he gave no indication of his attitude towards Davitt's more extreme tactics, beyond noting that Davitt was arrested during the Fenian Rising of 1867 'with a pike in his hand'.[24] His high regard for Davitt may stem from the fact that Davitt was the son of an evicted County Mayo tenant farmer who had been forced to emigrate with his family to Lancashire in 1852. The influence of Davitt's personal experience on his political activity and individual views was widely acknowledged. He had personally experienced a malignancy which Thaddeus recognised as being

20 Ibid., p. 175. 21 Ibid. 22 Archives Division, Dublin Public Libraries, Letter to the author, 5 April 1995. 23 H.J. Thaddeus, 1912, p. 177. 24 Ibid.

as prevalent, divisive and invidious in the 1880s as it had been when Davitt was a child, or indeed when Thaddeus first addressed the issue in his art over a decade earlier.

Thaddeus' contact with Irish politicians extended beyond the turn of the century, and encompassed all elements of the Home Rule movement. In 1901, he produced a portrait of John Redmond, the leader responsible for reuniting the Home Rule party in 1900 for the first time since the Parnell split (pl. 23). Redmond was a Parnellite, and a committed constitutional nationalist, who took it upon himself to draw back together the various strands of the party with a view to forging a united front. Significantly, his renowned, unwavering confidence in the parliamentary process was acknowledged and admired by Thaddeus, who remarked on the 'dignity and moderation with which he advances his political views in the House of Commons'.[25] He felt that Redmond stood apart in 'that assemblage of mediocrities, and for statesmanlike breadth of view, culture and polish, is not excelled by any living Englishman'.[26] It is perhaps understandable that someone as well travelled and cosmopolitan as Thaddeus should value Redmond's statesmanlike qualities. He would have respected Redmond's loyalty to Parnell and would have been aware of the tensions that had existed between Redmond and William O'Brien, who had assisted him in reuniting the party, and who was considered by some to be its *de facto* leader.[27] Of the politicians with whom Thaddeus came into contact, Redmond appears to have been the one he knew best. On one occasion, he dined with him at the House of Commons before attending a debate on the Irish question, for which Eva Thaddeus joined Redmond's wife in the Ladies' Gallery. One can understand how Thaddeus, who perpetually occupied English high society, with its associated jingoism, protocol, militarism and reliance on the *status quo*, responded positively to Redmond's refinement of character and conciliatory approach to the British government in his campaign for Home Rule.

Thaddeus' portrait of Redmond is another competent, if rather dated work, which demonstrates the artist's skill in rendering flesh tones. It is finely finished and well composed, but indicates no familiarity with or acknowledgement of contemporary trends in portrait painting. The pose is conventional, and again the hands are hidden (although the detail of the wrist that is visible is extremely accomplished). Thaddeus did not identify the sitter when the picture was on show at the RHA in 1902, or indeed any of his other portraits on that occasion, but that did not prevent the reviewer in the *Irish Times* from commenting that the portrait 'otherwise undesignated in the catalogue, doubtless that of Mr Redmond, is unhappy'.[28]

25 Ibid., p. 178. 26 Ibid. 27 See Warwick-Haller, 1990, pp. 203–7 28 *Irish Times*, 3 March 1902. None of the sitters in the portraits by Thaddeus on view was identified in the catalogue.

Another factor that coincided with one of Thaddeus' trips to Ireland, and which may help to explain his heightened interest in Irish affairs and identity, was his involvement in the ambitious Irish Exhibition at Olympia in Kensington in 1888.[29] The exhibition, organised and financed by members of the nobility and persons distinguished in the fields of politics, literature, science and commerce, ran from 4 June to 27 October, and aimed to showcase Irish industry, craft and culture and, in general, to present Ireland to an English audience in a more positive light than was usual in, for instance, news reports and parliamentary exchanges. The exhibition occupied the vast covered building itself called Olympia – the largest exhibition building in Britain – and six acres of adjacent grounds, and though its status was relatively minor compared with contemporary international exhibitions, such as the Glasgow International Exhibition (which ran from the beginning of May to the end of October), it was a significant undertaking both in terms of administration and engineering. It was also an imaginative and wide-ranging project, into which as many elements of Irish industry, art and custom were incorporated as was feasible. A strong emphasis was placed on the arts, both current and historical, and an impressive array of important and prestigious art works spanning the centuries were assembled for display.[30]

A large collection of contemporary artworks in various media were hung in two large galleries in the main building. Both galleries were sub-divided into 'suitably draped' bays, which themselves were devoted to specific media and genres, including water-colour, oil painting, drawings, bas-reliefs, photography, and loan collections of silver and sculpture.[31] Among other claims, the catalogues boasted that the collections represented 'an assemblage of some of the greatest masterpieces by major Irish artists'.[32]

Under normal circumstances in England, Irish pictures were hidden among all the other works in exhibitions of British and European art (as would have been the case at, for example, the Royal Academy or the Grosvenor Gallery). No doubt it was one of the aims of the organisers to impress upon the audience that one could speak of an 'Irish school' of painting, distinguished by its vitality and originality. Thaddeus, now firmly settled in London, would have been happy to subscribe to such an aim.

Many of the older, more established Irish artists were spoken of in customarily deferential tones in Irish newspapers, but their real excitement was focused on the younger generation. Though there were notable absentees, not the least of whom was John Lavery, who was otherwise engaged, though unofficially, as artist in residence at the more prestigious International

29 For a comprehensive account of the Irish Exhibition, see B. Rooney, 1998, pp. 100–19. 30 Ibid., p. 105. 31 *Freeman's Journal*, 2 July 1888. 32 Irish Exhibition in London, Official Daily Programme, 10 October 1888.

Exhibition in Glasgow, the group of young artists included a number who were destined to attract considerable plaudits and success in their careers, and/or to become major figures in the Irish artistic establishment.[33] These included Aloysius O'Kelly, Richard Thomas Moynan, William Gerard Barry ('Thaddeus' former pupil), Margaret Allen, Col. Egerton B. Coghill, Mildred Anne Butler, Edith Somerville and Walter Osborne.

Remarkably, however, Thaddeus was far and away the largest and most expensive painter on show and the only artist in oils to have had an entire bay devoted to his work in the main area of the exhibition. In total, there were twenty-two of his paintings on exhibit. Bay III contained sixteen pictures, drawn from all major areas of his *œuvre*, while other paintings were distributed among the work of other artists. Among his paintings were the Royal Academy portrait of the duchess of Teck, and the portraits of Franz Liszt, Father Anderledy, Pope Leo XIII, Grand Duchess Elene Vladimirovna Romanov, Gladstone and Miss Amy Tollemache, and various genre pictures including *The Wounded Poacher*, and *A Ray of Sunshine*, a fashionable sentimental picture of a little French urchin.

Thaddeus' dominant status within the exhibition did not pass unnoticed by the Irish press. *Freeman's Journal* gave his collection the lion's share of attention in its review of the art galleries. The paper's correspondent, remarking on the fact that one of the bays was occupied exclusively by Thaddeus' work, said that 'his dominant powers unquestionably are shown in portraiture, though he has not restricted himself exclusively to that branch of art' and that his 'versatility is amply demonstrated'.[34] These were impressive accolades to confer upon an artist who was still only twenty-eight years of age, and had not lived in Ireland for a decade.

Thaddeus' pictures were not guaranteed to sell, but their high prices must reflect not only the confidence Thaddeus had in the quality of his work but also in his capacity to sell it.[35] To put them in context, the highest price, and by quite some margin, being asked by Aloysius O'Kelly, slightly older than Thaddeus and also living in London, for his work, *Blessing This House, West of Ireland*, was £100, a substantial sum in itself. James Brenan, Thaddeus' former master in Cork, was charging no more that £40 for his painting *Bankrupt*. In contrast, Thaddeus' most highly priced painting, his portrait of *Father Anderledy, General of the Jesuits*, carried the extravagant price tag of £800. Not all of his paintings were so expensive, and in fact the cheapest was just £10 10s., but a significant number were priced in hundreds, including *Princess Mary Victoria of Teck* (£315), *Leo XIII* (£500), *M. de Compte de Brazza* [sic] (£315), and *Gladstone* (£420).

33 See McConkey, 1993, p. 54. 34 *Freeman's Journal*, 5 July 1888. 35 Not all of his pictures were on sale.

Thaddeus' large representation at Olympia must be attributable to some extent to the friendships and connections he could claim within fashionable English and Anglo-Irish society. This is borne out by the fact that the *Irish Times* felt it worthwhile to report on Thaddeus' reception at the exhibition of a party led by his old friend the duke of Teck. Newspapers habitually traced the movements of royalty, the aristocracy, dignitaries and popular personalities, but it certainly reflected positively on Thaddeus' status to have been mentioned as host. Thaddeus' 'guests' were a diverse party, consisting of Lieutenant Colonel Gore; the 6th earl of Arran, a distinguished and highly decorated soldier; Dr McNaughton Jones, one of Thaddeus' first sitters; Robert Percy ffrench, Thaddeus' old friend; Mr Justin McCarthy, Home Rule MP and member of the executive committee of the exhibition; and Mr Faudel Phillips, the son of a former lord mayor of London.[36] Phillips' association with Ireland was publicly manifest in 1894, when he was appointed governor of the Irish Society, responsible for the managing the Irish estates of the corporation of the city of London. He subsequently served as mayor of London himself from 1896 to 1897. With the exception of Lieutenant Colonel Gore, all members of the party were of a markedly different generation to their host, and Thaddeus, well versed in social protocol, would certainly have relished the prospect of escorting them around the art galleries and grounds. He would also have been well aware of the possible benefits of presenting himself in a sympathetic light to potential clients. The *Irish Times* reporter explained that the party was 'conducted through the north picture gallery to the bay in which are the principal pictures by Mr Thaddeus, who, as a native Irish artist, has accomplished much good work of late', where 'his Serene Highness expressed great praise at the artist's latest production, his portrait of Mr Gladstone, one of Mr Thaddeus's collection'.[37] Having accompanied the party around the art galleries, Thaddeus introduced them to the rest of the exhibition, including the popular Fancy Fair, which had been opened by the duchess of Teck. That such an ostensibly inconsequential event should have been recorded at length says much of the standing of both visitors and host.

As well as Thaddeus' reputation among the upper echelons of British society, there may be a more banal explanation for his prominent position at the Irish Exhibition. The event's management came under constant criticism from the press immediately prior to, and for about six weeks after the opening of the event for their apparent ineptitude and inability to adhere to a schedule, even though delays were a standard feature of exhibitions of this kind, and time invariably worked against the more ambitious projects.[38] It seems that the art section suffered more than most of the attractions, and here problems of poor organization were compounded by sheer neglect and procrastination, as those responsible had simply not allowed themselves enough time to assemble a

36 *Irish Times*, 25 June 1888. 37 Ibid. 38 See *Illustrated London News*, 28 July 1888, p. 106.

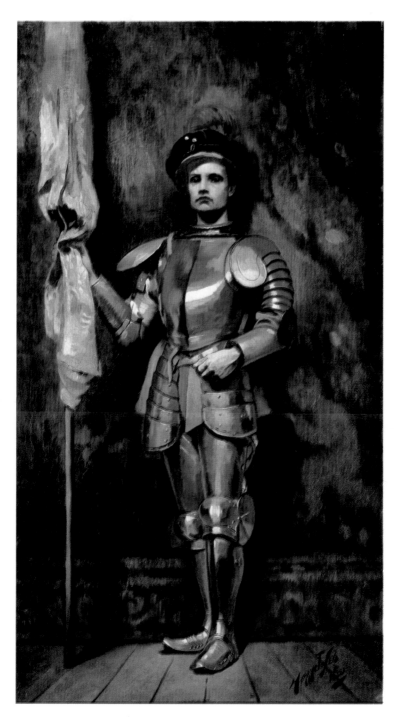

1 *Studio Model in Suit of Armour*, 1880. Oil on canvas 79 × 43.
Private collection.

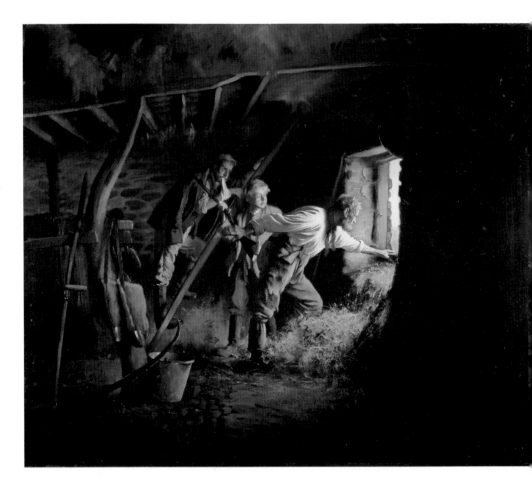

2 (above) *The Poachers*, *c*.1895. Oil on board 63.5 × 75.5. Private Collection.

3 (opposite page) *Le retour du braconnier, Irlande (The Wounded Poacher)*, 1880/81. Oil on canvas 120 × 85. National Gallery of Ireland.

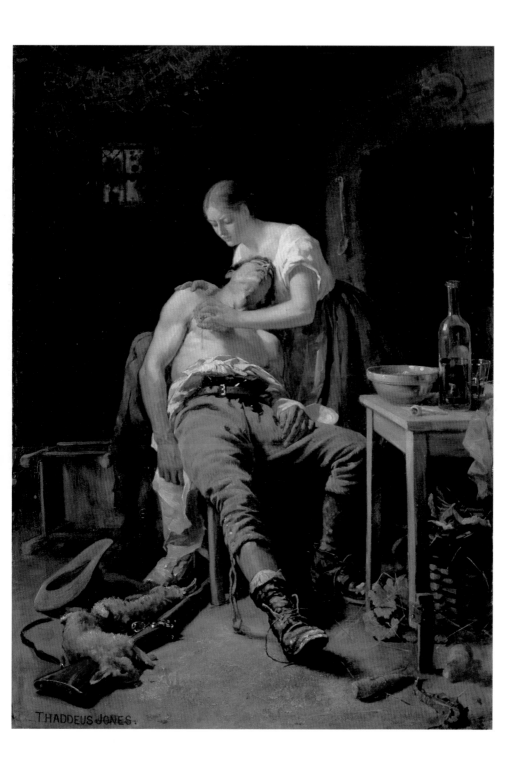

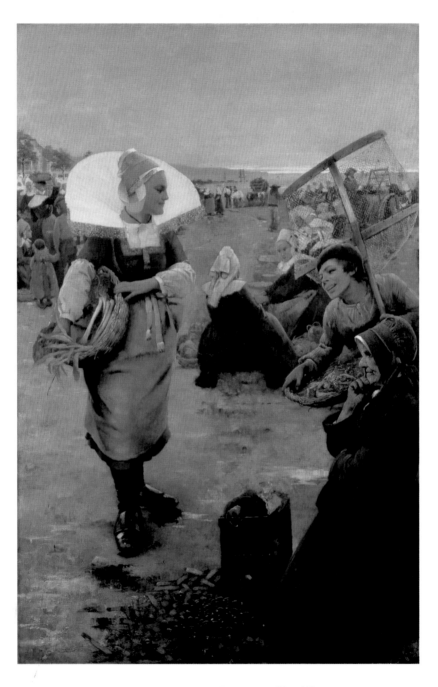

4 *Jour de marché, Finistère (Market Day, Finistère)*, 1882. Oil on canvas 201 × 132. National Gallery of Ireland.

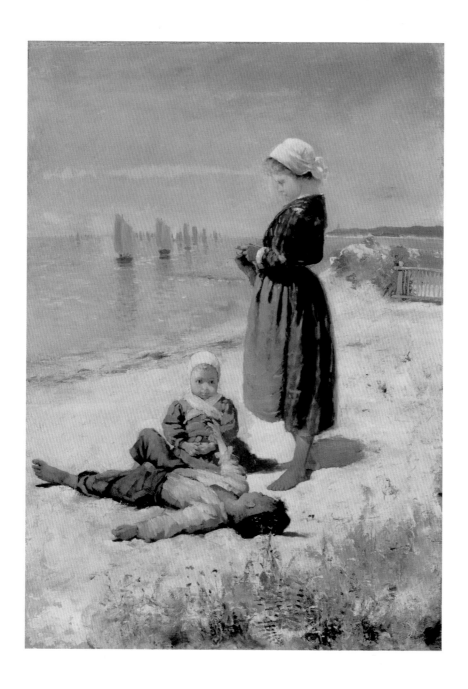

5 *On the Sands, Concarneau*, 1881. Oil on canvas on board 88 × 63. Private collection.

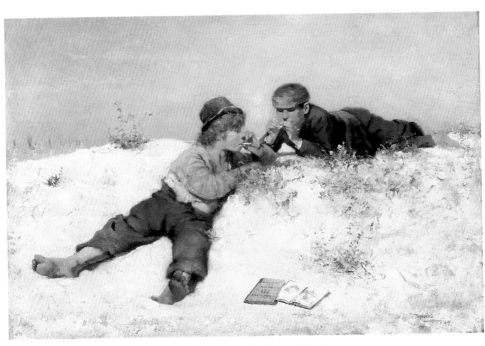

6 *On the Beach*, 1882. Oil on panel 35 × 53. Private collection.

7 *Spilt Milk*, 1881. Oil on canvas 24 × 38.5. Private collection.

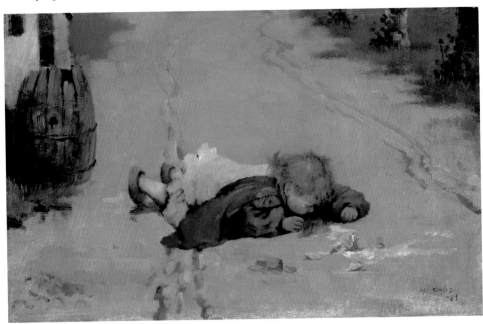

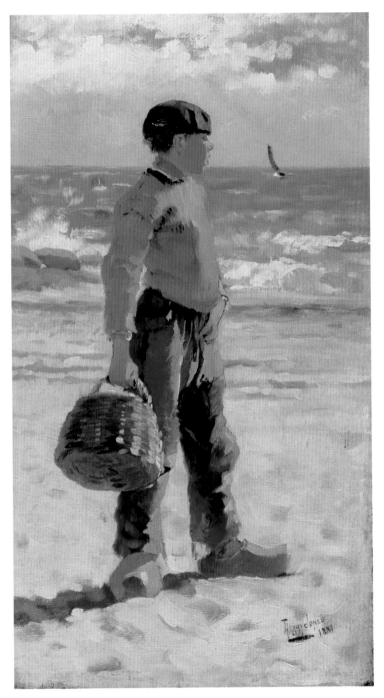

8 *Young Breton Fisherboy*, 1881. Oil on wood 38 × 21. Private collection.

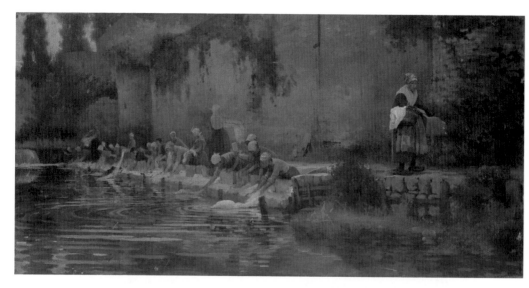

9 *Washing Day*, 1883. Oil on canvas 64.8 × 130.2. Private collection. Detail below.

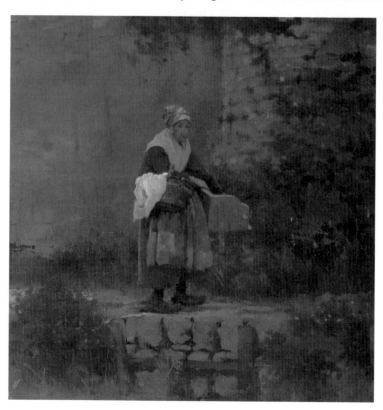

10 *An Old Widow*, 1883. Oil on canvas 84.2 × 111.1. Private collection.

11 *Well near the farm at I Cedri, near Florence*, 1884. Watercolour on paper 35.6 × 25.3. Royal Collection.

12 *Viareggio*, *c*.1884. Watercolour with white on blue paper 17.8 × 11.3.
Royal Collection.

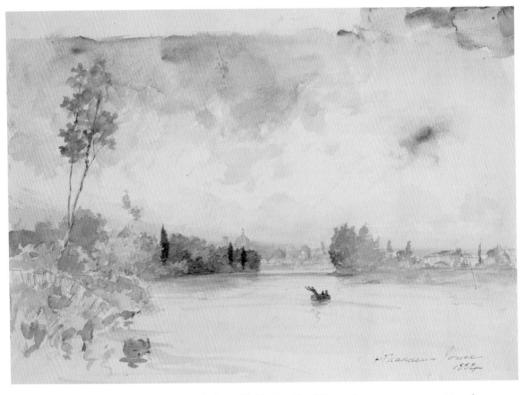

13 *Florence: Distant View from the Podere of I Cedri*, 1884. Watercolour on paper 25.3 × 35.6. Royal Collection.

14 *Father Anderledy*, 1886. Oil on canvas 124.5 × 85.6. Lady Lever Art Gallery,
Liverpool.

15 *The Obbedienza (Pope Leo XIII receiving the Oath of Allegiance from the Cardinals)*, 1902. Tinted mezzotint (after original in oil on canvas of 1899). St Mary's Cathedral, Sydney.

16 *Sir Arthur Hodgson*, 1889. Oil on canvas. Town Hall, Stratford-upon-Avon.

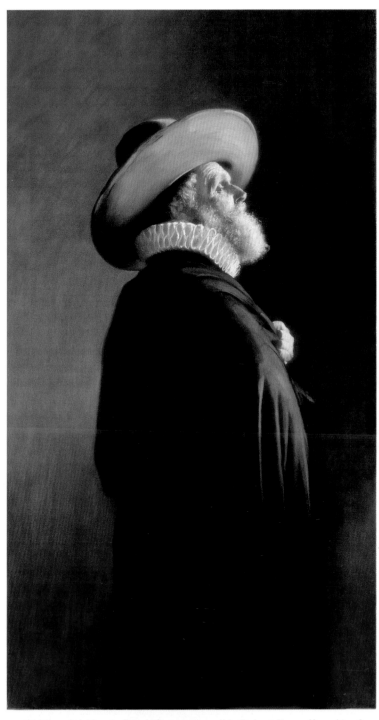

17 *Old Bearded Man in Dutch Costume* (possibly Robert Percy ffrench), 1890.
Oil on canvas 127 × 77. Private collection.

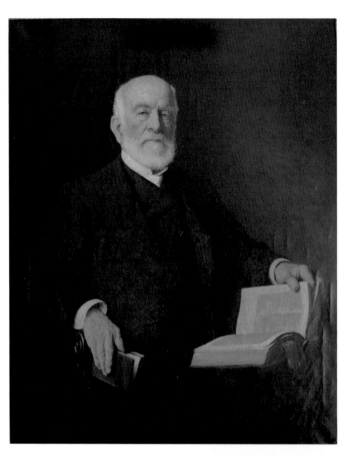

18 *The Rev. the Earl of Bessborough*,
1901. Oil on canvas. Stansted House.

19 *Self-portrait*, 1900.
Oil on canvas. Untraced.

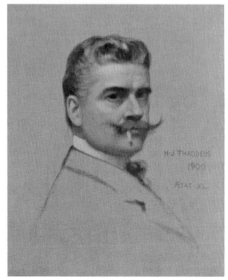

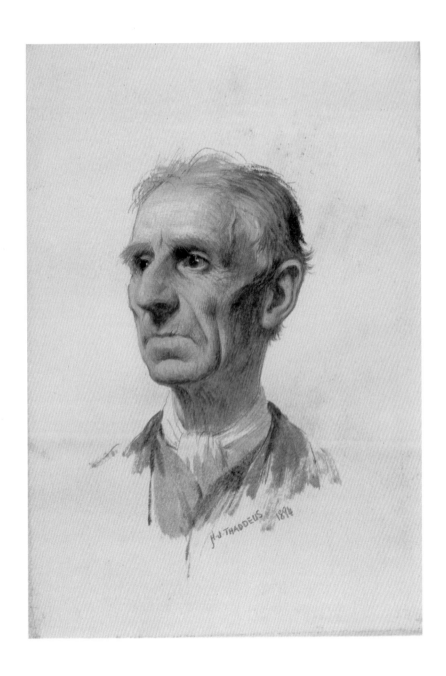

20 *Head of an Old Man*, 1894. Watercolour and pencil on paper 15 × 10.75.
Private collection.

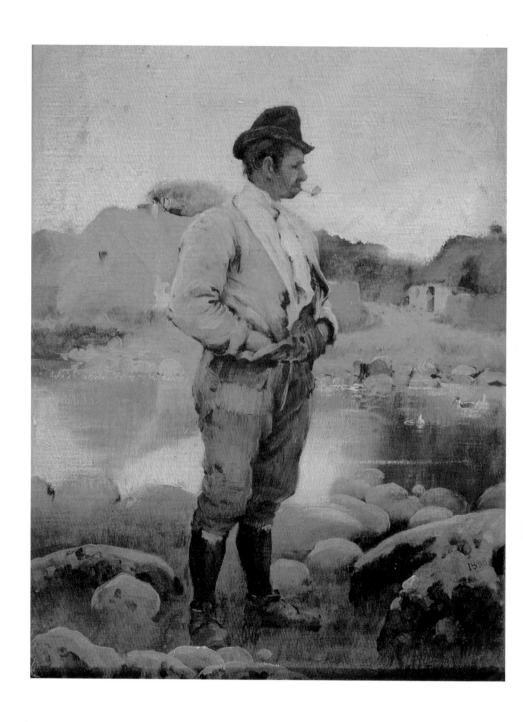

21 *An Irish Peasant*, 1888. Oil on canvas 30.5 × 23.2. Mappin Art Gallery, Sheffield.

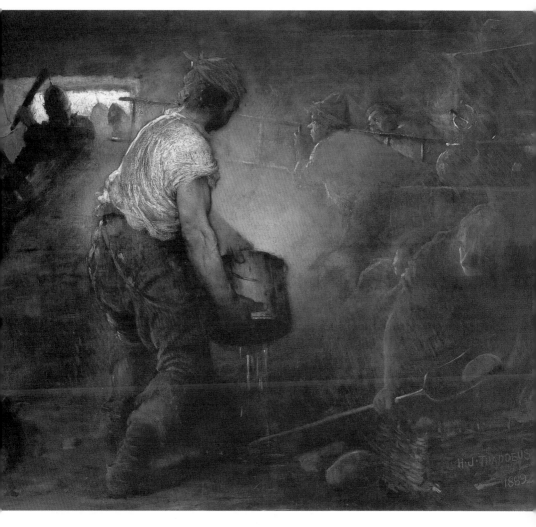

22 *An Irish Eviction – Co. Galway, Ireland*, 1889. Oil on canvas 119.4 × 152.4.
Private collection.

23 *John E. Redmond, MP*, 1901. Oil on canvas 102 × 82. National Gallery of Ireland.

24 *Michael Holland*, 1920. Oil on canvas 91.6 × 61.3. Crawford Municipal Art Gallery.

25 *The Origin of the Harp of Elfin*, 1890. Oil on canvas. 181.6 × 120. Royal Collection.

26 *Boat on a Lake*, 1884. Oil on panel 14.7 × 22.8. Private collection.

27 *Just before Dawn, Red Sea*, 1902. Oil on paper 23 × 32.5. Private collection.

28 *Sunset*, c.1902. Oil on paper 23 × 32.5. Private collection.

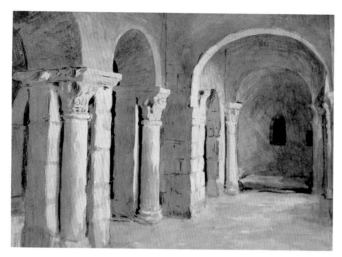

29 *View of the South Nave of the Church of Saint-Pierre, Montmajour, c.*1895. Watercolour on paper 22.5 × 31.5. Private collection.

30 *Washerwomen*, 1897. Watercolour on paper 23.5 × 34. Private collection.

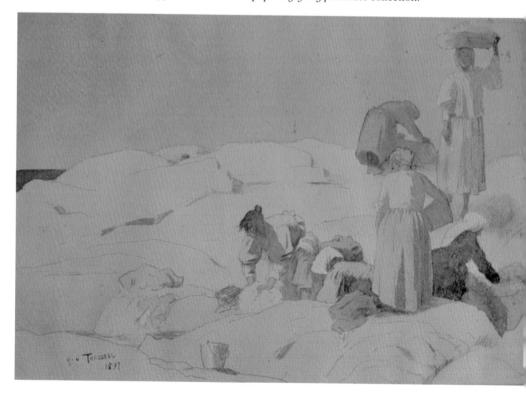

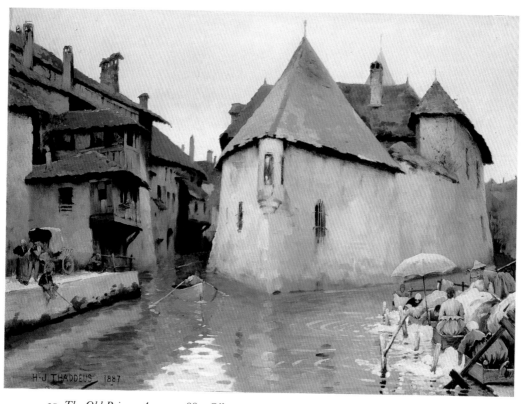

31 *The Old Prison, Annecy*, 1887. Oil on canvas 71 × 99. Private collection.

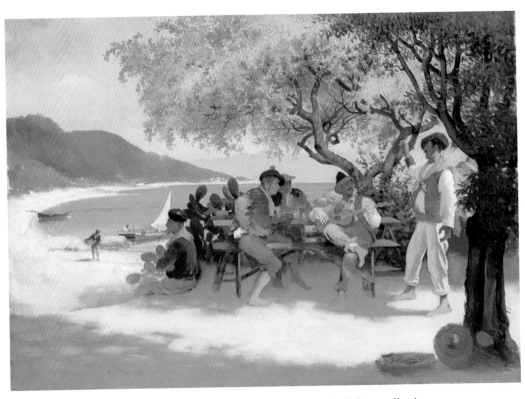

32 *Mediterranean Fishermen, c.*1895. Oil on canvas 43 × 61. Private collection.

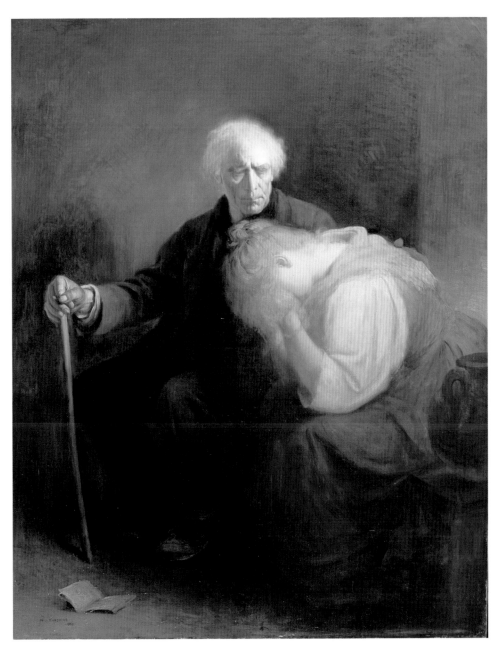

33 *The Comforter*, 1900. Oil on canvas 127 × 102. Private collection.

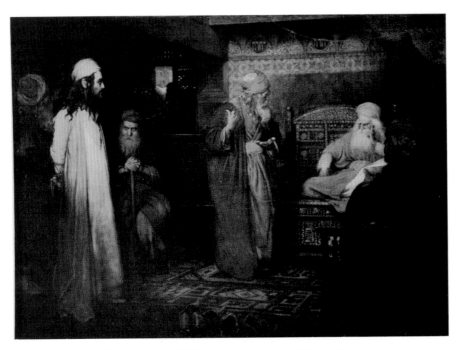

34 *Christ before Caiaphas*, 1890s? Oil on canvas 84 × 132. Untraced.

36 *The Cup that Cheers*, 1898. Oil on canvas 101.6 × 127. Private collection.

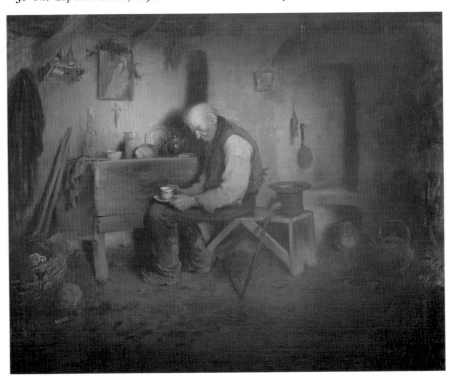

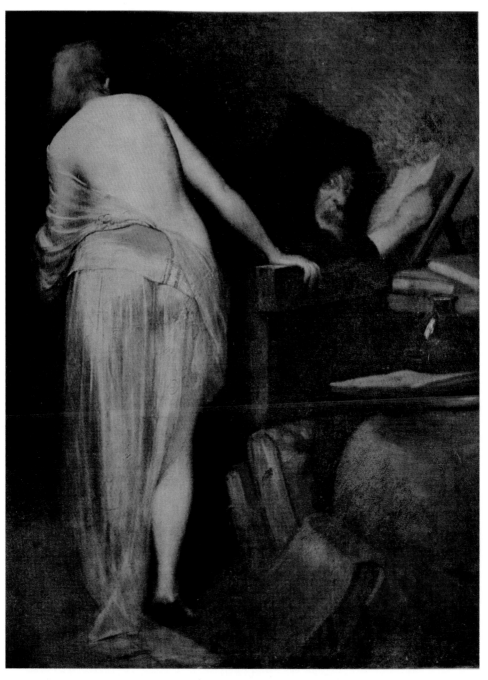

35 *The Temptation of Saint Anthony*, 1890s? Oil on canvas. Untraced.

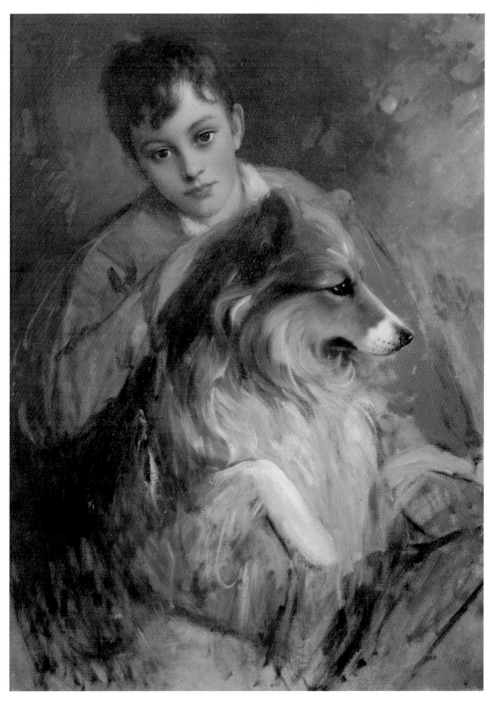

37 *Freddy Thaddeus with Ra, the family dog, c.*1905. Oil on canvas 89.7 × 69.5. Private collection.

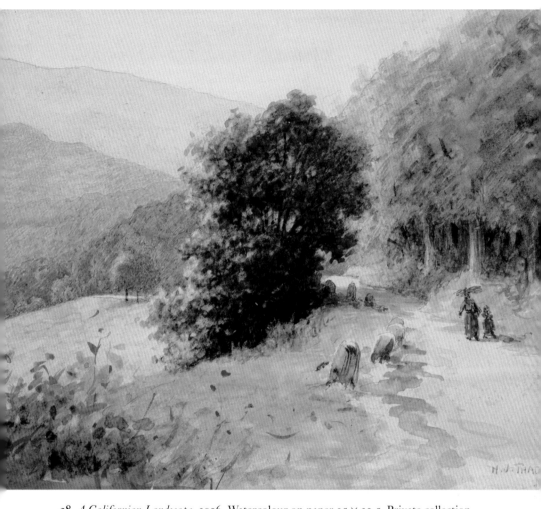

38 *A Californian Landscape*, 1906. Watercolour on paper 15 × 20.5. Private collection.

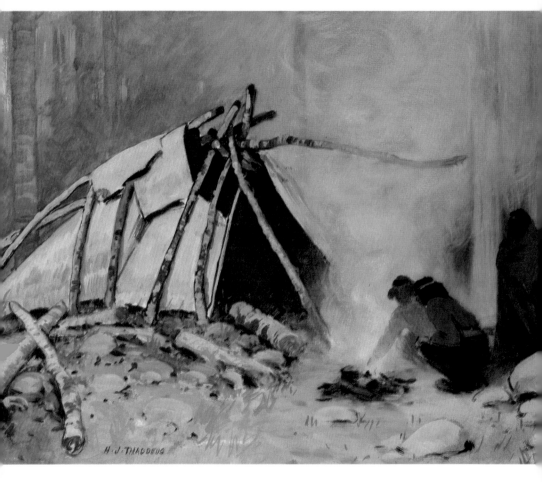

39 *A Native American Encampment, c.*1907–16. Watercolour on paper 27.5 × 37.5. Private collection.

satisfactory collection. While it would be simplistic to suggest that Thaddeus and others were encouraged to make up the numbers, it does seem reasonable to assume that they were invited to submit as many pictures as was practicable and necessary at that time. It is, moreover, noticeable how many works by the living artists on show came from those artists' own collections, and how few private collectors, relative to other major exhibitions, lent works. Thaddeus provided four of his own pictures, while the duke of Teck lent Thaddeus' portrait of him. Mrs Tollemache, the wife of a Conservative MP for Cheshire, also lent a portrait of her daughter, and Vincent Scully, one of Thaddeus' most loyal patrons, lent two pictures, *A Ray of Sunshine* and *The Wounded Poacher*.

Despite the relative chaos that attended the setting up of the galleries, and the unorthodox nature of the collection itself, the art exhibition was a success. Writers spoke of paintings being sold before they had even been put on display. As was hoped, the galleries proved a focal point of the Exhibition which, contrary to expectation, attracted large crowds in its opening few days – an estimated 20,000 visitors per day passed through the gates in the first week – and continued to do so throughout its duration.

As one might expect in a specifically Irish Exhibition, many identifiably Irish pictures featured among the art collection. Of these, a predictably large proportion were landscapes, but there was also a substantial number of genre scenes. Of the latter, scenes of Irish peasant life predominated, some purely descriptive, like Mildred Anne Butler's *Somewhat back from the Village Street*, Hablot Browne's *Interior of an Irish Cabin* and *A Load of Turf, Connemara* by Aloysius O'Kelly, others with a pronounced, and occasionally political, narrative, including *Bad News in Troubled Time*s by Margaret Allen, *The Village Politicians – A Scene from Real Life in Ireland* by Louisa d'Arcy, and *Notice to Quit* and *Bankrupt* by James Brenan. None of these was what one could describe as subversive, but they provided some commentary at least on a world with which the majority of their audience would have had limited knowledge and even less experience. Though the exhibition was not conceived with any explicit political goals in mind, it was a broadly propagandist venture or at the very least a serious public relations exercise, and presented artists with a rare and appropriate opportunity to display works with a political theme.

It seems extraordinary, then, in view of his interest in Irish affairs and recent contact with the country and its politicians that none of the pictures Thaddeus showed at Olympia, with the arguable exception of the *Wounded Poacher*, bore an Irish title or subject. As a young man, Thaddeus had been admired by the Irishman newspaper for the manner in which he considered Irish subjects 'fitting enough and fertile enough for even the widest display of the powers of any painter'.[39] Perhaps he felt that the inclusion of even vaguely political works

39 *Irishman*, 4 June 1881.

might jeopardize his reputation among the bourgeois, politically conservative art-buying public or at least negate his commercial aims at the exhibition. The career of the society portrait painter was precarious at the best of times, and the Irish Exhibition provided Thaddeus with unusual access to a large audience, which he presumably did not want to squander. That is not to say that the affection and sympathy he later expressed for his native country were contrived or insincere, but merely illustrates the rather unromantic fact that Thaddeus was, fundamentally, a businessman, who learnt quickly how to gauge the market and hold on to his clientèle. Alternatively, the reason for Thaddeus' apparent neglect of Irish subjects may be much more straightforward. He may simply not have had any works of Irish subjects on his hands at this time to include in the exhibition. The Irish Exhibition of 1888 contained more 'nationalistic-type subjects' than all previous Irish exhibitions put together, and it seems reasonable to speculate that, having seen these works (hidden though they were among over a thousand others) and various other attractions in the Exhibition grounds, such as the Irish peasants at work in the reconstructed Irish village, Thaddeus was further encouraged to reintroduce Irish subjects into his work.[40]

The earliest extant painting of an Irish theme dating from this period is a small picture entitled *An Irish Peasant*, now in the Mappin Gallery in Sheffield (pl. 21). The picture features a full-length study of an adult male peasant, standing on the bank of a river or lake, smoking a clay pipe, with a small cluster of cottages in the background. Technically, the picture fits comfortably into Thaddeus' *œuvre*, and with its even tonality, and greyish, hazy quality, so typical of Naturalist painting, harks back to Thaddeus' period in France at the beginning of the decade. It also features the dark delineation typical of his genre works. For this painting, Thaddeus evidently also employed a variation of the square-brush technique, which, as Lavery demonstrated in pictures from Grez-sur-Loing, was so effective in the rendering of still water, with its muted colours and delicate reflections. The idiosyncratic palette which distinguishes many of Thaddeus' landscape and genre works is not so much in evidence here, though he introduced occasional touches of crimson (as he had done many years earlier in *Market Day, Finistère*), to enliven the picture, and painted it over a noticeably orange ground. The detail of a duck in the water, diving for food, to the right of the figure provides a familiar hint of humour.

The real interest of this picture, however, lies in its subject, and more specifically, the representation of the figure, which calls to mind earlier nineteenth-century images of the Irish peasant and, in particular, the work of the Scottish artist Erskine Nicol. Nicol's images of the Irish peasant range from the grave, dramatic and ostensibly sympathetic (e.g. *The Evicted Family*, NGI; *Ejected*, Ulster Museum) to the picaresque and grotesque (e.g. *Don't Say Nay*,

40 Barrett, 1975, p. 402.

1854; *His Valentine, c.*1855). Though Nicol lived in Ireland from 1846 to 1850, and maintained a close association with it for the rest of his life, he chose never to tackle in his work the distressing effects of the Famine that he must have witnessed. Instead, his peasants, though sometimes despondent and disenfranchised, always appear well-fed and physically strong. Furthermore, with their distinctive physiognomy and costume, they often correspond to the negative stereotypical image of 'Paddy' propagated and promoted by the British illustrated press such as *Judy, Fun* and especially *Punch*, and appropriated by other genre painters.[41] One can detect in Thaddeus' figure faint echoes of this dishevelled, simian character, in coarse breeches, frock coat and felt-hat. This insidious, pervasive physical representation of the Irish peasant, often combined with an inherent indolence or inactivity (as also appears, complete with clay pipe, as a 'Stoic from the Emerald Island', in the background of Ford Madox Brown's celebrated painting *Work*, 1852–65), is entirely at odds with Thaddeus' apparent attitude towards Ireland and its rural population, so it is perplexing to find it reflected, albeit obliquely, in his painting. The facial type, with heavy eyebrows, prognathous chin and coarse expression, suggests none of the sophistication and cultivation Thaddeus identified in those Irish politicians he admired, such as Davitt and Redmond. Thaddeus' picture of the Irish peasant is fundamentally a descriptive piece, making no explicit reference to the Irish political situation, nor even, more generally, to the harsh conditions in which the Irish peasantry lived.

However, the Irish works he exhibited in 1890 were not so anodyne. At the Royal Hibernian Academy in March of that year, Thaddeus showed his fanciful portrait of *Robert Percy ffrench*, his portrait of *Gladstone* (fig. 12), and the incomparably powerful *An Irish Eviction – Co. Galway* (pl. 22). In the autumn he re-exhibited *An Irish Eviction* at the Walker Art Gallery in Liverpool, but on this occasion with a thematically similar picture entitled *A Home Ruler – Co. Galway*, and a rather less complementary picture painted in Algeria. Such was the attention that the eviction scene attracted, no mention was made in the press of the picture of the Home Ruler, but its title alone attests to its political character. Titles making specific reference to Irish politics were unusual, particularly in exhibitions in England, and it is regrettable that we do not know how Thaddeus distinguished a Home Ruler from a 'common' Irish peasant. He might have depicted the figure reading a newspaper with a suggestive headline, as the visiting American artist Howard Helmick had done in *News of the Land League* (NGI), or perhaps engaged in some lobbying activity. Both of Thaddeus' pictures were set in Galway, which, it is worth noting, had since the mid-

41 For a chronicle of the representation of the Irish in nineteenth-century British, American and Irish illustrated press, see L.P. Curtis Jr, *Apes and angels – the Irishman in Victorian caricature*, Washington and London 1997.

century been among the Irish counties to bear the brunt of the government's coercive policies. It had consistently experienced some of the highest levels of eviction of the thirty-two counties, as had Thaddeus' native county, Cork.[42] The Plan of Campaign had been instigated with particular voracity in those counties, for instance on the estates of Lord Clanricarde in Galway and Lord Ponsonby in Cork. The nature of Thaddeus' association with Galway is not known, though it certainly does appear to have been close. When applying for a bank account with Coutts & Co. in London in 1898, he was 'introduced' by the Bank of Ireland in Galway.[43]

While many nineteenth-century paintings present the Irish peasant as a boisterous, good-humoured and frivolous type, Thaddeus' *Irish Peasant* conforms to an alternative character, distinguished by his lack of activity, either industrial or recreational.[44] However, Thaddeus' monumental *An Irish Eviction – Co. Galway* corresponds to neither image. In the picture, which is emphatically of exhibition finish and scale, Thaddeus recorded the precise moment when a party of officers of the Royal Irish Constabulary, easily recognised by their pointed helmets, storm a peasant cottage, smashing down the door and rushing in to remove its occupants. Two of the peasants lunge at the leading police officers with a ladder held at shoulder height, while another, of powerful stature, in shirtsleeves and with his back to the viewer, holds a cauldron of hot liquid, ready to throw its contents at his assailants. The first officer entering the cottage draws his truncheon back as his colleagues follow close behind, their faces eerily indistinct. In the bottom right foreground a woman, glancing back at the door, reaches down to seize a pitchfork, while a small girl grips tightly on to her shawl. It was unusual in painting and illustration for women to be shown as directly involved in the violent behaviour that accompanied eviction or similar scenes, despite the fact that there is plenty of evidence to suggest that from the outset of the Land War, women not only became regularly embroiled in physical confrontation, but in many cases provided the initial, concerted resistance.[45]

It is a deliberately intense and claustrophobic scene, in which the use of almost Caravaggesque light and shade develops an effect that Thaddeus achieved in earlier pictures, such as *The Wounded Poacher* (pl. 3). Light enters the dark, cramped cabin over the shoulders of the silhouetted officers in the doorway, picking out the faces of the peasants and illuminating the steam that rises from the cauldron. It also reflects off a variety of items in the room, potential weapons in such desperate circumstances: a cauldron, a pitchfork, a ladder and copper pots hanging by the fireplace.

42 See W.E. Vaughan, 1984. 43 Coutts & Co., Letter to the author, 17 December 1997. 44 See S. Bhreathnach-Lynch, 1997, p. 247. 45 For a discussion of the role of women in the Land War and the representation of them in the illustrated press, see N. O'Sullivan 1998.

The figure holding the cauldron is the fulcrum of the composition, marking the point of confrontation between the peasants and the police. He is not, however, distinctively or conventionally Irish in appearance. The heavy woollen breeches and untailored white shirt are generic peasant costume, and the bright red headscarf is certainly not a common feature in Irish genre painting. The slight *contrapposto* of the figure, emphasised by the twists in the drapery of his shirt, his dynamism, and the careful, naturalistic modelling of the musculature of his arm are all indicative of the academic model, and probably owe a debt to the training in figure-drawing that Thaddeus received in Paris. However, if one compares the solid placement of this figure with the equally studio-based figure of the young girl in *Market Day, Finistère* (pl. 4), one can see that, though the viewpoint and orientation of the pictures are quite different, Thaddeus had made definite technical progress in the intervening years, despite his relatively limited output of large-scale subject pictures. Paradoxically, while this figure's physicality adds greatly to the dramatic impact of the picture, and the notion of resolute resistance, it also, to some extent, limits the pathos of the scene. However, Thaddeus' shared this disinclination to distance himself from academic forms with many artists of similar training.[46] From the few easel paintings dating from the period of the Famine, to these late nineteenth-century works, peasants were invariably shown as reasonably robust and in good health. In reality, the opposite was often the case, but Thaddeus did not present the viewer with the poverty-stricken and emaciated figures that appear in contemporary photographs, illustrations and writings, and who might have heightened further the emotive impact of his picture. He undoubtedly felt that the ennoblement of the figure was appropriate to both the *gravitas* and the drama of the scene.

A rather perplexing detail in Thaddeus' picture, then, is the left-hand figure holding the ladder, whose features again resemble the demonic caricature of the Irish peasant in the illustrated press. Facially, he contrasts markedly with the refined features of the tall, moustached policeman who bursts into the cottage. His appearance here, and in the *Irish Peasant*, make one wonder if Thaddeus actually accepted the image of the 'convivial savage' or 'amiable brigand', if only as two types among many, but this is very difficult to reconcile with what is known of Thaddeus' background and his sympathy for the Irish peasantry.[47] He did describe Michael Davitt as 'a singularly fine example of the black Celtic type; his deep-set dark eyes overhung by heavy black eyebrows', but Davitt was by no means unrefined in appearance.[48] In any case, Thaddeus was sufficiently skilled in portraiture to represent 'a black Celtic type' rather than a character whose features approximate those political cartoons. His inclusion of this

46 This point has been made by C. Marshall, 1996, pp. 46–7. **47** See S. Gilley, p. 84.
48 H.J. Thaddeus, 1912, p. 176.

figure-type, therefore, prominently placed and illuminated in profile, seems very deliberate. The theory that the *Illustrated London News* may have sanctioned Aloysius O'Kelly's politically charged Irish illustrations because they were inherently ambiguous, and therefore inoffensive to both sides of the political divide, might equally explain Thaddeus' figure, were it not for the fact that everything else about the picture suggests that the artist had no intention of facilitating such a duality or of appeasing his audience.[49] It is conceivable, however, that Thaddeus' intention was to present a figure with normally negative connotations as the victim, rather than the perpetrator, of violence. This would have challenged the long-standing image of the Irish, propagated by papers such as the *Illustrated London News*, as both victim *and* perpetrator of the violence that plagued Ireland.[50] Certainly, the figure is not there for any comic value as, quite apart from the lack of scope for humour in this particular scene, Thaddeus never promoted the picaresque image of the Irish, which in the work of certain artists, particularly in 'easel-painting', assuage the negative image of the coarse Irish peasant (see, for example, Samuel McCloy's *The Arrival of Phadrig na Pib*, 1873, Charles Hunt's *Paddy's Wedding*, 1896, and Thomas Alfred Jones's *Paddy's Proposal* 1891).

Evicted, painted by Lady Butler a year after Thaddeus' eviction scene, and of comparable size and finish, is probably as close in impact to Thaddeus' painting as any work of this period. In the picture, a young woman stands stoically among the ruins of her cottage, as an eviction party of policemen, bailiffs and 'emergency-men' (or crowbar brigade) disappear in the distance. There is a symbolic quality in the stance and demeanour of the female figure, of pride and defiance, that is not present in Thaddeus' picture, but the pictures share an immediacy that is conspicuously absent from most Irish nineteenth-century genre painting. In a sense, Butler's picture presents the viewer with the inevitable result of the confrontation taking place in Thaddeus' work, notwithstanding the peasants' concerted efforts to avoid it. Moreover, Lady Butler's picture records a scene that she actually witnessed in Wicklow, and described at length in her autobiography.[51] When this picture was shown at the Royal Academy, critics were slow to make connections between the sympathies of its author and the Home Rule movement, but this merely reflected their reluctance to acknowledge what was unpalatable.[52] Nor was this evasiveness the preserve of the press. Wilfred Meynell, Lady Butler's own brother-in-law, and editor of the *Magazine of Art*, in an insipid description of the artist's similarly emotive *Listed for the Connaught Rangers*, merely identified a 'tender regret concealed under masculine reserve' rather than investigating its root cause.[53]

49 See N. O'Sullivan, 1995, p. 16. 50 The significance of this position in the reporting of the Famine is discussed by L. Williams, 1997. 51 E. Butler, 1922. 52 See K. McConkey, 1990, pp. 21–2. 53 W. Meynell, 1898, p. 9.

In many of Aloysius O'Kelly's powerful illustrations of the early 1880s for the *Illustrated London News*, he focused on the *organised* opposition that became more politically sophisticated, more proactive, and more national as the century progressed.[54] O'Kelly developed a paradigm for communicating the complex and multidimensional nature of the Land War in a legible, coherent and arresting narrative way, thereby fulfilling, if not exceeding his brief as an *actualist*.[55] Thaddeus did not concern himself with developing such means to allow the collective to represent the individual. Any collective association beyond the cooperation of those individuals under siege within the cottage relied on the familiarity of the audience with the broader subject. However, this familiarity was fundamental to the success of the picture. The audience needed to place it, even if only to a limited degree, within a broader social and political context. Both Thaddeus' and Lady Butler's paintings, which concentrate on the confrontation of individuals, are microcosms of the turbulent Irish agrarian situation. Unlike O'Kelly's crowded public scenes or, for that matter, Lady Butler's slightly histrionic *Evicted*, Thaddeus' picture engages the audience's imagination, placing them, impossibly, in the midst of the action. His painting is uncompromising in its directness. Those few easel pictures (as distinct from newspaper illustrations) of the mid to late nineteenth century that deal with evictions or similar subjects tend to focus on the threat of eviction (e.g. Erskine Nicol's *Notice to Quit*, 1863, James Brenan's *Notice to Quit*, 1881), imminent eviction (e.g. R. Staunton's *An Impending Eviction*, exh. 1880), or the aftermath of eviction (e.g. R.G. Kelly's *An Ejectment in Ireland* or *A Tear and a Prayer for Erin*, 1847, and Frederick Goodall's, *An Irish Eviction*, 1850). In marked contrast, Thaddeus' picture deals with an eviction as it actually takes place. It is not a record or interpretation of a scene observed, but almost a re-enactment of a violent episode. It therefore goes beyond such environmentally similar works as Frederic William Burton's *The Aran Fisherman's Drowned Child*, Brenan's *Notice to Quit* or O'Kelly's *A Station Mass in a Connemara Cabin*, all of which can be read more easily as straightforward *reportage*. The inescapable involvement of the viewer in the activity defines Thaddeus' picture. Placing the viewer in the midst of the action was by no means a novel pictorial device, but one that had not been used to this effect in Irish painting.

Irish artists' reluctance to record sensitive events of Irish import, such as eviction, famine and emigration, with any degree of pique or invective was less attributable to their political apathy or ignorance than it was to commercial

54 O'Sullivan, Autumn 1995, p. 11. **55** This is not to suggest that O'Kelly's illustrations were always objective. His illustrations would, on occasion, depart from the textual descriptions of the scene depicted or, alternatively, correspond to the text which he himself had written.

factors. There was, simply, no ready market for such work. Among the art buying public, regardless of their demographic, cultural, religious or socio-economic background (though that too was relatively limited), Irish subject pictures of distinctly political content were not popular. Artists were careful to produce works that satisfied the interests and tastes of their clientèle, and embodied the dignity and propriety traditionally considered appropriate for the fine arts.[56] Irish 'social themes', as a result, generally elicited sympathy from the public and indulged its innate sentimentality rather than a sense of outrage or protest. Viewed in this context, Thaddeus' picture, and Lady Butler's, were not just novel, but brave. Thaddeus made no attempt to sentimentalise his scene by focussing on the terrified child, for instance, or drawing our attention to the pained expressions of the peasants.

The radical nature of Thaddeus' picture and its unconventional subject did not, as one might expect, herald a new phase in his art. In fact, *An Irish Eviction – Co. Galway* appears to have been the last of its kind that he produced, and was certainly the last of its kind that he exhibited. Moreover, he never alluded to it, nor, remarkably, did those individuals who wrote about him. It may have suffered the same fate that befell Lady Butler's equally unfashionable *Evicted,* which remained unsold for years above her own mantelpiece.[57] Thaddeus' painting was priced at £300 at the Royal Hibernian Academy in March 1890, but could be purchased at the Walker Gallery in Liverpool just a few months later for £157 10s., suggesting perhaps how uncommercial it was.

If Thaddeus' desire was to startle his audience, he appears to have had some success. At the Art Union prize giving ceremony at the Royal Hibernian Academy in 1890, Lord Powerscourt singled him out for special mention. He certainly knew Thaddeus, and had sat for him, but it is unlikely that their friendship was close enough to have had any influence on Powerscourt's assessment of the RHA exhibition. Referring to Thaddeus, Lord Powerscourt said:

> In the picture of the eviction, a most unpleasant subject he shows vigour and originality of treatment and a power both of drawing of the figure in the tenant preparing to receive his enemies with the can of boiling water and of form of colour and chiaroscuro which makes me think that there are great days before Mr Thaddeus.[58]

That Lord Powerscourt, a landowner, should avoid addressing the subject directly, other than referring to it as 'most unpleasant' is perhaps not surprising, but the picture did at least arrest his attention. Furthermore, his appreciation of the gravity of the subject was implicit in his subsequent comparison of it

56 See Bhreathnach-Lynch, 1997, p. 251. 57 Usherwood and Spencer-Smith, 1987, p. 95.
58 *Freeman's Journal*, 21 March 1890.

with a picture by Marec of a drunken husband assaulting his wife 'in their desolate home', which he had seen at the Paris Salon two years earlier.[59] The review of Thaddeus' picture in the *Liverpool Daily Post* was less circumspect:

> 'The Irish Eviction', by Thaddeus, will help to bring the horrors of the social warfare in the sister isle vividly home to English hearts. There is no doubt that many such scenes as this took place when the evictions were in full swing, and the incident is given from the interior of a dark cabin, half obscured in steam and smoke, with all the uncompromising details of a desperate struggle for home and liberty. It is a very dramatic and powerfully painted work ...[60]

One imagines that this reviewer's liberal choice of emotive language was much more in keeping with Thaddeus' intentions than the artistic niceties of Lord Powerscourt's praise. Having said that, both showed more regard for the subject than Lord Salisbury, the Prime Minister, famously did for Lady Butler's *Evicted*, when he announced disdainfully at the Royal Academy Banquet of 1890 that there was 'such an air of breezy cheerfulness and beauty about the landscape which is painted, that it makes me long to take part in an eviction myself whether in an active or a passive sense'.[61] Lord Salisbury would, no doubt, have made similarly facetious remarks about Thaddeus' painting, given the opportunity.

Though specifically Irish political affairs did not feature in Thaddeus' art after 1890, his interest in Ireland did not wane. Victor Thaddeus recalled that when his father was living in America, 'the Irish question burned as fiercely for him as when in the teens he painted his first successful picture'.[62] This opinion was corroborated by a letter Thaddeus sent to the Cork School of Art in June 1920, over a year into the War of Independence, in which he expressed his hope for 'a closer association in the future not only with the art life of his native city, but with that of a regenerated nation'.[63] The letter in question was one of a number concerning Thaddeus' portrait of Pius X, which he was offering on loan to the Cork Gallery. He was obviously eager to be represented in the gallery and in the course of this correspondence even offered to cover the costs of transporting the picture from London.[64] The letters also attest to the fact that Thaddeus visited Cork, as they are addressed from Hydro, St Anne's Hill in Blarney, where he was known to have used the studio built there by the Cork

59 Ibid. **60** *Liverpool Daily Post*, 16 September 1890. **61** Usherwood and Spencer-Smith, 1987, p. 95. **62** Victor Thaddeus, op. cit., 17 March 1943. **63** Transcript of a letter from Harry Jones Thaddeus to the Technical Instruction Committee of the County Borough of Cork, TICCBC, 28 June 1920. **64** Transcript of a letter from Harry Jones Thaddeus to the Technical Instruction Committee of the County Borough of Cork, TICCBC, 14 June 1920.

sculptor Richard Barter (d. 1896). Barter, who Thaddeus is said to have known well, built a studio on the grounds of the Hydropathic 'clinic' established by his friend and namesake, Dr Richard Barter.[65]

An alternative, and almost certainly apocryphal, account of the circumstances surrounding the Crawford Gallery's acquisition of the portrait of Pius X, provided by Seamus Murphy, suggested political motives on the part of the artist. It purports that while Thaddeus was on his final visit to Cork in 1920, the incumbent lord mayor, Tomás MacCurtain, was murdered, and that, having attended the public inquiry at Cork City Hall, the artist was 'so indignant that he gave the portrait of Pius X to Cork Corporation, to be sold as a gift to the national funds'.[66] Murphy continued that the Corporation, recognising that the picture did not have particularly high market appeal, placed it in the School of Art. MacCurtain was a former leader of the Cork Volunteers, and a Sinn Féin Councillor for Cork North-West, before becoming lord mayor of Cork in January 1920. He was assassinated in March of that year, probably by members of the Royal Irish Constabulary.[67] Diarmuid O'Donovan provided a variation of this account, saying that the picture was offered in 1920 'to a prominent Corkman to use as a means of raising funds for his beleaguered countrymen'.[68] Nothing in Thaddeus' correspondence with the Technical Instruction Committee indicated that his motives for offering the picture were in any way political. In any case, though he was at times guilty of grandiloquence, and obviously had great confidence in the quality of his work, he is unlikely to have overestimated the value of it to the extent that Murphy's theory indicates.

As Cork, to which Thaddeus was so emotionally attached, was one of the regions worst effected by the War of Independence (1919–21), one assumes that when Thaddeus, in 1920, talked of a 'regenerated nation', he was referring to a peaceful, post-revolutionary Ireland. Michael Holland emphasized that Thaddeus retained an 'old grah' for Cork, and that on Thaddeus' final visit in 1920, it gave the artist great pleasure 'to wander through the streets of the city, and recall memories of his boyhood days'.[69] It was probably on this final visit that Thaddeus executed his portrait of Holland, which, though unfinished, is the latest known work by him, and which he presented to the Cork School of Art in July 1920 (pl. 24).[70] Holland (1855–1950), an eclectic figure who played an important role in the development and dissemination of Cork's art and culture, was one of Thaddeus' oldest friends. He may even have attended the Cork School of Art at the same time as Thaddeus.[71] He enrolled as a member

65 See T. Crosbie, 1896, pp. 85–8. 66 Gwynn, 7 August 1951. 67 P. O'Farrell, 1980, p. 95. 68 O'Donovan, 1961, p. 42. 69 M. Holland, 1937, p. 32. 70 TICCBC, 12 July 1920. The Committee agreed to send a letter of thanks to Thaddeus and to make available £4 for the provision of frame for the picture. 71 See T. Snoddy, 1996, p. 196; C.Ó'S 1950, pp. 126–7; C.J.F. McCarthy, 1991, pp. 43–9 and C.J.F. McCarthy, 1985.

of the Cork Historical and Archaeological Society a year after its inception in 1891, contributed over forty articles to its journal, and ultimately became president of the organisation. He also contributed illustrated 'strips' to the *Cork Examiner* and the *Cork Weekly Examiner*.

The portrait of Holland is quite crudely painted, attributable perhaps to Thaddeus' apparent artistic inactivity in the last years of his life. The sitter's face, with pink cheeks, and remarkably blue eyes, lacks the naturalism that characterises Thaddeus' finest portraits, although the dashes of bright green to the right of the sitter, suggesting, one assumes, foliage, call to mind Thaddeus' portrait of the old widow in Florence of some forty years earlier. The picture's oddness, however, also makes it an arresting work, and it captures successfully the sitter's distinctive appearance, and the 'naïve gentleness' that C.J.F. McCarthy counted as one of Holland's well-known traits.[72] In judging the painting, one must also bear in mind that Thaddeus never finished it, apparently as a result of Holland's misguided decision to have his hair cut. Thaddeus was horrified to see 'one of the most interesting features of the picture' altered and decided instantly to give up on the painting. He even inscribed 'unfinished' at the bottom right hand corner of the portrait, and instructed that it should be titled *Portrait of a Gentleman*.[73]

The regularity with which Thaddeus managed to stay in contact with his native city is not known. However, his desire to do so was longstanding. In October 1895, shortly after his return from Egypt, Thaddeus contacted the Technical Instruction Committee offering to 'paint a head before the students' in the Cork School of Art.[74] One imagines that this represented an attempt to reassert his status in Cork following his period away, and that he deliberately chose to demonstrate a skill in which he had excelled, both while a student in Cork, and in his professional career. Moreover, it was a discipline to which as a student he, and those who followed him, would have had little exposure. Thaddeus' experience of portrait painting had initially been gleaned from activity outside the school. Unfortunately, though the offer was accepted, the demonstration appears never to have taken place, as the minute was struck from the record. Notwithstanding the setback, it was obviously an element of their training which Thaddeus felt ought to be encouraged, and just a year later, as mentioned before, he donated a prize, in his name, to the School of Art, to be presented for 'the best study of a Head from Life shaded in Chalk'.[75] His efforts to stay in touch with his *alma mater* were obviously successful, and in May 1912 Councillor Fleming suggested that it would be appropriate to apply to Thaddeus for a picture for the School of Art Gallery.[76] The simple fact that Thaddeus, who had already been living in America for five years by this time,

72 McCarthy, 1991, p. 49. 73 O'Donovan, 1961, p. 42. 74 TICCBC, 21 October 1895.
75 TICCBC, 31 January 1898. 76 TICCBC, 8 July 1912.

replied within two months indicates that the Cork School knew how to contact him. In response to the request, Thaddeus offered two pictures on loan to the gallery, which the committee accepted gladly, agreeing that one of its members, Mr Mulligan, should 'convey their thanks to Mr Thaddeus for his generosity' and should pay for the carriage of the pictures.[77]

Diarmuid O' Donovan claimed that Thaddeus attended the exhibitions of the Munster Fine Arts Club regularly, and exhibited there, but there is no evidence that either is true.[78] In fact, if Michael Holland's assertion that Thaddeus' last visit to Cork was in 1920, is correct, Thaddeus could have attended just one of their shows.[79] The Fine Arts Club was founded on the 18 October that year, by Timothy J. O'Leary and Hugh Charde. Its aims were to encourage art in Cork and its adjoining counties, and to hold an annual exhibition in the School of Art, the first of which took place in the autumn of 1920.[80]

Thaddeus' rather piecemeal and in some cases unqualified comments on Ireland and the various political figures with whom he came into contact, while not necessarily contradictory, make it difficult to gauge exactly how well informed he was about Irish affairs. Admittedly, avowing support for Parnell did not preclude one from admiring Michael Davitt, or indeed mean that one had to reproach Sexton and O'Brien, but it does seem that Thaddeus' response to these figures' personalities was a more conclusive factor in his approach to their portraits than his assessment of their political views or decisions. In that sense, his appreciation of the complexities of Irish politics during the turbulent period from 1885 to the 1920s may well have been relatively superficial, and essentially emotional.[81] However, one has to bear in mind that Thaddeus was a person of considerable intellect, diverse interests and broad experience. It is not clear from his shrewdly phrased accounts whether or not his completion of various portrait commissions ever actually required him to compromise his principles. At the very least, one suspects that, certainly in the case of the portrait of O'Brien, his professionalism took precedence over any political reservations he harboured, but it was O'Brien's demeanour that was fundamentally objectionable to him. One wonders if Thaddeus would have been more forgiving of O'Brien if he had known his wife better. Sophie O'Brien (née Raffalovich) was the daughter of a wealthy Russian, Jewish, international banker, who had served one of the Tsars. It might at least have amused Thaddeus that O'Brien's mother-in-law referred to him as 'mon pauvre Aiglon'

77 Ibid. 78 O'Donovan, 1961, p. 42. 79 M. Holland, 9 May 1929. 80 Timothy O'Leary, Manuscript in Munster Fine Arts Club Scrapbook, 1940, Crawford Municipal Art Gallery, Cork. 81 It is also interesting to note that *Recollections of a court painter* was published in 1912, the year that the third Home Rule Bill was passed in the House of Commons (albeit only to be vetoed by the House of Lords), which may have enhanced Thaddeus' interest in Ireland.

(my poor eagle).[82] With regard to developing a clearer picture of Thaddeus' politics, it is regrettable that we do not know more about his early life in Cork. More specifically, it would be very interesting to know what his early impressions of Isaac Butt may have been. By 1877, when Thaddeus painted his portrait, Butt's political energies were all but exhausted, but his contribution to the cause of Home Rule had been enormous. He, like Redmond, who Thaddeus so admired, was committed to constitutional nationalism, and did not countenance the kind of militant measures that were being employed with increasing regularity by his successors. In *Recollections*, Thaddeus the raconteur, was opinionated, and at times provocative, but the book was essentially too anecdotal to allow for any great political insight. Thaddeus' artwork remains our most reliable evidence. What is certain is that *An Irish Eviction – Co. Galway* testifies much more to heartfelt concern for the Irish situation than the 'ethnographical and detached' interest that has been pointed to in the work of other Irish artists of the nineteenth century.[83]

82 Warwick-Haller, 1990, p. 145. 83 Barrett, 1975, p. 396.

Apart from portraiture

This clever artist has shown so many portraits lately that the public were deceived into the notion that he had become a portrait painter, pure and simple. But the present canvas shows him as an artist of great versatility, a man whose brush makes precious anything it touches.[1]

Writing these lines about Thaddeus in an account of the Royal Hibernian Academy Exhibition of 1899, the reviewer for the *Irish Daily Independent* revealed, perhaps unwittingly, a fundamental truism about the art of Harry Jones Thaddeus. While the writer may have been guilty of some hyperbole in qualifying all Thaddeus' works as 'precious', the reference to the artist's versatility was perspicacious. If one examines broadly the work of Thaddeus' mature career, one finds an extraordinary diversity of subject type. Thaddeus flirted with various genres, including landscape painting and a wide range of subject pictures, from Mediterranean genre scenes, to bourgeois conversation pieces, to literary themes. As far as one can tell, his interest in some of these was transitory to say the least, but the variety indicates an expansiveness that is not manifest in his portraiture. In a sense, it is indicative of a conflict between Thaddeus' commercial and artistic ambitions and bears out the notion conceded by the *Art Journal* in 1901, that 'the majority of visitors to a picture exhibition search paramountly for subject: a well-told narrative, a landscape with a generous measure of photographic exactitude, these are what they want'.[2] More importantly, however, the scope of Thaddeus' work reflects both the peripatetic life that he led and the multifarious elements of his character.

THE ORIENT

Thaddeus had a close association with Egypt for a period of about three years, from the autumn of 1891 to the summer of 1894, but this does not represent the hiatus in his career, and isolation from London society, that one might infer from his detailed account in *Recollections*. His appointment as court painter to

1 *Irish Daily Independent*, 6 March 1899. 2 Rinder, 1901, p. 41.

the khedive in Cairo was undoubtedly a significant event in his life, but did not prevent him from returning regularly, and for lengthy periods, to Europe. He built a house and studio in Cairo, which were completed by November 1892, but generally spent just the winter months there, passing the remainder of the year in rented accommodation in London. When he arrived in Port Said in late 1891, Thaddeus had already visited North Africa at least twice, finding himself, somewhat serendipitously, in Algiers in 1886, and spending a winter, probably that of 1889, in Morocco with his friend, the explorer, Paul du Chaillu. Thaddeus wrote that 'before leaving for Egypt in 1889, I went to see [Professor Owen] at Sheen', but he may be mistaken, as there is no other evidence that he travelled there, rather than to Morocco, that year.[3] Notwithstanding the element of chance to these early encounters with North Africa, much of the work Thaddeus produced there seems to have resembled that of numerous European and American artists who flocked there throughout the nineteenth century. He claimed that his visit to Algeria was precipitated by the gloom and despondency that had resulted from an earthquake in Nice (though no such event was reported in the British press), where he was staying. However, his impressions of Algiers were expressed with an air of authority typical of the Orientalist tourist, rationalising and evaluating what he saw in terms of his European frame of reference, and his inherited expectations of the Orient.[4]

Thaddeus arrived in Algiers at the beginning of Ramadan, and held forth in his *Recollections* on the detrimental effect that the forty days fast had on 'the stomach, brain and temper' of the Islamic population.[5] He illustrated his contention with a theatrical account of being attacked by a frenzied mob for painting a sleeping beggar-man in the secluded burial grounds of a mosque. The rather patronising opinions he proposed about Islam were based on an assumed and apparently unchallenged knowledge of its history. 'Why Mohammed ever instituted this long and trying fast', he wrote, 'is to me inexplicable. The Arabs in his time were a frugal, hardy race, not addicted to gluttony, nor satiated with rich food, those of his wealthy and indolent followers ... belonging to a more recent date'.[6] Islam was problematic for Europeans and a source of confusion and fascination for Western artists. Considered by many to be a fraudulent version of Christianity, it was thought by some to provide in itself a justification for European involvement and 'guidance' in the East.[7] The broad strategy employed in the East by the West relied on the pretext that its peoples would learn about and, in turn, rediscover themselves through the mediation of Europeans.[8] The artist Lady Butler, who had considerable experience of North Africa, endorsed this argument, while recognising flaws in its implementation, asking of the people of Egypt, 'How shall these people be brought up to a

3 H.J. Thaddeus, 1912, p. 186. 4 Ibid., p. 123. 5 Ibid. 6 Ibid. 7 Ibid., p. 59.
8 M. Bernal, 1987, p. 236.

Christian level of thought? Where shall the work begin?'⁹ In Thaddeus'
comments, one can at least detect the altruistic notion that some sections of
society fared better than others during Ramadan, which is consistent with his
feelings about the plight of the rural poor in Ireland. Nor did he support all the
actions of the British in North Africa, and later, when discussing the conduct
of the military, decried their unscrupulousness, denouncing in particular the
supposedly heroic feats of General Gordon in the Sudan, who he felt displayed
no more religious tolerance than 'a Spanish Inquisitor'. Gordon, governor-
general of Sudan, had died in 1885 fighting the Mahdi when his garrison at
Khartoum was overrun before reinforcements could reach them. He was
lionised by the British press, for whom his valour became synonymous with what
they saw as the brave struggles of the British military to pacify Africa. Thaddeus
found the retribution sought after Gordon's death even more distasteful,
likening it to an infamous event in Irish history. 'The whole affair recalls to my
mind', Thaddeus wrote, 'another occasion when a sturdy Puritan spirit was
displayed by Oliver Cromwell; and he (also deeming himself a divinely appointed
avenger) put to the sword the women, children, and garrison of Drogheda ...'¹⁰
However, Thaddeus' criticisms of British colonial policy, and the sympathy he
felt for the fellaheen and foot soldiers of North Africa did not, as far as one can
tell, lead him to question, fundamentally, the legitimacy of a European presence
there. Instead, he harboured typically European preconceptions about the
nature of North African society, and the adjudged inability of its native peoples
to govern themselves. While he quoted the *gendarmerie* in Algeria as admitting
to him that 'we only hold the country by the sword', he nevertheless portrayed
Algeria and Egypt alike as relatively uncivilised and potentially anarchic nations
which required the guidance of European powers to ensure their stability.¹¹ The
Irish, in contrast, were both European and Christian, so Thaddeus must have
felt that they required no such enlightenment. The treatment meted out to the
Irish peasant, therefore, of whom Thaddeus had a greater understanding, was
from the colonisers' point of view more difficult to justify.

 Thaddeus arrived in Egypt with a letter of introduction from the duke of
Teck to the British consul-general, Sir Evelyn Baring, with whom he remained
in close contact throughout his sojourn in Cairo. He admired Baring tremen-
dously, while acknowledging the 'dread and respect associated with his name'.¹²
Baring's often ostensibly benevolent rhetoric regarding British involvement in
Egypt, which might have quelled reservations felt among the British public, was
mitigated by other statements, such as his telling remark that 'the mind of the
Oriental ... like his picturesque streets is eminently wanting in symmetry. His

9 Meynell, 1898, p. 28. 10 H.J. Thaddeus, 1912, p. 224. 11 For an account of British
colonial history in Egypt, see F. Brockway, 1973. 12 H.J. Thaddeus, 1912, p. 201.

reasoning is one of the most slipshod description'.[13] Similarly, Thaddeus portrayed Egypt as a fascinating multicultural country, but rife with underhand and nefarious dealings, conspiracies and corruption. His knowledge of the Orient, like that of so many Europeans, was gleaned from a relationship of control, which influenced judgements of taste, value, beauty, morals, as well as politics and economics. As a result, he did not address in his writings or his art the insidious nature of European hegemony. Instead, his subject pictures reflect a voyeurism and interest in the exotic based on a patriarchal pretext, which typifies Orientalist painting of the nineteenth century.

Arriving in Cairo in 1891, Thaddeus installed himself in the grand Shepheard Hotel, and his description of the scene observable from its terrace illustrates the manner in which European artists were captivated by North Africa. Before the hotel, Thaddeus recalled,

> passed a ceaseless *va et vient* of Oriental life; a veritable kaleidoscope of colour and interesting humanity. Trains of camels, laden with dates and other produce from the desert, with Berber or Soudanese drivers bobbing up and down on their backs, passed to their destination in the Bazaar; then would come a smart Parisian carriage containing ladies of the harem, the horses preceded by two running Syces, shouting lustily to clear the way; on the box seat by the driver the ubiquitous eunuch.[14]

Thaddeus' artistic output in Algeria, Morocco and Egypt illustrates those very elements of the Orient, some of which he mentioned, that Western artists sought by volition and discovered by design. For Thaddeus, like so many of his contemporaries, the East was, 'inevitably picturesque'.[15] Unfortunately, very few paintings by Thaddeus that would further substantiate this argument are known. However, two small works and a number of titles demonstrate how conventional Thaddeus' Oriental subjects were, and how readily he adopted a style advanced by visiting European and American artists. His small painting of a man sitting with legs crossed polishing a highly ornate musket is a typically mundane Orientalist image (fig. 30). Western artists were fascinated by the paraphernalia associated with standard 'types' in the East – the guard, the falconer, the dancer, the merchant, the musician – and Oriental firearms, so physically different from their European equivalents, appear in countless paintings, invariably as much as decorative as functional objects. In his painting, on which he may have based a later exhibition piece, *The Sheerif's Gun (Morocco)*, the simplicity of the figure's costume serves to focus attention on the elegant gun and the other, equally ornate accoutrements that lie by the man's side.[16]

13 Quoted in E.d Said, 1978, p. 38. **14** H.J. Thaddeus, 1912, pp. 193–94. **15** L. Nochlin, 1983, p. 129. **16** *The Sheerif's Gun (Morocco)* was shown at the Walker Art Gallery Autumn

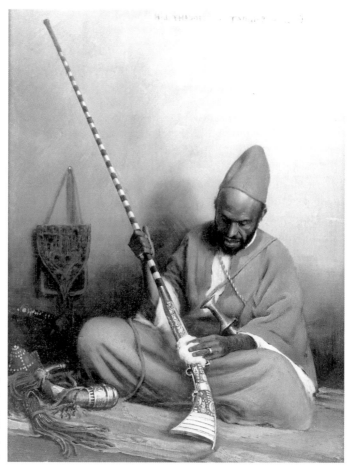

30 *'The Sheerif's
Gun' – Study
(Morocco)*, 1889.
Oil on panel
21.5 × 16.5.
Private collection.

The intricate detail and smooth finish of the picture are characteristic of a
particular Orientalist style, as is the figure's languorous absorption in his task.[17]

An alternative, but equally conventional, view of the East is provided by
another small painting by Thaddeus. In *Gypsy Eyes*, painted in 1890, which
Thaddeus presented to Mrs Smillie, his former landlady in Florence, a young
Circassian girl in ornate dress, sitting on a patterned carpet, admires herself in
a hand-held mirror (fig. 31).[18] The image conforms to an old stereotype of
Oriental women, which portrays them as narcissistic, exotic and titillatingly

Exhibition in Liverpool in 1889, priced at £105. **17** Thaddeus is sure to have been familiar
with the tight technique and high finish of the paintings of Jean-Léon Gérôme, who was
teaching at the École des Beaux-Arts when Thaddeus was in Paris, and whose work was
widely known in original and engraved form. **18** It is inscribed 'To Mrs Smillie. A tribute
of deep affection from the artist'.

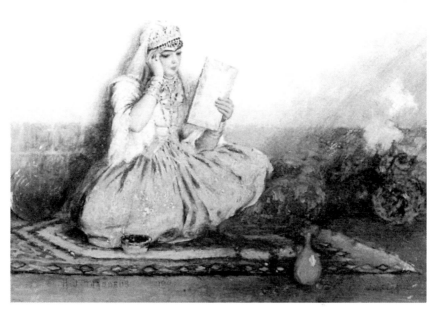

31 *Gypsy Eyes*, 1890. Oil on panel 18.5 × 23.5. Private collection.

unattainable. She is apparently oblivious to her observer, a condition that renders her simultaneously vulnerable and unavailable.[19] The viewer is placed in the position of the voyeur given clandestine access to a sequestered and exotic environment.

Pictures such as these were, for a Western audience, the stuff of fantasy and wish fulfilment.[20] The coyness that marks them contrasts with the directness of contemporary pictures, with which Thaddeus would have been familiar, of Parisian *coquettes*, mistresses and prostitutes. However, the traditional, thematic homogeneity of Orientalist painting often swayed the most innovative of artists. Thaddeus' pictures adhere to a long-standing paradigm, which perpetuated myths about the Orient, such as the indolence, inactivity and timelessness inherent in its society. In his exhibition works, which included *A Soudanese Love Song (Morocco)* (Walker Gallery Autumn Exhibition, 1889), *Street in Algiers* (Walker Gallery Autumn Exhibition, 1890), *The Mosque Abdelrahman, Algiers* (RHA, 1892) and *Water-seller, Cairo – a study* (RHA, 1896) he concentrated on those features of the Orient (customs, costumes and religious practice) deemed

19 R. Kabbani, 1986, p. 68. **20** D. A. Rosenthal, 1982, p. 98.

by the West to be picturesque not simply because of their 'Otherness', but because they were seen to represent precious elements of a *disappearing* and primitive way of life.[21] In that sense, they resemble pictures of Breton peasants produced by Thaddeus and many of his contemporaries, but lack those European images' inherent *decorum*.

The exploration of the East to 'discover' the exotic eclipsed the political and social considerations that had accompanied Thaddeus' focus on Ireland. However, these images of the East cannot be seen as completely apolitical or atemporal. Their very existence serves as a reminder of the subjugating and long-standing Western presence in the Orient. Europeans' influence and dominance allowed them to explore, to investigate, to possess and, fundamentally, to create, the Orient. Thaddeus was not innocent to the effect that the Orient had on artists, however predetermined or contrived it might have been, but indulged it nevertheless. 'Altogether', he wrote, 'it was a bewildering sight to one unaccustomed to Oriental life. The dust, noise, glare, and constant movement deadened the senses, and the scene was finally contemplated in a semi-conscious manner through blurred eyes'.[22] These words echo those of Thaddeus' fellow artists Richard Dadd, Dehodencq and Wilkie, all of whom maintained that the Orient had the power to affect the brain. Ireland did not have the Orient's exotic or picturesque connotations and material curiosities to distract Thaddeus from the political realities. He could not place Ireland outside time and observe it with the objectivity artists erroneously believed they employed in the Orient. In many ways, for the tourist, the Orient was too fragile to withstand serious examination. It was fascinating largely because it was seen to be inherently transient.[23] Again Lady Butler, whose experience of Ireland and the Orient was very similar to Thaddeus', wrote that 'I shall, soon, in my own happy way, cease to notice what I don't like to see and shall enjoy all that is left here of the original East and its fascinating Barbaric beauty.'[24] The Egyptians differed from these artists culturally, ethnically and, very importantly, religiously, and rather than trying to see beyond these differences and aspire to achieve a greater degree of objectivity, the artists chose to hone in on the curious, enchanting elements of the Orient and indulge Western taste for the exotic.

Inconsistencies in the portrayal of Ireland and Egypt was not Thaddeus' preserve. Aloysius O'Kelly, whose illustrations for the *Illustrated London News* elevated and dignified the Irish peasant, produced and exhibited a large number of stock Orientalist pictures. Often supremely executed, very much in the idiom of Gérôme, his former master at the École des Beaux-Arts in Paris, they feature the same picturesque and exotic peasants who populate the work of other

21 Another North African picture by Thaddeus, assigned the title *Arab Walking through Narrow Village* was sold at Christie's, New York, 15 January 1985. 22 H.J. Thaddeus, op. cit., 1912, p. 195. 23 J.M. MacKenzie, 1995, p. 53. 24 Butler, 1922, p. 202.

Western artists. Indeed, many of O'Kelly's works were substantially more ambitious than Thaddeus' appear to have been. Lady Butler also neglected to paint African subjects with the same conviction she reserved for *Evicted* and *Listed for the Connaught Rangers*, although it is evident from her writings, very much influenced by those of her outspoken husband, Major William Butler, that she was not convinced by British military policy there.

These artists evidently did not draw parallels between the experience of the Irish and Egyptian peasantry, though both, regardless of skin colour, were subjected as a matter of course to the hierarchical distinction between 'ruler and ruled'.[26] There had been a tradition in oil painting and illustration of representing the Irish as 'Other', in the way that British and Irish artists addressed subjects in North Africa. Thaddeus, O'Kelly and Butler challenged this representation of the Irish in a search for greater authenticity and accuracy, but did not manage to extend its logic to their artistic recording of North Africa.

Despite Thaddeus' adherence in his art to established Orientalist models, he evidently aspired to a greater knowledge of Egypt than was apparent among many of those with whom he came into contact there. He criticized the Consulate staff who 'knew little of Egypt or the Egyptians, and disdained to study the subject', and greatly admired the knowledge of the country and its people of his friend Harry Boyle, an Irishman who was chief secretary to Sir Evelyn Baring.[27] His ambivalence with regard to Egypt, its people and politics, however, must be attributable to some extent to the fact that, for much of the time, his lifestyle remained the same as he had enjoyed in Europe. Unlike many of his fellow artists and writers, who lived relatively frugally and independently, albeit for a short period, in North Africa, or like John Frederick Lewis, actually adopted local customs and costume, Thaddeus kept in contact with a comfortable European and Eurocentric community. In *Recollections*, Thaddeus spoke of attending private dinners at the consulate, and balls and evenings at the casino, just as he had done in Europe. His acquaintances in Egypt included Sir Philip Currie, Bax Ironside and Eldon Gorst, all members of the British administration, and Sir Francis Gorst and his successor Colonel (subsequently Lord) Kitchener, sirdars of the Egyptian army. He was assimilated into circles whose relationship with Egypt was profoundly and necessarily patrician. Rather than withdrawal, he called for increased honesty from the British government, and an adoption of the principle 'J'y suis, j'y reste' instead of the 'virtuous promise to eventually evacuate Egypt'.[28]

Europeans travelled in large numbers to North Africa and the Middle East for a number of reasons, including the fact that those regions offered a new,

26 E. Said, 1993, p. 275. 27 Ibid., p. 206. 28 H.J. Thaddeus, 1912, p. 221.

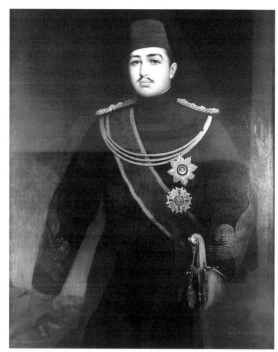

32 *Abbas II Hilmi,*
Khedive of Egypt, 1892.
Oil on canvas 130.8 × 96.8.
Royal Collection.

dramatic landscape and architectural environment to explore, as well as a
dramatic cultural and religious diversity, and because they were relatively close.[29]
All of these motivations might be said to apply to Thaddeus, but another
crucial, if rather banal attraction for him, was the potential for furthering his
career there among the colonial community. Thaddeus was not alone among
European artists in producing portraits while he was in North Africa, but he
was predisposed to such pursuits because of the connections he had already
established within European military, political, diplomatic and social circles. In
fact, it was these associations that facilitated his introduction to a new circle-
those of the indigenous community, including the khedive, who collaborated or
co-operated with their occupiers.[30]

Though Thaddeus' appointment as painter-in-ordinary to the khedive was
celebrated by those who wrote of him during his life and afterwards, and was a
source of considerable pride to the artist himself, it seems that it was merely an
honorary position and, practically, did not involve any proprietary duties. In
fact, it is possible that Thaddeus produced just one work for the khedive, and
had the title of 'khedival court painter' conferred upon him purely for the
purposes of delivering it with appropriate formality to Queen Victoria.

29 MacKenzie, 1995, p. 54. **30** Ibid., p. 46.

Thaddeus stated that his trip on the khedive's behalf from Cairo to London was his 'first and only official mission'.[31] Abbas II was just eighteen years of age when Thaddeus was introduced to him by Evelyn Baring, and had only recently assumed the role of head of state after the death of his father, Tewfik Pasha, on 7 January 1892. The artist found him an amiable character, and had a number of subsequent meetings with him before he was informed by Baring that the khedive wished him to paint his portrait (fig. 32). Thaddeus recalled that the khedive took a genuine interest in the progress of the painting, for which he provided a number of sittings over a protracted period.

The khedive, motivated as far as Thaddeus was concerned by 'noble ideas and lofty principles', decided to present Queen Victoria with his portrait as a gift, and asked the artist to deliver it in person, furnished with an autograph letter of esteem from the khedive himself.[32] Strangely, in the letter, the khedive did not announce Thaddeus as operating in any official capacity, but simply explained that 'I have availed myself of the presence of Mr H.J. Thaddeus in Cairo to have my portrait painted by him, in the hope that Your Majesty will be graciously pleased to accept it as a mark of my most respectful homage.'[33] The khedive then sent a second letter from Alexandria in July, reiterating these sentiments.[34] Arriving in May 1892, Thaddeus communicated with Sir Harry Ponsonby, private secretary to the queen, and arranged a private audience with her at Windsor. The painting was sent ahead to be hung advantageously and then covered until Thaddeus arrived to unveil it. He wrote that he was 'not altogether unknown to the Queen', presumably as a result of his friendship with the Teck family, and that she greeted him warmly.

Thaddeus' portrait of the khedive is unlike any other work by him, which suggests strongly the influence of the khedive himself. His tastes corresponded to those prevalent among Ottoman potentates and dignitaries throughout the nineteenth century, which found expression in the work of artists in the Near and Middle East.[35] The idealised, pale, porcelain-like finish to the face contrasts with Thaddeus' formal portraiture in Europe, which tended towards greater naturalism and accentuated the idiosyncratic contours of the face. The portrait conforms to a hybrid, schematic style adopted by Christian artists active in the region, combining elements of both Eastern and Western art. Thaddeus' picture makes an interesting comparison with the portraiture of the Lebanese artist Daoud Corm (1852–1930), whose career followed an uncannily similar path to that of his Irish contemporary. Corm studied in Rome at the Institute of Fine Arts, and while in Italy, eagerly familiarised himself with the work of great Italian artists such as Raphael, Michelangelo and Titian. He received

31 H.J. Thaddeus, 1912, p. 227. 32 Ibid. 33 Abbas II Hilmi, Khedive of Egypt, Letter to Queen Victoria, Abdin Palace Cairo, 7 April 1892, RW, RA 027/106. 34 See RW, RA 027/109. 35 Stephen Vernoit, Letter to the author, 11 June 1995.

important commissions in Rome, including one for a portrait of Pope Pius IX. He subsequently became official painter to the Belgian court under Leopold II.[36] Returning to Lebanon, Corm produced portraits of important figures in Syria, Lebanon and Egypt, including, in 1894, one of Abbas II, considered to be among his finest.[37] Corm's self-portrait and portrait of his wife, painted circa 1890, display the same appropriated Western style of portraiture, with its smooth finish, expressionless, almost bland features and blemishless complexion that are in evidence in Thaddeus' portrait of the khedive. Thaddeus paid considerable attention to the detail of the medals which adorn the sitter's jacket, a characteristic of Middle-eastern portraiture, which emphasises their significance and reduces perhaps the relative importance of the 'likeness', normally so crucial in European formal portraiture.[38] In Thaddeus' portrait, Abbas II wears the star of St Michael and St George, and the ribbon and star of the Order of Osman. Abbas II was evidently deeply involved in the conception and ultimate composition of Thaddeus' portrait of him, but that does not confer on the artist immunity from the charges of Orientalism that apply to so many of his European contemporaries. For the most part, the portraits that Thaddeus produced in Egypt were in a European idiom, because they were predominantly of European sitters.

Having inspected the picture, and asked Thaddeus some questions, Queen Victoria requested him to convey to the khedive her gratitude for the gift. Thaddeus implied that nothing short of an international incident ensued, as she had not shown due regard for Egyptian protocol by reciprocating the khedive's gift with one from herself. The khedive's expectation of a gift was evinced by his nomination of Thaddeus to travel back to Cairo with it. None was forthcoming, so Thaddeus made representations to Harry Ponsonby, Lord Rosebery, the foreign secretary, and Princess Beatrice, Queen Victoria's daughter, but to no avail. Consequently, Thaddeus afforded his painting a questionable significance in having precipitated a period of strained relations between Egypt and Britain. These events did indeed precede a rapid deterioration in the relationship between the khedive and the British. When Evelyn Baring wrote of Abbas II in 1915, he accused him of extreme Anglophobia, and later declared that when Abbas II was ultimately deposed by the British government, 'it was not just an act of political justice' but was acted 'in the best interests of the Egyptian people'.[39] Though Abbas II was forced to cooperate with the British authorities after 1900, he remained a thorn in their side, and was deposed in 1914 in favour of his uncle, Hussein Kamil.

Unlike his immediate predecessors, Abbas II promoted the arts and was certainly pro-Western. In February 1892, he opened the second Cairo Salon, which had a distinct Western bias. *The Times* extended guarded praise to the

36 British Lebanese Association, 1989, pp. 101–4. 37 Ibid., p. 101. 38 O. Millar, i, 1992, p. 253. 39 The earl of Cromer, 1915, vii.

khedive in its report of the event, remarking that 'in most Mohamedan countries pictures and reproductions in any form of the human figure are still held in abomination, so perhaps we must trace to his European education the liberal tendencies of the young Khedive, and the undoubted liberties he took in the pictures exhibited'.[40] Among the works on view were several by the French artists Jules Dupré and Théobald Chartran and the American, Frederick Arthur Bridgman. The place of honour, however, as reported by *The Times*, was given to 'the fine portrait of Sir Evelyn Baring, by Thaddeus, who also exhibits an unfinished portrait of Lady Alice Portal, which the Khedive particularly admired'.[41] It is significant that Thaddeus should have exhibited in Cairo portraits of Western sitters, which, certainly in the case of Lady Portal, would have looked no different had they been painted in London. Though he experimented with new subject matter there, the East provided Thaddeus with neither profound cultural nor technical liberation.[42] He may not even have ventured beyond the city.

LITERARY SUBJECTS

From the beginning of his career, Thaddeus seems to have been interested in literature and literary figures. He spoke enthusiastically, for instance, of meeting the influential writers Alphonse Daudet and Edmund de Goncourt when a student in Paris, and recorded with amusement that on his walks in the Cascine in Florence with the Duke of Teck, he used to expound his own radical theories based on the 'subversive doctrines of Jean Jacques Rousseau'.[43] In his *Recollections*, he also mentioned his introduction in London to Robert Browning and counted among his friends later in life the English journalist, critic and fiction writer Frank Harris and the American novelist Jack London.[44] Harry shared this interest in literature with Eva, who passed on to her son Victor 'a liking for good books', so it is not surprising that literary themes should feature in his *œuvre*. Their presence is even more appropriate when one recognises that in three important cases, the relevant pictures also allowed Thaddeus to communicate a sense of Irish identity, and his consciousness of artistic lineage.

Thaddeus seems to have held Daniel Maclise in particularly high regard. The parallels between their careers are worth noting. Alongside John Hogan and Samuel Forde, Maclise was among the first students at the Cork School of Art, the institution attended by Thaddeus nearly forty years later. Maclise left Ireland when aged around twenty-one, but always maintained strong links with his native country. Thaddeus left at seventeen, also to advance his career abroad,

40 *The Times*, 19 February 1892. **41** Ibid. **42** See MacKenzie, 1995, p. 65. **43** H.J. Thaddeus, 1912, pp. 60–1. **44** Victor Thaddeus, 30 March 1943.

and despite the extraordinary extent of his travels, never lost touch with Cork, visiting, exhibiting and maintaining close friendships there throughout his career. Maclise was generally considered one of the city's greatest sons, and was highly respected abroad. John Gilbert described him as 'a man of literary culture … modest, gentle and frank' and recalled that William Powell Frith wrote in his memoirs that Maclise's 'powers of drawing, his prodigality of invention, the facility with which he grouped crowds of figures, the splendour of his imagination displayed in all he did, carried me away captive. He was delightful in every way; very handsome in person and of a generous and noble disposition …'[45] Thaddeus certainly longed to emulate such an enviable reputation, and, as far as some were concerned, succeeded.

Thaddeus' first foray into literary subject matter appears to have been with an English legendary theme, *Arthur Finds the Sword Excalibur*, which he exhibited at the Society of British Artists in the winter of 1885/6, the sole occasion on which he showed works there. In the absence of the picture, one cannot comment on its formal or technical qualities, but it is reasonable to speculate that it was inspired by Maclise. When the new Moxon edition of *Alfred Tennyson's Poems* was published in 1857, Maclise produced two illustrations for it, both relating to the poem *Morte d'Arthur*, which follows the tale of King Arthur's quest and death.[46] A number of the young Pre-Raphaelites – Holman-Hunt, Millais and Rossetti – had also contributed illustrations to the book, Rossetti being rather irritated that he was not asked to illustrate *Morte d'Arthur*, his favourite poem by Tennyson.[47] One of Maclise's illustrations, depicting Arthur kneeling in a boat, about to seize Excalibur from the lady of the lake, deals with precisely the same subject as Thaddeus' later painting.[48] *Arthur Finds the Sword Excalibur* did not satiate Thaddeus' appetite for Arthurian subjects, as he exhibited another, entitled *Elaine-Tennyson*, at the RHA just a few months later in 1886. Again, he took the subject from Tennyson's poetry, but on this occasion, did not repeat an illustration by Maclise. Instead, he took the theme from another Arthurian poem, *Lancelot and Elaine*.[49]

If this evidence of the influence of Maclise seems less than conclusive, a later work, also of a literary theme, puts it beyond question. In 1890, Thaddeus painted *The Origin of the Harp of Elfin*, a large-scale picture with which, in effect, he paid homage to his Cork predecessor (pl. 25). In fact, at first glance, one could be forgiven for thinking that Thaddeus' picture is a copy of Maclise's *Origin of the Harp*, painted almost fifty years earlier. Though closer inspection

45 Gilbert, 1913, pp. 174–5. **46** See P. Henderson, 1978, p. 114. **47** R. Ormond and J. Turpin, 1972, pp. 73–4. **48** Frank Dicksee chose this as the subject for his large picture, *The Passing of Arthur*, exhibited at the Royal Academy in 1889, and awarded a gold medal at the Chicago International Exhibition in 1893. **49** C. Ricks, vol. iii, 1987. The poem was first published as *Elaine*, in 1859.

shows this to be far from the case, Thaddeus was obviously and unashamedly quoting Maclise's painting.

Curiously, in *The Origin of the Harp of Elfin*, Thaddeus does not appear to have sought to improve upon Maclise's effort, or even to modernise it stylistically. He did *modify* the composition, but if anything, made the undertaking slightly less demanding than Maclise had done. For example, in Thaddeus' picture, one cannot see the face of the woman, and there is considerably less modelling to the body than is evident in Maclise's painting. While Maclise's nude wipes the tears from her cheek with her left hand, Thaddeus' buries her face in the crook of her arm, her profile almost totally obscured by the hair cascading downwards. Maclise's nude adopts the pose of a studio model, and assumes her fantastical or mythical quality through her incongruous position in the sea and her juxtaposition with the pointed rock protruding from the water. Thaddeus' figure, in contrast, is ambiguous in form and does not seem to be placed firmly in real space. Her relatively undefined torso fuses with its own reflection, so that one cannot actually see where, or if at all, she breaks the surface of the water. This almost supernatural quality is emphasized further by the echoing of the patterns of the sea in the texture of the figure's mermaid-like lower half, which lends it an almost transparent quality. The horizon, placed almost halfway up the picture plane, represents the point at which the figure's form loses definition. One might say that she is 'of the sea' rather than 'from the sea'.

As regards the illusion of the formation of a harp, the two pictures differ greatly. In Maclise's painting, the sound box is formed by the upright rock on which the woman rests her right hand. In Thaddeus' later picture, the woman herself is the sound box of the instrument, while the seaweed-encased post serves as the forepillar. The harp is therefore reversed in Thaddeus' picture, though in both paintings, remaining faithful to the poem, the artists have allowed the arm of the woman to represent the neck of the harp ('... her hair, as, let loose, o'er her white arm it fell').[50] It might be said that Thaddeus' perhaps less naturalistic and indeed less technically challenging rendition of the scene allows for a more accurate representation of the harp, but this is unlikely to have been his priority. He was certainly no great exponent of the nude, nor was anatomical accuracy his particular métier. His nudes (or semi-nudes) vary in quality, from the unmistakably academic and well-executed figure in *An Irish Eviction – Co. Galway* of 1889 (pl. 21), to the ungainly nude who lumbers around in the middle-ground of *The Temptation of Saint Anthony* (pl. 35). It may not be maligning Thaddeus to suggest that in the posing of the female figure, he erred towards expediency rather than complexity.

Notwithstanding his admiration for and debt to Maclise, Thaddeus is unlikely to have chosen this theme solely in acknowledgement of his prede-

50 T. Moore, *Irish melodies* (edition for Ireland), Dublin 1857.

cessor, as he would also have been aware of the significance of the harp as a symbol of Irish nationalism, the origins and evolution of which are well documented. The harp was adopted by the United Irishmen as their official insignia in 1791, and was appropriated ultimately as a distinctly Irish *nationalist* symbol, without the crown that had previously featured on top.[51]

The origins of the personification of the harp itself, however, as depicted in Maclise's and Thaddeus' works, can be traced to the poem *The Origin of the Harp* by Thomas Moore. In fact, rather than drawing on the poem for inspiration, and adapting or developing its theme, the two artists provided a literal visual translation of Moore's text, first published in the third volume of his *Irish melodies* in 1810 (Moore's *Melodies* appeared in ten volumes and a supplement between 1808 and 1834). Maclise's representation of Moore's poem appropriated a longstanding and familiar Irish symbol to a nineteenth-century Romantic, and broadly nationalist setting.[52] When a revised edition of *Irish melodies* was published in 1846, Maclise was commissioned to illustrate it. Moore was appropriately impressed, stating: 'I deem it most fortunate that the rich, imaginative powers of Mr Maclise have been employed in its adornment; and that, to complete its national character, an Irish pencil had lent its aid to an Irish pen in rendering due honour to our country's ancient harp.'[53] One imagines that Thaddeus would have had this pedigree in mind when executing his work.

In 1893, Thaddeus presented his *Origin of Harp of Elfin* to Princess May and the duke of York on the occasion of their marriage. This may seem a rather odd destination for Thaddeus' picture, considering its possible nationalist connotations, but one has to bear in mind that the theme was more nostalgic and Romantic than it was subversive, and indeed, appealed to an English audience fascinated at the time by legend.[54] Presenting the picture to the duke and duchess may also have provided Thaddeus with access to an audience far larger than would have seen the picture at the RHA, where it was shown alongside a portrait of Sir Richard Owen and a painting entitled *Sweet Seventeen* two years earlier. At the time of the royal wedding, presents were put on display at the Imperial Institute, where an estimated one thousand persons per hour passed through the two relevant galleries to see them.[55] Thaddeus was undoubtedly discerning in his choice of gift, and it is interesting to note that he valued *The Origin of the Harp of Elfin* highly himself. Priced at the RHA at £420, it was the fourth most expensive painting Thaddeus ever put on public sale.

Giving the painting to the royal couple was a significant gesture, both formally and informally. Thaddeus was acknowledging the couple's official status, but also the friendship that he shared with May and her family in

51 See B. Boydell, 1995. 52 Ibid. 53 Ibid. 54 See J. Turpin, 1985, p. 25. Michael Holland maintains that Thaddeus actually painted *The origin of the harp of Elfin* during a visit to Ireland. M. Holland, 1937, p. 32. 55 *Graphic*, 15 July 1893, p. 70.

previous years. It is also possible that he was availing of the opportunity to draw attention to himself as an artist who might, in other circumstances, have been considered for an official portrait commission. That year, Princess May sat for Heinrich von Angeli, M. Laurits Tuxen, and Luke Fildes, the last of whom was invited by the proprietors of the *Graphic* to produce a portrait for reproduction in the special Wedding Number of their magazine.[56] Though he may not have had any contact with Princess May for many years, Thaddeus would very likely have been conscious of the fact that the portraits he had executed of the Teck family a decade earlier would stand for little when compared to a commission from Princess May as duchess of York. In practice, no such commission materialized. Admittedly, Thaddeus was alternating between homes in London and Cairo at the time of the duke and duchess of York's wedding, so it may have been, in any case, impracticable for him to have undertaken a major commission of this kind in England. More importantly, however, Eva, as a divorcee, would not have been accepted at court, so the chances of Thaddeus ever enjoying the patronage of British royalty again was minimal. The prevailing moral and social climate was evinced by Queen Victoria's repeated refusal to receive John Everett Millais' wife, Effie Gray, even though her previous marriage to John Ruskin had been annulled. The Queen did not relent until 1896. Eva Thaddeus would have encountered similar censure.

While Moore's *Irish Melodies* were very well known in the late nineteenth century, it is interesting to consider how Thaddeus came to be so familiar with Maclise's *Origin of the Harp*. The picture did not reach the City of Manchester Galleries until 1917, and had not been exhibited publicly since its appearance in an exhibition, *Art Treasures*, in Manchester in 1857. It was sold at Christie's on 31 May 1884, the month in which Thaddeus arrived back in London from Florence, but there is no evidence to suggest that he frequented auction houses.[57] The respective accompanying texts do little to clarify matters. Thaddeus chose a different stanza from Moore's poem to accompany his *Origin of the Harp of Elfin* when it was exhibited at the RHA to the one selected by Maclise for the same purpose at the RA. The stanzas he chose, however, were the same as those that appeared above Maclise's *illustration* of the subject of 1845, though on that occasion, while Maclise illustrated the modified version of the poem, Thaddeus quoted from the original in 1892:

> 'Tis believed that this harp which I wake now for thee,
> Was a siren of old who sung under the sea;
> And who often, at eve, through the bright billow roved,
> To meet on the green shore a youth whom she loved.

56 *Graphic*, 8 July 1893, p. 38. **57** Ormond and Turpin, 1972, pp. 73–4.

But she loved him in vain, for he left her to weep,
And in tears, all the night, her gold ringlets to steep,
Till heaven look'd with pity on true love so warm,
And changed to this harp the sea maiden's form.

The most likely source for Thaddeus' picture was an engraving after Maclise's painting, produced by Graves for the *Art Journal* in 1862. He is likely to have been well acquainted with Moore's poem anyway, and simply took his quotation from the most readily available source, which, in this case, featured the original text.[58]

OTHER SUBJECTS

The critical reaction to Thaddeus' *Origin of the Harp of Elfin* is difficult to judge. The reviewer for *Freeman's Journal* provided a rather circumspect assessment of it but concluded with the significant observation that the 'tone is aggressively blue, but there is undoubted skill in the drawing, and in the moonlight effect'.[59] The unorthodox colouring identified by this reviewer is a characteristic feature of Thaddeus' painting, never more so than in his relatively infrequent landscapes. Despite the impressive extent of his travels, Thaddeus produced a limited number of landscapes, and exhibited even fewer. Two paintings entitled *Venice*, shown at the RHA in 1886, and *Boat on Beach* and *The Sands, Drenheim, Holland*, which were exhibited at Olympia in 1888, may have been his only landscapes to feature in public exhibitions. Moreover, it is difficult to ascertain from titles alone the precise character of these works. Of those pictures that are known, few could be categorised as pure landscape. Thaddeus was never associated with landscape painting, nor did he write of it, except perhaps as a casual aside in a reference to a trip to Bellagio with the grand duke of Mecklenberg-Schwerin and Baron de Benckendorf in 1884, when he stayed on after their departure to complete 'some sketches' he had begun.[60]

Fundamentally, Thaddeus was not an instinctive landscape painter. Though occasionally successful in his efforts, his style and technique did not reflect a consistent vision or assiduous application to the genre. Of the pictures that are known, a tiny scene, painted in oil, and dated 1884, ranks as possibly Thaddeus' most attractive landscape from that period (pl. 26). It had been assumed that the artist painted it on the Adriatic, but there is no evidence available to demonstrate that Thaddeus spent any time on that Italian coast. Equally, the stillness of the water, and the close proximity of the town to the shore, suggest that it is a lake scene, conceivably Lake Constance, where Thaddeus stayed with the Teck family that year. Lake Constance's situation beyond Switzerland's main

58 Ibid., p. 74. 59 *Freeman's Journal*, 2 March 1891. 60 H.J. Thaddeus, 1912, p. 70.

alpine ranges might explain the relatively low level of the mountains in the background of the picture, particularly if the view is northwards towards Germany. Thaddeus certainly painted the lake during his holiday there, using it as the background for a portrait of Princess May. In the distance, a steamer, possibly one of those that crossed routinely between the German and Swiss shores of the lake, comes into port. In his *Recollections*, Thaddeus quoted from a letter he received from the duchess of Teck, in which she mentioned the boat that would take passengers from one side of the lake to the other. 'The Christoph, the steamer which took us all to Mainau', the duchess wrote 'and in which you crossed last Monday, was in the harbour at Friedrichshafen.'[61] The viewpoint for this picture, above but close to the subject, suggests that Thaddeus was possibly on board another vessel when he painted it. However, even if he did paint the picture *sur le motif*, it did not render his palette any more naturalistic than it was in other outdoor scenes. Instead, he juxtaposed the flat duck-egg green that reappears in other pictures with a delicate mauve and pale blue for the sky. Significantly, other details of the picture are reminiscent of Thaddeus' Breton work, particularly the rendering of the fishing boat in the foreground, the sail of which is little more than a dash of unmixed pigment.

Thaddeus' landscapes tend to be summary records of scenes observed. He was essentially a studio-oriented artist, but a number of works, including two of identical dimensions, evince an occasionally more spontaneous approach. In the first of these, dated 1902, and inscribed 'JUST BEFORE DAWN/RED SEA', Thaddeus demonstrated fastidious attention to detail in painting the fishing boat, describing the garb of the sailor at its stern with a little dab of red for the hat and blue for the clothing (pl. 27). There is little doubt that this picture was painted on location, perhaps while Thaddeus was returning to England from Australia. Unusually, the picture was painted in oil on paper, and Thaddeus employed a stock watercolour device in representing the moon, simply leaving an area of the surface blank and painting around it. Oil paints sit uncomfortably on thin paper, and one can only assume that Thaddeus, rather than experimenting technically, was using the only materials available to him at the time. The authenticity of the picture as a record of a scene witnessed is emphasised by the very prominent, even vulgar, bright red signature and inscription. The precise location, date and signature seem almost as important as the image itself. To this extent, the painting has much in common with a postcard, or even the late twentieth century concept of the 'holiday snap'. Judging from its bizarre colour range, and derivative composition, it is not the work of an artist committed to capturing the essential, transient or sublime qualities of nature, but of one who took an altogether more casual approach to the genre.

61 Ibid., p. 85.

33 *Melin y gof at Treaddur Bay*, 1903. Oil on board 25.5 × 20.5. Private collection.

This informality is even more in evidence in the other picture the appears to date from the same period. Beyond representing a sunset over a coastal setting, the painting provides little topographical information, and was certainly not meant for public consumption (pl. 28). The similarity in media may indicate that it too depicts the Red Sea, but this is impossible to ascertain from the image. Relying on colour and strongly directional brushwork (which demonstrates, incidentally, that he was right-handed), Thaddeus included a minimum of detail, with no modelling or definition, and little modulation of tone. Once again, the colour range is unorthodox, featuring purples, reds, yellows and aquamarine, which the artist appears to have 'dragged' across the paper surface with a coarse, dry brush, creating a striated effect.

Thaddeus' painting of Melin y gof, a windmill in Anglesey, in oil on canvas, with its mauves, duck-egg blue and viridian, presents a colour range just as unconventional as that of the pictures of the Red Sea, and exemplifies equally well Thaddeus' readiness to record, on location, scenes from his travels (fig. 33).[62] Melin y Gof lies about a kilometre from Treaddur Bay, near Holyhead. The precise spot from which the windmill is seen in Thaddeus' picture, a footpath

62 See B. Guise and G. Lees, 1992.

between a point called Four Mile Bridge and a house called Penybont, is still relatively difficult to reach.[63] Thaddeus is likely to have sketched the scene on one of his painting excursions from Maesmawr Hall, in mid-Wales, where he was living with his family in the early years of the century. Again, it does not seem to be a carefully conceived composition, intended for exhibition, but a scene impulsively chosen – it is novel rather than picturesque – and quite sketchily executed.

Thaddeus' willingness to commit images to paper in this way may be attributable to the fact that he was, apparently, staunchly opposed to the use of photography. It may also explain why so few photographs of the painter himself survive. Victor Thaddeus maintained that one should carry a sketch-pad when one travelled, believing the camera to be the 'lazy man's way of making an impression', a maxim he inherited from his father.[64] That position would be consistent with the two seascapes on paper, which were probably extracted from a sketchbook, and with the Welsh landscape, which may well have been worked up from a rudimentary sketch produced on the spot.

The incidental nature of Thaddeus' landscape painting is evinced further by the existence of a small landscape, painted while the artist was living in California, even more so by a pencil sketch of a Mediterranean landscape with harvesters and a church, and by a watercolour of the chapel of Saint-Pierre in Montmajour, near Arles in Provence. Thaddeus claimed to have lived in Tarascon and Avignon in Provence, and the last two of these pictures may have been produced while he was resident in the area.[65] The sketch in pencil is particularly loosely drawn, and, in character, quite unlike any other known work by Thaddeus. In the background, on a steep hill overlooking a cultivated landscape, stands what appears to be a pilgrimage church, around which large crowds of people have congregated. The scene may have reminded Thaddeus of the religious festivals he is bound to have witnessed in Brittany, and which for many decades fascinated so many artists who visited that region.

The chapel of Saint-Pierre in Thaddeus' watercolour belongs to a hermitage lying to the south-east of the more accessible monastery of Montmajour (pl. 29). The church, which probably dates from the eleventh century, is of a unique design, as the interior consists of two parallel naves, the northern of which was cut out of rock.[66] This explains why the ornamental capitals in Thaddeus' picture appear to be facing an aisle, on the 'wrong side' of the piers. The watercolour, in which the underdrawing is clearly visible, is judiciously composed, accurately detailed and delicately painted, and stands alone in Thaddeus' *oeuvre* as a purely architectural subject. However, it seems improbable that the

63 Peter Barton, Letter to the author, 4 March 1999. 64 Patrick and Jan Thaddeus, conversation with the author, September 1997. 65 H.J. Thaddeus, 1912, p. 235. 66 See J.-M. Rouquette, 1980, pp. 375–60.

architectural novelty of the building alone attracted Thaddeus' attention. What is much more likely is that he was introduced to the region through the writings of other visitors, who included Henry James, and more significantly in the context of Thaddeus' Parisian influences, Alphonse Daudet. In *A little tour of France*, published in 1884, which Thaddeus may well have read, James actually referred in some detail to Montmajour and 'a queer little primitive chapel, hollowed out of the rock' as one of the many places worth investigating there.[67] Daudet, for his part, developed a deep affection for Provence, where members of his extended family lived, and returned there regularly over a period of approximately thirty years. By writing about various areas in Provence, including Montmajour, many times, Daudet brought the pleasures of the south to a Parisian audience.[68] Coincidentally, Montmajour had also drawn the eye of Vincent van Gogh when he was living in Arles from 1888 to 1889, and features in many of his drawings and paintings, though Thaddeus is unlikely to have known of these at that time.

While Thaddeus may not have encouraged the practice of photography in recording outdoor scenes, he was not averse to adopting it for his own ends in portraiture. For instance, he appears to have employed the services of a photographer when painting Pius X to counter any rumours that the pontiff had not actually sat for him and that he himself was working from photographs. Elsewhere, he seems to have drawn on photography for the pose and composition of one of his important commissions. His portrait of 1889 of the anatomist and naturalist Sir Richard Owen (fig. 27), to whom he had been introduced years earlier by the duchess of Teck, bears an unmistakable similarity to a photograph by the London studio of Maull and Polyblank of the same sitter, which dates from the mid-1850s (fig. 34).[69] Though the inclination of the head and direction of the eyes are quite different, and the figure appropriately more upright in the earlier picture, the pose of the figures is otherwise almost identical, down to the resting of the finger tips of the right hand upon what looks like a crocodile skull. This may indicate that Thaddeus produced the portrait, as usual, from life, but effectively copied the body from Maull and Polyblank's photograph.[70] It does not mean, however, that Thaddeus had an extensive knowledge of photographic methods, or the same understanding of the medium's effects and potential that has been ascribed to some of his contemporaries, such as John Lavery.[71]

Many reviewers pointed to the quality of Thaddeus' draughtsmanship, which he had displayed when still very young in his pencil and chalk portraits of Cork personalities. Victor Thaddeus remembered that his father was a 'light–

67 H. James, *A little tour in France*, Boston 1884. **68** See, for example, Daudet's *Le Trésor d'Arlatan*, Paris 1897. **69** Information on Thaddeus' introduction to Owen courtesy of the Wellcome Trust, London. **70** The photograph of Owen was published in H. Fry, *Photographic portraits of living celebrities*, no. 1, May 1856. **71** See McConkey, 1993, p. 34.

ning draftsman [*sic*], and sitting in a room could with a few strokes of his pencil portray someone we know'.[72] Unfortunately, for all his apparent skill, relatively few drawings by him are known. Among these is a series of sketches of male figures, which attest to his analytical instinct but also echo evasive and economical tendencies evident in his portraits and genre paintings. None of the drawings is dated, but judging from the style, costume and signature, it seems likely that they were produced while Thaddeus was living in London in the mid to late 1890s, or during a visit to France around that time, and may well have originated from a single sketchbook. All feature middle-aged and elderly men, of diverse 'types'. Stylistically, they can be divided into three categories and include a number of features, technical and generic, which characterize the artist's work. Four

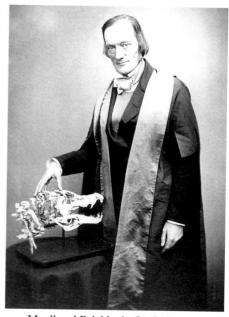

34 Maull and Polyblank, *Sir Richard Owen*, *c*.1855. Photograph. Wellcome Trust.

drawings executed in pencil and ink-wash show a tendency to caricature which is echoed in a large number of Thaddeus' paintings, ranging from minor portraits of friends to full-scale, prestigious commissions, such as the *Obbedienza* (fig. 35). They have a clarity and sureness of execution reminiscent of illustration, and call to mind the graphic work of William Rothenstein (1872–1945).

The second group consists of full-length, half-length and head studies of figures in profile, in which Thaddeus displayed a much looser hand in the outlines and hatching. Throughout his career, he showed in his portraits a propensity for presenting his sitters in profile. In a number of these drawings, he appears to have indulged this inclination, choosing characters with unusual and pronounced facial features (large noses, long beards and full moustaches), presumably fascinated by the distinctive contours. Though one's initial impression might be that these drawings were impromptu studies, produced away from the studio, it is more likely that the majority were rather deliberate, carefully posed (albeit quickly executed) works. Certain characters reappear in more than one drawing, in very different attire. Indeed, some of the figures look decidedly posed, and their stance recalls figures in a number of the artist's genre paintings.

72 Victor Thaddeus, 30 March 1943.

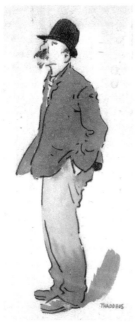

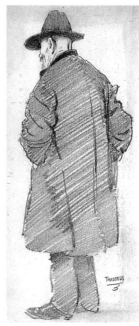

35 *Man in Bowler Hat with Hands in Pockets, c.*1895. Pencil and ink wash on paper 15.7 × 6.4. Private collection.

36 *Old Man in a Long Coat and Hat Seen from Behind, c.*1895. Pencil on paper 17.5 × 8.1. Private collection.

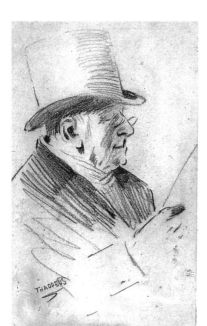

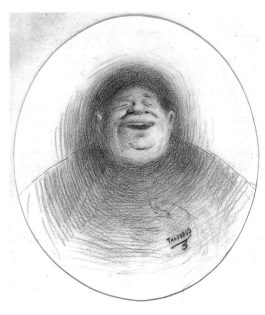

37 *Seated Man in Top Hat and Spectacles Reading the Newspaper, c.*1895. Pencil on paper 15.9 × 9.6. Private collection.

38 *Laughing Cleric, c.*1895. Pencil on paper 30 × 25. Private collection.

There are, however, at least three exceptions: a study of a man in a long coat and hat, seen from behind (fig. 36); another a three-quarter length drawing of a gentleman, again in top hat, with frock-coat and waistcoat, standing at a bar; and a third of a man in a top hat and *pince nez* reading a newspaper (fig. 37). These suggest the spontaneity of quickly observed scenes and stand quite apart from the other, more staged studies. They too may suggest that Thaddeus carried a sketchbook with him to record scenes or figures of interest.

A further three drawings of a bald, corpulent cleric in a variety of attitudes, are of similar dimensions to the figure studies mentioned above, but are distinctly more comical. In one, the character appears full-length wearing a soutane and grinning broadly. In another, bust-length sketch, he throws his head back in laughter (fig. 38), and in the third he inflates his cheeks in the act of whistling or blowing. A feature that the first of these curious sketches shares with others among Thaddeus' drawings is the rather strange, angular hatching, which does

39 *Study of a Soldier*, 1897. Watercolour over pencil on paper. Private collection.

not follow the contours of the figure, but is used solely to add volume, and approximate shadow. Significantly, in only two of all of these drawings, like so many of the artist's formal portraits, are the hands visible, and even then, they are merely suggested rather than properly observed.

A fine watercolour study of a French soldier, dated 1897, might be seen as a more advanced version of these pencil and charcoal drawings (fig. 39).[73] The relaxed posture and effective modelling of the figure attest to the artist's ability to move beyond the strict constraints of academic composition, although his isolation does remind one of a studio exercise. The solid stance of the figure recalls Thaddeus' painting of the *Young Breton Fisherboy*, a work that was also probably begun outside the studio (pl. 8). The soldier is obviously not in ceremonial uniform, which might indicate that Thaddeus executed the work while observing military manoeuvres, as he had certainly done in earlier years in Württemberg.

Occasionally, Thaddeus' interest in figure drawing and human activity combined with his irregular and unpredictable approach to landscape in large-

73 Information on uniform provided by the Commissaire-Colonel de Lasalle, Conservateur au Musée de l'Armée. Letter to Col Serge Paveau, 30 September 1999.

scale works in oil. *Mediterranean Fishermen* (pl. 32) and *The Old Prison Annecy* (pl. 31), though probably painted about a decade apart, demonstrate his understanding of compositional balance and his competent draughtsmanship, but also exemplify his persistent choice of distinctive, unorthodox hues, arguably to the point of gaudiness. *Mediterranean Fishermen* is not dated, but is likely to have been painted in Corsica in 1895. Thaddeus visited Bastia, Corte, and Ajaccio that year, staying at a villa belonging to Count Pozzo di Borgo, which was, according to the artist, situated near a small cove, inhabited by a few fishermen. 'Here', Thaddeus explained 'I spent many happy hours sketching, and we became great friends, the fishermen and I. When after a good catch the pot of *bouillabaisse* was cooked amongst the rocks … I was always invited to share the appetising meal, pleasantly enlivened as it was by the younger men, who afterwards sang and played the guitar; my contribution to the feast being wine and coffee from the cabaret near by.'[74] As Thaddeus rarely alluded to any pictures other than his portraits, this passage from *Recollections* provided a rare glimpse of the circumstances in which he produced a large genre work. The picture's smooth finish, high tonal range and bright sunlight effects are redolent of the Orientalist painting with which Thaddeus was familiar, and of which he had very recently been an exponent in North Africa.[75]

Annecy, a market town beside the lake of the same name, is situated in the Haute Savoie, a short distance over the French border from Geneva. Thaddeus is not known to have lived there, but could have travelled there on one of his frequent visits to Cannes, or when he lived in the Avignon region, which was accessible by train. The island prison visible at the centre of Thaddeus' painting, situated on the river Thiou, dates from the twelfth and sixteenth centuries, and remains one of the town's most picturesque landmarks. Thaddeus would have painted it from the main bridge in the town, in much the same way as he painted Provencher's Mill in Moret-sur-Loing in 1883. In fact, washerwomen define the Annecy picture as they did Thaddeus' painting of Moret, though in the later work the quantity of clothing the women handle suggest that they are certainly laundresses earning a living.

Both pictures communicate Thaddeus' enduring interest in the life of the peasantry, which contrasted so acutely with the world that was providing his lucrative portrait commissions. He recorded washerwomen again in 1897, in a delicate tinted drawing of figures at work among rocks, possibly on Lake Constance, where he is known to have spent some time that year (pl. 30). It was executed with great economy, relying on clarity of line and the suggestiveness of negative space. In technique, *The Old Prison Annecy* is quite progressive by Thaddeus' standards. Though he was understood to have little time for *avant-*

74 H.J. Thaddeus, 1912, p. 237. **75** See, for example, works by Gérôme, including *The Gulf of Aqaba* (*c*.1897, National Gallery of Ireland).

40 *Virtuoso Performance*, 1890s? Oil on canvas 114 × 152. Private collection.

garde methods, the short overlapping *taches* with which he rendered the water, and the square dabs with which he painted the prison walls and roofs suggest a greater debt to modern movements than he would have cared to admit. At no point, however, did he adopt these techniques wholeheartedly. The painting of the Corsican fishermen is more conservative, but betrays a lack of patience in Thaddeus' approach. Though he painted meticulously the yellow foliage of the tree over the figures' heads, he fudged the figure with the red beret seated on the far side of the table. His underdrawing in pencil is clearly visible throughout the composition.

Despite Thaddeus' intimate association with the upper middle classes, aristocracy and royalty from the early 1880s onwards, and the numerous portraits he produced of its members, on just one occasion is he known to have recorded a scene from their life. There are intimations in some of his *mis en scene* portraits of their lifestyle, but these are never made explicit, nor is their presence central to the paintings in question. A large conversation piece, to which the title *Virtuoso Performance* has been assigned, is yet another example of Thaddeus' willingness to try his hand at diverse subject matter (fig. 40).[76] In the picture, a

76 This title appears to have been assigned to the painting by Sotheby's, through whom the picture was sold in 1978. No applicable title presents itself among Thaddeus' exhibition works.

scene of post-prandial relaxation (rather than seduction), a fashionable young woman sits playing an upright piano. She is attended by a young man who stoops to kiss her left hand, which he has taken in his. In the background, in an adjacent room, a portly older man sits at the table at which he and his company have recently been dining. The picture approaches the bourgeois scenes exemplified by the English work of James Tissot (1836–1902), some of whose portraiture Thaddeus' work also often resembles. However, while Tissot's paintings of modern elegant society tend to concentrate on large social occasions, such as balls and evenings at the theatre, or more public scenes, such as fashionable women in the street, Thaddeus' scene takes place in a sequestered, domestic interior. His picture is also much more gloomy than Tissot's invariably radiant scenes with their 'fashion-plate elegance and chocolate box charm'.[77] Instead, it closely resembles relatively rare paintings such as Frank Dicksee's *Memories* (1886), in which the narrative is more pronounced, and Solomon J. Solomon's *A Conversation Piece*, set in a similarly cluttered bourgeois interior, which also features a young woman playing the piano, this time in the company of a young couple and an older man.[78] Like Solomon's 'cushioned, padded, patterned fortress of middle-class respectability', Thaddeus' scene has all the trappings appropriate to middle-class comfort: the piano; the china vases; the brass ornaments; the lady and gentlemen's formal attire; even the ubiquitous aspidistras and kentia palms.[79] It is worth noting that Thaddeus' bourgeois scene captured his own domestic experience more accurately than it did that of his aristocratic patrons. Victor Thaddeus recalled that his mother 'played the piano well' while his father sang 'a fine baritone'.[80]

For subject pictures, Thaddeus was, as a rule, more comfortable with themes drawn from the peasantry, which allowed him to engage the sympathy and sentimentality of the viewer. The type of suggestive and often moralistic titles that proliferated in Victorian Britain, and were drawn from a world far removed from the apathetic salubriousness of *Virtuoso Performance*, feature in Thaddeus' work as well. He painted *The Convalescent* while still in his teens in Cork, a painting that, in the opinion of its owner Michael Holland, portrayed 'faithfully ... local life of the period'.[81] Its scope was broader than that, however, as its focus on illness corresponded to one of the most popular themes of the late Victorian period in Britain. Holland attempted to sell it to the Cork Gallery along with a *Study of an Irish Girl* by Scanlon for £25 in 1930, but the

77 I. Chilvers and H. Osborne, 1988, p. 496. 78 Solomon, like Thaddeus, attended Heatherley's studio before continuing his studies in Paris, where he studied under Cabanel. See A.L. Baldry, 'The work of Solomon J. Solomon, A.R.A.', *The Studio*, vol. 8, 1896, pp. 3–11, and E.R. Dibdin, 'The art of Frank Dicksee, R.A.', *Christmas Art Annual*, 1905, pp. 3–32. 79 C. Wood, 1976, p. 34. 80 Victor Thaddeus, 30 March 1943. 81 M. Holland, 9 May 1929.

Committee, on the advice of expert advisors, including Dermod O'Brien, refused the offer.[82]

By the time Thaddeus addressed a similarly popular Victorian subject, it was considerably out of date, but surprisingly well received by the Irish press. *The Comforter* figured among four paintings, including the *Obeddienza* that Thaddeus exhibited at the Royal Hibernian Academy in 1901 (pl. 33). A badly abraded and probably original gilded plaque on its frame adds significantly to one's appreciation of the painting. The quotation printed on the plaque, which, curiously, is mentioned in neither the relevant RHA exhibition catalogue nor contemporary newspaper reviews, was taken from *Has Sorrow Thy Young Days Shaded*, another one of Thomas Moore's *Irish Melodies*.[83] The lines in question feature at the end of the first and final stanzas of the poem, and read: 'Then, child of misfortune, come hither, I'll weep with thee, tear for tear.'

Though it is possible that Thaddeus appropriated these lines to the painting when he came to exhibit it, it seems more likely that the poem actually inspired the subject. The painting is not, admittedly, a literal translation of the poem, which deals abstractly with the transience of youth, and the frequent cruelty of circumstance, but does communicate pictorially the despair and compassion that are central to Moore's poem. These concerns are also communicated through the gloomy shadows of the sparse domestic setting.

This was not, of course, the only exhibition work by Thaddeus to have been inspired by Moore's *Melodies*, although it differs profoundly in character from *The Origin of the Harp of Elfin* (pl. 25). Moore's words echo the tone of *The Comforter* rather than explain its narrative. In fact, Thaddeus judiciously avoided clarifying the story. The presence of an open letter on the floor in the bottom left of the painting, and the way in which the young woman buries her head in her hands implies that she has received distressing news, but whether this involves the death of a spouse, the infidelity of a lover or perhaps rejection by a suitor is unknown. The inclusion of a letter was a common and versatile device in Victorian narrative painting, and *The Comforter* is reminiscent of a plethora of nineteenth-century British scenes, both paintings and illustrations, of mourning, heartbreak, despair and compassion, such as Alfred Rankley's *Old Schoolfellows* (1854), Frank Holl's *No Tidings from the Sea* (1885) and Frank Bramley's *A Hopeless Dawn* (1885).

Of the four works Thaddeus showed the RHA in 1901, *The Obbedienza*, *Master Harold Maxwell* and *The Comforter* elicited considerable positive comment from the Irish press.[84] The critic for the *Irish Daily Independent* asserted

82 TICCBC, 10 March and 14 April 1930. 83 See A.D. Godley, ed., *The poetical works of Thomas Moore*, Oxford 1915. Moore's *Irish Melodies* were first published in ten volumes and a supplement between 1808 and 1834. 84 The fourth painting was a portrait of the Duke of Cambridge.

that *The Comforter* was 'certainly one of the most brilliant, if not one of the most ambitious works in the exhibition'.[85] Such praise was mitigated by the fact that the picture was relatively old fashioned by the standards of contemporary art criticism in 1901. However, there was still a significant appetite for such sombre, sentimental narrative paintings among the public in the early years of the twentieth century. Significantly, *Freeman's Journal*, describing the painting as 'one of the most important and beautiful canvasses of the year', maintained that Thaddeus, in terms of 'suggestiveness and simple pathos', had not produced a work of such quality since the feted *Wounded Poacher* of 1880/81 (pl. 3).[86]

In 1901, a conservative audience would have considered skills of draughts-manship and the ability to communicate drama of paramount importance, and with *The Comforter*, Thaddeus succeeded handsomely in these respects. Typically, he was meticulous in his modelling of the face of the old man, which resembles a number of Thaddeus' craggy-faced characters. In *The Comforter*, the dark, featureless background, redolent of Thaddeus' portraiture, increases the intensity of the scene, and accentuates the contours of the old man's features. Thaddeus paid particular attention to the old man's eyes, which appear weathered and sore, and to the hand that he rests upon a cane. The man's features were described appositely by one observer as 'Irvingesque', referring to Sir Henry Irving, the renowned Shakespearian actor.[87] The softer modelling and lighting of the young woman is consistent with Thaddeus' *œuvre* (see, for example, *The Wounded Poacher*, his portrait of *Lily*, *Lady Elliot* and *The Origin of the Harp of Elfin*), and indeed with late Victorian academic painting in general. The juxtaposition of youth and age, with its suggestions of transience and the cycle of life, was also a popular leitmotif in British painting of the period.

As has been mentioned, Thaddeus was not averse to taking pictorial shortcuts in his work, provided they did not diminish the overall impact of his pictures. In *The Comforter*, the manner in which the young woman buries her face in her hands, which is evocative but was also easier for the artist to depict, recalls *The Origin of the Harp of Elfin*, in which the female figure hides her face in the crook of her arm. Significantly, it was on the strength of *The Comforter* and the three other works that Thaddeus showed at the Royal Hibernian Academy that the artist was elected a full member of that institution in 1901 (he had been made an Associate in 1893).

It could be said that *The Cup that Cheers*, which Thaddeus exhibited at the RHA two years earlier, both expressed the artist's interest in Irish subject matter in a more anodyne fashion than was evident in his recent picture of the eviction in Ireland, and tapped into the Victorian appetite for poignant, sentimental imagery (pl. 36). Unlike the uncompromising *An Irish Eviction – Co. Galway*,

85 *Irish Daily Independent and Nation*, 11 March 1901. **86** *Freeman's Journal*, 11 March 1901. **87** *Irish Daily Independent and Nation*, op. cit., 11 March 1901.

this picture appealed to its audience's sentimentality without challenging its collective conscience. The title was taken from the poem *The Task* of 1785 by William Cowper (1731–1800), which exalts the dignified life of the rural population. However, the image of an old man sitting alone in a humble cottage interior presented in Thaddeus' picture contrasts with the reassuring, cosy and communal scene conjured up by Cowper's verse:

> Now stir the fire, and close the shutters fast,
> Let fall the curtains, wheel the sofa round,
> And while the bubbling and loud-hissing urn
> Throws up a steamy column, and the cups,
> That cheer but not inebriate, wait on each
> So let us welcome peaceful ev'ning in.[88]

The solitude of the old man who sits gazing into a mug, and the physical conditions in which he lives are presented as a statement of fact. The audience is neither furnished with a clear explanation for these, nor made to feel in any way responsible for his situation. In this sense, it is a very uncomplicated theme. The old man's piety is communicated through the religious imagery visible on the wall behind him, while his wistfulness and optimism are implied through the satisfaction he gleans from as simple a comfort as a drink. Moreover, as pointed out in the *Irish Times*, alluding directly and appropriately to the original source of the title, the old peasant imbibes from a 'cup that cheers but does not inebriate', thus acknowledging his sobriety and moral rectitude. Indeed, the phrase was adopted by the temperance movement. The man's top hat and his use of a saucer emphasise his respectability.

The figure of the old man, sitting with hunched shoulders in coarse working clothes and muddy boots in a gloomy cottage, calls to mind the much younger peasant in Luke Fildes' *The Widower* (1876), and even echoes van Gogh's seminal image of an old peasant man with his head in his hands entitled *At Eternity's Gate* (1882), which itself was probably inspired by British illustration. However, while both van Gogh's and Fildes' images connote despair or unadulterated hardship, such concerns are mitigated in Thaddeus' painting by the intimation that the old man obtains solace, however marginal, from a cup of tea and from his religious faith. Thaddeus thus avoided the censure of the press to which Frank Holl fell victim having produced a large number of images of domestic tragedy. Nor could the picture be seen as a didactic attempt to inspire guilt among a middle class audience by forcing it to acknowledge what it tried to ignore.[89] In fact, so unchallenging was the picture that the *Irish Daily*

88 *The Task* IV, *The Winter Evening*, 36. 89 See J. Treuherz, 1987, p. 85.

Independent described it as 'one of those paintings which one covets and would fein [sic] procure'.[90]

Compositionally, it is an unusual picture, in which the oddly shaped and arranged pieces of furniture contrast with the featureless, and relatively spacious foreground. The table remains unfolded, as there is no one there to sit at it with the old man, and he has not even moved the bench from its place along the wall. Thaddeus even painted out a cat, which sat by a wicker basket on the left of the painting, to emphasise the old man's solitude. The shape of the interior is difficult to discern, and it has the manipulated quality of a stage-set.

Though the atmosphere of the picture is profoundly different to that of *An Irish Eviction – Co. Galway*, and the subject is not political, the household depicted is distinctly Catholic, and probably Irish. Directly above the table hangs a crucifix, and above that a framed picture of the Virgin and Child. The artist's attention to detail indicates that he based the scene, as Maclise had done for his illustrations for *Hall's Ireland, its Scenery and Character* (1841), on his own experience and observation.[91] For example, it was common practice in Irish homes to place 'palms', blessed at the Palm Sunday ceremonies, above a religious picture.

The geographical setting for Thaddeus' images of peasants (or the nationality or religious affiliation of the peasants themselves) were not necessarily identifiable. In his enigmatic *The Wounded Poacher* (pl. 3), for example, or his repeat of the theme of poachers (pl. 2), or even his watercolour of 1888 of an old man leaning on a half-door, smoking a clay pipe, Thaddeus provided no explicit indications of nationality or location (fig. 41). *The Poachers* is undated, but the quality of finish and colour range suggest that it dates from the 1890s rather than the early 1880s, as has been suggested, and it is not recognisably Irish in character.[92] It seems that the subdued tones and palette to which rustic images lent themselves very much suited Thaddeus' own tastes and inclinations. These pictures, sombre in tone, with very deliberate touches of bright colour to lift them, complement some of Thaddeus' finest portraits. In *The Cup that Cheers*, a red cloth falls over the edge of the table, lifting an otherwise brown and grey composition, while in *An Old Man Smoking a Pipe*, the blue of the veins of the figure's hand is also worked into the wooden door against which he leans. These touches, indiscernible at first glance, might have appeased the critic who longed for just a 'touch of Venetian charm' in the paintings of Frank Holl.[93] In 1889, an exasperated Rosa Mulholland appealed for colour in the work of Irish artists specifically. She did not accept that the lack of colour could be attributed to the climate, and added that 'in a land of rain, cloud and mist, we crave for the sun; yet these artists grudge us a little warmth, as though the sunlight were a sin'.[94]

90 *Irish Daily Independent*, 6 March 1899. 91 See Turpin, 1985, p. 24. 92 See *Gorry Gallery Catalogue*, 24 Nov–7 Dec 1989. 93 *The Academy*, 11 August 1888, p. 92. 94 R. Mulholland, 1889, p. 484.

41 *Old Man Smoking a Pipe*, 1888. Watercolour on cartridge paper 33 × 25. Private collection.

However, it is unlikely that Thaddeus' lurid Continental pictures, or the touches of colour in other works, would have satisfied her. Other writers of an alternative outlook remarked positively that Thaddeus' paintings, portraits and subject pictures alike, had an aged quality about them, which afforded them a seriousness and antiquity that one could not identify in the work of his contemporaries. The background of *The Cup that Cheers*, wrote the *Irish Times*, 'is exceptionally clever, and the general effect is heightened by that charm of old tone which Mr Thaddeus is so well able to impart, and which gives his work a peculiar attractiveness which comes to other paintings with age alone'.[95] It is a reflection of the conservatism of the Irish press that this was meant as a compliment, rather than to highlight a regressive tendency in Thaddeus' practice. Of Thaddeus paintings at the RHA in 1896, the *Irish Daily Independent* of 2 March said that they 'suggest drawings and colouring modelled on an older style of painting' while *Freeman's Journal* of the same day remarked that 'the peculiarity about their treatment is that the artist has succeeded in giving to them a suggestion of their being quite ancient works'.

95 *Irish Times*, 6 March 1899.

RELIGIOUS SUBJECTS

Thaddeus' experience and output in North Africa advanced the more colourist tendency that he had exhibited in landscapes of the 1880s such as *The Old Prison, Annecy,* and informed much of the landscape work that he was to produce subsequently. However, it also fuelled an interest that found expression in *Christ before Caiaphas,* the painting described by the correspondent with the *New York Herald* as Thaddeus' '*magnum opus*' (pl. 34).[96] It would seem that Thaddeus travelled up to Palestine while living in Egypt, where he made studies, or at least sketches, for the painting, which he later used in the composition. The *New York Herald* journalist believed erroneously that

> perhaps for the first time, the Saviour is presented historically correct, as far as type and costume is concerned, down to the tiniest detail. The fleshless, emaciated form with the fathomless, steadfast look in the eyes, are just such as are found in dervishes, in the few who do really lead a pure, meditative, ascetic life, far removed from any worldly surroundings.[97]

Thaddeus was far from the first to attempt accurate representations of New Testament subjects, nor was he alone among his contemporaries. He joined a long list of artist-antiquarians who, in keeping with the rational and scientific spirit of the age, sought to add authenticity to their work of classical, historical and biblical themes by adopting a documentary approach to their work. Topographical, architectural, racial and ethnic accuracy became of paramount importance, though they were not always accurately recorded. Marie Bashkirtseff, for example, wrote in her diary in 1885 of a composition she had undertaken depicting Mary Magdalene at Christ's tomb, saying that she wanted 'no conventional sanctities, but to paint it as you imagine it happened'.[98] Later she wrote of her desire 'to go to Jerusalem, and to paint this picture from native heads, and in the open air', an ambition that, sadly, she never realised.[99] Mihály Munkácsy exhibited a picture entitled *Christ before Pilate* in Paris in 1881 and at the Conduit Street Galleries in London the following year, which the *Athenæum* maintained threatened 'to prove a formidable rival to the attractions of the Doré Gallery', where Gustave Doré exhibited detailed religious works he had been producing since the 1860s.[100] James Tissot took a particularly formal and analytical approach to the accurate representation of biblical themes. He had travelled to the Middle East in 1886, where he made records and sketches of scenes that were relevant to the gospel accounts, and on the strength of these published, in 1897, *The Life of Our Saviour Jesus Christ,* in twelve volumes,

96 *New York Herald*, op. cit., 27 March 1896. 97 Ibid. 98 Bashkirtseff, 1985, p. 408 (25 May 1880). 99 Ibid. (27 May 1880). 100 *Athenæum*, no. 2845, 6 May 1882, p. 580.

which consisted of 365 compositions from all four gospels, with notes and explanatory drawings. In the introduction to the book, Tissot claimed that 'the imagination of the Christian world has been led astray by the fancies of artists; there is a whole army of delusions to be overturned before any ideas can be entertained approaching the truth in the slightest degree'.[101] Two hundred and seventy of Tissot's illustrations were exhibited in Paris in spring 1894, in London in 1896 and again in Paris in 1897. Thaddeus may well have seen them, if not the published volumes, and appears to have had a similar agenda to Tissot when he travelled to Palestine and made preparatory drawings for *Christ before Caiaphas*. The final product, however, owes as much debt to Orientalist painting as it does to his direct observation in the Middle East.

The episode chosen by Thaddeus shows Christ, having been apprehended in the Garden of Gethsemane, being presented to Caiaphas, the high priest, and questioned about his teaching.[102] The scene takes place in the high priest's palace, where all the chief priests, elders and scribes had assembled. According to the New Testament, Christ's claim in the course of his interrogation that he was the Messiah constituted blasphemy under Jewish law and carried a penalty of death, though, under Roman rule, the Sanhedrin did not have the authority to carry out the sentence. Traditionally in art, the representation of the episode featured Caiaphas, in apoplectic rage, ripping open his robes and bearing his breast, while exclaiming 'Blasphemy!'. Thaddeus chose instead to depict the preceding moment at which the chief priest, elders and 'all the Council tried to find false testimony against Jesus' while the high priest sits listening sternly, cradling his chin in his hand.[103] Christ, in accordance with artistic convention, stands before Caiaphas with his hands tied, as one of the prosecutors presents his case. Meanwhile, in the background, the entrance to the building is choked with onlookers, whose faces are dimly lit in the shadows.

Though the subject is remarkable in the context of Thaddeus' œuvre, important formal elements of the picture connect it with other works by him. For instance, the dramatic device of including a crowded doorway in the background, sealing off the only obvious means of escape, is employed to even more claustrophobic effect in *An Irish Eviction – Co. Galway* (pl. 22), as is the manner in which the chief protagonists are picked out by raking light while the greater part of the scene remains in shadow. This bright directional light, which enters the room from above Christ's head but beyond the picture plane, illuminates not only the principal figures, but also elements of the ornate and colourful decor and furnishings. This reflects the interest in the exotic and luxurious that had characterised Orientalist painting in North Africa since the beginning of the nineteenth century. In the meticulous representation of the

101 J. Tissot, 1897, ix. **102** Matt. 26:57–68; Mark 14:53–65; Luke 22:66–71. **103** Matt. 26:59, Knox translation of the Bible, 2nd edition, London 1956.

surface patterns on the wall, the wooden panels of the dividing screen to the left, the complex marquetry of Caiaphas' throne, the colourful carpet on which the figures stand, and the pointed shoes lying in the foreground, Thaddeus displayed the same fascination with fabrics, decoration and ornament that was a staple concern of artists from Eugène Delacroix to John Frederick Lewis to Rudolf Ernst, and had defined his own work in Egypt and Morocco. The repetition of the Tetragrammaton below the cornice above Caiaphas' head is perhaps a tokenistic and slightly inaccurate means of defining this as a Jewish scene.

Portraiture, too, made a recognisable contribution to the overall appearance of this Biblical work, as Thaddeus included a series of arresting facial studies, of which Caiaphas and the old man seated behind Christ are the most striking. Again, typically, he presented two other figures in profile. He may have been aspiring to verisimilitude and historical accuracy in his picture, but obviously idealised the figure of Christ, whose slender frame, refined features and white robes contrast with the old, wizened countenances, grey beards and aged frames of the men who try him.

It is interesting to compare Thaddeus' picture with Tissot's of the same episode in the context of their common pursuit of verity. In his accompanying text, Tissot mentioned the Judgement Hall, the Presidential Chair, and Caiaphas flanked by the judges, but none features in the illustration. Instead, he focused on the figure of Christ, standing still and vulnerable amongst a hysterical crowd. Arms flail, bodies stretch out over the parapet and men swing from columns as Christ stands stoically, listening to the accusations being made against him from beyond the picture plane. The architecture is on a grand scale, boasting columns, ornate capitals, a waist-high stone-parapet and a flight of semi-circular steps leading up to the unseen Judgement Hall. Atmospherically, Tissot's and Thaddeus' images differ fundamentally. One is chaotic and frenzied, the other tense and static. Thaddeus' painting has a sinister stillness, as a single figure, rather than an unruly crowd, seeks to determine Christ's fate. In the foreground on the left, a scribe commits the evidence to paper or perhaps corroborates the legal aspects from a text. There is a striking, binding resemblance between the two images of Christ, however, and a shared interest in the minutiae of the setting, from costume to ornament, which betray not simply empirical observation, but the artists' irrefutably Western perspective and attraction to the 'exotic'.

Michael Holland maintained that Thaddeus' painting was based on drawings produced while he was in Egypt and Palestine, but it is difficult to establish when it was actually completed. It was certainly painted before March 1896, as it is mentioned in a newspaper article of that date. John Gilbert counted it as one of Thaddeus' 'well-known works', despite the fact that it appears to have been exhibited just once in Ireland, at the International Exhibition in Dublin in

April 1907, when Thaddeus' reputation had already begun to decline.[104] Michael Holland maintained that Thaddeus' picture was exhibited at the Doré Gallery in London, but was often mistaken with his facts and, in any case, exhibition at that establishment would not necessarily have ensured the picture's renown.[105] A number of years after Gilbert asserted the popularity of the painting, it was reproduced in a rather obscure and short-lived English periodical entitled *Masterpieces of Modern Art*, with the cursory remark that it showed 'considerable knowledge in the details of costume and surroundings' but no other information about its origins or whereabouts.[106] Thaddeus may have based other pictures on that religious work, as a large study of an old bearded man in turban-like head-dress, dated 1898, is remarkably close to his figure of Caiaphas. It is an unfinished work, too large to be just a preliminary sketch, confidently painted and distinctive in character. At the very least, it reflects the artist's enduring fascination with facial types, and more specifically, with Oriental characters.

Christ before Caiaphas appears to have been Thaddeus' only work of a biblical theme, but it is not his only religious (as distinct from ecclesiastical) painting. *Masterpieces of Modern Art* also reproduced one of the artist's most bizarre and inexplicable works, of which there appears to be no other record. Even when one takes into account Thaddeus' less successful portraits, occasionally gaudy landscapes and maladroit subject pictures, *The Temptation of St Anthony*, which appeared in an earlier issue of the periodical, is an aberration (pl. 35). While the apologist might claim that the picture is an extravagant joke, only the most blindly generous could concur with the claim of the editor of *Masterpieces of Modern Art* that despite the variety of forms this subject had taken in painting, the temptation had not been presented 'in such an aesthetic form as that exhibited by the line from shoulder to ankle'.[107] Admittedly, the quality of reproduction in the periodical is poor, but it is obvious that, on this occasion, Thaddeus struggled with composition, scale and, most strikingly, anatomical accuracy. Ultimately, he presented the viewer with an irreverent interpretation of a religious theme that had enjoyed renewed popularity in the nineteenth century.[108] A cowled St Anthony turns his head, alarmed by the arrival of a female figure dressed only in a diaphanous drape, which appears to be falling rapidly from her body. He sits in his cell amidst books, with his back to the viewer. Beside him stands an incongruous and astonishingly large urn, and, perched on top of it, a deep green bottle.

It seems reasonable to assume that this picture's principal function was humorous. The traditional account of St Anthony's ascetic life in the desert

104 Gilbert, op. cit., 1913, p. 177. The painting was listed inaccurately in the accompanying catalogue as *Christ before Pilate*. **105** M. Holland, 9 May 1929. **106** *Masterpieces of Modern Art*, no.17, vol.1, illustration no. 8, undated. **107** *Masterpieces of Modern Art*, no. 16, vol. 1, illustration no. 8, undated. **108** G. Flaubert published his *La tentation de Saint Antoine* in 1874.

maintains that he was subjected to mental torment and hallucinations, which can be divided broadly into demonic or erotic visions. Of these Thaddeus opted for the latter as a subject for his picture, reckoning, one assumes, that in it there was more potential for humour. He neglected the standard iconography associated with images of St Anthony, such as a Tau-cross, a pig, or the bell that alludes to the monks' practice of ringing a bell to attract alms.[109] The female nude dominates the picture, as she rests one hand against the arm of the monk's chair. As a result, the picture has a distinctly irreligious or secular flavour, which it appears to share with Thaddeus' equally impious painting of St Patrick, exhibited in 1883. While Tissot struggled to convey visionary subjects convincingly, invariably drifting into a more spiritualist idiom, in *The Temptation of St Anthony*, Thaddeus is bound to the old academic concerns with corporeality. However, the picture demonstrates clearly his innate, but essentially unrealised and unrecognised, versatility.

Religious subjects do not, however, point to an increasing religiosity on Thaddeus' part. Unlike Tissot, who embraced Catholicism and spiritualism with equal and alarming zeal, Thaddeus harboured distinct reservations about organised religion, and its divisive potential. What his attitude might have been towards spiritualism is more difficult to judge. The argument that, in the final decades of the nineteenth century, spiritualism was embraced by many, including Tissot, as a means of accommodating religious doubt, rather than as an orthodoxy in its own right, seems appropriate to Thaddeus' character.[110] In his *Recollections*, he did admit to taking part in many *séances*, and it is interesting that he obviously believed in the genuineness of his first, a 'table-rapping' *séance* at the residence of the duchess of Hamilton in Bad Horn, which he attended while travelling with the Teck family.[111]

109 See D.H. Farmer, 1992, p. 26, and J. Hall's 1993, pp. 21–2. **110** C. Wood, *Tissot*, reprint, London 1998, p. 145. **111** H.J. Thaddeus, 1912, pp. 80–1.

New horizons

The turn of the century brought with it a change of fortunes for the Thaddeus family. Shortly after Harry's return from Australia, he took out a lease on Maesmawr Hall, a large Elizabethan house in the Severn Valley in mid-Wales (fig. 42). The house, built in 1535, had been in the Davies family since about 1653, and William Eden Nesfield (1835–88) designed an extension to it in the late nineteenth century. The head of the Davies family in 1903 was an Anglican clergyman, whose employment as curate in the Midlands prevented him from managing the house and estate. He rented the house out from about 1900 until 1920, when he sold the whole estate.[1] Thaddeus' first payment of rent, received in advance, was on 1 September 1903.

42 Maesmawr Hall, Caersws, Powys.

1 Major E.H.C. Davies, Letter to the author, 5 November 1997.

Maesmawr Hall was an extravagant symbol of a newly recovered prosperity, and was to prove a happy home. The house stood in its own extensive and impressive grounds a short distance from the tiny village of Caersws. Its remote, but extremely picturesque location marked it as a kind of hideaway, quite unlike the accommodation to which the family had been accustomed in central London, and, one presumes, in Cairo. It is possible that the family had moved there to escape the censorious attentions of those who disapproved of Harry and Eva's marriage, but they were isolated rather than reclusive. In Maesmawr, Harry and Eva could pursue their own interests, orchestrate their social activities, and enjoy nature in freedom and comfort. Harry must have set up a studio in the house (there was, to say the least, plenty of room in which to do so), though he certainly would have travelled for sittings, rather than ask his patrons to make the journey to Wales. Though situated deep in the countryside, Maesmawr was not as cut off as one might imagine. Weather permitting, Harry could travel easily by carriage to the train, which in turn would transport him to London and other major centres in a matter of hours. As had always been his practice, he would have produced preparatory sketches and studies at the residence of a given sitter, occasionally staying overnight or longer to facilitate their completion, and then return to Maesmawr to execute the full easel painting. Professional commitments in Britain, and trips abroad meant that Harry probably spent many lengthy periods away from his Welsh residence. He travelled extensively during the three and a half years that he and the family spent at Maesmawr, although his work rate was beginning to decline. Eva was also frequently absent from the house, though not necessarily with her husband. While Harry spent time in Italy, Germany and France, Eva travelled to such places as India and Iceland. From October 1903 until July 1905, Freddy and Victor were placed in Sandbach, a private boarding school in South Cheshire, where they engaged in various extra curricular activities (fig. 43). The boys, referred to in the school register as 'Thaddeus (i)' and 'Thaddeus (ii)', excelled at sports, despite the fact that Victor was the youngest boy at the school throughout his time there.[2] The Thaddeuses maintained contact with Sandbach to some extent following their departure from Britain, and the school annual, *The Old Sandbachian*, of 1912, recorded Victor's progress in university in America, and the receipt by the school of a copy of *Recollections of a court painter* from his father.[3] Having left Sandbach, the boys enrolled at a private school outside Stuttgart, where Harry knew they would be within reach of his old friend, King William of Württemberg, who had a schloss at Stuttgart, and a massive palace at Ludwigsburg.[4]

2 John Owen, Learning Resources Centre, Sandbach School, Letter to the author, 21 January 2002. 3 Ibid., 24 January 2002. 4 Victor Thaddeus, 30 March 1943.

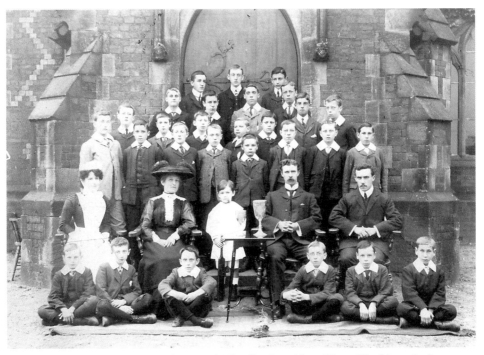

43 Sandbach School, 1904. Photograph. Sandbach archives. Victor Thaddeus sits front row, third from left, while Freddy Thaddeus stands in back row, also third from left.

The family were very happy when together at Maesmawr. Harry was able to indulge his avocation, gardening, as the large grounds, with their 'roses and … immemorial elms' kept him busily and contentedly occupied.[5] Freddy and Victor enjoyed a carefree existence there, spending hours in the open air, and Harry and Eva were spared domestic responsibilities. They lived according to the established upper middle class order, employing a modestly sized staff and impressing on their children the strict distinction between 'upstairs' and 'downstairs'.[6] Among the servants were a cook (and assistants), a butler of some kind, and even a bootblack called 'Tommy', who, no doubt much to the displeasure of the parents, fascinated the two sheltered Thaddeus boys by 'talking dirty'.[7] The boys themselves for the most part grew up at a distance from their parents, and were normally under the care of a nanny or governess, one of whom, Fräulein Gretchen, was the daughter of a Prussian Officer, in Britain to improve her English.[8]

5 H.J. Thaddeus, 1912, p. 294. **6** Maria Thaddeus, Letter to the author, 7 November 1997.
7 Ibid. **8** Ibid.

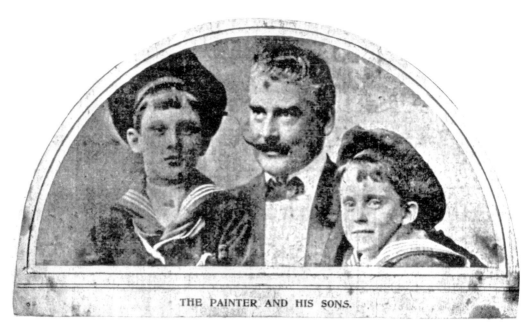

THE PAINTER AND HIS SONS.

44 Harry Jones Thaddeus with his sons Freddy and Victor, *c.*1903. Photograph.

As a father, Thaddeus was simultaneously stern and progressive, and accessible to his children (fig. 44). He certainly wanted them to be hardy and robust, and was known to instruct them in drill exercises on the flagstones outside the house.[9] The boys never wanted for anything, but neither were they showered with material things, receiving a nominal amount of pocket money and extremely simple toys.[10] However, Harry was not a martinet, and did not intimidate his sons. They were sometimes allowed to accompany him on his painting-outings, when he would load a rather unroadworthy caravan and drive into the countryside.[11] He instilled in them a love and respect for nature, and stressed that one should always be humane to animals. Later in America, Harry was vociferous in his criticism of cowboys, whose actions he found cruel. There were stables and a paddock at Maesmawr, where Freddy and Victor were both taught to ride on their own ponies. The Thaddeuses also kept a number of horses, and a donkey, which pulled the cart that Eva used on jaunts to the village.[12] Harry was fond of dogs, particularly collies, one of which, Ra, is visible lying on the lawn by the house in a photograph of Maesmawr in the snow taken while the Thaddeus family were living there (fig. 45). The same dog appears in a portrait of Freddy that Thaddeus painted while at Maesmawr

9 Patrick Thaddeus, Interview with the author, 1 September 1997. 10 Ibid. 11 Maria Thaddeus, Letter to the author, 7 November 1997. 12 Ibid.

45 Maesmawr Hall, Caersws, Powys, *c*.1903–7.

(pl. 37). It was produced for the family, and remained unfinished. The 'rouged' complexion of the young boy and saccharine colouring overall were very dated by the early years of the century, when the picture was executed, but it was nevertheless a sensitive portrait, and was, presumably, painted with Eva's or Harry's own tastes in mind. Unlike Harry's finest portraits, in which the sitters have a marked intensity and striking presence, this work is rather lightweight, thinly painted, and lacks solid modelling. However, it is stylistically very similar to a number of Thaddeus' society portraits. It is an unattractive, but reasonable, proposition that Thaddeus actually preferred this 'porcelain', idealised style of portraiture, to the more imposing and dramatic type, such as his portraits of Father Anderledy, Gladstone or the earl of Bessborough. It is perhaps easy to forget that he relied for his livelihood on society portraits, such as those of the marchioness of Zetland and Lord George Dundas (1886), Lady Howard de Walden (1894, fig. 21) and Lily, Lady Elliot (*c*.1897, fig. 22), which are stylistically so close to the picture of Freddy, and that it was not necessarily or exclusively the patrons' own conservative tastes that dictated the form the portraits took. It is also interesting, though not conclusive, to note that in none of his self-portraits or portraits of the family does Thaddeus appear to have employed those dramatic devices that distinguish his outstanding portraits.

Life at Maesmawr seems to have been idyllic. Eva and Harry enjoyed privacy and entertainment in equal measure, as many friends were invited to the house. Various notables were among the guests there, which impressed the Thaddeus boys immeasurably. Victor remembered in particular the explorers Sven Hedin (1865–1952) and Paul du Chaillu (1835–1903), who had been 'students in drawing' under Thaddeus, as well as Harry's old friend Henry Savage Landor.[13] French-born du Chaillu, associated primarily with discovering the gorilla, published a number of books describing his travels and discoveries, the last of which, *King Mombo*, was published in 1902. He and Thaddeus were close friends, and spent a winter travelling together in Morocco, du Chaillu relating his adventures to Thaddeus as they went. It was, according to Thaddeus, largely due to the support of Professor Richard Owen, who Thaddeus painted in 1889, that du Chaillu's findings were accepted in official circles. If du Chaillu did visit Maesmawr, rather than the Thaddeus residence in London, the family must have been ensconced there by March of 1903, as du Chaillu died in April of that year, 'universally regretted, and still in the plenitude of his powers'.[14] Sven Hedin was born in Sweden, and was most famous for his expeditions in Asia, including Mongolia, Tibet and China. Phil May, one of the most admired and successful illustrators of the time, who worked for *Punch*, the *Graphic*, the *Illustrated London News* and a number of other periodicals, as well as publishing independently, was also a regular at Maesmawr.[15] Thaddeus and May, who was a renowned *bon viveur*, must have been a formidable duo, and appropriate companions, having probably met in London, where May was an enthusiastic patron of the artists' clubs. Thaddeus may have identified in May a kindred spirit. From humble origins in Leeds, and only rudimentary education and artistic training, May had become one of the best-known illustrators of his day. His perceived knowledge and experience of 'low life' added pathos to otherwise humorous drawings, to which his audience responded positively. Coincidentally, May was also friendly with John Lavery.[16]

Notwithstanding Thaddeus' propensity to travel, removal to Maesmawr may have had an adverse effect on his career. In May 1904, Hugh Lane's 'Exhibition of a Selection of Works by Irish Painters' opened in the Guildhall in London. There, the British public were presented with 465 exhibits both by artists who had long been associated with Ireland and others, including Phil May, whose connection with the country had never previously been acknowledged. The exhibition commanded a very high profile, and eighty thousand people visited it during its eight week duration.[17] It was an unprecedented showcase for Irish art, which enabled the contributors to assert a common Irish identity at the same time as presenting their individual works for judgement to a vast audience.

13 Victor Thaddeus, 17 March 1943. 14 H.J. Thaddeus, 1912, p. 182. 15 Victor Thaddeus, 17 March 1943. 16 See Lavery, 1940, p. 81. 17 T. Bodkin, 1956, p. 9.

As well as many of the greatest Irish artists of previous generations, all the most prominent and pioneering artists of the day, from Roderic O'Conor to Jack B. Yeats were represented at the Guildhall, in some cases by a number of works. An extraordinary array of newspapers and periodicals covered Lane's exhibition, from the main Irish and English dailies, to smaller regional publications from as unlikely places as Plymouth. Moreover, reviews tended to be comprehensive, if not always as affirmative as Lane would have wished. While many of the critics lauded the work of individual artists, most found it hard to identify any discernible common Irish identity within the body of work on show. The exhibition provided the sort of platform for advertisement that Thaddeus had exploited on numerous occasions before: in Dublin in 1882, Cork in 1883 and 1902, and at Olympia in 1888. However, at the Guildhall, he seems, curiously, to have squandered the opportunity of securing himself a place among Ireland's artistic elite. He exhibited just one painting, an unremarkable portrait of Mrs Claude Cane, 'one of the best known women in County Kildare', which the press all but ignored.[18] Even those that did mention it did so politely at best. The most generous was the *Westminster Gazette*, which commented that 'from Cork came two of the most famous of the old Irish painters, James Barry and Daniel Maclise, and one of the most celebrated of Ireland's modern painters, H.J. Thaddeus', an association that would undoubtedly have pleased him.[19] However, for an artist who had for so long been the darling of the Irish press, relative anonymity in a major exhibition can only have been deeply wounding. Thaddeus may have been invited to exhibit just one work at the exhibition, but he seems to have erred in its selection. One imagines that between trips abroad, a degree of ostracism, and the responsibilities involved with his move to Wales, his work rate had been far from prodigious during this period and that he miscalculated the importance of Lane's exhibition.

It was from Maesmawr that Thaddeus travelled to Rome in 1903 to secure the commission to paint the newly elected Pope Pius X. He also made a trip to the east coast of America in 1904, though the background to this is unknown. It seems reasonable to assume that it was a financially lucrative and professionally important venture, as within two or three years of the visit, he had emigrated with his family to the United States. He declined to mention this first trip to America in *Recollections*, but included three illustrations in the book of paintings executed during that visit. One is a rather austere three-quarter length portrait of General Roe (fig. 46), another a portrait of the glamorous Mrs Philip Lydig (fig. 47), both of which were painted in New York. These pictures show, once again, that Thaddeus was disinclined to paint whole-length portraits, but the detailing is well observed and, as far as one can tell from the poor reproductions in the *Recollections*, the figures are confidently and effectively

18 *Belfast Evening Telegraph*, 1 June 1904. 19 *Westminster Gazette*, 31 May 1904.

46 *General Roe, New York*, 1904. 47 *Mrs Philip Lydig, New York*, 1904.
 Oil on canvas. Untraced. Oil on canvas. Untraced.

modelled. The brushwork in the portrait of Mrs Lydig, with long wisps of paint echoing the principal contours, calls to mind the work of the Italian Giovanni Boldini (1842–1931), though the painting does not feature the extreme, expressive distortions that characterise Boldini's portraits.

The third painting in *Recollections* dating from this trip is a watercolour portrait study of Sir Mortimer Durand, British Ambassador to Washington, which exemplifies Thaddeus skills of draughtsmanship, and connects with his very early portraits of *Denny Lane* and *Isaac Butt* (fig. 48). These competent, if uninspiring American pictures may be more significant than is immediately evident, and indicative of a demand for his portraiture that ultimately influenced his decision to move to the United States.

The contradictions that one can identify throughout Thaddeus' life might suggest that his apparent adaptability should rather be interpreted as fickleness. He made undisguised, and uncompromising, criticisms of America and its inhabitants, going as far as to claim that he had first left Paris on account of the large numbers of Americans who were arriving at the art schools in the city. Elsewhere, he pointed to the Americans' lack of *joie de vivre* and unchecked 'pursuit of the dollar'.[20] In this context, Thaddeus' choice to cross the Atlantic

20 H.J. Thaddeus, 1912, p. 20.

seems rather unexpected and the fact that he remained there for about a decade even more so. This could reflect at the very least a mellowing of his views were it not for the fact that *Recollections of a court painter*, in which Thaddeus made these observations, was actually written while he was living in the United States, so his opinions and his actions seem rather incompatible. Against this, one must bear in mind Thaddeus' ambitious instinct and occasional impetuousness, and the influence of the formidable Eva. If the move to America was professionally motivated, or sought fundamentally by his wife, the question of compromised opinions loses its urgency.

Thaddeus' emigration must be attributable to some extent to the pecuniary difficulties he had experienced in recent years, which themselves might be partly explained by the circumstances of his marriage.

48 *Sir Mortimer Durand, British Ambassador at Washington – a study*, 1904. Watercolour on paper. Untraced.

Though his family's tenure at handsome Maesmawr, his and Eva's regularity of travel, and the placement of the boys in expensive education in England and on the Continent suggest that he was now financially secure after the unsuccessful court cases and threat of bankruptcy of a few years earlier, his confidence was probably shaken. Crucially, having owned property in Cairo alone, he had limited assets on which to fall back. Eva's private income was presumably not sufficient to support the family's lifestyle, nor perhaps was it even available to her husband at all. America represented, therefore, an opportunity to consolidate, as well as to explore new horizons. Victor Thaddeus always understood that the family moved to the United States because his father saw a better life for his sons there than in England, and emphasized how enormously driven Harry was towards making and accumulating money, despite recurring failure to do so.[21] Having recently redeemed himself with major commissions and exhibitions, and now solvent, Thaddeus may have seen this as an ideal moment to exploit new business opportunities in the United States. Since his bankruptcy scare, Thaddeus had painted such individuals as the earl of Bessborough, Prince William of Württemberg, John Redmond, Pope Pius X and various other sitters in Australia. Moreover, his visit to America of a few

21 Victor Thaddeus, 17 March 1943.

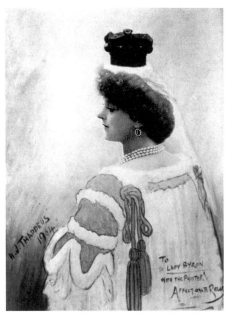

49 *Lady Byron – a sketch*, 1904. Hand-tinted photograph. Untraced.

years earlier had probably demonstrated not only that work was available there, but that his particular skills could impress a new audience.

The distress and acrimony resulting from Eva's marriage to Harry meant that there were no family ties keeping her in Britain. Moreover, it may have been the more general reaction to their marriage that prompted them to start afresh in America. Harry, for his part, was accustomed to living away from friends and family. He had not lived in Ireland for almost thirty years, and his siblings were, as far as one can tell, scattered throughout the world. Admittedly, both Eva and Harry left behind many friends and social acquaintances but, as seasoned travellers, they may well have expected to see those closest to them in the course of subsequent trips. Foremost among Eva's friends was the irrepressible Lady Houston (née Fanny Lucy 'Poppy' Radmall). Lady Houston was the former wife of Theodore Brinckman, whom she married in 1883 and divorced in 1895, and widow of the 9th Lord Byron (d. 1917), whom she had married in 1901. She was to exercise a profound influence on Eva's later life in particular, although Eva was one of her 'oldest and closest friends, who knew her from the Paris days onwards'.[22] Oddly, Thaddeus included an image of Lady Houston in *Recollections*, but did not mention her in the text.[23] The picture, a tinted photograph dated 1904, which is inscribed 'To Lady Byron/ with the Painter's Affectionate Regards', is a curious hybrid work, in which the sitter is shown in the coronet and tassled gown worn by the wives of peers at the coronation of a monarch (fig. 49). Of no artistic merit whatsoever, the picture sits uncomfortably among the other illustrations in the book, and one can only imagine that Eva somehow influenced its inclusion. In 1924, Lady Byron married Sir Robert Paterson Houston MP (1853–1926), the shipping magnate, in Paris, and on his death in 1926 inherited one of the greatest fortunes in Europe. Despite her frailty, Lady Byron, subsequently Lady Houston, was always a sociable personality, and entertained at her home in Hampstead some of the most eminent actors, poets, painters and musicians of the day. There is

22 J.W. Day, *Lady Houston D.B.E. – the woman who won the war*, London 1958, pp. 25–8.
23 For a detailed, but utterly partisan account of her life, see Wentworth Day, op. cit., 1958.

little doubt that she and Eva stayed in contact while the latter was living in America.

The Davies family received the final rent instalment for Maesmawr Hall from the Thaddeuses on 28 February 1907, though it is highly unlikely that the family were still living in the house at that stage. They left certain items behind, including the abovementioned picture of Freddy and the dog, and other pictures. It is impossible to ascertain whether these were left as gifts to friends in Wales, in lieu of rent, or were among items that the family simply felt they could not take with them. It would make sense for Harry and Eva to have spent some time in London, which had been the fulcrum of their social and professional lives for so long, prior to their departure, but there is no evidence of this.

On reaching the east coast of America, the Thaddeus family sailed up the Delaware River to Philadelphia, where they disembarked. Though Harry had visited the east coast before, and worked there, it would appear that he planned to move on quickly to California. The family did visit Atlantic City, but did not spend much time there. On that occasion, Thaddeus was understood to have levelled to the ground three 'ruffians' who had accosted him for wearing his Panama hat after Labour Day, a serious *faux pas* according to a peculiar American tradition.[24] Victor suggested that his father's initial reason for travelling to California specifically was to view the destruction wrought by the massive earthquake that had struck in 1906 and that, finding the climate very agreeable, had decided to stay.[25] Though Thaddeus did mention witnessing an earthquake in Nice in the 1890s (although there is no record of that tremor ever occurring), it seems somewhat implausible that his interest in such phenomena should have drawn him all the way across America. In any case, the family settled first in Coronado, a town in southern California, near San Diego. They did not remain there for long, preferring to venture north to Carmel, just south of San Francisco. Though Thaddeus may well have had significant reservations about living in America, these did not inhibit him professionally. He took a studio on 5th Avenue in San Francisco, opposite the old Waldorf hotel, and soon infiltrated the art establishment, which was vibrant at the time. He appears to have forged some connection with the Bohemian Club in the city, but was not a member. An introduction may have come about through the Art Association of San Francisco, in whose rooms the Bohemian Club met in the early years of the century. It is quite possible that the two clubs were so close together that Thaddeus became a member of the Art Association, and was simply welcomed into the Bohemian Club by his friends.[26] He certainly appears to have mixed with the wealthy and well-connected of California, perhaps endeavouring to assemble a clientèle for possible portrait commissions. Through the Bohemian

24 Maria Thaddeus, 7 November 1997. 25 Victor Thaddeus, 17 March 1943. 26 Charles H. Townes, letter to Patrick Thaddeus, 17 May 1996.

Club, he met Major Hutcheson, the British consul in San Diego, about whom, as it happens, he had been extremely uncharitable until the two men actually met. As well as genial company, Hutcheson was a competent sculptor (he had completed a bust of Robert Louis Stevenson in the South Seas), and Thaddeus ultimately held him in very high regard. Victor Thaddeus wrote that originally his father was apt to say that Hutcheson was 'ignorant and insular, reeked with British insolence and snobbish, hadn't an idea in his head, was in short just the sort of Englishman who made England disliked all over the world'. His father would 'ridicule the consul's way of speech, and taking up a crayon with lightning speed make a series of sketches of Hutcheson in his white duck trousers – sketches which showed Hutcheson in all postures of stupidity and bombast'.[27] Previous travels had brought Thaddeus into contact with various British diplomats, a number of whom he greatly admired – not least his close friend Robert Percy ffrench – so his initial reservations about Major Hutcheson are perhaps not quite as politically rooted as his son imagined. Thaddeus ultimately thought the British Government very foolish to have stifled such talent as Hutcheson's by imposing on the man the 'petty cares attached to the life of a consul'.[28]

Carmel was little more than a remote settlement when the Thaddeus family arrived, Victor recalling that there was nothing there save 'a few houses and a Carmelite mission'.[29] However, artists had been coming to the town since the 1870s, and in large numbers since the early 1900s in search of 'inexpensive housing, inspiration and amusement' and within a short period, Carmel became one of the most popular artists' colonies in the United States.[30] Indeed, the Carmelite mission itself, the Mission San Carlos Borromeo, proved a very popular subject among painters, who recorded it 'in various stages of decay, and ultimately, restoration'.[31] The town attracted artists from all over the country, and rivalled such colonies as Santa Fe (New Mexico), New Hope (Pennsylvania) and Monhegan Island (Maine), though not Provincetown (Massachusetts).[32] Coincidentally, Thaddeus may well have arrived in the year of the inaugural art show of the Carmel Arts and Crafts Club, which had been established in 1906. The club, which functioned as a co-operative, flourished, and from 1913 ran an annual summer school of art, for which the organisers managed to enlist the services of nationally known artists from New York including William Merritt Chase and George Bellows.[33] Chase, whose students in the east included Georgia O'Keefe, was best known for his impressionist *plein air* landscapes, and

27 Victor Thaddeus, 17 March 1943. 28 Ibid. 29 Deirdre Stapp (daughter of Victor Thaddeus), Letter to the author, 7 July 1998. 30 Promotional literature of the Henry Meade Williams Local History Department, Harrison Memorial Library, Carmel-by-the-Sea, California, 1997. 31 H. G. and A. Gilliam, 1992, p. 145. 32 See Jacobs, 1985, p. 171. 33 Ibid., p. 147.

taught at the school in 1914 and 1915, while Bellows taught there in 1917. Though Thaddeus was apparently not a member of the club, he would have been familiar with, and presumably approved of, its activities.[34] Despite Carmel's obvious popularity, few of the artists who settled and/or worked there or in the Monterey region achieved wide recognition. The most celebrated artists include the Frenchman Jules Tavernier, German-born William Ritschel, who won the coveted Ranger award from the National Academy three times, Xavier Martinez and Maynard Dixon.

Thaddeus did not own a residence in Carmel, but maintained the family's high standard of living, and could afford to take on at least one servant, referred to by the family as the 'Chinaman'.[35] The cost of living in the town was famously low, and indeed another of its great attractions, although it is difficult to imagine Harry or Eva ever succumbing to the very bohemian lifestyle in which 'today's ten cents is as good as yesterday's dollar', which was widely espoused.[36] Thaddeus built himself a small studio at the mouth of the Carmel River and, as he had done in Wales, would drive around the local countryside sketching. A story that became part of Thaddeus family folklore suggests that Harry was arrested by a local cavalry platoon for being in communication with a German submarine off the coast near Carmel, but was released from prison when it was discovered that he had been painting a pod of whales! Harry obviously enjoyed his painting excursions, on which he was sometimes accompanied by his sons. One summer in California he took them on a walking trip over the Sierras, and terrified old prospectors in remote bars 'in the old Bret Harte country' with crayon drawings of imaginary monsters 'peopling the canyons'.[37] Bret Harte, born in Albany, New York, moved to San Francisco as a young man, and wrote novels focussing on life in the mining camps and towns of California in the late nineteenth century. Sadly, none of the drawings described by Victor survives.

The social life in Carmel was as it had been in Wales, and Thaddeus' group of friends and artistic associates included a number of esteemed individuals in various artistic fields. Conspicuous among them were the maverick novelist and prose writer, Jack London (1876–1916), a native of San Francisco, and George Sterling (1869–1926), the poet, who had come to Carmel with his wife in 1908.[38] In Carmel, Sterling became, in the words of his mentor Ambrose Bierce, 'the High Panjandrum' of the artists' colony there. He published numerous volumes of verse and other writings, including pieces referring specifically to Carmel. He committed suicide in his rooms in the Bohemian Club in San Francisco in November 1917. Jack London, who had also arrived at the beginning of the

34 See 'Art colony developed at turn of the century', *Monterey Peninsula*, 1 June 1970.
35 Victor Thaddeus, 30 March 1943. 36 D.F. Bostick and D. Castlehun, 1925, p. 51.
37 Victor Thaddeus, 30 March 1943. 38 A. Johnson and D. Malone, eds, iii, 1964.

century, would have recently returned from his aborted attempt at sailing round the world on his yacht, the *Snark*, when he encountered Thaddeus. Following the trip, which had taken over two years, he concentrated on his ranch, and the planning of a great estate. He was a prolific writer, publishing forty-three volumes of work during his life (seven more were published posthumously). His work, which invariably dealt with the primitive and the savage, also featured sailors, tramps, Native Americans and members of the working class, and reflected the author's left-wing politics. In this respect, London was an unlikely associate of Eva Thaddeus, who was deeply opposed to socialism. Harry, in contrast, at the very least paid lip service to the Left. Neither his pro-Bolshevik nor, oddly, his pro-German stances, remembered by his son Victor, would have been congenial to his wife.[39] Victor Thaddeus, who enlisted in the United States army during the First World War, was horrified when, arriving on a visit to his parents in Carmel while on leave, he discovered that his father was plotting the advance of the German armies on a map on the wall of his studio. Victor left the house, vowing never to visit again. He did in fact return, by which time Harry had removed the offending map from view.[40] In general, the political differences, if only rhetorical, between Harry and Eva, are difficult to reconcile.

London and Sterling were regular visitors to the Thaddeus home, as was the cartoonist Homer Davenport (1867–1912). Possibly as a consequence of this politicised company, Thaddeus' ambitions in America extended beyond his painting and he and Davenport talked enthusiastically about founding a 'great middle western' newspaper, for which Davenport would produce the cartoons and Thaddeus any portraits and drawings. Davenport was one of the most influential political cartoonists of his generation, who had worked for newspapers in Portland, in his native Oregon, San Francisco and New York and published a number of books, including *The dollar or the man?* (1900), *My quest of the arab horse* (1909) and *The country Boy* (1910). He possessed an unusual perspicacity and satirical wit, was particularly civic-minded, and in San Francisco, was an ardent advocate of municipal reform. The plans for the paper, however, like Thaddeus' investment ventures in California, never came to fruition.

On the west coast of America, with its kinder climate and picturesque landscape, Thaddeus encouraged the respect for and interest in nature that he had made great efforts to instil in his sons in Wales, and tried to foster a self-sufficiency and hardiness that he hoped they would develop. He endeavoured to teach them survival skills, and encouraged them to engage in outdoor pursuits. On one occasion, when the boys were in their early teens, Thaddeus deposited them in the wilds of the countryside with nothing but basic equipment and a rifle, arranging to pick them up only after several days spent on their own.[41] He

39 Patrick Thaddeus, Letter to the author, 28 May 1997. **40** Maria Thaddeus, 7 November 1997. **41** Ibid.

also took his sons sailing in Carmel Bay, and even built a sailing canoe for them himself.[42] He was known to go walking for long distances and on lengthy camping trips to the Sierras and elsewhere, and practised callisthenics, a discipline viewed by his neighbours as a rather European eccentricity.[43]

Though it is possible that Thaddeus prospered from portrait commissions undertaken in California, and painted on his forays into the countryside, very few works dating from this period are known. His son claimed that he made 'a lot of money painting', but there is little evidence to support this. Nor does it necessarily mean that he was prolific.[44] Furthermore, one cannot assume that the paintings he produced as he travelled through the countryside were all of saleable quality, or indeed intended to be. A small Californian landscape, dated 1906, which may well

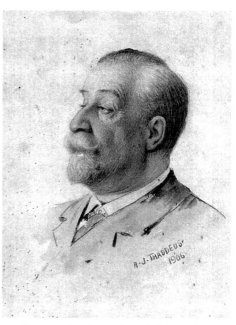

50 *Baron de Benckendorf*, 1906. Watercolour on paper. Private collection.

have been executed on one of these trips, is more of a personal record than a fully-worked, marketable landscape (pl. 38). It is a cheerful picture, which captures successfully the climate that was apparently so much to Thaddeus' liking, and again demonstrates the facility with which Thaddeus used watercolour, albeit in a very conventional idiom. The more impressive painting known to date from this period, depicting a Native American camp (pl. 39), may also originate from sketches executed on the spot in California, or elsewhere in the Sierra Nevada, and stylistically is reminiscent of some of the artist's youthful work in Europe such as *Spilt Milk*, *The Old Prison Annecy* and *Mediterranean Fishermen*. In all of these works, the artist's reliance on strong dark outlines and relatively limited modulation of tone, much akin to illustration, is very much in evidence.

A small portrait in watercolour, technically and formally identical to the portrait of Mortimer Durand of 1904, may also have been painted in America. The sitter is Baron Dmitri de Benckendorff, Thaddeus' old friend, who he described as the 'enfant gaté of the [Russian] imperial household' (fig. 50).[45] The two men had met many years before in Florence, and had even witnessed

42 Deirdre Stapp, Letter to the author, 13 July 1998. 43 Ibid. 44 Victor Thaddeus, 17 March 1943. 45 H.J. Thaddeus, 1912, p. 118.

together a train crash in Monte Carlo, the account of which Thaddeus embellished considerably in his *Recollections*. It is unlikely that the small watercolour was a sketch for a larger picture, and certainly was not intended to make the artist any money.

From his early days in Cork, Thaddeus had been a supremely confident and seemingly inexhaustible self-promoter. This was instinctive, but also required application and the ability to persevere when circumstances, such as impending bankruptcy, posed a challenge. As a result, as time passed, Thaddeus' enthusiasm for outdoor activities did not extend to artistic pursuits. Just as there is no record of how prolific he was in America, it is not known what efforts he made to remain visible within social and professional circles, either there or in Britain. A succession of occurrences suggests strongly that he was drawing his professional career to a close, or was at least scaling it down rapidly. He was remembered in Carmel in the early 1950s by an elderly woman who owned a seascape by him as a rather difficult neighbour, but not as an individual of any great renown.[46] Fundamentally, one wonders if the publication of *Recollections of a court painter* in 1912, written far away from the world it represented, was an incidental event, an opportunity to take stock, or an acknowledgement by the artist that his career was in decline.

Without doubt, Thaddeus 'the artist' was more distractible in America than he had been to date. He talked of founding newspapers and, susceptible to influence and careless with money, squandered most of what he had made on various schemes and investments. Admittedly, he had never shown particular prudence in matters financial. In Wales, for instance, he lost money regularly playing cards against Father Clark, an eccentric travelling priest who visited the family. In America, he proved easy prey to 'promoters of phoney oil stock, airplane stock, the inventor of an electric balloon', and even 'a man with a perpetual motion machine whose engine derived its energy from simply "breaking up the atom"'.[47] Despite his conventional artistic tastes and rejection of the camera, Thaddeus was genuinely fascinated by inventions and innovation. He had a particular interest in aeronautics, and in *Recollections* mentioned how much he admired Count Zeppelin's ingenuity in designing his airship, when he met him at Friedrichshafen. In America, he took the family on picnic trips to the North Island to watch Curtiss experimenting with his flying boats, and would point out the strengths and weaknesses of their designs.

The frenetic years leading up to his departure for the United States, punctuated by lengthy trips abroad, social pressures, court cases, threats of bankruptcy and major commissions, took its toll. Thaddeus' paintings were

46 Deirdre Stapp, 7 July 1998. The Henry Meade Williams Local History Department, in the Harrison Memorial Library in Carmel, holds no information on Thaddeus. 47 Victor Thaddeus, 17 March 1943.

irregularly on exhibition. Following his surprising anonymity at Hugh Lane's prestigious Guildhall exhibition in 1904, and his limited showing at the Irish International Exhibition in Dublin, which opened in Leeson Park in April 1907, Thaddeus was represented by two rather incongruous pictures at the Whitechapel Exhibition of Irish Art in London in 1913. These were his very early drawing of Isaac Butt, lent by Count Plunkett (who had commissioned the piece over thirty years earlier), and his portrait of Gladstone, lent by the Reform Club. Astonishingly, these appear to be the last paintings Thaddeus exhibited in Britain. Moreover, he is likely to have had no more influence on or involvement in the exhibition than to have given his consent to the display of his pictures. In any case, it seems a rather apologetic swan-song. At least the Cork School could be relied upon to maintain his status. In May 1912, the Committee applied to him for a picture for the School of Art Gallery. Thaddeus, who had never lost contact with his native city, obliged without hesitation, offering two pictures.[48]

In December 1916, Thaddeus' fellowship of the Royal Geographical Society, which he had held for over twenty years, was rescinded. He did not formally resign, but rather, failing to pay the annual subscriptions, allowed his membership to lapse.[49] Perhaps most telling of all of his drift from the social and artistic worlds that he had inhabited for so long was his failure to exhibit at the RHA again after 1902 (when he was just forty-two). He had exhibited just once as a full Academician. Moreover, he claimed, rather implausibly, to have resigned that distinction 'in order to make way for a younger man'.[50]

Thaddeus undoubtedly had an ambiguous relationship with the United States. He criticised Americans' acquisitiveness and lack of good humour, and was disparaging about the expatriate community with whom he studied in Paris, but was willing to uproot his family to settle in America and exploit its business opportunities. Furthermore, he grew attached to California and enjoyed its literary and artistic society. During the First World War (albeit during America's period of neutrality), he expressed pro-German sympathies, but made it clear that he wanted his sons to become 'good Americans'.[51] However, there are strong signs that neither Harry nor Eva ever felt truly at home in America. They were both heard to remark wistfully of their life there that they were 'just camping out', and it seems clear that Harry was never comfortable with the relative informality of American society.[52] One story, for example, suggests that, while checking into a hotel in San Francisco with his family, Thaddeus was outraged by the interchangeable nature of the terms 'guy' and 'gentleman'.[53]

48 TICCBC, 13 May and 8 July 1912. 49 Original Certificate of Candidate for Election, Royal Geographical Society. 50 Michael Holland, Letter to B. MacNamara (Registrar of the National Gallery of Ireland), 19 March 1928, National Gallery of Ireland Archives. 51 Maria Thaddeus, 7 November 1997. 52 Ibid. 53 Patrick Thaddeus, Letter to the author, 1 September 1997.

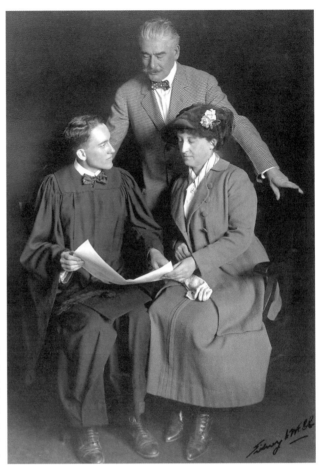

51 Harry Jones Thaddeus and Eva Thaddeus with their son Victor on the Occasion of his Graduation from the University of California, *c*.1916. Photograph. Private collection.

He was known to pine for life in Europe, and each New Year, received a cable from the king of Württemberg, which could reduce him to tears. Victor remembered that at this time, his father would sit outside 'with a demijohn of Zinfandel beside him', his eyes fixed on the distance.[54] Predictably, Harry and Eva's apparent disillusionment with life in America influenced their expectations for their children. Their son Victor claimed that though he was instinctively drawn to writing, his parents, who 'knew well the ups and downs of the artist's life', persuaded him to study Chemistry at university. He did so, but inevitably returned to his real passion, and ultimately produced novels, biographies, short stories and numerous articles. Victor's biography of Voltaire, published in the 1920s, was particularly well received. By this time, however, his mother and father had long since returned to Europe.

54 Victor Thaddeus, 30 March 1943.

Victor claimed that his mother was in London during the Zeppelin air-raids over the city, which began in May 1915, but Harry and Eva probably did not leave America until after it had entered the war, in April 1917.[55] They were certainly in the United States for Victor's graduation from the University of California in 1916 (fig. 51). On arriving back in Britain, they moved into Appley Court, a large house in a fashionable area in St Helen's, near Ryde, on the north coast of the Isle of Wight, a short ferry journey from the mainland.

Sadly for the family, differences between Harry and his elder son, Freddy, had had enduring consequences. Some time between 1916 and 1920, Freddy married Margaret, a woman of an Irish-American working-class family. Evidently, Harry and particularly Eva disapproved of the marriage, and an unbridgeable rift developed between themselves and Freddy. It is not known for sure if Freddy severed links with his parents immediately, but what seems certain is that, though he stayed in contact with his brother, the break with his parents was absolute.[56] The schism was such that Freddy was disinherited and was not even mentioned in his mother's will of 1946. History had repeated itself. It is not known with which parent, if either, Freddy's grievances primarily lay. Eva seems to have been more acutely class conscious than her husband, but it appears that words were exchanged between Freddy and his father that 'were unforgivable'.[57] Curiously, Freddy and Margaret named their first child, born around 1918, Eva. Many years later, Frances Thaddeus, their second daughter, bought two paintings by her grandfather. Freddy died in Bakersfield, California in the late 1950s or early 1960s.

In the last ten years or so of his life, Thaddeus effectively relinquished painting. He continued to travel, certainly spending time in the south of France.[58] It has been suggested that he travelled back to Cork regularly, and the portrait of his friend Michael Holland of 1920 (pl. 24) is the latest known work by him. His health was beginning to fail, perhaps as a result of an over indulgence of alcohol and, in stark contrast to his life in earlier years, he led a relatively reclusive existence, to the extent that the *Isle of Wight County Press*, in a short obituary, referred to him as 'a somewhat reserved character'.[59] It is conceivable that his arrival in England at the end of the war, and his lack of involvement in the war effort in general, were judged with suspicion and/or disapproval by his neighbours. So much had Thaddeus' profile diminished, in fact, that the registrar of the National Gallery of Ireland wrote to Michael Holland in 1928 asking him for the artist's death date for the gallery's records.[60] Thaddeus was looking forward to visiting Ireland in 1929, but was prevented by ill health from doing so. He was well aware of his physical demise, assuring his friend Holland

55 Victor Thaddeus, 20 September 1939. 56 Patrick Thaddeus, 1 September 1997.
57 Ibid. 58 Michael Holland, 19 March 1928. 59 *Isle of Wight County Press*, 4 May 1929.
60 B. MacNamara, letter to Michael Holland, 20 February 1928. NGI Archives.

wistfully that if they did not meet again in Ireland they would 'meet anon, adorned with seraphic wings'.[61]

Thaddeus died alone at his home on 1 May 1929, his apparent isolation 'accompanying' him to his death. That few on the Isle of Wight knew him was cruelly illustrated by the failure to record his name or age correctly on his death certificate, or in local newspaper reports. His death certificate recorded his name as 'Henry Jones Thaddeus', though any friend would surely have known him as Harry. Furthermore, the certificate stated that he was eighty-two years of age, inaccurate by some thirteen years. It also stated, under 'Occupation', that he was of 'independent means' rather than an artist. The announcement in the *Isle of Wight County Press* said that Thaddeus' 'only son' was in Canada (not America), and therefore unable to attend the funeral. This would support the notion that all links between Thaddeus and Eva and Freddy were broken by this time. The same announcement made other errors, including the deceased's age (it stated 'eighty'). In fact, neither Freddy and Victor, nor Eva, attended his funeral three days later at St John's Church, Ryde, or the interment in nearby Westridge Cemetery.[62]

Eva was always convinced that drink had hastened her husband's death. He was just sixty-nine, and for a man whose physical prowess and constitution had been a source of some pride, and humour, his decline had been rapid. Victor's letters attested to over-indulgence, many of the anecdotes featuring pointed references to alcohol.[63] Thaddeus' penchant for alcohol can be traced back to his trip through Holland with his old friend Henry Savage Landor. In his account of their experiences together in Zeeland, Landor mentioned that at each house, 'we had to stop and have a parting drink, which Thaddeus enjoyed for himself and for me, of home-brewed beer or *skidam*'. In his account of his father's death, Victor related that Thaddeus died at the kitchen table, with 'a bottle of port and a half empty glass beside him', and his favourite Irish collie lying asleep at his feet.[64] The causes of death recorded on Thaddeus' death certificate are certainly consistent with over-indulgence in alcohol.

Eva's life had followed a very different course to her husband's on their return to England. She spent an increasing amount of time with Lady Houston, and was cruising on Houston's 1,600-ton yacht, the *S.Y. Liberty* (Joseph Pulitzer's old vessel) in the Mediterranean when Harry died. A short time after his death, she was visited on the Isle of Wight by her daughter-in-law Elizabeth (Victor's first wife), who caught a glimpse of the lifestyle she enjoyed there. Her

61 Michael Holland, 19 March 1928. 62 Mr Roy Brinton, Curator, Carisbrook Castle Museum, Letter to the author, 26 October 1995. See also Roy Mattocks, Acting Verger, St John's Church, Ryde, Letter to the author, 21 June 1997. 63 H.S. Landor 1924, p. 37. Thaddeus' death certificate records the cause of death as (i) a. Coma; b. Cerebral Haemorrhage and (ii) Arterio Sclerosis. 64 Victor Thaddeus, 30 March 1943.

social circle consisted of an 'amiable, fairly extensive set of English people, retired civil, military people and writers' who represented 'fashionable, probably more intellectual than commercial, society'.[65] The society that Harry had enjoyed for most of his life did not desert Eva altogether.

For portrait painters who, like Thaddeus, relied on regular commissions for their livelihood, profile was almost as important as product. Having spent almost three decades building a reputation as a competent and sought-after artist, Harry Jones Thaddeus faded from public view. At the height of his career, from the mid 1880s to the mid 1890s, he was praised by the Irish press and patronised by significant members of Europe's elite. This was attributable largely to the considerable professional and social acumen he had displayed from an early stage, and represented an achievement far beyond his expectations as a student in Cork. Success became Thaddeus, and his readiness to facilitate and indulge the conventional tastes in art and social protocol that endured among his patrons ensured its continuation. The breadth of his *œuvre*, however, points to a more adventurous and unorthodox spirit.

Thaddeus experimented with a variety of genres and, to a lesser extent, styles, in search of a combination that would accurately reflect his imagination, erudition and practical skill. The variety of his work beyond portraiture, and the indecision and restlessness that it represents, are clear manifestations of the artist's desire to express himself more effectively or completely than portraiture would allow. The indecision may itself be symptomatic of Thaddeus' pragmatism, as he searched for a means of expression that both complemented his existing reputation as a portrait painter, and enriched it. Thaddeus was, ultimately, profoundly career oriented, and neither willing nor inclined to risk the respectability that portraiture guaranteed for the kudos that could attach to counting oneself among the *avant-garde*. His challenge lay in establishing himself for posterity as more than just a journeyman artist or a skilled technician. He wanted to be remembered as an artist of remarkable ability, and singular vision, albeit within an academic tradition. For much of his career, Thaddeus came close to realizing that ambition. His portraiture was desirable, while his works in other genres were regularly accepted, and well received at major exhibitions. In the end, however, his personal circumstances and the momentum of modernism overtook him. He was, admittedly, not alone in this respect. Comparable artists such as Frank Dicksee and Luke Fildes could not keep pace with emerging trends, and consequently fell out of favour. Dicksee was elected president of the Royal Academy in 1924, but this reflected the conservatism of that institution more than it did the currency of his artistic output.

It is significant that though Thaddeus could count some of Europe's most influential and glamorous personalities among his most important clients and

65 Patrick Thaddeus, 1 September 1997.

friends, many were approaching the ends of their careers or lives, and their patronage was not assumed by a subsequent generation. Thaddeus may have succumbed prematurely to nostalgia. In a letter to Princess May of 14 August 1901, King William of Württemberg mentioned that the artist paid a ten day visit to the king's home in Friedrichshafen, and hinted at the fact that the world that had effectively launched, and secured Thaddeus' career, was fading fast. 'Isn't it funny', he reflected 'that we should meet up again after so many years. We have been speaking much of the dear old Seefeld days as well as ... your dear old parents'.[66] As Thaddeus' clientèle diminished, so did the public enthusiasm for the type of genre and subject pictures he was inclined to produce.

In general, the Europe to which Thaddeus returned around the end of the First World War was irrevocably different from that in which he had prospered in the 1880s and 1890s. The war had created massive and irreconcilable divisions, as well as uncomfortable alliances, between nations with which Thaddeus had always maintained close associations. Ireland had been in a state of political flux for many years, and was edging ever closer to an independence that was only beginning to seem a possibility when Thaddeus left Europe for America. If, as seems to be the case, Thaddeus had been suspicious of modern movements in art before the turn of the century, he may well have felt overwhelmed and isolated by the proliferation of new styles, manifestos and techniques that characterized the first two decades of the century. Society portraiture, the genre in which he had held so firm a position had also changed radically, and now, with the erosion of the authority of the upper classes and aristocracy, was moribund. Thaddeus had been absent for its swan-song, when artists such as Sargent, Sickert, John and Ambrose McEvoy as well as Irish artists like Orpen and Lavery, had celebrated in their work an extraordinary community, in decline but, paradoxically, at the zenith of its confidence and flamboyance.[67]

James Pope Hennessey unconsciously reinforced the degree to which Thaddeus had been left behind, suggesting that his youthful artistic efforts among the Teck family in Florence at the beginning of his career did not warrant comparison with the formal portraits of Princess May executed after she became duchess of York. 'All this outburst of portraiture', he wrote 'was one more symptom of the dignity of Princess May's new position. In earlier years she merely sat to Thaddeus Jones for fun; now, as duchess of York, she was being solemnly recorded for Posterity'.[68] It is a sad reflection on Thaddeus' descent from the high ranks that Princess May, who had enjoyed his company so much in her youth, did not invoke his expertise in later years and sit for him.

Thaddeus' avoidance of an exclusively artistic fraternity, its associated clubs and cliques, may also have ultimately worked against him. During his mature

66 King William of Württemberg, Letter to Princess May, duchess of York, 14 August 1901, RW, RA CC 45/246. 67 See McConkey, 1991, p. 386. 68 Pope-Hennessy, 1959, p. 290.

career, his involvement and interaction with other artists and artistic institutions was deliberately peripheral or transitory, which meant that he relied almost exclusively on his own connections and personal tenacity for the maintenance of his profile. The negative social repercussions of his marriage to Eva would have made that task all the more difficult. That Thaddeus' dislocation from the art world was compounded by his faltering health cannot be overlooked either, particularly as his ebullience and physical presence had contributed greatly to his popularity.

Thaddeus was neither blind to his demise, nor untouched by it, but rather found himself lacking the resources to redress the situation. 'My father I think was hurt at times', Victor Thaddeus wrote 'by the thought that among painters he was considered to be a successful and good painter, conservative in treatment, but not great in the sense of the modernists.'[69] Not that Thaddeus considered himself a modernist, or had any desire to be identified as one. He had always been a competent and enthusiastic technician, who had had a few notable moments of innovation and, in the case of the *Irish Eviction – Co. Galway*, artistic bravery but, overall, his work relied heavily on the achievements and developments of others. By the early years of the century, his work had insufficient currency to allow him to forge a new career in Britain and Ireland among a public whose tastes and sensibilities had changed radically. Thaddeus was suspicious of modernist trends and, symptomatic both of his taste and education, was sceptical about the skills of those who adhered to them. Victor explained that his father 'had no patience with an artist who could not draw a thing to look as it actually was, and brushed aside a great part of modern art as the deliberate imposture of quacks'.[70] It seems clear that Thaddeus suffered a lingering discontent at not fulfilling, or not being allowed to fulfil, his artistic potential. Victor, again, attributing this failure partly to his father's gregarious personality, suggested that Thaddeus felt that he could do 'some very great things in painting if he only ever got around to it'.[71] But in reality, it is unlikely that in Thaddeus' case, even endless application to his work would have ensured universal praise into the second decade of a new century. It is amusing to see the artist's son expand upon his father's artistic philosophy by referring to still-life, a genre in which there was a resurgence of interest among *avant-garde* painters, but in which, of all genres, Thaddeus never displayed the slightest interest. 'For anaemic art such as a meagre apple on a table', Victor elucidated, 'with perhaps a few sardines beside it, or some other such bit of still life, he had no use at all'.[72]

Rimbault Dibdin's rueful reflections on the art of Frank Dicksee (published in 1905, some twenty-three years before the artist's death), might equally be applied to Harry Jones Thaddeus, and would no doubt have been endorsed by the Irish painter. 'At the present time', maintained Rimbault Dibdin 'the public

69 Victor Thaddeus, 30 March 1943. 70 Ibid. 71 Ibid. 72 Ibid.

taste, or the fashion, or whatever it is that regulates the fluctuations of opinion, is for pictures that have little in common with those of Mr Dicksee. Classical feeling for design, romantic sentiment in art, are decried: the most clamant opinion condemns all pictorial qualities, the presence of which differentiates art from mere painter-craft'.[73]

It is touching to see that one constant in Thaddeus' life, right up to the final years, was his attachment to Ireland. Lest one should ever doubt his credentials as an Irish artist, it should be remembered that he maintained contact with Cork, endorsed its exhibitions and returned regularly, less to seek adulation for what he had achieved during his career than to acknowledge his origins. Despite his success abroad and the cosmopolitan world he had occupied for so long, Thaddeus appears to have never subscribed to the notion that Ireland was little more than a provincial outpost. On the contrary, he valued its artistic inheritance, and its contribution to European art. Indeed, it is fitting that the earliest and latest known works by Thaddeus are portraits of Denny Lane (1877) and Michael Holland (1920) respectively, both Corkonians, committed to facilitating, patronising and promoting the arts in Ireland. In later years, Thaddeus' representations to the country have something of the tone of the fond, retired ambassador, rather than the bohemian, enlightened expatriate. Retrospection for Thaddeus, precipitated by his change in fortunes- artistic, social, financial and health related – began prematurely, but that does not negate his contribution to Irish painting, nor his unique and unsurpassed position as an Irish court artist in Europe and beyond.

The Irishman newspaper stated prophetically as early as 1881 that Thaddeus had 'energy and push enough to advance himself in his particular sphere'.[74] Perhaps as knowledge of his life and pictures increases, his friend Michael Holland's typically loyal assertion that 'the place of Harry Jones Thaddeus in art is assured' will prove equally correct.[75]

73 R. Dibdin, 1905, p. 31. 74 The *Irishman*, op. cit., 4 June 1881. 75 M. Holland, 9 May 1929.

Appendices

Though *An Irish Eviction – Co. Galway* was the last painting of its kind that Thaddeus exhibited, a rather complex and baffling illustration in *Le Monde Illustré* suggests that it was not the only work by him of its kind (fig. 52). The caption below the picture states that it depicts members of the Land League coercing a tenant to swear on the Bible that he will withhold his rent. The Land League, founded in October 1879 by Davitt, and succeeded by the National League in 1882, employed a variety of persuasive tactics in pursuit of their goals (land reform and ultimately Home Rule), including the 'no rent' policy that encouraged tenants to hand their rent over to local relief groups, rather than to their landlord. Tenants who refused risked being 'boycotted' (i.e. ostracised by those members of the community who supported the Land League strategy).[1] It proved an

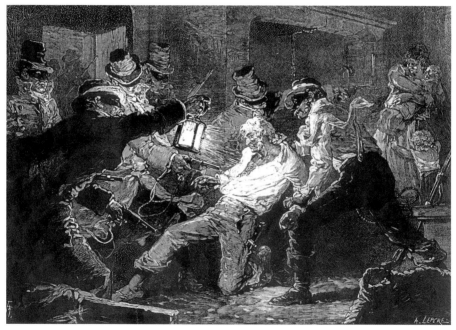

52 Auguste Louis Lepère (after F. de Haenen, possibly after Thaddeus), '*En Irlande: Affiliés de la Land-League faisant jurer sur la Bible à un fermier ce ne plus payer son tenancier*'. Engraving from *Le Monde Illustré*, no date.

1 This term was coined as a result of a specific case involving the land agent Captain Hugh Cunningham Boycott (1832–7) at Lough Mask in Mayo in 1880.

effective, if often divisive, approach, and received widespread support, with the
establishment of relief groups in nineteen counties between late 1880 and September
1881. The Land League was proscribed in October 1881, and Parnell, who had been
imprisoned with most of the executive, and had released the 'no rent' manifesto while
in Kilmainham, effectively dismantled the organisation on his release. It attracted,
however, a militant element, including members of a shadowy secret society called the
Moonlighters, who took their name and example from the infamous Captain Moonlight,
the collective identity adopted by extremists who orchestrated a campaign of ruthless
violence earlier in the century. Captain Moonlight had been targeted by the British
illustrated press as the epitome of the treasonous, bloodthirsty Irish nationalist, and was
commonly represented, in typical simian form, wearing a mask over his eyes. The motif
became established, and was appropriated to the militant nationalists of the early 1880s.
This grotesque, masked figure was used, for example, to represent those individuals
calling themselves the 'Invincibles', who were responsible for the murder of the Chief
Secretary Lord Frederick Cavendish, and Under Secretary T.H. Burke in the Phoenix
Park on 6 May 1882. It seems probable that the image of the masked Land League
members in the French illustration was similarly borrowed from an English model.
However, though Thaddeus was certainly prone to caricature, as much in his formal
portraiture as in his genre painting, it is highly implausible that he would have chosen
to depict Irish nationalists in such an opprobrious and derivative manner. Other aspects
of the illustration make it difficult to establish the extent to which it is genuinely
attributable to Thaddeus. Not least among these is the rather anachronistic subject.
Thaddeus was producing works of Irish socio-political subject matter in his youth, when
the Land League existed, but nothing on the scale or complexity suggested by this
picture. Moreover, the acknowledgement in the caption is to 'M. Thaddeus', which
indicates that it must have been at least printed after 1885, when Thaddeus changed his
name officially. It is unlikely that he would have executed works of subjects up to six
years out of date. The subject was too recent to be considered a history painting, yet too
old to serve as contemporary reportage. The costumes also appear rather inaccurate, as
though they have been estimated by an artist who had inherited ideas of how the Irish
peasantry looked. The hats in particular relate more to the attire of the mid-century
(1850s and 1860s) than they do to that of the 1880s, although, again, the overall
appearance is not unlike figures in the illustrated press in England, in which the Irish
were represented as somewhat backward in lifestyle as well as intellect.

 The political tone of the illustration is also difficult to reconcile with what appear to
have been Thaddeus' views. A sinister scene of thuggish vigilantes coercing cooperation
from a defenceless tenant, as his wife and children cower in the background, certainly
did not promote the cause of land reform or present Home Rule in a positive light.
Thaddeus was genuinely interested in the plight of the Irish peasantry and, as far as one
can tell, subscribed to Home Rule as an ideal, but at no point condoned the employment
of violent methods in rural agitation.

 Whoever was responsible for the picture displayed erudition and eclecticism in its
design, and particularly a knowledge of the great Italian and Northern masters.
Fundamentally, the illustration is an appropriation of a 'Taking of Christ', relying for
its impact on the submissive nature of the figure being apprehended. The illumination
of the scene by a prominent light source suspended above the action calls to mind the

work of the Caravaggisti. Furthermore, the figure on the left who thrusts the lantern forward with a rather exaggerated, and awkward, gesture, is reminiscent of the Borghese gladiator, which had been in Paris since the early nineteenth century, and which Thaddeus would surely have known, having spent time in the Louvre as a student. In the background on the right cower a distinctly Michelangelesque mother and child, whose behaviour echoes the gravity and drama of the scene, but who are not actually reacting to a specific action directed at them (i.e. being threatened at gunpoint). As a result, that small figure group looks strangely detached from the main protagonists. All the above is arguable, and even if correct, does not necessarily indicate Thaddeus' authorship. He had an extensive knowledge of Italian art, and was also familiar with Dutch art, but in no other works does he quote literally from great masters and/or their individual works.

While the above connections are merely speculative, and inconclusive, the figure of the tenant suggests Thaddeus' involvement more convincingly. It bears a strong resemblance to John Hogan's celebrated *Drunken Faun*, which was in Cork by the mid-century, and which Thaddeus knew well. The manner in which the peasant's left leg is bent underneath him, and his right outstretched with the foot turned, was one of Hogan's innovations. The way in which one of the peasant's arms, planted behind him, bears most of his weight, is also very close to Hogan's figure.

Other characteristics are consistent with Thaddeus' involvement. The setting of the scene inside a gloomy, crowded, claustrophobic space, with figures entering through a door at the back on the left, also feature in *An Irish Eviction – Co. Galway* (pl. 21), and *Christ before Caiaphas* (pl. 34), but that was not unknown in illustration. The horizontal composition, and movement also parallel those in *An Irish Eviction*. More specifically, the placement of a creel in the bottom right-hand corner of both pictures is almost identical, and deliberately employed to close off the space. The depiction of the hearth is also generic, but close to details in Thaddeus' work. The treatment of the drapery on the central figure can also be said to resemble that of the principal figure in *An Irish Eviction*, although it can be misleading to make direct comparisons between woodcuts and oil paintings.

The word *croquis* may be the key to establishing the extent of Thaddeus' involvement in the picture. The term is used generally for a sketch, but sometimes more specifically to a drawing that is even more rudimentary than a preliminary sketch. Both F. de Haenen, who had worked regularly for the *Graphic*, and Auguste Louis Lepère, the engraver, who contributed many works to *Le Monde Illustré*, produced their own original work, so it would not have been unusual for either to have produced an image based on an idea, form or composition by another artist. It is not clear how a picture by Thaddeus (in any form) might have come into the hands of French artists. The compositional similarities between the illustration and *An Irish Eviction* may indicate that Lepère knew Thaddeus' painting – he might even have seen it on exhibition at the Walker Gallery – and adopted it as a model for his illustration. Such a loose interpretation would explain the inaccuracy of the costume and incongruity of the subject. It would not, however, account for the pose of the central figure, which may represent perhaps the most direct link between Thaddeus and the illustration.

APPENDIX TWO: HARRY'S DEATH, EVA'S LIFE

Following Harry's death, Eva remained in their house on the Isle of Wight for a short period, but began to spend more time with her friend Lady Houston, who now lived permanently aboard her palatial yacht, which was usually moored along the Seine or on the French Riviera. From there, Lady Houston, who was a firebrand conservative and, by this time widely considered an eccentric (albeit an extraordinarily rich one), edited the *Saturday Review*, a reactionary periodical, from 1933 till her death in 1937. In the magazine, she repeatedly stressed the importance of maintaining the empire, and lashed out with invective at the 'scourge of Bolshevism' and of the danger posed by Germany's increasing air power. Lady Houston had inherited a vast fortune from her third husband, Sir Robert Houston (1853–1926), the shipping magnate and politician, and contributed a significant amount to such projects as the development of the Spitfire aircraft. Lady Houston's generosity and munificence were as extraordinary as they were selective. She reputedly gave her guests aboard the *Liberty* a stipend to buy fashionable clothes if they required it.[1] In 1932, she offered Neville Chamberlain, then Chancellor of the Exchequer, £200,000 to be invested in national defence (Chamberlain was obliged to decline the offer). On another occasion, the Miners' Distress Fund received a donation from her for £30,000, accompanied by a letter urging the miners to think for themselves and to send all Trade Unions 'to the place where all bad people go'.[2] While Eva was possibly not quite as vehemently political as her friend, her views were closer to Lady Houston's than to many of those held by her husband.

Eva moved from the Isle of Wight to Paris, whence she contributed regular articles on French society to the *Saturday Review*, under the simple heading 'Eve in Paris'. These articles were among the less political included in the magazine, which served explicitly as a vehicle for Lady Houston's right-wing agenda. Among the individuals Eva knew in the French capital was her elder sister Grace, who despite the family rift was 'devoted to her'.[3] Grace had married a member of the French nobility, the Baron d'Orgeval, who himself had been at various times secretary to the novelist and playwright Alexandre Dumas *fils* (1824–95), and had worked with the engineer and diplomat Ferdinand de Lesseps (1805–94) at the building of the Suez Canal. Eva always saw the baron as a 'thoroughly bad lot', who had squandered her sister's money. Grace was a distinguished poet and playwright, having works published and produced by the Comédie Française and the Opéra Comique. Despite her husband's interference, she was very wealthy, and though disabled later in life, lived between her house in Rutland Gate in London and an apartment on the Avenue Foch. Another friend of Eva's in Paris was Count O'Kelly, Irish minister to Paris and Brussels. Victor Thaddeus liked O'Kelly, whose manner reminded him more of a 'good American salesman' than a diplomat. He was something of a 'roughneck' when compared with the British diplomats Victor had known previously, but had a powerful intellect and tremendous common sense.[4] Victor recalled that the Irish ministry in Paris was full of Irish products, from textiles to

1 Anne de Lagarenne, Letter to the author, 11 August 1997. 2 'Tributes to Lady Houston-Patriot', *Saturday Review*, 9 January 1938. 3 de Lagarenne, 11 August 1997. 4 Victor Thaddeus, 30 March 1943.

furniture, and that the count was prepared to sell anything in which a guest expressed an interest.

Lady Houston died in December 1937, and Eva wrote a lengthy appreciation of her, entitled 'My Greatest Friend' for the *Saturday Review*.[5] Eva did not continue to write for the magazine but remained in Paris until forced to leave at the beginning of the Second World War. As a result of her 'dreadful escape' from the Continent, she lost practically everything she had. Victor helped to support her after her return, but in 1943 described her as 'an invalid and close to want'.[6] Nevertheless, she managed to tour Morocco with a Miss Getty when aged about 80.[7] She is known to have retained just one painting by her husband, a portrait of Cardinal Merry del Val, which hung in her apartment in Swan Court, Chelsea.[8] When she died in December 1946, Eva left just over £8,000. She had been residing in a very expensive nursing home in Bath in her final years, but had little to show for a life of affluence. She left all her estate to her son Victor, and did not even mention her son Freddy in the will. Contact was never restored between herself and her three daughters from the previous marriage.

5 Eva Thaddeus, 'My Greatest Friend', *Saturday Review*, vol. 163, January 1938. **6** Victor Thaddeus, 17 March 1943. **7** de Lagarenne, Letter to the author, 8 September 1997. **8** Ibid.

Chronology

1859 Born Harry Thaddeus Jones, 32 Sheares Street (then known as Nile Street), Hammond's Marsh, Cork. Mother's name O'Sullivan. Father, Thomas Jones, an artificer in japanning. Eldest sibling of possibly eight brothers and two sisters.

1870 Entered Cork School of Art.

1871 Elevated from freehand to cast-room. **August** received award from the Department of Science and Art

1875 Awarded a free studentship at the Cork School of Art.

1876 Appointed assistant master.

1878/9 Spent some months in Dublin.

1879 Won Taylor Art Prize of £15 at RDS (with *A Composition of Four Figures. Interior of a Cottage*).
Went to London.

1879–80 Studying at Heatherley's studio. May have worked for illustrated newspapers.

1880 Won Taylor Art Prize of £50 at RDS (with *Renewal of the Lease Refused*). Confined to bed through illness for some months, but returned to studies at Heatherley's. **September/October** travelled to Paris. **November** joined the Académie Julian, studying under Boulanger and Lefèbvre.

1881 **May** exhibited at the Paris Salon (address: Cité du Retire, 3 Faubourg Saint-Honoré): 1228 *Le retour du braconnier – Irlande*. **30 May** Interviewed by correspondent with the *Irishman*. Exhibited at the RDS: *A Passing Mist on the Champs Elysées; The Wounded Poacher*.
Early Summer departed Paris for Brittany. Spent approximately two weeks in Pont-Aven before moving on to Concarneau. Exhibited at the Society of British Artists (address: Grand Hotel, Concarneau, Finistère) 416 *On the beach: Concarneau*

1881–2 **Winter** remained in Concarneau despite small pox epidemic.

1882 *c.***April** left Concarneau. Returned to Paris (address: [?] Boulevard Saint Michel). **May** exhibited at the Paris Salon: 1426 *Jour de marché, Finistère;* 1427 *Les amies du modèle*. Spent 'some months' at Moret-sur-Loing, painting *en plein air*. **Autumn/Winter** exhibited at the Irish Exhibition of Arts and Manufacturers in Dublin: 462 *A Sea-side Idyll* (attributed to 'Henry Jones'); 1382 *By the Well* £6 6 0; 1469 *The Sunshine of Life* £25 0 0; 1479 *The Wounded Poacher* £50 0 0. **September** left Paris for Florence with a friend. Quickly acquired a studio at 13 Via Ghibellina.

1883 **May** exhibited for the first time at the Royal Academy: 216 *A Wine Carrier*.
Summer visited Siena. **July** exhibited at the Cork Industrial and Fine Arts Exhibition: 19 *Washing Day* £30 0 0; 23 *Without a Care* £60 0 0; 63 *St. Patrick* £50 0 0; 70 *Young Fishermen* £20 0 0; 138 *The Friends of the Model* £50 0 0; 163 *Market Day, Finistère* £150 0 0; 330 *The Wounded Poacher* (Lent by Vincent Scully); 379 *Lelia* £5 0 0; 469 *'Study'* £10 0 0; 1066 *Rent Day* (Lent by D. Arnold).
Exhibited at the Royal Scottish Academy: 601 *Friends of the Model;* 748 *Market Day in Finistere, Brittany;* 761 *Portrait*. **Summer** presented to HSH The Duke

of Teck at the English Club in Florence. Returned briefly to Cork, where he taught William Gerard Barry.

1883–84 **Mid-winter** went on a walking tour over the Appenines from Florence to Viareggio with Henry Savage Landor. Travelled via Pistoia, San Marcello, the Baths of Lucca and Lucca.

1884 **March** renting Al Studio, 7 Lung Arno Guicciardini, while lodging with Mrs Eliza Jane Smillie, an elderly Scottish woman. **May** exhibited at the Royal Academy: 432 *H.S.H. The Duke of Teck;* 617 *H.R.H. The Princess Mary Adelaide, Duchess of Teck.* **3 May** attended dinner-party at I Cedri, where he met the Grand Duke of Mecklenberg-Schwerin. Also present were Baron Dmitri de Benckendorf, Peter Wells, Prince Wolkonski and Marzials, the composer. *c.*17 **May** visited Lake Como with the Grand Duke of Mecklenberg-Schwerin and Baron de Benckendorf. Returned to London to see his pictures in RA. **Summer** exhibited at the Grosvenor Gallery as H.T. Jones (address: Care of Mr W.A. Smith, 22 Mortimer St. W.): 149 *A Portrait.* Lived for some weeks with Robert Percy ffrench in his house at 3 Lower Grosvenor Place. **20 July** left London to rejoin Duke and Duchess at Seelisberg. Stayed there with the Teck family at the Hotel Sonnenberg. **August** travelled by train to Bad Horn on the Bodensee with the Teck party, where he stayed at the Hotel Horn with the Tecks' Württemberg cousins. **September** witnessed cavalry manoeuvres on the plains of Württemberg. Spent winter in Florence.

1885 **Spring** visited the Grand-Duke in Cannes. **May** left Florence for London. Settled in a house and studio at 42 Clairville Grove. **22 June** changed name by deed-poll to Harry Jones Thaddeus. Went on another sketching tour, this time through Holland, with Henry Savage Landor, **Winter** travelled to Rome for the first time. Used a studio in the Palazzo Savorgnon di Brazza, placed at his disposal by Count Ludovico. Painted Pope Leo XIII.

1885–6 **Winter** exhibited at the Society of British Artists: 24 *Arthur Finds the Sword Excalibur.*

1886 **Spring** spent in Cannes with Grand-Duke. **March** witnessed Monte Carlo train Crash with Baron de Benckendorff. Subsequently present in Nice during an earthquake. Travelled across to Algeria for a short visit, during last days of Ramadan. Exhibited at the RHA: 81 *Elaine – Tennyson;* 390 *Venice;* 407 *Venice.* **Autumn** went to Aske, Lord Zetland's country seat in Yorkshire. During a short visit to Bray, met Charles Stewart Parnell and Fr Healy

1887 Visited Annecy in the Haute Savoie. **Summer** exhibited at the Grosvenor Gallery: 65 *Portrait of His Holiness Pope Leo XIII.*

1888 **January** back in Florence, were he met and painted W.E. Gladstone. Returning to London, moved to 44A Maddox St, Hanover Square. **June-October** exhibited at the Irish Exhibition at Olympia, Kensington: 29 *The Old Prison Annecy, France* (Lent by the artist) 32 *His Serene Highness Prince Algernon of Teck* 68 *Miss Amy Tollemache* (Lent by Mrs. Tollemache) 69 *Boat on Beach* £10 0 0 70 *The Wounded Poacher* (Lent by Vincent Scully) 71 *Her Serene Highness the Grand Duchess Etene [sic] Vladimirovna* £315 0 0 72 *A Tribute from the Artist* 73 *A Ray of Sunshine* (Lent by Vincent Scully) 74 *Her Serene Highness Princess Mary Victoria of Teck* £315 0 0 75 *Father Anderledy, General of the Jesuits* £800 0 0 76 *His Holiness Leo XIII* £500 0 77 *Franz Lizst* 78 *Madame Machetta (Blanche Roogevelt)* £250 0 0 79 *His Imperial Highness the Grand Duke Michael Michaelovitch* 80 *The Right Hon. W.E. Gladstone, M.P.* £420 0 0 81 *H.S.H. The Duke of Teck* (Lent by the Duke of Teck) 82 *A Sketch*

83 *A Portrait* 96 *M. de Compte de Brazza £315 o o* (Lent by the artist) 154 *The Sands, Drenheim, Holland £21 o o* (Lent by the artist) 1116 *An Italian Wine Carrier* (Lent by the artist) **23 June** received a party of guests including R. Percy ffrench and Dr McNaughton Jones, and headed by the duke of Teck at the Irish Exhibition, and escorted them round the Fine Art Galleries and beyond. **10 October** went to Stratford with George Augustus Sala for the unveiling of Ronald Gower's Shakespeare Monument.

1888–9 **Winter** travelled to Tangier, where he spent the winter with the explorer Paul du Chaillu

1889 **Summer** exhibited at the Grosvenor Gallery: 105 *Rosalind* 249 *Resting* 285 *A Study* **Autumn** exhibited at the Walker Art Gallery Autumn Exhibition of Modern Pictures: 1090 *The Sheerif's Gun (Morocco) £105 o o* 1145 *A Soudanese Love Song (Morocco) £210 o o* 1156 *The Rt. Hon. W.E. Gladstone M.P.*

1890 **March** exhibited at the RHA: 10 *An Irish Eviction £300 o o* 14 *Robert Percy French, of Monivea* 92 *Right Hon. W.E. Gladstone, M.P.* **August-November** staying in the North of England. **Autumn** exhibited at the Walker Art Gallery Autumn Exhibition of Modern Pictures. 205 *An Eviction in Ireland, Co. Galway £157 10 o* 1033 *A Home Ruler – Co. Galway £31 10 o* 1036 *Street in Algiers £21 o o* **December** defendant in court case relating to engraving of portrait of Sir Richard Owen. Action brought by engraver Frank Sternberg. Lost the case.

1890–91 **December/January** donated copy of portrait of Leo XIII to Cork Art Gallery. Presented portrait of Thomas Sexton to Lord Mayor, in Dublin.

1891 **January** visited Sir Richard Owen at Sheen Lodge, Richmond Park, where Owen signed the proofs of Thaddeus' own engraving after his portrait. Contactable at 11, Grand Avenue, Brighton. **March** exhibited at the RHA: (address given as Villin Elera, Via Michele de Lando, Porto Romano, Florence). 29 *Sir Richard Owen, K.C.B.* 90 *The Origin of the Harp: 'Tis believed that this harp Which I wake now for thee Was a siren of old …' – Moore £420 o o* 105 *Sweet seventeen £210 o o* **Summer/Autumn** on board the *SS Austral*. **Autumn** travelled to Port Said in Egypt. **Late autumn** moved on to Cairo, where he stayed first at the Shepheard Hotel, and then at the Continental Hotel.

1892 **February** exhibited at the Second Cairo Salon: *Sir Evelyn Baring, Lady Alice Portal* (unfinished) **February-April** painted Abbas II Hilmi, Khedive of Egypt **March** exhibited at the RHA: 32 *Portrait of the Abbé Liszt* 85 *Portrait of the Chevalier Macaroni Spaghetti of Milan* 131 *Portrait of the Rt. Hon. Thomas Sexton, M.P., Lord Mayor of Dublin, 1888, 1889* 284 *The Mosque Abdelrahman, Algiers* 338 *A 'Bon-Viveur' £315 o o* **April** left Cairo for London. **May** presented portrait of Khedive to Queen Victoria at Windsor. **November** returned to Cairo, where he moved into his newly built studio and house.

1893 **March** exhibited at the RHA: 28 *Portraits [sic] of the late Father General of the Jesuits* 45 *Portrait of George Augustus Sala* 146 *The Old Prison, Annecy* Elected Associate of the Royal Hibernian Academy. **2 November** married Mary Evelina Julia Grimshaw at the Register Office in the District of St George, Hanover Square. Thaddeus' address recorded as 19 Bury Street, St James, Eva's as 38 Montpelier Square, Knightsbridge. Visited Gladstone twice in relation to 'quasi-sitting'.

1894 First son, Frederick Francis, born in Egypt. **10 December** elected Fellow of the Royal Geographical Society, having been proposed by Lord Mayo and Henry Savage Landor.

1895 **24/25 January** second son, Victor, born in Whitehall, London. **March** travelled to Corsica. **Early summer** resident at Whitehall Court. **April** plaintiff in case against his landlord, Mr Annan, after a leaky ceiling damaged some of his sketches. Lost the case. **Early July** travelled to Homburg to take a cure for a 'gouty infection'. Stayed there until September. **21 October** offered to 'paint a head before the students' of the Cork School of Art.

1896 **March** exhibited at the RHA: *7 Portrait of Mrs. Thaddeus and her son Frederick Francis* 55 *Portrait of Lady Tatton Sykes* 252 *Blanche, Lady Howard de Walden* 264 *Water-seller, Cairo- a study* £75 0 0 266 *'Primroses' portrait of the Countess Bathurst* 23 interviewed by the *New York Herald*. **26** left Monte Carlo for Paris with Eva. **September** had serious accident. Broke leg in three places. Went to Italy while convalescing. Sailed to Naples where he remained for a few weeks. Visited Herculaneum and Pompeii. Travelled on to Rome. Painted the *Obbedienza*. **November** presented Thaddeus Gold Medal to Cork School, to be awarded for 'Best study of a Head from Life shaded in Chalk'.

1897 **Spring** Thaddeus Gold Medal awarded to Miss Nagle. **Summer** stayed with King Württemberg at Friedrichshafen.

1898 **22 January** cited in the 'Bankruptcy' section of the *Times*. **24 November** opened bank account with Coutt's & Co., London.

1899 **March** exhibited at the RHA: 5 *The cup that cheers* **Summer** stayed in Homburg. Possibly held an exhibition of his work in London.

1901 **March** exhibited at the RHA: *4 His Holiness Pope Leo XIII, receiving the Oath of Obedience from the Cardinals* £1000 0 0 95 *The Comforter* £500 0 0 103 *Master Harold Maxwell* 282 *H.R.H. The Duke of Cambridge* Elected a full member of the RHA. **3–31 August** stayed at Friedrichshafen with the king of Württemberg. **October** left London for Australia on board a steamship of the Orient Line. Disembarked for a short time in Colombo, Ceylon. Travelled with a friend from Melbourne via Fremantle and Adelaide to Sydney.

1902 **January** staying at the Hotel Brighton, Lady Robinson's Beach Kogarah, Sydney. Presented Cardinal Moran of Sydney with a tinted print of *The Obeddienza*. **January-February** travelled to Mount Kosciusko with Minister O'Sullivan, other ministers and a photographer. **8 March** left Australia aboard the *SS India*. Visited Red Sea en route to England. Exhibited at the RHA: (address given as 59 Drayton Gardens, London SW) 14 *Portrait* 40 *Portrait* 47 *Portrait (Mr John Redmond)* Elected full Academician of the Royal Hibernian Academy. **July** exhibited at the Cork International Exhibition (address: Rossetti Studios, Rossetti Gardens, Chelsea, SW): 249 *The Wounded Poacher* (Lent by Vincent Scully, Cashel) 254 *A Ray of Sunshine* (Lent by Vincent Scully) **1 September** paid first rent instalment for Maesmawr Hall, Severn Valley, Mid-Wales.

1903 **July** travelled to Rome. **August** painted Pope Pius X. **October** Frederick and Victor Thaddeus started as boarders at Sandbach School, Cheshire.

1904 **May** exhibited at Hugh Lane's 'Exhibition of a Selection of Works by Irish Painters' at the Guildhall, London: 191 *Mrs. Claude Cane (30 × 25)* (Lent by Mrs Claude Cane) Travelled to New York and Washington.

1905 **July** Frederick and Victor leave Sandbach School.

1907 **28 February** final payment of rental for Maesmawr Hall. **April** exhibited at the Irish International Exhibition, Dublin: 111 *Portrait of the late Father Anderledy, General of the Jesuits (47 × 32)* (Lent by P. Naumann Esq.) 221 *Christ before Pilate* [sic] *(84 × 132)* (Lent by P. Naumann Esq.) **Summer**

emigrated to United States. Visited Philadelphia and Salt Lake City before moving on to California. Settled first in Coronado, in southern California, near San Diego and then in Carmel, south of San Francisco.

1912 *Recollections of a court painter* published in London. **13 May** invited to donate a picture to the Crawford School of Art Gallery. **July** offered two pictures to the gallery. Exhibited at the Whitechapel Exhibition of Irish Art, London: 52a *Isaac Butt* (Lent by Count Plunkett) 89 *The Right Hon. W.E. Gladstone* (Lent by the Reform Club) **December** presented a copy of *Recollections of a court painter* to Sandbach School.

1916 **December** Fellowship of the Royal Geographical Society rescinded.

*c.*1916 Attended Victor Thaddeus' graduation from the University of California with Eva.

*c.*1916–18 Returned to England. Settled on the Isle of Wight, at Appley Court, St Helens.

1920 **June** visited Cork, staying at Richard Barter's Hydro, St Anne's Hill. **14 June** gave portrait of *Pope Pius X* on loan to Crawford Gallery. **12 July** presented a portrait to the Crawford Gallery.

1928 **March** staying with Eva in the South of France due to poor health.

1929 **1 May** died suddenly at home on the Isle of Wight. Buried at Westridge (St John's) Cemetery after a short service in St John's Church.

1946 **15 December** Mary Evelina Julia Thaddeus died at Oaklands Nursing Home, 27 Lawrie Park Road, Sydenham, London.

Works by Harry Jones Thaddeus

The 'Literature' category presents the principal publication(s) etc. in which an individual work is discussed, referred to, illustrated, or listed. It does not provide a comprehensive listing of all publications when relevant information (sales, exhibition details etc.) is available in an alternative category. A question mark after a field denotes that the information contained therein is speculative, but probably accurate. All measurements are in centimetres (height × width).

1. *Timothy Joseph Murphy*
1876; pencil and watercolour on paper?
untraced

Provenance: William Ludgate, Gillabbey Street, Cork, 1951
Literature: D. Gwynn, *Cork Examiner*, 3 August 1951.

2. *Mrs Timothy Murphy*
1876; Pencil and watercolour on paper?
Untraced

Provenance: William Ludgate, Gillabbey Street, Cork, 1951.
Literature: D. Gwynn, *Cork Examine*r, 3 August 1951.

3. *Eviction Scene*
s.d. *Jones 77*; Watercolour on paper;
10.5 × 15 (approx.); private collection

Provenance: Private collection, Cork.

4. *Petitioning for Rent*
s.d. *H. Jones 1877;* oil on canvas; 58 × 71;
private Collection

Provenance: Christie's South Kensington, 18 February 1993, lot 135, from whom purchased by present owner.

5. *Rent Day*
***c.*1877; oil on canvas; untraced**

Provenance: Collection of D. Arnold, 1888.
Exhibition: Cork Industrial and Fine Arts Exhibition, 1883, no. 1066.
Literature: (Michael Holland), *Cork Examiner*, 9 May 1929.

6. *Peter Paul McSwiney*
***c.*1877; pastel on paper; untraced**

Literature: M.H. (Michael Holland), '*Christmas Number Cork Holly Bough and Weekly Examiner*, 1937, p. 32.

7. *Denny Lane*
s.d. *H. Jones 1877*; pencil and watercolour on paper; untraced

Literature: D. Lane *Cork Historical and Archaeological Society Journal*, 1895, p. 543; F.J. Healy, *Cork Historical and Archaeological Society Journal*, 1907, pp. 174–82; (Michael Holland) *Holly Bough and Weekly Examiner*, Christmas 1937; M.H. (Michael Holland) *Christmas Number Cork Holly Bough and Weekly Examiner*, 1937.

8. *The Convalescent*
***c.*1878; oil on canvas?; untraced**

Provenance: Collection of Michael Holland until at least 1930.
Literature: Michael Holland, *JCHAS*, 1942–3, M.H. (Michael Holland), *Christmas Number Cork Holly Bough and Weekly Examiner*, 1937, p. 32; (Michael Holland), *Cork Examiner*, 9 May 1929.

9. *A Letter from America*
***c.*1878; oil on canvas?; untraced**

Literature: (Michael Holland), *Cork Examiner*, 9 May 1929.

10. *Isaac Butt*
s.d. *Harry T. Jones/ 78;* pencil and white
chalk on card; private collection

Provenance: By descent, through family of
Count Plunkett; Adams, Dublin.
Exhibition: Whitechapel Exhibition of Irish
Art, London 1913, no. 52a.
Literature: Anne Stewart, comp., 1990.

11. *A Composition of Four Figures: Interior
of a Cabin*
exh. 1879; oil on canvas?; untraced

Exhibition: Taylor Art Prize, RDS 1879.

12. *Man Drinking*
Oil on canvas; untraced

Provenance: Crawford Municipal Art Gallery,
Cork (1953).

13. *Old Connoisseur*
Oil on canvas?; untraced

Provenance: Crawford Municipal Art Gallery,
Cork (1953).

14. *Collin's Explorer*
Oil on canvas?; untraced

Provenance: Crawford Municipal Art Gallery,
Cork (1953).

15. *A Gentleman*
Oil on canvas; untraced

Provenance: Crawford Municipal Art Gallery,
Cork (1953).

16. *Renewal of the Lease Refused*
*c.*1879; oil on canvas; untraced

Provenance: Purchased from artist by Henry
Chaplin MP.
Exhibition: Taylor Art Prize, RDS 1880.
Literature: Michael Holland, *JCHAS*,
1942–43, *Christmas Number Cork Holly Bough
and Weekly Examiner*, 1937, p. 32; H.
Thaddeus, 1912, p. 3.

17. *Studio Model in Suit of Armour*
s.d. *Harry Jones/ 1880;* oil on canvas;
79 × 43; private collection

Provenance: By descent to present owner.

18. *Le retour du braconnier, Irlande
(The Wounded Poacher)*
s. *THADDEUS JONES;* 1880/81; oil on
canvas; 120 × 85; National Gallery of
Ireland

Provenance: Bought from artist by Vincent
Scully, Dublin 1882; Mr B. De Jongste, The
Hague, from whom purchased by National
Gallery of Ireland, 1984.
Exhibition: Salon, Paris 1881, no. 1228; Irish
Exhibition of Arts and Manufactures, Dublin
1882, no. 1479; Cork Industrial and Fine Arts
Exhibition, 1883, no. 330; Irish Exhibition at
Olympia, London, 1888, no. 70; Cork
International Exhibition, 1902, no. 249; 'The
Irish Impressionists', Dublin and Belfast,
1984–5, no. 43; 'French 19th and 20th
Century Paintings from the National Gallery
of Ireland', Japan 1996–7, no. 40.
Literature: Irish Art Loan Exhibitions, vols
1–2; *Cork Examiner*, 6 Oct. 1883; *Cork
Constitution*, 3 July 1902; *The Times*, 8 May
1929; *Isle of Wight County Press*, 4 May 1929;
New York Herald, 24 March 1896; *Cork
Examiner*, 7 April 1896; *Cork Examiner*,
9 May 1929; *Holly Bough*, Christmas 1961;
J. Campbell, in D. Delouche, *Artistes étrangers
à Pont-Aven*, R. 1988, pp. 92–99; Julian C.,
The Irish Impressionists, 1984, J. Campbell,
Irish Arts Review Yearbook, 1986, pp. 16–18;
J. Campbell, in D. Delouche, *Pont-aven et ses
peintres*, Rennes 1986, *French 19th and 20th
Century Painting from the National Gallery of
Ireland. Corot to Picasso*, cat. 1996; P. Murray,
comp., *Illustrated Summary Catalogue of the
Crawford Municipal Art Gallery*, 1991.

19. *A Parisian Fairground Scene*
s.d. *THADDEUS JONES 81*; oil on canvas;
46 × 63.5; private collection

Provenance: Sotheby's, Slane Castle, 3 Nov.
1981, lot 659.

20. *A Passing Mist on the Champs Elysées*
1881; oil on canvas; untraced

Exhibition: RDS 1881.

21. *The Dutch Boy*
s.d. *Harry T. Jones/ 1881;* oil on board;
37 × 19; unknown

Provenance: Sotheby's West Sussex (Pulborough), 2 June 1987, lot 1394

22. *Young Breton Fisherboy*
s.d. *T. Harry Jones/ 81;* oil on wood; 38 × 21; private collection

Provenance: Gorry Gallery, Dublin 1987, no. 25, from whom purchased by present owner. *Exhibition*: Gorry Gallery, Dublin 1987; 'Onlookers in France', Crawford Municipal Art Gallery, Cork, 1993; 'Peintres Irlandais en Bretagne', Musée de Pont-Aven 1999, no. 55. *Literature*: J. Campbell, *Onlookers in France*, 1993, p. 18; J. Campbell, *Peintres Irlandais en Bretagne*, 1999.

23. *Spilt Milk*
s.d. *Thad Jones/ 81;* oil on canvas; 24 × 38.5; private collection

Provenance: Gorry Gallery, Dublin, 1988, no. 9, from whom purchased by present owner.

24. *On the Sands, Concarneau*
s.d. *H. THADDEUS JONES/ 1881;* oil on canvas on board; 88 × 63; private collection

Provenance: Gorry Gallery, Dublin, 1995, no. 6, from whom purchased by present owner. *Exhibition*: Society of British Artists, 1881–2, no. 416. *Literature*: J. Campbell, *Gorry Gallery Catalogue*, 1995.

25. *Figures in the Snow*
*c.*1882?; oil on canvas; private collection

Literature: J. Campbell, 1980.

26. *A Seaside Idyll*
s. *Henry Jones;* exh. 1882; untraced

Exhibition: Irish Exhibition of Arts and Manufacturers, Dublin, 1882, no. 462.

27. *By the Well*
exh. 1882; oil on canvas; untraced

Exhibition: Irish Exhibition of Arts and Manufactures, Dublin, 1882, no. 1382.

28. *The Sunshine of Life*
exh. 1882; oil on canvas; untraced

Exhibition: Irish Exhibition of Arts and Manufactures, Dublin, 1882, no. 1469.

29. *On the Beach*
s.d. *THADDEUS/ '82;* oil on panel; 35 × 53; private collection

Provenance: Gorry Gallery, Dublin, 1997, no. 21, from whom purchased by present owner. *Literature*: B. Rooney, 1997.

30. *Jour de marché, Finistère* (Market Day, Finistère)
s.d. *H. THADDEUS JONES;* oil on canvas; 201 × 132; National Gallery of Ireland

Provenance: Vincent Scully; Sotheby's, 16 April 1986, lot 229; Gorry Gallery, October, 1986, no. 14, from whom purchased by National Gallery of Ireland. *Exhibition*: Salon, Paris, 1882, no. 1462; Cork Industrial and Fine Art Exhibition, 1883, no. 19; Royal Scottish Academy, 1883, no. 748; 'Peintres Irlandais en Bretagne', Musée de Pont-Aven 1999, no. 56. *Literature*: J. Campbell 1986; J. Campbell, 1980; J. Campbell, 1984; J. Campbell, 1988 J. Campbell, 1999, pp. 96–7; National Gallery of Ireland, *Acquisitions 1986–88*, 1988; D. Yonnet and A. Cariou, 1993, p. 113.

31. *Les amies du Modèle (The Friends of the Model)*
*c.*1882; oil on canvas; untraced

Exhibition: Salon, Paris, 1882, no. 1427; Cork Industrial and Fine Arts Exhibition 1883, no. 138; Royal Scottish Academy, 1883, no. 601. *Literature*: *Cork Constitution*, 4 July 1883.

32. *A Breton Fisherman*
*c.*1882; oil on board; 20 × 54; private collection

Provenance: Thomas Adams and Co. Ltd., Blackrock, Co. Dublin, 23 June 1997, lot 80, from whom purchased by present owner.

33. *Washing Day*
1883; oil on canvas; 64.8 × 130.2; private collection

Provenance: Christie's, Dublin, 26 May 1989, lot 353, from whom purchased by present owner.

Exhibition: Cork Industrial and Fine Art Exhibition, 1883, no. 19.

34. *Fisherman in a Punt*
s.d. *H. THADDEUS/ 1883;* oil on canvas; 15 × 20; untraced

Literature: J. Campbell, 1980.

35. *A Portrait*
exh. 1883; untraced

Exhibition: Royal Scottish Academy, 1883, no. 761.
Literature: C.B. de Laperriere, 1990.

36. *An Old Widow*
s.d.i *THADDEUS JONES/ 1883/* FLORENCE; oil on canvas; 84.2 × 111.1; private collection
Provenance: Private collection
Literature: B. Rooney, 'Henry Jones Thaddeus: An Irish Artist in Italy', 1999, pp. 126–33.

37. *A Wine Carrier (An Italian Wine Carrier)*
exh. 1883; oil on canvas; untraced

Provenance: Collection of the artist (1888).
Exhibition: RA 1883, no. 216; Irish Exhibition at Olympia, London, 1888, no. 1116.

38. *Without a Care*
exh. 1883; oil on canvas; untraced

Exhibition: Cork Industrial and Fine Arts Exhibition, 1883, no. 23.

39. *St Patrick*
exh. 1883; oil on canvas; untraced

Exhibition: Cork Industrial and Fine Arts Exhibition, 1883, no. 63.
Literature: *Cork Constitution*, 4 July 1883.

40. *Lelia*
exh. 1883; oil on canvas?; untraced

Exhibition: Cork Industrial and Fine Arts Exhibition, 1883, no. 379.
Literature: Anne Stewart, comp., 1990.

41. *Young Fishermen*
exh. 1883; oil on canvas?; untraced

Exhibition: Cork Industrial and Fine Arts Exhibition, 1883, no. 70.
Literature: Anne Stewart, comp., 1990.

42. *'Study'*
s. *H.T. Jones;* exh. 1883; untraced

Exhibition: Cork Industrial and Fine Arts Exhibition, 1883, no. 469.
Literature: Anne Stewart, comp., 1990.

43. *Don Carlos with his Four Daughters as the Seasons*
1884; oil on canvas?; untraced

Exhibition: Royal Academy 1883, no. 216.
Literature: 'A Chat with a Famous Painter', *New York Herald* 27 March 1896; Thaddeus, 1912, p. 64.

44. *The Duke of Teck*
s.d. *THADDEUS JONES/ 1884;* oil on canvas; untraced

Provenance: Teck family.
Exhibition: Royal Academy 1884, no. 432; Irish Exhibition at Olympia, London, 1888, no. 32.
Literature: B. Rooney, 'Henry Jones Thaddeus: An Irish Artist in Italy', 1999, pp. 126–33.

45. *The Duchess of Teck*
s.d. *H. THADDEUS JONES/ 1884;* oil on canvas; untraced

Exhibition: Royal Academy 1884, no. 617.
Literature: B. Rooney, 'Henry Jones Thaddeus: An Irish Artist in Italy', 1999, pp. 126–33.

46. *Princess May of Teck with Lake Constance in the Background*
1884; untraced

Literature: J. Pope-Hennessy, 1959, p. 148; H.J. Thaddeus, 1912, p. 81.

47. *Prince Adolphus (Dolly) of Teck*
*c.*1884; Oil on canvas?; untraced

Literature: Prince Francis of Teck, Letter to his brother Adolphus (Dolly), 23, 24, 26, 28 and 30 January 1885, Royal Archives Windsor, RA CC 50/126.

48. *Prince Francis of Teck*
*c.*1884; oil on canvas?; untraced

Literature: H.J. Thaddeus, 1912.

49. *Boat on a Lake*
s.d. *H. THADDEUS JONES 1884;* oil on
panel; 14.7 × 22.8; private collection

Provenance: Christie's Ireland, 29 May 1980,
no. 83; Christie's, Dublin, 9 Dec. 1992, lot 460.
Exhibition: 'The Irish Impressionists', Dublin
and Belfast, 1984–5, no. 45.
Literature: J. Campbell, 1984, p. 183; B.
Rooney, 'Henry Jones Thaddeus: An Irish
Artist in Italy', 1999, pp. 126–33.

50. *A Young Woman*
s.d. *H. THADDEUS JONES 1884;* oil on
canvas; private collection

Provenance: The marchioness of Cambridge;
Sotheby's, 22 March 1989, lot 181.

51. *Florence: Distant View from the Podere
of I Cedri*
s.d. *H. THADDEUS JONES 1884;*
watercolour on paper; 25.3 × 35.6; Royal
Library Windsor

Provenance: Teck Album (RL 28481), Royal
Library Windsor, presented to the duchess of
Teck by the artist.
Literature: D. Millar, 1995, p. 486. B. Rooney,
'Henry Jones Thaddeus: An Irish Artist in
Italy', 1999, pp. 126–33.

52. Well near the farm at I Cedri, near
Florence s.d.i. H. THADDEUS
*JONES/1884/ to H.R.H. Princess Mary
Adelaide/ Souvenir of the 'Cedri';*
watercolour on paper; 35.6 × 25.3; Royal
Library Windsor

Provenance: Teck Album, Royal Library
Windsor (RL 28480), presented to the
duchess of Teck by the artist.
Literature: D. Millar, 1995, p. 486; B. Rooney,
'Henry Jones Thaddeus: An Irish Artist in
Italy', pp. 126–33.

53. Viareggio
s.i. *a thumbnail souvenir/ of Viareggio/ by
"Thady"./ Sketched/ whilst thinking/ of
Florence; c.*1884; watercolour with white

on blue paper. 17.8 × 11.3; Royal Library
Windsor

Provenance: Teck album, Royal Library
Windsor (RL 28482).
Literature: D. Millar, 1995, p. 486. B. Rooney,
'Henry Jones Thaddeus: An Irish Artist in
Italy', 1999, pp. 126–33.

54. *Prince Alexander (Algy) of Teck*
*c.*1885; oil on canvas?; untraced

Exhibition: Irish Exhibition at Olympia,
London, 1888, no. 32 (as 'Algernon' of Teck)
Literature: Anne Stewart, comp., 1990; Prince
Francis of Teck, Letter to his brother
Adolphus (Dolly), 23, 24, 26, 28 and 30
January 1885, Royal Archives Windsor.

55. *Princess May of Teck*
1885; oil on canvas?; untraced

Exhibition: Irish Exhibition at Olympia,
London, 1888, no. 74.
Literature: Anne Stewart comp., 1990; Prince
Francis of Teck, Letter to his brother
Adolphus (Dolly), 23, 24, 26, 28 and 30
January 1885, Royal Archives Windsor,
Princess May of Teck, Letter to Augusta,
grand duchess of Mecklenburg-Strelitz, 22
March 1885, Royal Archives Windsor.

56. *Pope Leo XIII*
1885; oil on canvas; untraced

Provenance: Christie's, 20 July 1901, lot 101
from whom purchased by Agnew.
Exhibition: Grosvenor Gallery, Summer
Exhibition, 1887, no. 65; Irish Exhibition,
Olympia, Kensington, June 1888, no. 76.
Literature: (Michael Holland), *Cork Examiner*,
9 May 1929; M.H. (Michael Holland),
*Christmas Number Cork Holly Bough and
Weekly Examiner*, 1937, p. 32; D. O'Donovan,
Cork Weekly Examiner and Holly Bough,
Christmas 1961, p. 42; H.J. Thaddeus, 1912,
pp. 128–31.

57. *Pope Leo XIII (copy)*
1885; oil on canvas; untraced

Provenance: Copy donated by the artist to
Cork Art Gallery, December 1890/January
1891.

58. *A Spring Beauty*
s.d. *H.J. THADDEUS/ 1885;* oil on
canvas; 72 × 59.5; untraced

Provenance: Christie's London, 26 October
1979, lot 119.
Literature: P. Hook and M. Poltimore, 1986.

59. *Arthur Finds the Sword Excalibur*
exh. 1885/6; oil on canvas; untraced

Exhibition: Society of British Artists Winter
Exhibition 1885–6, no. 24.
Literature: J. Johnson comp., 1975.

60. *Princess Pauline of Württemberg*
c.1886; oil on canvas; untraced

Provenance: King William II and Queen of
Württemberg.
Literature: J. Pope-Hennessy, 1959, pp. 240–1

61. *The Marchioness of Zetland and Lord*
George Dundas
1886; oil on canvas; private Collection

Provenance: By descent through family of
sitter to present owner.
Exhibition: RHA 1890, no. 46.
Literature: H.J. Thaddeus, 1912, pp. 152–3.

62. *Lady Goldsmid*
1886; oil on canvas?; untraced

Literature: H.J. Thaddeus, 1912, p. 155.

63. *Grand Duchess Olga Alexandrovna*
Romanov
s.d. *H.J. THADDEUS/ 1886;* Inscribed
with the coat of arms of the Romanov
family; oil on canvas; 91.4 × 60.9;
untraced

Provenance: Christie's London 2 Feb. 1979, lot
181.

64. *Grand Duchess Vladimir (Marie*
Pavlovna von Mecklenburg) (1854–1920)
1886; oil on canvas; untraced

Literature: *Who Was Who 1929–1940*, 1967.

65. *Grand Duchess Helen (Elene)*
Vladimirovna Romanov of Russia
(1882–1957)
1886; oil on canvas; untraced

Exhibition: Irish Exhibition at Olympia,
London, 1888, no. 71.
Literature: H.J. Thaddeus, 1912, pp. 111–12.

66. *Father Anderledy*
s.d.i. *H.J. THADDEUS/ 1886/ Rome;* oil
on canvas; 124.5 × 85.6; Lady Lever Art
Gallery, Liverpool

Provenance: P. Naumann Esq. Accepted by
Lever as security for a loan which he made to
Wilson Barrett in 1916. Acquired by Lever
1923.
Exhibition: Irish Exhibition at Olympia,
London, 1888, no. 75; Irish International
Exhibition, 1907, no. 111.
Literature: Edward Morris, ed., 1994; W.T.
Stead, 1891.

67. *M. de Compte de Brazza* [sic]
1886; oil on canvas?; untraced

Provenance: Collection of the artist (1888).
Exhibition: Irish Exhibition at Olympia,
London, 1888, no. 96.
Literature: Anne Stewart, comp., 1990.

68. *Savorgnan de Brazza en costume de*
brousse
s.d.i. *ROME/ H.J. THADDEUS/ 1886;* oil
on canvas; 153 × 100; Musée des Arts
d'Afrique et d'Oceanie, Paris

Exhibition: 'Cent ans de Republique', Hotel de
Rohan, Paris, February-April 1978, no. 142.
Literature: *Cent ans de Republique*, 1978; H.J.
Thaddeus, 1912, p. 134.

69. *Franz Liszt (Abbé Liszt)*
s.d.i. *H.J. THADDEUS/ Rome Febr./ 1886;*
oil on canvas; 107 × 84; private Collection

Provenance: Dr Fritz Nagel (Galleries),
Stuttgart, 22–3 June, 1966.
Exhibition: Irish Exhibition at Olympia,
London, 1888, no. 77; RHA 1892, no. 32.
Literature: H.J. Thaddeus, London, 1912, p. 134.

70. *Elaine- Tennyson*
exh. 1886; oil on canvas?; untraced

Exhibition: RHA 1886, no. 81.
Literature: Anne Stewart, comp., 1985.

71. *Venice*
exh. 1886; untraced

Exhibition: RHA 1886, no. 390.
Literature: Anne Stewart, comp., 1985.

72. *Venice*
exh. 1886; untraced

Exhibition: RHA 1886, no. 407.
Literature: Anne Stewart comp., 1985.

73. *The Old Prison, Annecy*
(A Continental Town on a River with Figures)
s.d. *H.J. THADDEUS/ 1887;* **oil on canvas;**
71 × 99; private collection

Provenance: Collection of the artist; Christie's
London, 10 October 1980 (*A continental town
on a river with figures*), lot 114; Gorry Gallery
May 1987, no. 25, from whom purchased by
present owner.
Exhibition: Irish Exhibition at Olympia,
London, 1888, no. 29; RHA 1893, no. 146.
Literature: Anne Stewart, comp., 1985.

74. *A Young Lady, Dressed in Brown – a*
Sketch (Portrait of Young Lady)
s.d. *H.J. THADDEUS/ 1887;* **oil on panel;**
29 × 21; private collection
Provenance: Sotheby's Slane, 12 May 1980;
Spink and Son, London, 1982.

75. *A Young Lady*
s.d. *H.J. THADDEUS/ 1887;* **oil on panel;**
2 × 21 [sic]; private collection

Provenance: Sotheby's Tokyo, 13 May 1980,
lot 452.

76. *Princess Victoria Alexandra Olga Mary*
s.d.i. *H.J. THADDEUS/ 1887/ a tribute*
from the artist; **oil on canvas; (oval)**
25 × 21; untraced

Provenance: Lord Glendevon; private
collection.

77. *A Woman in Black Coat and Bonnet*
s. *H.J. THADDEUS;* **oil on board; 25 × 17**
(approx.); private collection

78. *Miss Amy Tollemache*
exh. 1888; oil on canvas?; untraced

Provenance: Collection of the sitter's family,
1888.
Exhibition: Irish Exhibition at Olympia,
London, 1888, no. 34.
Literature: Anne Stewart, comp., 1990.

79. *Madame Machette (Blanche Roogevelt)*
[sic]
exh. 1888; oil on canvas?; untraced

Exhibition: Irish Exhibition at Olympia,
London, 1888, no. 78.
Literature: Anne Stewart comp., 1990.

80. *Grand Duke Michael Michaelovitch*
exh. 1888; oil on canvas?; untraced

Exhibition: Irish Exhibition at Olympia,
London, 1888, no. 79.
Literature: Anne Stewart, comp., 1990.

81. *Boat on Beach*
exh. 1888; oil on canvas?; untraced

Exhibition: Irish Exhibition at Olympia,
London, 1888, no. 68.
Literature: Anne Stewart, comp., 1990.

82. *A Ray of Sunshine*
exh. 1888; oil on canvas?; untraced

Provenance: Collection of Vincent Scully until
at least 1902.
Exhibition: Irish Exhibition at Olympia,
London, London, 1888, no. 73; Cork
International Exhibition 1902, no. 254.
Literature: Anne Stewart, comp., Dublin, 1990.

83. *A Sketch*
exh. 1888; untraced

Exhibition: Irish Exhibition at Olympia,
London, 1888, no. 69.
Literature: Anne Stewart, comp., 1990.

84. *A Tribute from the Artist*
exh. 1888; untraced

Exhibition: Irish Exhibition at Olympia,
London, 1888, no. 72.
Literature: Anne Stewart comp., 1990.

85. *The Sands, Drenheim, Holland*
exh. 1888; oil on canvas?; untraced

Provenance: Collection of the artist (1888).

Exhibition: Irish Exhibition at Olympia,
London, 1888, no. 154.
Literature: Anne Stewart, comp., 1990.

86. *Old Man Smoking a Pipe*
s.d. *H.J. THADDEUS/ 1888;* **watercolour
on cartridge paper; 33 × 25; private
collection**

Provenance: Bonham's London 9 June 1994,
lot 113; Adam's Dublin, March 1996, lot 71.

87. *Thomas Sexton, Lord Mayor of Dublin*
**1888; oil on canvas; destroyed in a fire at
the Council Chamber of City Hall,
Dublin in 1908.** (Replica painted
subsequently by Dermod O'Brien, currently
in the Mansion House, Dublin)

Provenance: Dublin Corporation
Exhibition: RHA 1892, no. 131.
Literature: H.J. Thaddeus, 1912, p. 175.

88. *Gerald, 5th Duke of Leinster*
s.d.i. *GERALD DUKE OF LEINSTER/
H.J. THADDEUS/ 1888;* **oil on canvas;
68.5 × 53.5 private collection**

Provenance: Sotheby's London, 4 July 1984, lot
225; de Veres Dublin, 11 June 11 1996, lot 83.

89. *An Irish Peasant*
s.d. *H.J. THADDEUS/ 1888;* **oil on canvas
30.5 × 23.2 Sheffield City Art Galleries
(Mappin Gallery)**

Provenance: Presented to the gallery as part of
the Graves Gift by Alderman John Georges
Graves, 1935.
Literature: Sheffield City Art Galleries, 1982;
T. Snoddy, 1996.

90. *Sir Ronald Sutherland Gower*
s. *H.J. THADDEUS; c.*1888; **oil on canvas;
70 × 63; untraced**

Provenance: Frank Hird.
Literature: H.J. Thaddeus, 1912, p. 172.

91. *William Ewart Gladstone, MP*
s.d.i. *H.J. THADDEUS/ FLORENCE/
1888;* **oil on canvas; reform Club, London**

Provenance: Purchased from artist by present
owner, *c.*1888.
Exhibition: Irish Exhibition at Olympia,

London 1888, no. 80; Walker Art Gallery
Autumn Exhibition, Liverpool 1889, no. 1156;
RHA 1890, no. 92; On view between 3 and 6
o'clock in the painter's studio 6 William
Street, Albert Gate, London, 18th June, 1894.
Literature: 'A Chat with a Famous Painter',
New York Herald 27 March 1896, p. 3; B.
Rooney, 'Henry Jones Thaddeus: An Irish
Artist in Italy', 1999, pp. 126–33; H.J.
Thaddeus, 1912, pp. 100–3; T. Wemyss Reid,
1889, pp. 82–9.

92. *Michael Davitt*
1889; oil on canvas; untraced

Literature: D. O'Donovan, *Cork Weekly
Examiner and Holly Bough*, 1961, p. 42;
H.J. Thaddeus, 1912, pp. 176–7.

93. *An Irish Eviction – Co. Galway, Ireland*
s.d. *H.J. THADDEUS/ 1889;* **(signed on
label on stretcher); oil on canvas; 119.4 ×
152.4; private collection**

Provenance: Sotheby's London, 12 April 1985,
lot 121; Cynthia O'Connor Gallery, August
1985, lot 11.
Exhibition: Walker Art Gallery Autumn
Exhibition, Liverpool 1890, no. 205; RHA
1890, no. 10; Irish Museum of Modern Art
1998.
Literature: C. Marshall, 1996, pp. 46–50.

94. *Robert Percy ffrench of Monivea*
s.d.i. *H.J. THADDEUS/ ROBERT
PERCY FFRENCH OF MONIVEA/ 1889;*
**(also inscribed with coat of arms of the
ffrench family); oil on canvas; 140 × 87;
Crawford Municipal Art Gallery, Cork**

Provenance: Presented to the Crawford
Gallery 1980.
Exhibition: RHA 1890, no. 14.
Literature: H.J. Thaddeus, 1912, pp. 72–3.

95. *Young Russian Woman (Three-quarter
length portrait of young woman in white
dress, with green scarf wearing feather hat
and holding parasol)*
s.d. *H.J. THADDEUS/ 1889;* **oil on canvas;
120 × 59.5; private collection**

Provenance: Mealy's, Garretstown House, 27
July 1999, lot 453, from whom purchased by
present owner.

96. *Sir Arthur Hodgson*
s.d. H.J. THADDEUS/ 1889; oil on canvas;
Town Hall, Stratford-upon-Avon

Provenance: Painted for Stratford Town Hall
1889.
Literature: H.J. Thaddeus, 1912, p. 172.

97. *Sir Richard Owen*
s.d. *H.J. THADDEUS/ 1889;* oil on canvas;
165 × 100; Lancaster Town Hall

Provenance: Lancaster Town Hall.
Exhibition: RHA 1891, no. 29.
Literature: W.T. Stead, 1891; H.J. Thaddeus,
1912, pp. 182–6.
Engraved by Frank Sternberg.

98. *Rosalind*
exh. 1889; oil on canvas?; untraced

Exhibition: Grosvenor Gallery Summer
Exhibition 1889, no. 105.

99. *Resting*
exh. 1889; oil on canvas?; untraced

Exhibition: Grosvenor Gallery 1889, no. 249.
Literature: *Grosvenor Gallery Catalogue*, 1889.

100. *A Study*
exh. 1889; untraced

Exhibition: Grosvenor Gallery 1889, no. 285.
Literature: *Grosvenor Gallery Catalogue,* 1889.

101. *A Soudanese Love Song (Morocco)*
exh. 1889; oil on canvas?; untraced

Exhibition: Walker Art Gallery Autumn
Exhibition 1889, no. 1145.
Literature: *Walker Art Gallery Catalogue*, 1889.

102. *'The Sheerif's Gun'- Study (Morocco)*
s.d.i. *H.J. THADDEUS/ TANGIER/ 1889*
oil on panel; 21.5 × 16.5; private collection

Provenance: Sotheby's London, 8 November
1984, lot 366.
Exhibition: Walker Art Gallery Autumn
Exhibition 1889, no. 1090

103. *Old Bearded Man in Dutch Costume*
(possibly Robert Percy ffrench)
s.d. *H.J. THADDEUS/ 1890;* oil on canvas;
127 × 77; private collection

Provenance: Neale and Son, Nottingham, 29
September 1994, lot 1677; Christie's South
Kensington, 7 November 1996, lot 17; Gorry
Gallery, Dublin November–December 1997,
no. 22, from whom purchased by present
owner.
Literature: B. Rooney, 'Henry Jones Thaddeus:
Bearded Figure in Dutch Costume', 1997.

104. *The Origin of the Harp of Elfin*
s.d. *H.J. THADDEUS/ 1890;* oil on canvas;
181.6 × 120; Royal Collection,
Buckingham Palace

Provenance: Presented by the artist to the
Duke and Duchess of York on the occasion of
their marriage, 1893. By descent to Queen
Elizabeth II.
Exhibition: RHA 1891, no. 90
Literature: O. Millar, 1992.

105. *William O'Brien, MP*
(unfinished) 1890; oil on canvas; 125 × 105;
University College Cork

Provenance: Presented by the Cork Young
Ireland Society to Mrs William O'Brien on
the occasion of her marriage to William
O'Brien, June 1890. University College Cork.
Literature: H.J. Thaddeus, 1912, pp. 172–5.

106. *A Home Ruler – Co. Galway*
exh. 1890; oil on canvas?; untraced

Exhibition: Walker Art Gallery Autumn
Exhibition 1890, no. 1033.
Literature: *Walker Art Gallery Catalogue,* 1890.

107. *W.T. Stead*
s.d. *H.J. THADDEUS/ 1890;* oil on canvas;
untraced

Provenance: By descent, through sitters family,
until at least 1933.
Literature: H.J. Thaddeus, 1912, p. 171.

108. *Dr Macnaughton Jones*
exh. 1890; oil on canvas?; untraced

Exhibition: RHA 1890, no. 214.
Literature: Anne Stewart comp., 1985.

109. *Sir Evelyn Baring*
c.1890; oil on canvas; untraced

Exhibition: Cairo Salon, 1892.
Literature: H.J. Thaddeus, 1912, pp. 201–2.

110. *Queen of Harem*
c.1890; 20 × 25; private collection

Provenance: Bonham's London, 2 February 1978, lot 103.

111. *Gypsy Eyes*
s.d.i. *H.J. THADDEUS/ 1890/ To Mrs Smillie. A tribute of deep affection from the artist*; oil on panel; 18.5 × 23.5; private collection

Provenance: Christie's Ireland, 29 May 1980, lot 82; Sotheby's Belgravia, 22 September 1982, lot 212.

112. *Street in Algiers*
exh. 1890; oil on canvas?; untraced

Exhibition: Walker Art gallery Autumn Exhibition 1890, no. 1036.
Literature: *Walker Art Gallery Catalogue*, 1890.

113. *Arab Walking through Narrow Village*
s. *H.J. THADDEUS*; *c*.1891; oil on board; 23 × 13; untraced

Provenance: Christie's New York, 15 January 1985, lot 70

114. *The Moor*
Oil on canvas?; untraced

Provenance: Collection of Mrs M.J. Walsh, Cork, 1932.
Literature: Letter from Mrs M.J. Walsh to the National Gallery of Ireland, 10 December 1932.

115. *Portrait of a Young Woman*
s.d.i. *A peace offering/ from the painter/ SS Austral/ H.J. Thaddeus/ 1891;* oil on panel; 30.5 × 20; private collection

Provenance: Gorry Gallery, January 2002, no. 50
Literature: *Gorry Gallery Catalogue*, January 2002.

116. *Young Lady in a Fur-lined Coat*
s.d. *H.J. THADDEUS/ 1891;* inscription, possibly in French, illegible; oil on panel; 30.5 × 20.3; private collection

Provenance: Christie's Ireland, 28 June 1995, lot 82.

117. *Colonel Thomas Garrett*
s.d. *H.J. THADDEUS/ 1891;* oil on canvas; 142 × 91.5; private collection

Provenance: Sotheby's, 4 July 1988, lot 411.
Literature: H.J. Thaddeus, 1912, p. 154.

118. *Mrs Mitchel*
1891; oil on canvas?; untraced

Literature: H.J. Thaddeus, 1912, p. 154.

119. *Sir Richard Owen Signing the Proofs of his Portrait*
d.i. *Sir Richard Owen Signing the Proofs of his/ portrait – 1891;* pen and ink on paper; untraced

Literature: Unidentified journal, January/February 1891.

120. *Sir Richard Owen's Favourite Walking Stick, which he has used for Fifty Years*
Pen and ink on paper; untraced

Literature: Unidentified journal, January/February 1891.

121. *Sketch after Portrait of Sir Richard Owen*
s. d. '9T1'
pen and ink on paper; untraced

Literature: Unidentified journal, January/February 1891.

122. *Sweet Seventeen*
exh. 1891; oil on canvas? untraced

Exhibition: RHA 1891, no. 105.
Literature: Freeman's Journal, 2 March 1891.

123. *Abbas II Hilmi, Khedive of Egypt*
s.d. *H.J. THADDEUS/ 1892;* oil on canvas; 130.8 × 96.8; Royal Collection, Osborne House

Provenance: Presented by the artist (on behalf of the sitter) to Queen Victoria, May 1892. By descent to Queen Elizabeth II.
Literature: Abbas II Hilmi, Khedive of Egypt, Letters to Queen Victoria, 7 April and 27 July 1892, O. Millar, 1992; H.J. Thaddeus, 1912, pp. 224–33

124. *The Mosque, Abdelrahman, Algiers*
exh. 1892; oil on canvas?; untraced

Exhibition: RHA 1892, no. 284.
Literature: Anne Stewart, comp., 1985.

125. A 'Bon Viveur'
exh. 1892; oil on canvas?; untraced

Exhibition: RHA 1892, no. 338.
Literature: Anne Stewart, comp., 1985.

126. *Lord Charles Beresford*
c.1891/2; oil on canvas? untraced

Literature: H.J. Thaddeus, 1912, p. 214.

127. *The Chevalier Macaroni Spaghetti of Milan*
s.d. *H.J. THADDEUS/ 1890;* oil on canvas;
127.6 × 78.6; private collection

Provenance: Christie's Dublin 28 June 1995,
lot 25.
Exhibition: RHA 1892, no. 85.

128. *George Augustus Sala, Esq.*
exh. 1893; oil on canvas?; untraced

Exhibition: RHA 1893, no. 45.
Literature: H.J. Thaddeus, 1912, p. 103.

129. *Blanche, Lady Howard de Walden*
1894; oil on canvas; untraced

Exhibition: RHA 1896, no. 252.
Literature: H.J. Thaddeus, 1912.

130. *Head of an Old Man*
s.d. *H.J. THADDEUS/ 1894;* watercolour
and pencil on paper; 15 × 10.75; private
collection

131. *George, Duke of Cambridge (1819–1904)*
1895; oil on canvas; untraced

Exhibition: RHA 1901, no. 282.
Literature: H.J. Thaddeus, 1912, p. 241.

132. *Viscount Powerscourt*
1895; oil on canvas? untraced

Literature: H.J. Thaddeus, 1912, p. 161.

133. *Countess Pozzo di Borgo and her Son*
1895; oil on canvas?; untraced

Provenance: Family of the sitter.

Literature: H.J. Thaddeus, 1912, p. 237.

134. *Mediterranean Fishermen
(Mediterranean Fisherfolk)*
s. *H.J. THADDEUS; c*.1895; oil on canvas;
43 × 61; private collection

Provenance: Christie's London, 14 June 1991,
lot 207; Gorry Gallery September-October
1991, no. 27, from whom purchased by
present owner.
Literature: H.J. Thaddeus, 1912, pp. 23738.

135. *'Primroses' – Portrait of the Countess
Bathurst*
c.1895; mezzotint ((original) oil on canvas);
untraced

Exhibition: (original) RHA 1896, no. 266.
Literature: *Illustrated London News*, 29 June
1895 (ill. as *Primroses*).

136. *Princess Charming*
c.1895; mezzotint; untraced

Literature: *Illustrated London News*, Summer
Number 1895.

137. *Old Man in a Long Coat and Hat Seen
from Behind*
s. *THADDEUS; c*.1895; pencil on paper;
17.5 × 8.1
Private collection

Provenance: Gorry Gallery May-June 1998,
no. 26, from whom purchased by present
owner.
Literature: B. Rooney, 'Henry Jones Thaddeus
RHA 1860–1929', 1998.

138. *Seated Man in Top Hat and Spectacles
Reading the Newspaper*
s. *THADDEUS; c*.1895; pencil on paper;
15.9 × 9.6; private collection

Provenance: Gorry Gallery May-June 1998,
no. 31, from whom purchased by present
owner.
Literature: B. Rooney, 'Henry Jones Thaddeus
RHA 1860–1929', 1998.

139. *Man in Bowler Hat with Hands in Pockets*
s. *THADDEUS; c*.1895; pencil and ink
wash on paper; 15.7 × 6.4; private
collection

Provenance: Gorry Gallery May-June 1998, no. 29, from whom purchased by present owner.
Literature: B. Rooney, 'Henry Jones Thaddeus RHA 1860–1929', 1998.

140. *Man with Hand in Pocket Leaning on a Cane*
s. *THADDEUS; c.*1895; pencil and ink wash on paper; 15.7 × 8.6; private collection

Provenance: Gorry Gallery May-June 1998, no. 34, from whom purchased by present owner.
Literature: B. Rooney, 'Henry Jones Thaddeus RHA 1860–1929', 1998.

141. *Man with Flat Broad Brimmed Hat in Profile*
s. *THADDEUS; c.*1895; pencil on paper; 13.2 × 8.1; private collection

Provenance: Gorry Gallery May-June 1998, no. 36, from whom purchased by present owner.
Literature: B. Rooney, 'Henry Jones Thaddeus RHA 1860–1929', 1998.

142. *Bearded Man with Hands in Pockets*
s. *THADDEUS; c.*1895; pencil on paper; 17.2 × 6.8; private collection

Provenance: Gorry Gallery May-June 1998, no. 35, from whom purchased by present owner.
Literature: B. Rooney, 'Henry Jones Thaddeus RHA 1860–1929', 1998.

143. *Man with Moustache in Profile with Arms Folded*
s. *THADDEUS; c.*1895; pencil and ink wash on paper; 16.1 × 7.4; private collection

Provenance: Gorry Gallery May-June 1998, no. 27, from whom purchased by present owner.
Literature: B. Rooney, 'Henry Jones Thaddeus RHA 1860–1929', 1998.

144. *Man with Hands in Pockets and Cummerbund (seen from the front)*
s. *THADDEUS; c.*1895; pencil and ink wash on paper; 16.1 × 8.4; private collection

Provenance: Gorry Gallery May-June 1998, no. 28, from whom purchased by present owner.
Literature: B. Rooney, 'Henry Jones Thaddeus RHA 1860–1929', 1998.

145. *Bearded, Stooping Old Man with Hands behind his Back*
s. *THADDEUS*
*c.*1895; pencil on paper; 16.6 × 10.2; private collection

Provenance: Gorry Gallery May-June 1998, no. 30, from whom purchased by present owner.
Literature: B. Rooney, 'Henry Jones Thaddeus RHA 1860–1929', 1998.

146. *Bearded Man with Top Hat and Frock Coat at a Bar*
s. *THADDEUS; c.*1895; pencil on paper; 17.3 × 11.5; private collection

Provenance: Gorry Gallery May-June 1998, no. 25, from whom purchased by present owner.
Literature: B. Rooney, 'Henry Jones Thaddeus RHA 1860–1929', 1998.

147. *Old Bearded Man Smoking (playing the piano)*
s. *THADDEUS; c.*1895; pencil and ink wash on paper; 13.7 × 8.0; private collection

Provenance: Gorry Gallery May-June 1998, no. 33, from whom purchased by present owner.
Literature: B. Rooney, 'Henry Jones Thaddeus RHA 1860–1929', 1998.

148. *Seated Man in a Bowler Hat*
s. *THADDEUS; c.*1895; pencil on paper; 15.6 × 8.9; private collection

Provenance: Gorry Gallery May-June 1998, no. 32, from whom purchased by present owner.
Literature: B. Rooney, 'Henry Jones Thaddeus RHA 1860–1929', 1998.

149. *Caricature of a Cleric*
s. *THADDEUS; c.*1895; charcoal on paper; private collection
Provenance: By descent, through family, to present owner.

150. *Laughing Cleric*
s. *THADDEUS; c.*1895; pencil on paper; 30 × 25; private collection

151. *Man Whistling*
s. *THADDEUS*; pencil on paper; 30 × 25; private collection

152. *Mediterranean Landscape with Church*
s. *THADDEUS;* pencil on paper; 12.5 × 25;
private collection

153. *The Poachers*
*c.*1895; oil on board; 63.5 × 75.5; private
collection

Provenance: Gorry Gallery, Nov. Dec. 1989,
no. 2; Phillips Leeds 10 May 1989, lot 233.

154. *View of the South Nave of the Church
of Saint-Pierre, Montmajour*
s. *THADDEUS; c.*1895; watercolour on
paper; 22.5 × 31.5; private collection

Provenance: By descent, through family, to
present owner.

155. *Mrs Thaddeus and her son Frederick
Francis*
1896; oil on canvas; untraced

Exhibition: RHA 1896, no. 7.
Literature: *New York Times* (European
Edition), 27 March 1896.

156. *Water Seller, Cairo – a study*
exh. 1896; untraced

Exhibition: RHA 1896, no. 264.
Literature: Anne Stewart, comp., 1985.

157. *Lady Tatton Sykes*
exh. 1896; oil on canvas?; untraced

Exhibition: RHA 1896, no. 55.
Literature: Anne Stewart, comp., 1985.

158. *Lewis, 9th Lord Clifford of Chudleigh*
s.d. *H.J. THADDEUS/ 1896*; oil on canvas;
180 × 90; private collection

Provenance: By descent through family of
sitter.

159. *Mabel Townley, 9th Lady Clifford of
Chudleigh*
s.d. *H.J. THADDEUS/ 1896*; oil on canvas;
180 × 90; private collection

Provenance: By descent through family of sitter.

160. *Self-portrait – a sketch c.*1896; untraced

Literature: *New York Herald* (European
Edition), 27 March 1896.

161. *Study of a Soldier*
s.d. *H.J. THADDEUS 97*; watercolour
over pencil on paper; private collection

Provenance: Sotheby's Slane, 12 May 1981, lot
340.

162. *Washerwomen*
s.d. *H.J. THADDEUS/ 1897*; watercolour
on paper; 23.5 × 34; private collection

Provenance: By descent, through family, to
present owner.

163. *Lily, Lady Elliot*
1897?; oil on canvas; untraced

Literature: H.J. Thaddeus, 1912.

164. *Christ before Caiaphas*
1890s?; oil on canvas; 84 × 132; untraced

Provenance: P. Naumann Esq. (1907).
Exhibition: Irish International Exhibition,
London, 1907, no. 221.
Literature: *Masterpieces of Modern Art*, n.d.,
no. 17.

165. *The Temptation of Saint Anthony*
1890s?; oil on canvas; untraced

Literature: *Masterpieces of Modern Art*, n.d.,
no. 16.

166. *A Bearded Man*
s.d. *H.J. THADDEUS 98;* oil on canvas;
102 × 78; private collection

Provenance: Sotheby's London, 5 July 1983,
lot 102.

167. *Virtuoso Performance*
1890s?; s. *H.J. THADDEUS;* oil on canvas;
114 × 152; private collection

Provenance: Sotheby's Belgravia, 28 Feb.
1978, lot 164.

168. *The Lady Alington*
1890s?; s. *H.J. THADDEUS;* oil on canvas;
untraced

Literature: Mrs F. Harcourt-Williamson, 1896.
Mezzotint by F. Jenkins

169. *The Cup that Cheers*
s.d. *H.J. THADDEUS/ 1898;* oil on canvas;
101.6 × 127; private collection.

Provenance: Grace Pym Gallery, Dublin;
Christie's, 20 May 1987, lot 214.
Exhibition: RHA 1899, no. 5.
Literature: Anne Stewart, comp., 1985.

170. *The Lady Alice Portal*
s. *H.J. THADDEUS*; 1890s? oil on canvas;
untraced

Exhibition: The Salon, Cairo, February 1892.
Literature: Mrs F. Harcourt-Williamson, 1896.

171. *Study for a portrait: Leo XIII*
s.d.i *H.J. THADDEUS/ 1899/ STUDY
FOR PORTRAIT/ LEO XIII;* oil on
canvas; untraced

Literature: *Illustrated London News*, 5
December 1903, p. 872.

172. *The Obbedienza (Pope Leo XIII
Receiving the Oath of Allegiance from the
Cardinals)*
s.d.i. *H.J. THADDEUS RHA PINXT
ROMA 1899/Leo XIII/ This proof tinted
by me HJT/To Cardinal Moran a tribute of
respect and esteem from the Painter/
Sydney Jan 1902;* tinted print (after
original in oil on canvas); St Mary's
Cathedral, Sydney

Provenance: Presented to Cardinal Moran of
Sydney by the artist, January 1902.
Exhibition: Sydney 1902?; (original) RHA 1901,
no. 4.
Literature: B. Rooney, 'Henry Jones
Thaddeus: An Irish Artist in Italy', 1999, pp.
126–33; H.J. Thaddeus, 1912, pp. 259–62.

173. *Self-portrait*
s.d.i. *H.J. THADDEUS/ 1900/ AETAT XL;*
oil on canvas; untraced

Literature: H.J. Thaddeus, 1912.

174. *The Rev. the Earl of Bessborough*
s.d. *H.J. THADDEUS/ 1901;* oil on canvas;
private collection

Provenance: By descent through family of sitter.
Literature: Major General Sir John Ponsonby,
1929; H.J. Thaddeus 1912.

175. *The Comforter*
s.d. *H.J. THADDEUS/ 1900;* oil on canvas;
127 × 102; private collection

Provenance: Gorry Gallery, January 2002, no. 14
Exhibition: RHA 1901, no. 95.
Literature: *Irish Daily Independent and Nation*,
11 March 1901.

176. *John E. Redmond, MP*
s.d. *H.J. THADDEUS/ 1901;* oil on canvas;
102 × 82; National Gallery of Ireland

Provenance: Callingham and Co., 1927, from
whom purchased by the National Gallery of
Ireland.
Exhibition: RHA 1902, no. 47 (as 'Portrait')
Literature: H.J. Thaddeus, 1912, pp. 178–9.

177. *King William of Württemberg – a study*
1901; oil on canvas?; untraced

Literature: King William of Württemberg,
Friedrichshafen, Letter to the duchess of York
(Princess May of Teck), 14 August 1901.

178. *Master Harold Maxwell*
exh. 1901; oil on canvas; untraced

Exhibtion: RHA 1901, no. 103.
Literature: Anne Stewart, comp., 1985.

179. *Sir Edmund Barton*
1901/2; oil on canvas?; untraced

Literature: H.J. Thaddeus, Letters to Sir
Edmund Barton, January 1902, Papers of Sir
Edmund Barton.

180. *Minister Edward O'Sullivan*
s.d. *H.J. THADDEUS/ 1902;* oil on canvas;
Town Hall, Sydney

Provenance: Town Hall, Sydney.
Literature: B.E. Mansfield, 1965; H.J.
Thaddeus, 1912, p. 284; H.J. Thaddeus,
Letters to Edward O'Sullivan, 9 March 1902,
Papers of Edward William O'Sullivan.

181. *Just Before Dawn, Red Sea*
s.d.i. *H.J. THADDEUS/ 1902/ JUST
BEFORE DAWN/ RED SEA;* oil on paper;
23 × 32.5; private collection

Provenance: By descent, through family, to
present owner.

182. *Sunset*
s. *H.J. THADDEUS; c.*1902; oil on paper;
23 × 32.5; private collection

Provenance: By descent, through family, to present owner.

183. *Portrait*
exh. 1902; oil on canvas?; untraced

Exhibition: RHA 1902, no. 14.
Literature: Anne Stewart, comp., 1985.

184. *Portrait*
exh. 190; Oil on canvas?; untraced

Exhibition: RHA 1902, no. 40.
Literature: Anne Stewart, comp., 1985.

185. *Pope Pius X*
s.d. *H.J. THADDEUS/ 1903;* also inscribed with the Papal Crest; oil on canvas; 124.5 × 102.2; Crawford Municipal Art Gallery

Provenance: Presented on loan to the Crawford Municipal Art Gallery by the artist, 14 June 1920.
Literature: 'First Portrait of Pope Pius X', *New York Herald* (European Edition), 20 September 1903; D. Gwynn, *Cork Examiner*, 20 July 1951; D. Gwynn, *Cork Examiner*, 7 August 1951; B. Rooney, 'Henry Jones Thaddeus: An Irish Artist in Italy', 1999, pp. 126–33; H.J. Thaddeus, 1912, pp. 316–23.

186. *Monsignor Merry del Val*
1903; oil on canvas?; untraced

Provenance: Collection of Eva Thaddeus (c. 1947).
Literature: 'Cardinal Joseph Sarto Elected to Throne of St. Peter', *New York Times* (European Edition), 5 August 1903 H.J. Thaddeus, 1912, p. 310.

187. *Duchess of Mondragone*
1903; oil on canvas?; untraced

Literature: 'Cardinal Joseph Sarto Elected to Throne of St Peter', *New York Times* (European Edition), 5 August 1903.

188. *Melin y gof at Treaddur Bay*
s.d. *H.J. THADDEUS/ 1903;* oil on board; 25.5 × 20.5; private collection

Provenance: Private collection; de Veres, Dublin, 11 June 1996, lot 87, from whom purchased by present owner.

189. *Lady Byron – a sketch*
s.d.i. *H.J. THADDEUS/ 1904/ TO LADY BYRON/ WITH THE PAINTER'S/ AFFECTIONATE REGARDS;* hand-tinted photograph; untraced

Literature: H.J. Thaddeus, London, 1912.

190. *Mrs Claude Cane*
exh. 1904; oil on canvas; 75 × 62.5; untraced

Provenance: Family of the sitter.
Exhibition: Guildhall Exhibition of Works by Irish Painters, London 1904, no. 191.

191. *Sir Mortimer Durand, British Ambassador at Washington – a study*
1904; watercolour on paper; untraced

Literature: H.J. Thaddeus, 1912.

192. *Mrs Philip Lydig, New York*
1904; oil on canvas; untraced

Literature: H.J. Thaddeus, London, 1912.

193. *General Roe, New York*
1904; oil on canvas; untraced

Literature: H.J. Thaddeus, 1912.

194. *Freddy Thaddeus with Ra, the family dog*
c. 1905; oil on canvas; 89.7 × 69.5; private collection

Provenance: Presented by the artist to neighbouring family, *c.*1907. By descent, through family, from whom purchased by present owner 1998.

195. *Baron de Benckendorf*
s.d. *H.J. THADDEUS/ 1906;* watercolour on paper; private collection

Provenance: By descent through artist's family.

196. *A Californian Landscape*
s.d. *H.J. THADDEUS/ 1906;* watercolour on paper; 15 × 20.5; private collection

Provenance: By descent through artist's family (though acquired many years after artist's death).

197. *A Seascape*
*c.*1907; watercolour on paper?; untraced
Provenance: Private collection, Carmel CA, (1953).

198. *A Summer Landscape*
oil on canvas; 19.5 × 25.5; private collection

Provenance: Adams, Dublin, 8 October 1987, lot 144.
Literature: Adams Catalogue, 8 October 1987.

199. *A Native American Encampment*
s. *H.J. THADDEUS; c.*1907–16;
watercolour on paper; 27.5 × 37.5; private collection

Provenance: By descent through artist's family (though acquired many years after artist's death).

200. *Michael Holland*
s.d.i. *H.J. THADDEUS/ 1920/ UNFINISHED;* oil on canvas; 91.6 × 61.3; Crawford Municipal Art Gallery, Cork

Provenance: Presented by the artist to the Crawford Art Gallery, 12 July 1920.
Literature: C.J.F. McCarthy, 'Letter from 'Man in Unfinished Portrait' – John Mitchel's Last Visit to Cork', *Evening Echo,* 30 December 1985; Diarmuid O'Donovan, 'A Court Painter from Cork', *Cork Weekly Examiner and Holly Bough, Christmas* Number 1961.

POSSIBLE ATTRIBUTIONS:

Girl with a Yellow Scarf
s.d. *THADDEUS JONES 1882;* oil on canvas; 53.5 × 42; private collection

Provenance: de Vere's, 17 June 1997, lot 84, from whom purchased by present owner.

'En Irlande: Affiliés de la Land-League faisant jurer sur la Bible à un fermier ce ne plus payer son tenancier'

Drawing by F. de Haenen after a sketch by Thaddeus. Engraved by A. Lepère. Printed in *Le Monde Illustré,* no date.

Bibliography

PRIMARY SOURCES

Manuscripts

Abbas II Hilmi, Khedive of Egypt, Abdin Palace Cairo, Letter to Queen Victoria, 7 April 1892, Royal Archives Windsor, RA 027/106.

Abbas II Hilmi, Khedive of Egypt, Alexandria, Letter to Queen Victoria, 27 July 1892, Royal Archives Windsor, RA 027/109.

Susan Ashworth (Senior Keeper: Social Keeper, Lancaster City Council Museum Services), Letters to the author, 31 May and 17 July 1995.

Sir Edmund Barton, Memos (for himself), 3 February and 15 May 1902 (written on letters from Harry Jones Thaddeus to Sir Edmund Barton, January 1902, Papers of Sir Edmund Barton), State Library of New South Wales, ML MSS 249/4.

Peter Barton, Welshpool, Powys, Letter to the author, 4 March 1999.

Earl of Bessborough, Wiltshire, Letter to the author, 28 November 1995.

Margaret Betteridge, Curator, Sydney Town Hall Collection, Letter to the author, 14 May 1996.

British Embassy Washington, Letter to the author, 8 December 1995.

Roy Brinton, Curator, Carisbrooke Castle Museum, Newport, Isle of Wight, Letters to the author, 29 September and 26 October 1996; 11 March 1997.

Edie Bourke, *Recollections of Edie Bourke of French's Walk, Cobh*, Crawford Municipal Art Gallery Records, Cork, undated.

Calender of all grants of probate and letters of administration made in the Probate Registries of the High Court of Justice of England, Wills and Probate Office, Somerset House, London.

Julian Campbell, 'Irish Artists in France and Belgium 1850–1914 , PhD thesis, Trinity College Dublin 1980.

Charles Clarke, Cork, Letters to the author, 11 and 25 March, 12 April, 29 June 1996.

Mary Clark, Archivist, Dublin Corporation, Letter to the author, 5 April 1995.

Lord Clifford of Chudleigh, Letters to the author, 28 June; 27 July; 10 August 1995.

Cork School of Design, Daily roll (19th century), Crawford Municipal Art Gallery, Cork.

Coutts and Co., Strand, London, Letters to Patrick Thaddeus, 16 and 17 December 1997.

Crawford Minutes Books, 3 November 1896; 31 January 1898; 28 February 1898, Crawford Municipal Art Gallery, Cork.

Major E.H.C. Davies, Powys, Letters to the author, 27 October and 5 November 1997.

Death Certificate of Harry Jones Thaddeus, 30 April [sic] 1929, Public Record Office, Myddleton St., London.

Viscount Duncannon, Hampshire, Letters to the author, 3 December 1995; 8 April 1996.

Lady Stella Durand, Sligo, Letter to the author, 7 January 1996.

Arthur Easton, Manuscripts Section, State Library of New South Wales, 4 June 1996.

General Minutes of the Gibson Bequest, 10 March 1930; 14 April 1930, Crawford Municipal Art Gallery, Cork.

General Minutes of the Technical Instruction Committee of the County Borough of Cork, 21 January 1891; 21 October 1895; 16 December 1895; 24 February 1896; 12 March

1896; 31 January 1898; 28 February 1898; 13 May 1912; 8 July 1912; 14 and 28 June 1920; 12 July 1920, Crawford Municipal Art Gallery, Cork.

Arlene Hess, Local History Department, The Henry Meade Williams Local History Department, Harrison Memorial Library, Carmel-by-the-Sea CA, Letters to the author, 29 May 1998; 5 January 1999.

Michael Holland, Letters to B. MacNamara, 22 and 28 February 1928; 19 March 1928, National Gallery of Ireland Archives, Dublin.

John Charles Kinoulty, 'A Biographical Dictionary of Ireland from 1500', unpublished work presented to Trinity College Dublin by the Kinoulty Family, January 1992.

Anne de Lagarenne, St Jacut de la Mer and Paris, Letters to the author, 9 July 1997; 11 and 25 August 1997; 8 September 1997; 30 November 1997; 27 February 1998.

Le Commissaire-Colonel de Lassalle, Conservateur au Musée de l'Armée, Paris, Letter to Col. Serge Paveau, 30 September 1999.

Marriage Certificate of Harry Jones Thaddeus and Mary Evelina Julia Grimshaw Woodward, 2 November 1893, Public Record Office, Myddleton St, London.

Roy Mattocks, Acting Verger, St John's Church, Ryde, Isle of Wight, Letter to the author, 21 June 1997.

Philip McEvansoneya, 'Frank Holl and the Profession of Portrait Painting in Victorian Britain', Transcript of lecture given at the National Portrait Gallery, London 1995.

B. MacNamara, Registrar National Gallery of Ireland, Dublin, Letter to Michael Holland, 20 February 1928, National Gallery of Ireland Archives, Dublin.

Minutes of a Special Meeting of the Art Committee of the County Borough of Cork, 6 February 1899, Crawford Municipal Art Gallery, Cork.

Minutes of a Special Meeting of the Technical Instruction Committee of the County Borough of Cork, 21 January 1891, Crawford Municipal Art Gallery, Cork.

Christopher Moock, The Heatherley's School of Fine Art, Chelsea, London, Letter to the author, 7 October 1998.

Blánaid O'Brolcháin, Dublin, Letter to the author, 13 March 1996.

Timothy O'Leary, Manuscript in Munster Fine Arts Club Scrapbook, 1940, Crawford Municipal Art Gallery, Cork.

C. Conor O'Malley, Letter to Diarmuid O'Donovan, 8 August 1968, Crawford Municipal Art Gallery, Cork.

Edward O'Sullivan, Extract from diary, undated [1901], Library of New South Wales, ML MSS B595.

'Painting of the Month: Pope Pius X', Information sheet, Crawford Municipal Art Gallery, Cork 1951(?).

Victoria Rawlings, Department of Fine and Decorative Art, National Army Museum, London, Letters to the author, 6 May and 10 June 1999.

Rev. Vincent J. Redden, Dean, St Mary's Cathedral, Sydney, Letter to the author, 18 May 1995.

Brendan Rooney, 'The Life and Work of H. Jones Thaddeus 1859–1929', PhD Thesis, Trinity College Dublin 2000

Royal Academy of Arts, Piccadilly, London, Letter to the author, 11 February 1997.

Royal Dublin Society, Records of the Taylor Prizes and Scholarships.

Royal Geographical Society, 1 Kensington Gore, London, Certificate of Candidate for Election (Harry Jones Thaddeus), Proposed 26 November 1894, Elected 10 December 1894, Removed December 1916.

Deirdre Stapp, New York, Letters to the author, 7 and 13 July 1998.

A.F. Tatham, Keeper, Royal Geographical Society, 1 Kensington Gore, London, Letters to the author, 28 February and 22 May 1997.

Prince Francis of Teck, Letter to his brother Adolphus (Dolly), 23, 24, 26, 28 and 30 January 1885, Royal Archives Windsor, RA CC 50/126

Princess May of Teck, Letters to Augusta, Grand Duchess of Mecklenburg-Strelitz, 13 March 1884, RA CC 21/10; 13 March 1884, RA CC 21/22; 22 March 1885, RA CC 21/22, Royal Archives Windsor.

Princess May of Teck, Letter to Prince Adolphus of Teck, 23, 24, 25, 28 and 30 January 1885, RA CC 50/107–126; March 1884, RA CC 50/107, Royal Archives Windsor.

Eva Thaddeus, Codicil to the Last Will and Testament of Mary Evelina Julia Thaddeus, 26 March 1946

Eva Thaddeus, The Last Will and Testament of Mary Evelina Julia Thaddeus, 1946, Wills and Probate Office, Somerset House, London.

Harry Jones Thaddeus, Letters to Sir Edmund Barton, January 1902, Papers of Sir Edmund Barton, State Library of New South Wales, ML MSS 249/4.

Harry Jones Thaddeus, Letters to Edward O'Sullivan, 9 March 1902, Papers of Edward William O'Sullivan, State Library of New South Wales, ML MSS 239/2.

Harry Jones Thaddeus, Transcripts of letters to the Technical Instruction Committee of the County Borough of Cork, 14 June 1920; 28 June 1920, Crawford Minute Books, Crawford Municipal Art Gallery, Cork.

Maria Thaddeus, Fort Collins CO, Letters to the author, 25 September 1997; 7 November 1997; 5 December 1997; 9 March 1998; 12 July 1998.

Patrick Thaddeus, Cambridge MA, Letters to the author, 1, 11, 19, 28 May 1997; 10 June 1997; 3, 21 July 1997; 12 August 1997; 16 September 1997; 1, 28 October 1997; 24 December 1997; 14 July 1998; 16 February 1999.

Victor Thaddeus, Arden DE, Letters to Henry L. Mencken, 20, 30 September 1939; 14 February 1941; 1 July 1942; 17 March 1943; 30 May 1943; 28 November 1943; 28 December 1950; 13, 24 September 1955, Mencken Collection, Manuscripts and Archives Section, New York Public Library.

Charles H. Townes, University of California, Letter to Patrick Thaddeus, 17 May 1996.

Stephen Vernoit, London, Letter to the author, 11 May 1995.

'William Gerard Barry (d. 1940)', Manuscript record, Crawford Municipal Art Gallery Records, Cork.

King William of Württemberg, Friedrichshafen, Letter to the Duchess of York (Princess May of Teck), 14 August 1901, Royal Archives Windsor, RA CC45/246.

The Marquess of Zetland, Letter to the author, 13 December 1995.

Audio Recordings
Maria Thaddeus, 'Victor Thaddeus and Old Mrs Arlt', hour-long programme first presented to the Theatre and Film Department, Pratt Institute, New York, 1977.

Recorded Interviews
Patrick and Jan Thaddeus, Conversation with the author, Trinity College, 1 September 1997.

SECONDARY SOURCES

Exhibition Catalogues
Allan Braham, *El Greco to Goya: The Taste for Spanish Paintings in Britain and Ireland*, exh. cat. The National Gallery, London, 1981.

Julian Campbell, *Frank O'Meara and his contemporaries*, exh. cat. Hugh Lane Municipal Gallery of Modern Art, Dublin, 1989.

Julian Campbell, *Gorry Gallery Catalogue*, Dublin, October 1986.

Julian Campbell, 'Henry Jones Thaddeus: On the Sands, Concarneau', *Gorry Gallery Catalogue*, Dublin, May-June 1995.

Julian Campbell, *The Irish Impressionists: Irish Artists in France and Belgium 1850–1914*, exh. cat. National Gallery of Ireland, Dublin, 1984.

Julian Campbell, *Onlookers in France: Irish Realist and Impressionist Painters*, exh. cat. Crawford Municipal Art Gallery, Cork, 1993.

Cent ans de République, exh. cat. Hôtel de Rohan (Musée des Arts d'Afrique et d'Oceanie), Paris, 1978.

Rosa Eva, 'Heatherley's: The First 100 Years', *The Heatherley's School of Fine Art: 150th Anniversary Exhibition*, exh. cat. Heatherley's School of Fine Art, London, 1996.

Denise Ferran, *William John Leech, An Irish Painter Abroad*, exh. cat. National Gallery of Ireland, Dublin, 1996.

Funnell P. et al. *Millais: Portraits*, exh. cat. National Portrait Gallery, London 1999, p. 166.

Caroline Fox and Francis Greenacre, *Artists of the Newlyn School (1880–1900)*, exh. cat. Newlyn Art Gallery, Plymouth and Bristol, 1979.

French 19th and 20th Century Painting from the National Gallery of Ireland. Corot to Picasso, exh. cat. Daimaru Museum, Tokyo, Daimaru Museum, Kyoto, Kawaguchiko Museum of Art, Daimaru Museum Umeda, Osaka, Aomori Municipal Gallery of Art, Mainichi Newspapers, 1996.

Elaine Kilmurray and Richard Ormond, eds, *Sargent*, exh. cat. Tate Gallery, London, 1998.

Lebanon – The Artist's View. 200 Years of Lebanese Painting, exh. cat. Barbican Centre (The British Lebanese Association), London, 1989.

Peter Murray, 'Artist and Artisan: James Brenan as Art Educator', in Adele M. Dalsimer and Vera Kreilkamp, eds, *America's Eye: Irish Paintings from the Collection of Brian P. Burns*, exh. cat Boston College Museum of Art, 1996, pp. 40–46.

Richard Ormond and John Turpin, *Daniel Maclise 1806–1870*, exh. cat. National Portrait Gallery, Arts Council of Great Britain, 1972.

Niamh O'Sullivan, *Aloysius O'Kelly. Re-orientations: Painting, Politics and Popular Culture*, exh. cat. Hugh Lane Municipal Gallery of Modern Art, Dublin 1999.

Christina Payne, 'Philanthropy and Politics: Rural Genre Paintings and Reform', *Rustic Simplicity: Scenes of Cottage Life in Nineteenth-Century British Art*, exh. cat. Djanogly Art Gallery, University of Nottingham, 1998.

Elizabeth Prettejohn, *Interpreting Sargent*, exh. cat. Tate Gallery, London, 1998.

Catherine Puget, ed., *Peintres Américains en Bretagne 1864–1914*, exh. cat. Musée de Pont-Aven, 1995.

Brendan Rooney, 'Harry Jones Thaddeus: The Comforter', *Gorry Gallery Catalogue*, Dublin, January-February 2002.

Brendan Rooney, 'Harry Jones Thaddeus: Portrait of a Young Woman', *Gorry Gallery Catalogue*, Dublin, June 2000.

Brendan Rooney, 'Henry Jones Thaddeus: Bearded Figure in Dutch Costume', *Gorry Gallery Catalogue*, Dublin, November-December 1997.

Brendan Rooney, 'Henry Jones Thaddeus: On the Beach', *Gorry Gallery Catalogue*, Dublin, June 1997.

Brendan Rooney, 'Henry Jones Thaddeus (drawings)', *Gorry Gallery Catalogue*, Dublin, May-June 1998.

Donald A. Rosenthal, *Orientalism: The Near East in French Painting 1800–1880*, exh. cat. Memorial Art Gallery of the University of Rochester, 1982.

Alison Smith, ed., *Exposed. The Victorian Nude*, exh. cat. Tate Britain, London 2001.

Theodore E. Stebbins Jr and William H. Gerdts, *The Lure of Italy: American artists and the Italian experience 1760–1914*, exh. cat. Museum of Fine Arts Boston, New York, 1992.

Paul Usherwood and Jenny Spencer-Smith, *Lady Butler: Battle Artist 1846–1933*, exh. cat. National Army Museum, London, 1987.

Gabriel P. Weisberg, *The Realist Tradition: French Painting and Drawing 1830–1900*, exh. cat. The Cleveland Museum of Art, Bloomington, 1980. (Cleveland Museum of Art in cooperation with Indiana University Press)

Andrew Wilton, *The Swagger Portrait: Grand Manner Portraiture in Britain from Van Dyck to Augustus John 1630–1930*, exh. cat. Tate Gallery, London, 1993.

General Works

Marie Bashkirtseff, *The Journal of Marie Bashkirtseff* (Mathilde Blind [trans.]), London, 1985.

Martin Bernal, *Black Athena: The Afroasiatic Roots of Classical Civilization*, London, 1987.

Mrs Lionel Birch, *Stanhope A. Forbes and Elizabeth Stanhope Forbes*, London, 1906.

Henry Blackburn and Randolph Caldecott, *Breton Folk*, London, 1880.

Thomas Bodkin, *Four Irish Landscape Painters*, Dublin and London, 1920.

Thomas Bodkin, *Hugh Lane and His Pictures*, Dublin, 1956.

Daisy F. Bostick and Dorothea Castelhun, *Carmel – At Work and Play*, place of publication unknown, 1925.

Fenner Brockway, *The Colonial Revolution*, London, 1973.

Norma Broude, *The Macchiaioli: Italian Painters of the Nineteenth Century*, New Haven and London, 1987.

Elizabeth Butler, *An Autobiography*, London, 1922.

Susan P. Casteras and Colleen Denney, eds, *The Grosvenor Gallery – A palace of art in Victorian England*, New Haven and London, 1996.

D.F. Cheshire, *Music Hall in Britain*, London, 1974.

John Collier, *The Art of Portrait Painting*, London, 1906.

Virginia Cowles, *The Romanovs*, London, 1971.

Walter Crane, *An Artist's Reminiscences*, London, 1907.

The earl of Cromer, *Abbas II*, London, 1915.

Anne Crookshank and the Knight of Glin, *The Painters of Ireland 1660–1920*, London, 1978.

L. Perry Curtis Jr, *Apes and Angels – The Irishman in Victorian Caricature*, Washington and London, 1997.

David Duff, *Queen Mary*, London, 1985.

Henry Festing-Jones, *Samuel Butler: author of Erewhon (1835–1902). A memoir*, i, London, 1919.

Lois Marie Fink, *American Art at the Nineteenth Century Salons*, Cambridge, 1990.

William John Fitzpatrick, *Memories of Father Healy of Little Bray*, London, 1896.

Paula Gillett, *The Victorian Painter's World*, Gloucester, 1990.

Harold Gilliam and Ann Gilliam, *Creating Carmel: The Enduring Vision*, Salt Lake City, 1992.

Edmund de Goncourt, *Paris and the Arts, 1851–1896: From the Goncourt Journal* (George J. Becker and Edith Philips, eds and comps), London, 1971.

Lord Ronald Sutherland Gower, *My Reminiscences*, London, 1895.

Lord Ronald Sutherland Gower, *Old Diaries 1881–1901*, London, 1902.

Barry Guise and George Lees, *Windmills of Anglesey*, Builth Wells, 1992.

Mrs. F. Harcourt Williamson, ed., *The Book of Beauty (Late Victorian Era): A collection of beautiful portraits with literary, artistic and musical contributions by men and women of the day*, London, 1896.

A.S. Hartrick, *A Painter's Pilgrimage through Fifty Years*, Cambridge, 1939.

Francis Haskell and Nicholas Penny, *Taste and the Antique – The Lure of Classical Sculpture 1500–1900*, New Haven and London, 1988.

Julian Hawthorne, *Shapes that Pass*, London, 1928.

Frances Hays, *Women of the Day*, London, 1885.

Philip Henderson, *Tennyson – Poet and Prophet*, London, 1978.

Blanche Willis Howard, *Guenn: A Wave on the Breton Coast*, Boston, 1883.

Michael Jacobs, *The Good and Simple Life: Artist Colonies in Europe and America*, Oxford, 1985.

Rana Kabbani, *Europe's Myths of the Orient*, London, 1986.

Zsigmond László and Béla Mátéka, *Franz Liszt: A biography in pictures*, London, 1968.

John Lavery, *The Life of a Painter*, London, 1940.

Michael Levey, *Florence: A Portrait*, London, 1996.

F.S.L. Lyons, *Charles Stewart Parnell*, London, 1977.

John M. MacKenzie, *Orientalism: History, Theory and the Arts*, Manchester and New York, 1995.

Tessa Mackenzie, *The Art Schools of London: Painting, Music etc.*, London, 1896.

Patricia Mainardi, *The End of the Salon: Art and the State in the Early Third Republic*, Cambridge, 1993.

H.C.G. Matthew, ed., *The Gladstone Diaries*, vol. 12, Oxford, 1994.

Kenneth McConkey, *British Impressionism*, London, 1989.

Kenneth McConkey, *Sir John Lavery*, Edinburgh, 1993.

Mortimer Menpes, *Whistler as I Knew Him*, London, 1904.

Delia Millar, *The Victorian Drawings and Watercolours in the Collection of Her Majesty the Queen*, London, 1995.

Oliver Millar, *The Victorian Pictures in the Collection of Her Majesty the Queen*, 2 vols, Cambridge, 1992.

George Moore, *Confessions of a Young Man*, London, 1961.

George Moore, *Impressions and Opinions*, London, 1891.

George Moore, *A Modern Lover. A Realistic Novel*, Chicago, 1887 (London, 1883).

Thomas Moore, *Irish Melodies* (edition for Ireland), Dublin, 1857.

Thomas Moore, *The Poetical Works of Thomas Moore* (reprinted from the early editions, with explanatory notes etc.), London and New York, 1881.

Edward Morris, ed., *Victorian and Edwardian Paintings in the Lady Lever Art Gallery*, London, 1994.

William M. Murphy, *Prodigal Father: The Life of John Butler Yeats (1839–1922)*, Ithaca and London, 1978.

National Portrait Gallery, *Victorian Portraits*, London, 1996.

Christopher Newall, *The Grosvenor Gallery Exhibition: Change and Continuity in the Victorian Art World*, Cambridge, 1995.

D.J. O'Donoghue, *The Geographical Distribution of Irish Ability*, Dublin and London, 1908.

Padraic O'Farrell, *Who's Who in the Irish War of Independence*, Dublin and Cork, 1980.

John O'Grady, *The Life and Work of Sarah Purser*, Dublin, 1996.

S.F. Pettit, *This City of Cork 1700–1900*, Cork, 1977.

David Piper, *The English Face*, London, 1992.

Marcia Pointon, *Hanging the Head: Portraiture and social formation in eighteenth-century England*, New Haven and London, 1993.

James Pope-Hennessy, *Queen Mary 1867–1953*, London and Sydney, 1959.

Richard Redgrave and Samuel Redgrave, *A Century of British Painters* (reprint) Oxford, 1981.

A.M. Reynolds, *The Life and Work of Frank Holl*, London, 1912.

Christopher Ricks, ed., *The Poems of Tennyson*, 3 vols, Harlow, 1987.

Jean-Maurice Rouquette, *Provence Romane: La Provence Rhodanienne*, 1974.

Edward Said, *Culture and Imperialism*, London, 1993.

Edward Said, *Orientalism*, London, 1978.

Henry J. Savage Landor, *Everywhere: The Memoirs of an Explorer*, London, 1924.

Walter Shaw Sparrow, *John Lavery and his Work*, London, 1912.

Edward Simmons, *From Seven to Seventy*, New York and London, 1922.

Lindsay Smith, *The Politics of Focus: Women, Children and Nineteenth-Century Photography*, Manchester, 1998.

W.T. Stead, *Portraits and Autographs: An Album for the People*, London, 1891.

Arthur Symons, *Studies in Seven Arts*, London, 1906.

H. Jones Thaddeus, *Recollections of a Court Painter*, London, 1912.

James Tissot, *The Life of Our Saviour Jesus Christ* (Notes translated by Mrs Arthur Bell), London, 1897.

Julian Treuherz, ed., *Hard Times. Social Realism in Victorian Art*, London and New 1987.

Julian Treuherz, *Victorian Painting*, London, 1993.

Helen Mabel Trevor, *The Ramblings of an Artist*, London, 1901.

William E. Vaughan, *Landlords and their Tenants in Ireland 1848–1904*, Dublin, 1984.

Kirk Varnedoe, *Gustave Caillebotte*, New Haven and London, 1987.

Kirk Varnedoe, *Northern Light: Nordic art at the turn of the century*, New Haven and London, 1988.

Alan Walker, *Franz Liszt. Vol III.: The Final Years 1861–86*, London and Boston, 1997.

Giles Walkley, *Artists Houses in London, 1764–1914*, Aldershot, 1994.

Michael J. Walsh, ed., *Lives of the Popes*, London, 1998.

Sally Warwick-Haller, *William O'Brien and the Irish Land War*, Blackrock, 1990.

H. Barbara Weinberg, *The Lure of Paris: Nineteenth-century American painters and their French teachers*, New York, 1991.

H. Barbara Weinberg, Doreen Bolger and David Park Curry, *American Impressionism and Realism – The Painting of Modern Life 1885–1915*, New York, 1995.

Gabriel P. Weisberg, *Beyond Impressionism – The Naturalist Impulse in European Art 1860–1905*, London, 1992.

J. Wentworth Day, *Lady Houston, D.B.E. – The Woman Who Won the War*, London, 1958.

Nancy Weston, *Daniel Maclise. Irish Artist in Victorian London*, Dublin, 2001.

Christopher Wood, *Tissot: The life and work of Jacques Joseph Tissot 1836–1902* (reprint), London, 1998.

Christopher Wood, *Victorian Panorama: Paintings of Victorian Life*, London, 1976.

Michael Wynne and Adrian le Harivel, *National Gallery of Ireland. Acquisitions 1984–1986*, Dublin, 1986.

Andrew McLaren Young, Margaret MacDonald, Robin Spencer and Hamish Milles, *The Paintings of James McNeill Whistler*, 2 vols, New Haven and London, 1980.

Articles

[Untitled note on Mihály Munkácsy's painting *Christ before Pilate*] *The Athenæum*, no. 2845, 6 May 1882, p. 580.

Cyril Barrett, 'Irish Nationalism and Art 1800–1921', *Studies*, Winter 1975, pp. 393–409.

René le Bihan, 'Concarneau sous la troisième République, ou l'académisme aux bains le mer', in Henri Belbéoch, ed., *Les peintres de Concarneau*, Quimper, 1993, pp. 25–30.

Barra Boydell, 'The Female Harp: The Irish Harp: The Irish Harp in Eighteenth- and Early Nineteenth-Century Romantic Nationalism', *RIdIM/RCMI* (Répertoire International d'Iconographie Musicale/ Research Center for Musical Iconography) Newsletter, vol. XX, no. 1, Spring 1995, pp. 10–17.

Síghle Bhreathnach-Lynch, 'Framing the Irish: Victorian Painting and the Irish Peasant', *Journal of Victorian Culture*, vol. 2, no. 2, Autumn 1997, pp. 245–63.

Richard R. Brettell, 'The "First" Exhibition of Impressionist Painters', in Charles S. Moffett, Ruth Berson, Barbara Lee Williams and Fronia E. Wissman, *The New Painting: Impressionism 1874–1886*, exh. cat. The Fine Arts Museums of San Francisco and The National Gallery of Art, Washington, 1986, pp. 188–202.

Denys Brook-Hart, 'Introduction', in Jane Johnson, ed., *Works Exhibited at the Royal Society of British Artists 1824–1893*, Antique Collectors' Club, Woodbridge, 1975.

Gertrude E. Campbell, 'Frank Holl and his Works', *Art Journal*, 1889, pp. 53–59.

Julian Campbell, 'Artistes irlandais en Bretagne', *Peintres irlandais en Bretagne*, exh. cat. Musée de Pont-Aven, 1999, pp. 4–30.

Julian Campbell, 'H.J. Thaddeus, Jour de Marché, Finistère' in D. Delouche, *Artistes étrangers à Pont-Aven*, Rennes, 1988, pp. 92–99.

Julian Campbell, 'Irish artists in Brittany, 1860–1914', in Catherine Laurent and Helen Davis, *Irlande et Bretagne. Vingt siècles d'Histoire*, Rennes, 1994, pp. 228–35.

Julian Campbell, 'Irish Painters in Paris, 1868–1914', *Irish Arts Review Yearbook*, vol. 11, 1995, p. 163.

Julian Campbell, 'Jour de Marché, Finistère', *Irish Arts Review Yearbook*, vol. 3, no. 3, Autumn 1986, pp. 16–18.

Julian Campbell, 'Les Irlandais en Bretagne, 1860–1914', in D. Delouche, *Pont-Aven et ses peintres*, Rennes, 1986, pp. 35–46.

Joan Crossley, 'A Sense of Identity', in Sara Holdsworth and Joan Crossley, *Innocence and Experience. Images of Children in British Art from 1600 to the Present*, exh. cat. Manchester City Art Galleries, 1992, pp. 31–36.

E. Rimbault Dibdin, 'The Art of Frank Dicksee, R.A.', *The Christmas Art Annual* 1905, pp. 3–32.

Richard Dorment, 'James McNeill Whistler 1834–1903', in Richard Dorment and Margaret F. Macdonald, *James McNeill Whistler*, exh. cat. Tate Gallery, London, 1995, pp. 13–22.

Catherine Fehrer, 'New Light on the Académie Julian and Its Founder', *Gazette des Beaux Arts*, vol. CIII, no. VI, May–June 1984, pp. 207–16.

Catherine Fehrer, 'Women at the Académie Julian in Paris', *The Burlington Magazine*, vol. CXXXVI, no. 1100, November 1994, pp. 752–7.

John Gilbert, 'A Record of Authors, Artists and Musical Composers born in the County of Cork', *JCHAS*, vol. XIX, series 2, pp. 168–81.

Sheridan Gilley, 'English Attitudes to the Irish in England, 1780–1900', in Colin Holmes, ed., *Immigrants and Minorities in British Society*, London, 1978, pp. 81–110.

Birge Harrison, 'The New Departure in Parisian Art', *Atlantic Monthly* 66, December 1890, pp. 753–64.

'H.J. Thaddeus "Christ before Caiaphas"', Masterpieces of Modern Art, vol 1, no. 17, n.d. (c. 1924/5. Copy stamped by British Library, 10 February 1925).

'H.J. Thaddeus R.H.A. "The Temptation of St. Anthony"', *Masterpieces of Modern Art*, vol. 1, no. 16, n.d. (c. 1922/3. Copy stamped by British Library, 26 February 1923).

Dagmar Höher, 'The Composition of Music Hall Audiences 1850–1900', in Peter Bailey, ed., *Music Hall – The Business of Pleasure*, Milton Keynes, 1986, pp. 73–92.

Clive Holland, 'Student Life in the Quartier Latin, Paris', *The Studio*, vol. XXVII, 1902–03, pp. 33–40.

Michael Holland, 'Culture and Customs: A Cork Miscellany', *JCHAS*, series 2, vols. 47–48, 1942–43, pp. 99–105.

Julius Kaplan, 'Jules Lefèbvre', in *Macmillan Dictionary of Art*, vol. 19, London, 1996, p. 66.

P.H. Kelly, 'Pope Leo XIII', in Charles G. Herbermann and Edward Pace, eds, *The Catholic Encyclopaedia*, London, 1907.

Louis Pierre le Maitre, 'Concarneau: Entre les ports, une ville close', in Henri Belbéoch, ed., *Les peintres de Concarneau*, Quimper, 1993, pp. 31–36.

M.A.P. (Mainly About People), vol. XXI, no. 549, Christmas Edition 1908, p. 581.

Catherine Marshall, 'Painting Irish History: The Famine', *History Ireland*, Autumn 1996, pp. 46–50.

Kenneth McConkey, "Well-bred Contortions' 1880–1918', in Christopher Newall ed., *The British Portrait 1660–1960*, Woodbridge, 1991.

Wilfrid Meynell, 'The Life and Work of Lady Butler', *Art Journal*, Christmas Number 1898.

Cosmo Monkhouse, 'The Royal Academy III', *The Academy*, no. 630, 31 May 1884.

Edward Morris and Amanda McKay, 'British Art Students in Paris 1814–1890: Demand and Supply', *Apollo*, vol. CXXXV, February 1992, pp. 78–84.

Rosa Mulholland, 'Irish Painters of the Present Year', *Irish Monthly*, vol. XVII, September 1889, pp. 481–84.

Peter Murray, 'Art Institutions in Nineteenth Century Cork', in P. O'Flanagan and C. Buttimer, eds, *Cork History and Society*, Dublin, 1993, pp. 813–72.

Peter Murray, 'Artist and Artisan: James Brenan as Art Educator', in Adele M. Dalsimer and Vera Kreilkamp, *America's Eye: Irish Paintings from the Collection of Brian P. Burns*, Boston College of Art, 1996, pp. 40–46.

Peter Murray, 'Cork Art 1851–75', in Peter Murray, comp., *Illustrated Summary Catalogue of the Crawford Municipal Art Gallery*, Cork, 1991.

Christopher Neve, 'London Art School in Search of Home: Heatherley's – I', *Country Life*, 17 August 1978, pp. 448–50.

Christopher Neve, 'A Question of Survival', Heatherley's School of Art– II', *Country Life*, 31 August 1978, pp. 570–71.

Christopher Newall, 'The Victorians 1830–1880', in Christopher Newall, ed., *The British Portrait 1660–1960*, Woodbridge, 1991.

Linda Nochlin, 'The Imaginary Orient', *Art in America*, May 1983, pp. 119–131, 187–89.

C. Ó'S, 'Obituary – The Late Mr. Michael Holland', *JCHAS*, series 2, vol. 52, 1950, pp. 126–27.

Niamh O'Sullivan, 'Painters and Illustrators: Aloysius O'Kelly and Vincent van Gogh', *Irish Arts Review Yearbook*, vol. 14, Dublin 1998, pp. 134–39.

Niamh O'Sullivan, 'The Iron Cage of Femininity: Visual Representation of Women in 1880s Land Agitation', in Tadhg Foley and Seán Ryder, eds., *Ideology and Ireland in the Nineteenth Century*, Dublin, 1997, pp. 181–96.

Niamh O'Sullivan, 'Through Irish Eyes: the work of Aloysius O'Kelly in the *Illustrated London News*', *History Ireland*, Autumn 1995, pp. 10–16.

Marcia Pointon, 'Portrait-Painting as a Business Enterprise in London in the 1780s', *Art History*, vol. 7, no. 2, June 1984.

F. Rinder, 'J.J. Shannon, A.R.A.' *Art Journal* 1901, pp. 41–45.

Brendan Rooney, 'Henry Jones Thaddeus: An Irish Artist in Italy', *Irish Arts Review Yearbook*, vol. 15, 1999, pp. 126–33.

Brendan Rooney, 'The Irish Exhibition at Olympia, 1888', *Irish Architectural and Decorative Studies – The Journal of the Irish Georgian Society*, vol. I, 1998, pp. 100–19.

'Science and Art Prospects in Cork', *Irish Builder*, vol. XVIII, no. 391, 1 April 1876, p. 85.

Jeanne Sheehy, 'The Flight from South Kensington: British Artists at the Antwerp Academy 1877–1885', *Art History*, vol. 20, no. 1, March 1997, pp. 124–53.

John Turpin, 'The Education of Irish Artists 1877–1975', *Irish Arts Review Yearbook*, vol. 13, 1997, pp. 188–93.

John Turpin, 'Maclise as a Book Illustrator', *Irish Arts Review*, vol. 2, no. 2, Summer 1985, pp. 23–27.

T. Wemyss Reid, 'Mr. Gladstone and his Portraits', *Magazine of Art*, 1889, pp. 82–89
Leslie Williams, 'Irish Identity and the *Illustrated London News*, 1846–1951– Famine to Depopulation', in Susan Shaw Sailor, ed., *Representing Ireland: Gender, Class, Nationality, Florida*, 1997, pp. 59–93.
Helen Zimmern, 'Artists' Homes: Mr. Frank Holl's, in Fitzjohn's Avenue', *The Magazine of Art*, vol. VIII, 1885, pp. 144–50.

Newspaper Columns
'Art Colony Developed at Turn of the Century', *Monterey Peninsula Herald*, 1 June 1970.
'A Famous Cork Painter – Interview with Mr. H.J. Thaddeus' [abridged reprint of article from *New York Herald* (European Edition), 27 March 1896], *Cork Examiner*, 7 April 1896.
Denis Gwynn, 'Now and Then: An Occasional Commentary', *Cork Examiner*, 7 August 1951.
Denis Gwynn, 'Now and Then: An Occasional Commentary. A Cork Portrait', *Cork Examiner*, 20 July 1951.
Denis Gwynn, 'Now and Then: An Occasional Commentary. Early Thaddeus Portraits', *Cork Examiner*, 3 August 1951.
Denis Gwynn, 'Now and Then: An Occasional Commentary. Portrait of Pius X', *Cork Examiner*, 31 July 1951.
M[ichael].H[olland]., 'From the Marsh to the Vatican: Romance of a Court Painter', *Christmas Number Cork Holly Bough and Weekly Examiner*, 1937.
'Irlande et France', *The Irishman*, 21 May 1881.
'Diarmuid O'Donovan, 'A Court Painter from Cork', *Cork Weekly Examiner and Holly Bough*, Christmas Number 1961.
Eoin O'Mahony, 'A Cork Artist', Letter to the editor, *Cork Examiner*, 26 July 1951.
'Sternberg v Thaddeus', *The Times*, 2 December 1890.
'Thaddeus v Annan', *The Times*, 1 May 1895.
[Harry Jones Thaddeus' declaration of change of name], *The Times*, 24 June 1885.

Obituaries
'Cork Painter Dead', *Cork Examiner*, 8 May 1929.
Thomas Crosbie, 'Richard Barter, Sculptor – Necrology', *JCHAS*, series 2, vol. 2, 1896, pp. 85–88.
'Death of Noted Painter', *Isle of Wight County Press*, 4 May 1929.
Eve (Eva Thaddeus), 'My Greatest Friend – by the writer of "Eve in Paris"', *Saturday Review*, vol. 163, 9 January 1937, p. 43.
'Henry Jones Thaddeus, R.H.A.' (death notice), *The Connoisseur*, vol. 84, 1929, p. 60.
(Michael Holland), 'Henry Jones Thaddeus: An Appreciation (by one who knew him), *Cork Examiner*, 9 May 1929.
'The Late Mr. H.J. Thaddeus', *Isle of Wight County Press*, 11 May 1929.
'Obituaries: Mr. H.J. Thaddeus', *The Times*, 8 May 1929.
'Tributes to Lady Houston – Patriot', *Saturday Review*, vol. 163, 9 January 1937.

Works of Reference
F. Boase, *Modern English Biography*, 6 vols, Truro, 1892–1921.
Ian Chilvers and Harold Osborne, *The Oxford Dictionary of Art*, Oxford, 1988.
Rodney K. Engen, *Dictionary of Victorian Engravers, Print Publishers and their Works*, Cambridge, 1979.
David Hugh Farmer, *The Oxford Dictionary of Saints*, 3rd edition, Oxford, 1992.
James Hall, *Dictionary of Subjects and Symbols in Art*, London, 1993.

Charles G. Herbermann and Edward Pace, eds, *The Catholic Encyclopaedia*, London, 1907.

Alan Johnson and Dumas Malone, eds, *Dictionary of American Biography*, vol. III, New York, 1959.

Knox Translation of the Bible, 2nd edition, London, 1956.

Stanley Kunitz and Howard Haycraft, eds, *British Authors of the Nineteenth Century*, New York, 1936.

L.C. Sanders, *Celebrities of the Century: Men and women of the nineteenth century*, 2 vols, London, 1887.

Geoffrey Serle, ed., *Australian Dictionary of Biography*, vol. XI 1891–1939, Melbourne, 1988.

Theo Snoddy, *Dictionary of 20th Century Irish Artists*, Dublin, 1996.

Walter Strickland, *A Dictionary of Irish Artists*, 2 vols, Dublin, 1913.

Ulrich Thieme and Felix Becker, comps, *Allgemeines Lexikon der Bildenden Künstler von der Antike bis zur Gegenwart*, Leipzig, 1933.

Index

giving page no.; figure no.; plate no.;
with 'List of Works' no. in parentheses